CREATIVE
DRAWING

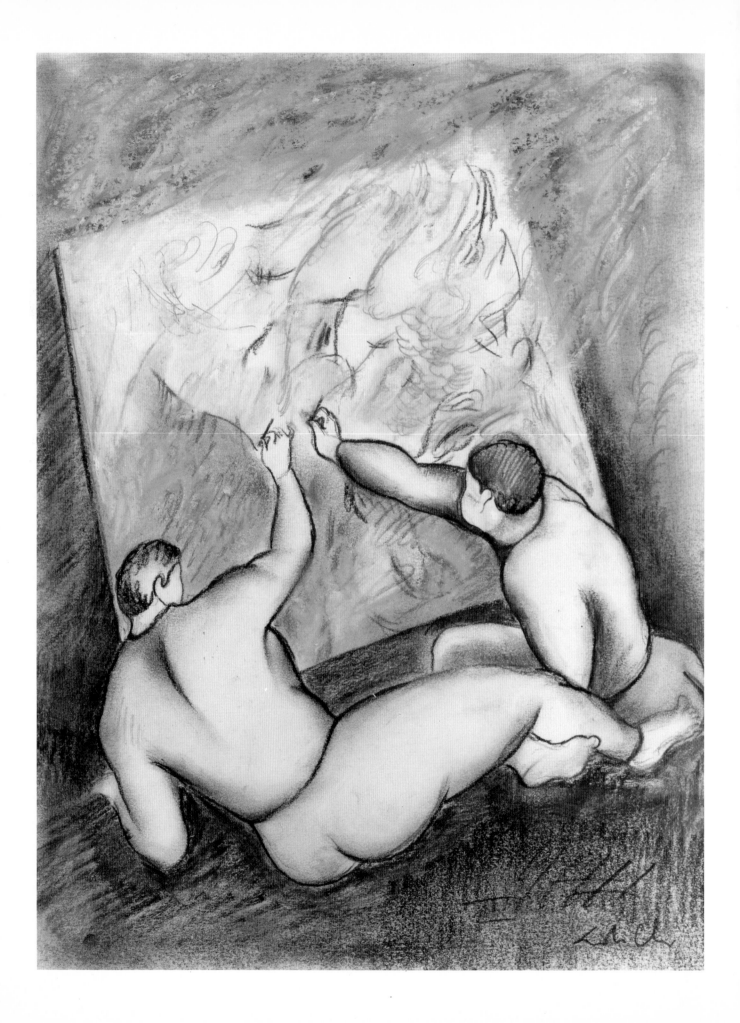

CREATIVE DRAWING

HOWARD J. SMAGULA
FELICIAN COLLEGE, NEW JERSEY

Book Team

Editor *Kathleen Nietzke*
Developmental Editor *Deborah Daniel Reinbold*

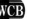
Brown &
Benchmark
A Division of Wm. C. Brown Communications, Inc.

Vice President and General Manager *Thomas E. Doran*
Executive Managing Editor *Ed Bartell*
Executive Editor *Edgar J. Laube*
Director of Marketing *Kathy Law Laube*
Director of Production *Vickie Putman Caughron*
National Sales Manager *Eric Ziegler*
Marketing Manager *Steven Yetter*
Advertising Manager *Jodi Rymer*

Wm. C. Brown Communications, Inc.

Chairman Emeritus *Wm. C. Brown*
Chairman and Chief Executive Officer *Mark C. Falb*
President and Chief Operating Officer *G. Franklin Lewis*
Corporate Vice President, Operations *Beverly Kolz*
Corporate Vice President, President of WCB Manufacturing *Roger Meyer*

Library of Congress Catalog. Card Number: 92-81859

ISBN 0-697-14954-4

This book was designed and produced by
Calmann and King Ltd, London.

Designer *Karen Stafford*
Picture Researcher *Donna Thynne*

Typeset by Edna A. Moore, ⚘ Tek-Art, Addiscombe, Croydon, Surrey

Printed in Hong Kong

10 9 8 7 6 5 4 3 2 1

Front cover: Edgar Degas, *Danseuse au Repos*, c. 1880.
Pastel, 29½ × 21 in (75 × 75 cm).
Christie's, London, Courtesy The Bridgeman Art Library, London.

Frontispiece: Sandro Chia, *Evening of Collaboration*, 1981.
Crayon and pastel, 16 × 12 in (40.5 × 30.4 cm). Courtesy,
Anthony d'Offay Gallery, London.

Back cover: Miguel Barceló *Le Marché du Charbon*, 1988.
Gouache on paper, 19¾ × 27 in (50.1 × 70 cm).
Courtesy, Leo Castelli Gallery, New York.

CONTENTS

PROJECT LIST

PREFACE

Despite advancing technology in the fields of design and graphics, the hand-drawn image still exerts a powerful hold over the imagination, and the act of drawing continues to give a special satisfaction. Sadly, many people believe they lack the natural ability or "talent" to produce drawings that they feel are worthwhile. This book seeks to disprove that myth. Here, drawing is presented as a visual language with its own vocabulary and internal logic. Like any other language that is not our mother tongue, the art of drawing can be learned with proper instruction and practice. *Creative Drawing* introduces beginning and intermediate students to the traditions, the theoretical concepts, and the technical and creative skills that are the basis for achieving rewarding results in this artform.

My experiences of teaching drawing at colleges and universities over the past twenty years have shown me that nothing is as important to the student as actual drawing practice. In order to learn to draw, students must commit their vision to paper over and over again. A considerable part of this book is therefore devoted to well-defined drawing projects which complement the text. Reinforcing guidance given by the instructor, these projects enable students to make use of the concepts that have been discussed and illustrated. All these assignments can be done without unusual materials or costly equipment. To enable students to see how individuals like themselves have responded to the challenges of drawing, I have included forty-two student illustrations in conjunction with the many reproductions of contemporary and historic drawings.

Creative Drawing is divided into three main parts, "The World of Drawing," "The Elements of Drawing," and "Creative Expressions," taking students from basic information about drawing, through to beginning exercises involving the study of the visual elements, and on to more advanced personal and creative applications.

Part I, "The World of Drawing," introduces and defines drawing as an important form of visual expression and communication and offers examples of its enormous range of expressive possibilities in the contemporary world. Chapter 1, "The Evolution of Drawing," focuses on the traditions of drawing and the practical lessons that can be learned from the past. Students are also introduced to non-Western drawing traditions, thus broadening their cultural perspectives and enriching their conceptual understanding.

Part II, "The Elements of Drawing," introduces the graphic techniques and visual elements used in the drawing process. Chapter 2 gives guidance in the initial selection of materials. Exercises involving basic media such as charcoals

and chalk, graphite, and brush and ink introduce students to the process of mark-making and allow them to experience and control the interaction of paper and media. Chapter 3 covers gesture drawing and continuous line drawing techniques. Students are also introduced to construction methods and shown how to analyze, plan, and organize their drawings. Chapters 4, 5, and 6 discuss the roles played by the visual elements line, value, and texture and offer further projects aimed at giving students practical experience in how they are used. Once students have had a chance to explore how these elements work and how they can be manipulated to achieve a variety of effects, Chapter 7, "Composition and Space," helps them to integrate these visual elements into unified compositions while Chapter 8 introduces the principles of perspective.

Part III, "Creative Expressions," encourages the application of fundamental drawing skills toward more personally expressive goals. Chapter 9, "Visual Thinking," examines the role of creativity in the drawing process and offers students practical help in overcoming creative blocks.

Chapters 10, 11, and 12 focus on creative applications of the concepts and techniques already covered. Since the element of color plays an increasingly important role in contemporary drawing, Chapter 10, "Exploring Color," invites the student to experiment with a variety of wet and dry color media. Chapter 11 examines the way both historic and contemporary artists have developed and interpreted a set of themes that feature frequently in Western drawing traditions: still-lifes, figure drawings and portraits, and the landscape. In the projects, students are encouraged to make their own personal interpretations of these themes. The next chapter, "Image and Idea," profiles eight contemporary artists who have developed special themes and ways of visually expressing them. Using these artists as conceptual "models," students are made aware of how artists transform personally meaningful concepts into significant works of art.

Chapter 13, "Computer-Aided Drawing," looks toward the future, explaining how computers work and how their special capabilities can be used in drawing.

Some of the terms in this book may be new to students and have therefore been explained in the glossary. To encourage students to widen their experience of drawing, I have also included a list of museums and galleries with drawing collections and a list of suggestions for further reading.

It is my hope that students, having been given a solid foundation in the art of drawing, will continue to learn and develop and thus extend the body of knowledge and accomplishment upon which this discipline is based.

— PART I —
THE WORLD OF DRAWING

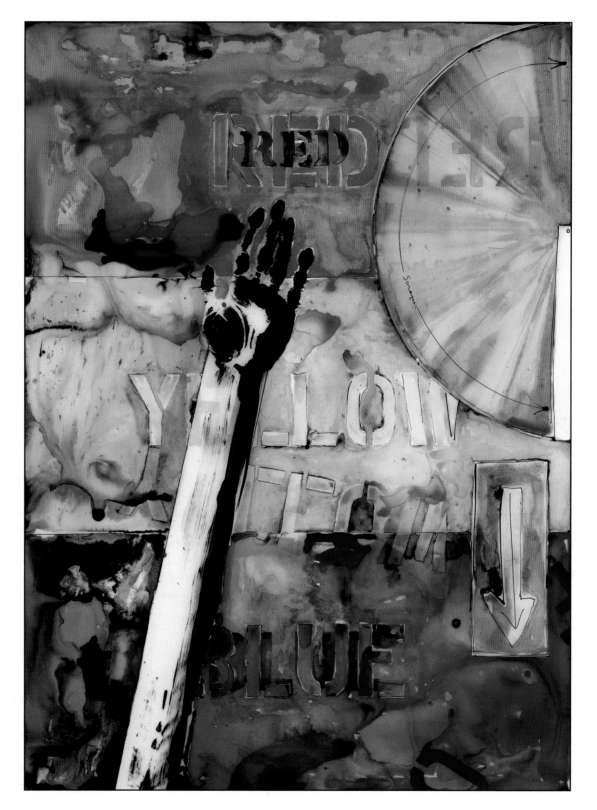

Introduction
Looking at Drawings

Throughout history few artforms have achieved the universality that drawing has. Every culture, from the most ancient and primitive to the most modern and technologically advanced, has made use of drawing in some form or another.

Much of the power and expressiveness of this visual medium stems from a marvelous paradox that surrounds it. Drawing is at once a remarkably simple and spontaneous process, yet one which produces results that are visually rich and deeply involving. Compared to painting, sculpture, and other costly and time-consuming media, drawing is a relatively straightforward and immediate process. Most drawings are made by organizing a series of lines or marks (usually dark) on a sheet of paper or other suitable flat surface. Simple enough. Yet one of the most compelling aspects of this simple process is the extraordinary range of visual effects, images, spatial concepts, and feelings that can be expressed through this medium.

The primary reason drawing can communicate such an array of information and sensibilities is because it functions as a basic language, a *visual* language that predates the written word. Drawing has always played a vital role in the achievements of humankind, serving as an important means of visual notation and expression. Learning and practicing this artform will heighten your perceptions and enable you to discover important aspects about yourself and the world around you.

By the time most people reach adulthood they have seen a remarkable number of drawings. This artform is included with increasing regularity in many museum and gallery exhibits. And magazines and newspapers are full of drawings calling our attention to a feature article or editorial opinion.

To help you become a skilled maker of drawings you need to learn how to "read" drawings from the special perspectives of art professionals. How are the lines and spaces organized? What materials and drawing techniques are used? What visual effects or concepts are communicated? Knowledge gained from this kind of active viewing can be applied to your own efforts and hasten your progress as a student of drawing.

DRAWING TODAY

The range of images, feelings, and concepts that can be expressed through the drawing medium is virtually limitless. Every artist uses the materials and methods of drawing in unique and personally expressive ways – this is part of its fascination. The drawings featured in this section will give you some idea of what this medium can express and how the organization and look of a drawing responds to individual concerns and contemporary concepts.

(overleaf) Jasper Johns, *Land's End,* 1982. Ink on plastic, 34 × 25½ in (86.4 × 64.8 cm). Courtesy, Leo Castelli Gallery, New York.

0.1 Claes Oldenburg, *Apple Core,*
1989. Charcoal and pastel, 12⁷/₈
× 9¹/₅ in (32.7 × 23.2 cm).
Courtesy, Marlborough Gallery,
New York.

M any people associate art and drawing with lofty sentiments of idealized beauty
and "truth." Artists today, however, often take delight in challenging or
redefining these concepts in terms of twentieth-century sensibilities.

Claes Oldenburg's amusing drawing of an apple core (Fig. **0.1**) makes us think
about the nature of beauty in strikingly modern terms. This drawing cleverly
transforms the way we perceive an object so commonplace that we rarely notice it.

By placing the modestly sized image of the apple core slightly above center in
this drawing the artist isolates it and elevates the image of a piece of organic refuse
into the realm of the visual arts. Also, by contrasting the vigorous charcoal and pastel
lines and marks with the smooth expanse of the creamy white paper that surrounds
them, Oldenburg imparts a curious importance and monumentality to this object
that belies its humble origins. Spontaneously flowing lines follow the contours of
the apple core and define its shape, while tonal variations between the light flesh
of the apple and the reddish skin are rendered with a seemingly casual flair. The
artist is also calling attention to the means of drawing, the flowing lines, choppy
strokes, and smudged color passages that form this arresting image.

Claudio Bravo's drawing, *Three Heads* (Fig. **0.2**), makes superb use of classical drawing techniques that are usually associated with European masters of the seventeenth and eighteenth centuries. A Chilean by birth, Bravo lives in Tangier in Morocco, partly drawn by the solitude of this foreign city, but also attracted by its special qualities of light and the unique subject matter of North Africa.

Although his work may look "photo-realistic", Bravo only works directly from the model, whether he is doing a landscape, a still-life, or a portrait series. Such direct observation produces drawings that are detailed and naturalistic, yet far removed from the kind of wall-to-wall realism achieved with a camera. *Three Heads* presents us with a dreamy romantic vision that lavishes great care on visual details yet manages to transcend the factual world of mere appearance. Bravo evokes the mystery and unique presence of these three men and makes us wonder about their lives.

These three portraits form a unified composition, yet Bravo presents them in isolation, each subject seemingly involved in quiet introspection. Technically, Bravo reinforces the concept of isolation by drawing each head with a different combination of colored chalk. The largest and most prominent portrait is created with carefully blended lines of black conté crayon, sanguine (a reddish chalk), and sepia, a dark brown colored chalk. The center portrait is created entirely with black conté crayon and the smallest head is drawn only with sanguine.

Each portrait plays a special role in the drawing's scenario and each contributes to the richness of experience made possible by the artist's vision. In this drawing Bravo carefully describes the features of three men but at the same time manages to evoke feelings about Morocco and its ancient history and traditions. In a sense he is also revealing to us something of his adopted country's soul and being.

0.2 Claudio Bravo, *Three Heads*, 1990. Black conté crayon, sanguine, and sepia on beige paper, 16½ × 22½ in (42.3 × 57.2 cm). Courtesy, Marlborough Gallery, New York.

0.3 Elizabeth Murray, *Black Tree*, 1982. Pastel on 2 sheets of paper, 48 × 36 in (121.9 × 91.4 cm). Courtesy, Collection Estée Lauder Cosmetics, Paula Cooper Gallery.

Elizabeth Murray makes drawings that are large, dynamic, and richly embellished with dense textures and complex coloristic tonalities. She has developed a style of pastel drawing characterized by bold, curved shapes which refer, in semi-abstract ways, to everyday objects in the world. *Black Tree* (Fig. **0.3**) was made by overlapping two sheets of paper and creating what is referred to as a shaped format. On this slightly irregular sheet the artist has created a stylized image of a tree. Many of the images in Murray's drawings are marvelously ambiguous and make reference to more than one object or thing. For instance, referring to *Black Tree*, the artist observed that "the trunk could be a neck and the foliage a head with hair or ears."

Murray loves the immediacy and directness of drawing with charcoal and pastel. Often she will blacken the paper and then use her eraser to lift off portions of the pastel until a ghost-like image seems to emerge from the depths of the paper. The vigorous chalk marks, the scrubbed and rescrubbed surfaces, and the overlapping forms found in this drawing allow viewers' insights into the artistic process that gave birth to this work of art.

13

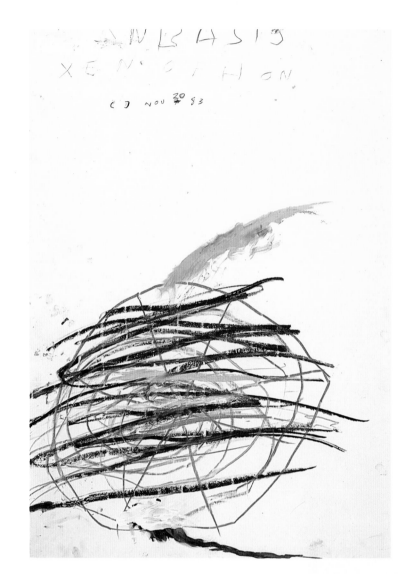

0.4 Cy Twombly, *Anabasis*, 1983. Oil and wax crayon on paper, 39½ × 27½ in (100 × 70 cm). Courtesy, Galerie Karsten Greve, Cologne, Germany.

All the drawings we have viewed so far have made use of some form of recognizable imagery. By comparison, Cy Twombly's drawing *Anabasis* (Fig. **0.4**) seems to have no subject matter and to be the result of randomly and naively scrawled lines. But, beyond their outward appearance, his drawings have a subtle and sophisticated sense of order that is meditatively thoughtful and sensuously pleasurable. In this work Twombly participates in a form of expressive, intense engagement with the very process of mark making that is the essence of drawing. In doing so the artist explores various aspects of his conscious and unconscious self. *Anabasis* makes reference to no image other than the image created by the act of drawing. Twombly is not presenting us with a representational image, he is inviting us to participate, through our viewing, in the pleasurable activity of mark making.

Although there is no traditional imagery in Twombly's drawing this does not mean that there is no content or meaning to the piece. Twombly is a serious student of Classical Greek and Roman literature and quite often themes suggested by his reading find their way into his drawings. In the case of this drawing "anabasis" means to "go up" or "walk" in ancient Greek. This term was further defined by the ancient Greek writer Xenophon, whose name is written faintly in the drawing, to mean a bold military advance. Certainly the activity, vigor, and thrust of the massed lines in *Anabasis* suggest action and movement and perhaps allude to the kind of forceful military mission Xenophon described in his writing.

Contemporary drawing increasingly takes place within the multicultural context of an international art world. Mimmo Paladino is a contemporary Italian artist whose work reflects a wealth of artistic sources and traditions. One of the artist's favorite themes is what he refers to as "nomadism." "For me it means crossing the various territories of art," he says, "both in a geographical and temporal sense, and with maximum technical and creative freedom. So if, on the one hand, I feel close to Giotto and Piero della Francesca [both well known Italian Renaissance artists], on the other I pay attention to Byzantine and Russian Icons."

Paladino's work is evidence of the many historic sources that influence the drawings of contemporary artists. Our information age has made it possible for artists to become familiar with, and to assimilate, a variety of styles of art from other time periods and cultures.

In *Alceo*, (Fig. **0.5**) Paladino smoothly crosses these territories of art and incorporates many of the artistic influences he mentions above. For instance, the sketchy drawings of hand and finger gestures that surround the central figure of this artwork allude to Giotto's use in his paintings of certain codified body gestures that were common to Italy in the fourteenth century. Paladino's gestures, however, refer to the local folk-myths and superstitions of his native land, southern Italy.

0.5 Mimmo Paladino, *Alceo*, 1990. Woodcut and screenprint on paper, 62⅘ × 88 in (159.5 × 223.5 cm). Courtesy, Waddington Graphics, London.

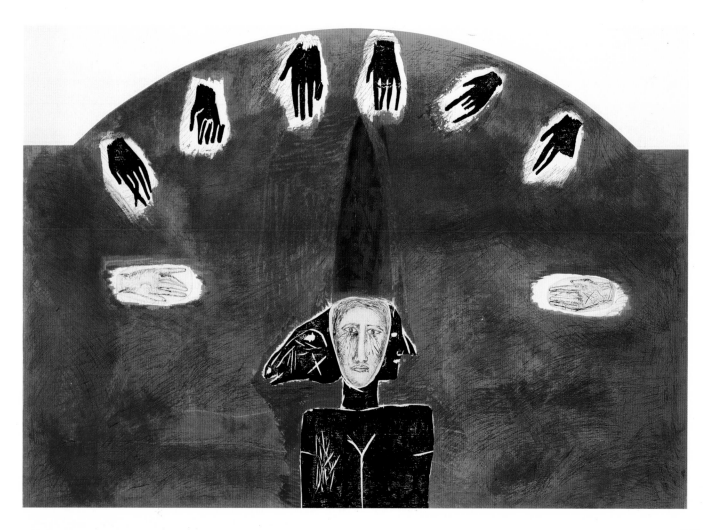

0.6 Jean-Michel Basquiat, *Untitled,* **1981. Oil stick on paper, 40 × 60 in (102 × 152 cm). Courtesy, Robert Miller Gallery, New York.**

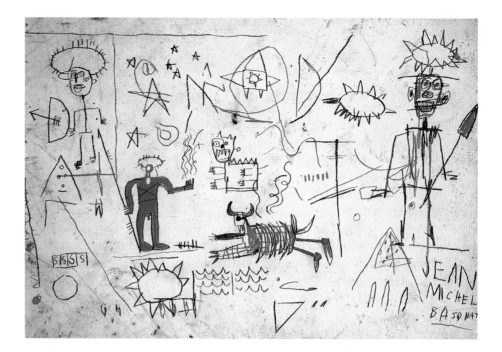

Another concern among some contemporary artists is the desire to use their work to express deeply personal and sometimes urgent social concerns and frustrations.

Jean-Michel Basquiat, a young black man of Haitian origin, created a powerful body of work that drew upon his personal experiences growing up in New York City. His drawings and paintings communicate with an urgency and directness that is derived from the social contrasts and contradictions he found in this metropolis. *Untitled* (Fig. **0.6**) amounts to an angry denouncement of the realities of hopelessness and poverty that Basquiat saw surrounding the lives of New York's minority citizens, despite pronouncements of equality and justice for all. A reddish-brown haloed athlete holding an olympic torch is one of the central focus points of this drawing. The large figure on the far right is shown with a crudely fashioned spear; a particularly sharp and angular halo hovers over his anguished face. Cryptic shapes and lines fill almost the entire surface of the drawing and seem to boil with rage and hostility.

Basquiat's art draws heavily upon African-American myths and symbols. It is populated with skulls, masks, and images of black people rendered with jagged lines and staccato rhythms, conveying to the viewer a sense of urgency and anger. Until his tragic and untimely death recently, at the age of twenty-eight, Basquiat's art called attention to the social conditions of his race and through his art made their concerns and plight highly visible.

So far we have examined drawings done within a so-called fine art or personally expressive context. But many drawings are made to serve the practical needs of advertisers and publishers. Artists working as illustrators play an important role as visual communicators enlivening the printed page and helping to make complex ideas more understandable.

Henrik Drescher, a German illustrator now working in America, created the amusing ink drawing of a hooked creature – half-fish, half-fisherman – seen in Figure **0.7**. This drawing was commissioned for an article in the Boston Globe expressing concern for the dwindling fishing resources along the New England coast. Drescher

was asked to do a drawing to call attention to this ecological problem and to help persuade us to read the article. Despite the seriousness of this topic Drescher's visual approach is full of wry humor and playfulness (note the inset boxes along the edge containing a variety of whimsical sea-creatures) and prevents the tone of the drawing from becoming heavy-handed and off-putting.

Many contemporary illustrators achieve graphic results equal to those of the so-called fine arts. What makes a drawing an illustration is that it is used to accompany the written word or to visually reinforce an idea contained in the text.

Drawing also plays a vital role in the world of industry and commerce, for instance helping to solve complex engineering and visual problems in urban building projects. Before any large architectural commission gets to the construction stage hundreds of drawings must be made, from preliminary sketches defining the basic shape of the structure to blueprints specifying minute building details. Because of their need to draw and redraw various elements, architects have been keen proponents of drawing's newest tool – the computer.

Once visual information about a building is programmed into a computer data base, architects can draw the building from a variety of perspectives. This drafting automation saves countless hours of drawing time, particularly when the structure is as complex as the pyramidal glass and steel addition Pei Cobb Freed & Partners created for the Louvre Museum in Paris (Fig. **0.8**).

This image employs both computer-aided and hand-rendered drawing techniques. A mechanized pen, called a plotter, was driven by a computer to create the highly accurate and complex geometric network of lines that represent the framework of this transparent structure. To show how the building might look from the interior and to give it scale, artists hand-drew the figures in the foreground and the exterior buildings using felt-tip pens and pencils.

Despite the effectiveness of the computer to automate the drawing process we must remember that without the guidance of the human hand and mind no significant results could be achieved. Humans taught this electronic device to draw in the first place by creating complex software, or operating instructions, and people must feed it crucial information every step of the way. This computer-aided drawing system is another instrument in the tool box of the contemporary artist.

As the examples in this brief section reveal, there is little that contemporary drawing cannot describe or express. The next chapter will enable you to learn more about this fascinating artform and offer practical guidance for your own work in drawing.

0.7 (below left) Henrik Drescher, _Fish Man_, 1990. Pen and ink, 9³⁄₈ × 16¹⁄₈ in (24 × 41 cm). Courtesy, _Boston Globe_.

0.8 (below right) Pei Cobb Freed & Partners, _Interior View of Addition to the Louvre from the Pyramid Looking into the Court Napoléon_, 1986. Plotter drawing (by Paul Stevenson Oles and Rob Rogers) with felt-tip pen and pencil on paper, 18 × 22 in (45.7 ×55.9 cm). Courtesy, Pei Cobb Freed & Partners.

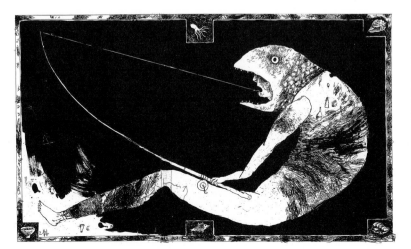

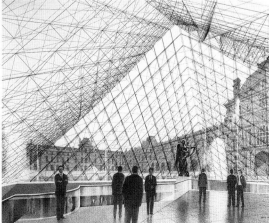

1 THE EVOLUTION OF DRAWING

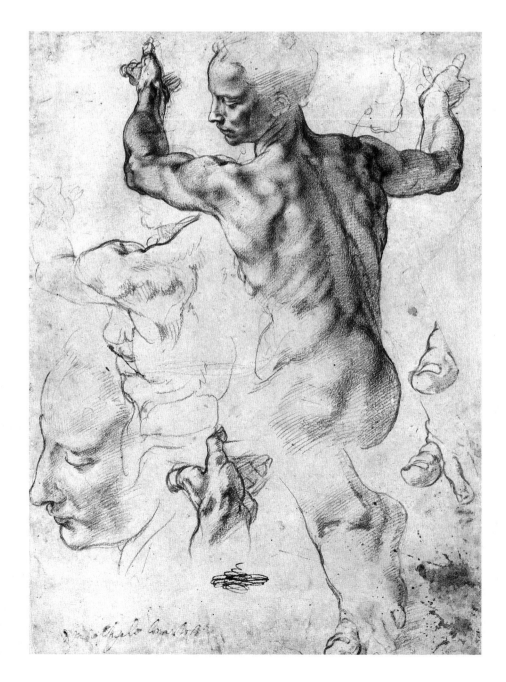

B efore we begin to draw we should become familiar with some of the aims and traditions of this popular artform. Different cultures and time periods have approached drawing from a variety of perspectives, but all have used this form of visual expression to communicate significant ideas and record important information.

This chapter will provide you with a better technical understanding of how the elements of drawing have been used to create images and record information. The purpose of this section is not to provide you with a comprehensive historical survey of this artform. Our objective is for you to acquire personal drawing skills that you can use to express your own ideas and communicate your own perceptions. But much practical information and applicable theory can be gleaned from an understanding of this craft's origins and evolution.

(opposite) Michelangelo, *Studies for the Libyan Sibyl,* 1511. Red chalk on paper, 11⅜ × 8⅜ in (28.8 × 21.3 cm). The Metropolitan Museum of Art, New York. Joseph Pulitzer Bequest.

THE ORIGINS OF DRAWING

Some of the earliest drawings known to the world, discovered in Lascaux, France as recently as 1940, bear silent testimony to the power of prehistoric visual expression. No doubt earlier examples vanished due to weathering and deterioration of the rock. But, if the caves of Lascaux are any indication, prehistoric forms of visual expression were quite lively and strikingly modern in appearance.

Jean Leymarie, a French scholar specializing in the history of drawing, eloquently describes Lascaux's mesmerizing visual and psychological effects:

> This cave imposes its powerful and symbolic hold even before one comes face
> to face in the semi-darkness with its astounding display of overlapping
> paintings, engravings and drawings . . . At Lascaux there are human figures,
> hand-prints, abstract signs, but the main theme is the procession of animals, in
> a style at once realistic and magical . . . After the impressive rotunda of bulls

1.1 Bull and kneeling bovine animal, c. 16,000–14,000 BC. Paint on limestone rock, length of bull: 11 ft 6 in (3.5 m). Main Hall, Lascaux, France.

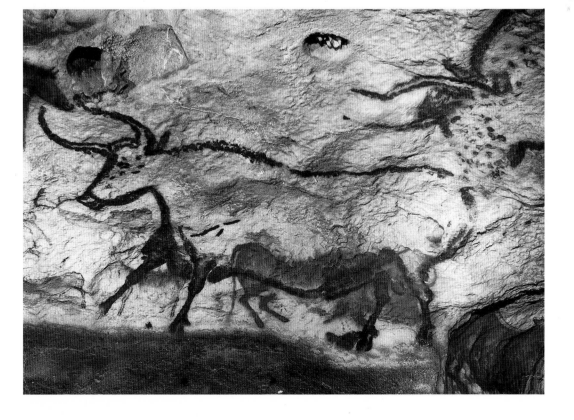

coupled with horses (Fig. **1.1**, p.19), a narrow corridor leads to the main nave. On the right side extends a frieze of deer which seem to glide along the rock-face as if swimming in a moving stream (Fig. **1.2**), the antlers of their upraised heads forming supernatural patterns of lines.

We will probably never fully understand the motivations behind the creation of these remarkable drawings. However, it is safe to assume that they were associated with magical beliefs that connected an animal's visual representation with control over that creature. Although the purpose of these drawings was probably to ensure an adequate food supply we must also acknowledge their haunting beauty. Whatever spiritual mission these drawings might have had, they also bear witness to another significant aspect of the human psyche, our need for aesthetic expression.

Susan Rothenberg is a contemporary artist whose work uses animal forms in a way that calls to mind some of the images found in the Lascaux Caves. Her *Untitled Drawing No. 44* (Fig. **1.3**) reveals the silhouetted shape of a horse dramatically set against the stark white background of the paper. Given the role the horse has played in the development of our civilization, Rothenberg's drawing recalls the remote past and the role of animals in determining the course of human progress.

1.2 Frieze of deer heads. Main Hall, Lascaux, France.

1.3 Susan Rothenberg, *Untitled Drawing No. 44*, 1977. Synthetic polymer paint and tempera on paper, 38½ × 50⅛ in (97.3 × 127.4 cm). Collection, The Museum of Modern Art, New York. Gift of Mrs. Gilbert W. Chapman.

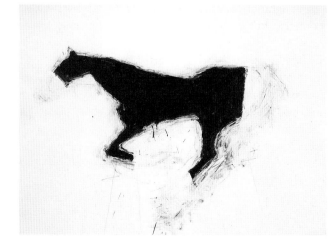

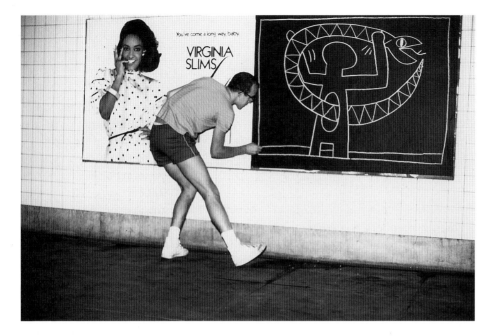

In this drawing, Rothenberg is able to evoke both primitive and modern sensibilities. The outline of the horse is as simple and direct as many of the cave drawings, yet by cutting off sections of the outline at the extremities – head, feet, and flank – she subtly compresses the overall shape into a modern geometric design. The transformed floating shape of the angular horse thus becomes a striking emblem for our time, part ancient, part contemporary.

Like the Magdalenian hunters who descended into the limestone caverns of Lascaux, Keith Haring, a contemporary American artist, entered the underground passageways of New York's subway system in the early 1980s and created a series of cryptic, Pop Art inspired *chalk* drawings on blacked-out advertising signs. Keeping one eye out for the transit police (drawing on subway signs is a misdemeanor in New York), Haring rapidly created many drawings like the one seen in Figure **1.4** in a simple linear style with white chalk.

There is no doubt that contemporary artists seek to rekindle the visual power and magical effects associated with humanity's earliest surviving art forms.

EARLY CIVILIZATIONS

After the prehistoric period the next clear stage of graphic expression occurs with the establishment of agrarian societies around 8,000 BC. Here drawings tend to be well-planned geometric, linear compositions that suggest a new sense of order and control (Fig. **1.5**). At this stage of evolution humanity had for the most part abandoned nomadic life in favor of increasingly structured communal societies that lived in villages, tended herds of domesticated animals, and grew crops. The hallucinatory cave visions of a people greatly dependent on chance and fortune have been transformed into carefully organized structures that suggest linear rows of crops and the geometric layout of early towns.

The art of Ancient Egypt represents, perhaps, the longest unbroken span of stylistic continuity in the history of the world. Many of this early civilization's artistic principles were well formulated by 3,000 BC and remained viable for over 3,000 years. Many of the achievements of this civilization profoundly influenced Greek and Roman art and through the influence of these important cultures Egyptian art still affects our world.

1.5 Painted pottery bowl from Susa, Iran, late 4th millennium BC. Height 8 in (20.5 cm). British Museum, London.

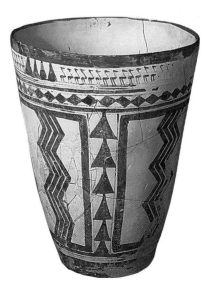

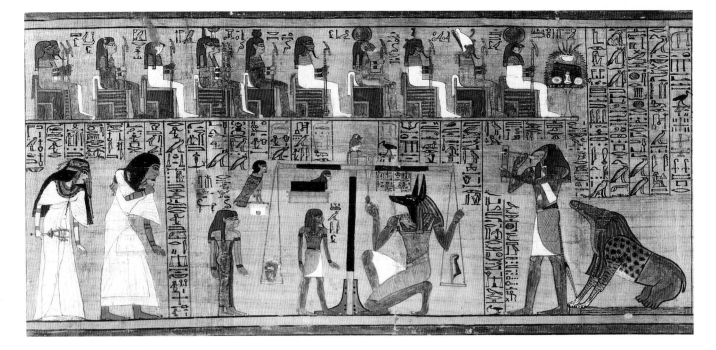

1.6 *Last Judgement from Osiris,* from the *Books of the Dead,* found at Theban Necropolis. c. 1,300 BC. Painted papyrus, height 2¾ in (7 cm). British Museum, London.

Some of the earliest paper drawings in existence can be found in Egyptian manuscripts known as the *Books of the Dead*. These scrolls are actually made of papyrus, a substance created from the thin-shaved pith of the papyrus plant and glued together to form a continuous sheet. These ancient manuscripts contain a series of carefully orchestrated instructions, prayers, and illustrations for the guidance and protection of the deceased soul in its dangerous journey to the other world. The most dramatic moment in the *Books of the Dead* comes when pilgrims' hearts are weighed against a feather (Fig. **1.6**) to see if they are worthy to enter the Kingdom of the Dead. In this illustration the deceased is represented by the small human-headed hawk above and slightly to the left of the balancing heart. Fortunately

1.7 From *Thomas, Argondessi, & DeZuniga,* 'Infinity, Inc.' no. 42, 1987. Courtesy of DC Comics Inc.

for this individual, the heart achieves equilibrium with the feather, otherwise the hapless pilgrim would be thrown to the hyena-like creature waiting at the far right.

All the human figures and mythological creatures in this Egyptian manuscript are drawn in a highly stylized and strictly codified manner. Every subtle position of their hands, faces, and feet is predetermined and executed according to formulas that tended to remain unchanged for centuries. These drawing conventions were so well-established they quite literally became a visual language. The flat linear patterning of the large figures in the *Books of the Dead* is echoed by the smaller hieroglyphic characters that comprise their written language. In ancient Egypt, pictographic symbol and drawn image are fused.

The modern comic strip image illustrated in Figure **1.7** owes much to these early Egyptian drawings. Not only does it pay homage to the staying power of Egyptian art and myth (highly popularized of course) but it also emulates the way the *Books of the Dead* integrate text and linear image.

1.9 Egyptian Apis.

EARLY WRITING

The development of drawing and written language parallel each other, perhaps more closely than you might think. The shapes of the letters of the words you are reading are derived from Middle Eastern pictograms that portrayed people, animals, objects, and ceremonial activities. There is general agreement among scholars that not only our written language (directly modeled on Roman letters) but practically all of the world's writing started with simple, diagrammatic, or diagram-like images. Written language (and the refinement of drawing) began around 3,000 BC when pictograms were combined to express an idea that could not be represented by a single image. For instance, the Sumerians, who lived in what is now Iraq, depicted "wild ox" by combining their signs for "ox" and "mountain" (Fig. **1.8**).

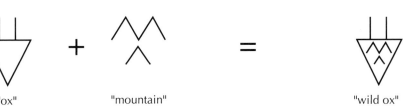

"ox" "mountain" "wild ox"

1.8

1.10 Phoenician Aleph.

To synchronize with the sounds of spoken language, visual symbols evolved into representations having constant sound values. The evolution from pictographic image to the modern alphabet can be traced in the history of our Roman letter "A."

The Egyptian character for their sacred bull, called "apis," was represented by a visual image of a bull with horns (Fig. **1.9**). Around 1,000 BC the Phoenicians (a seafaring people who lived in city-states along the Mediterranean coast near present-day Lebanon) greatly advanced the development of writing. They invented a simplified system of visual sound-symbols that was easy to learn, read, and write. Their word for "ox," "aleph," is shown in Figure **1.10**. Out of this Phoenician system the Greeks developed their alphabet of twenty-four characters by changing various unused Phoenician consonant characters into vowel letters such as "alpha." The visual letter for the Greek "alpha" (Fig. **1.11**) evolved from the Phoenician "tilted ox," or "aleph." The Romans further refined the Greek shape into the more elegantly proportioned and symmetrical letter "A" (Fig. **1.12**) which has remained in this form, virtually unchanged to the present day.

1.11 Greek Alpha.

1.12 Roman "A."

1.13 The Foundry Painter, *Lapith and Centaur* **(interior of an Attic red-figured kylix), c. 480–470 BC. Staatliche Antikensammlungen, Munich.**

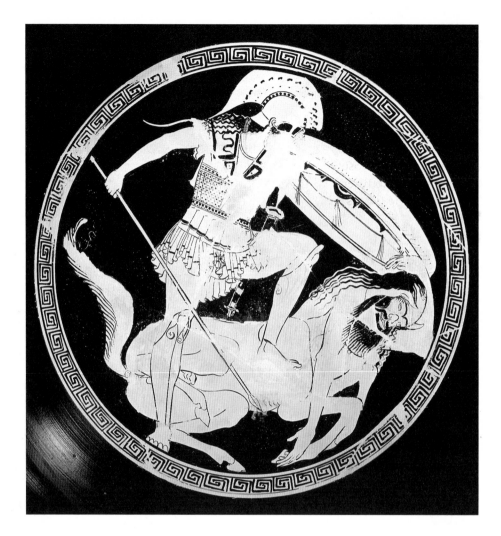

THE CLASSICAL WORLD

During the Classical Greek period, between 500 and 300 BC, a dramatic shift in drawing occurs. The formalized, diagrammatic look, stemming from the earliest agrarian drawings, gives way to illusionistic works that feature the human figure in naturalistic settings. Few conventional drawings on paper and paintings survive, but many remarkable drawings are preserved as vase paintings.

The drawing seen in Figure **1.13**, *Lapith and Centaur*, was done on the interior of a shallow drinking cup, called a "kylix," by an anonymous artist known today as the "Foundry Painter." Using freely drawn brush lines this artist suggests a three-dimensional space through the use of overlapping forms. Lavish detail focuses our attention on the warrior's costume and the features of the man and centaur. The art of the Romans further extended the ancient Greek interest in naturalism and together they established the foundation for European art's obsession with pictorial realism.

THE MEDIEVAL PERIOD

After the fall of the Roman Empire, about 500 AD, the Christian church slowly began to fill the social and governmental void left by the passing of this great empire. Although Roman religious beliefs were abandoned, other aspects of the Classical

past were used during this period. The development of a finely designed alphabet by the Romans had a profound influence on the evolution of drawing in the West. Roman calligraphers (master scribes) used chisel-edged pen points that varied the width of the lines as the letters of the alphabet were drawn. These thick and thin lines swelled and curved according to the angle of the hand to the paper and the shape of the letter. In fact, the elegantly proportioned design of the letters themselves greatly influenced drawn images in Europe for centuries. Medieval illuminated manuscripts (Fig. **1.14**), like their Egyptian counterparts, harmoniously combined verbal and visual information to instruct the faithful. Unlike the art of the Classical world, however, realism was not the goal of the medieval artists, who favored symbolic images representing timeless theological truths.

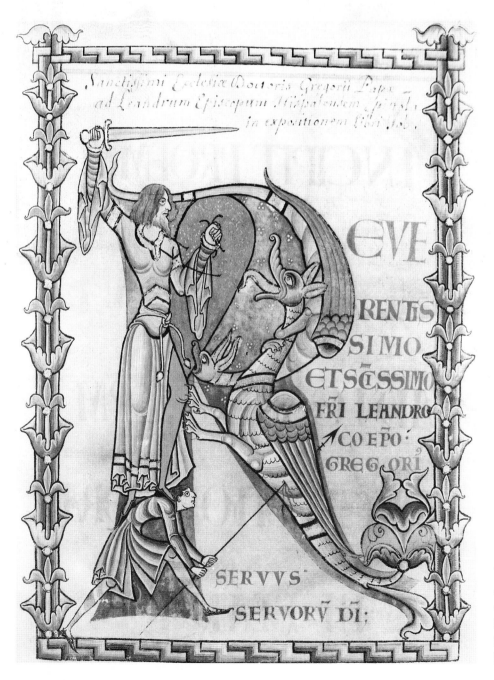

1.14 *Initial R with Saint George and the Dragon,* from the *Moralia in Job,* **early 12th century. Illuminated manuscript, 13¾ × 9¼ in (34.9 × 23.5 cm). Bibliothèque Municipale, Dijon.**

THE RENAISSANCE

Not until the end of the fourteenth century, most significantly in northern Italy, do we see a sharp transition from stylized manuscript drawings to images drawn from life. This was the beginning of a period known in the West as the "Renaissance". It was at this time that the Italian artist Antonio Pisanello extended the possibilities of descriptive drawing in remarkable ways. Working in a style that combined some of the features of late medieval art with an emerging concern for naturalism, Pisanello made numerous drawings directly from life. His *Study of a Horse* (Fig. **1.15**) represents the new interest artists found in the world of appearances. Its free-flowing lines, naturalistic recording of light, and its *composition* clearly point the way toward Renaissance concepts of drawing. Unlike the flat, linear styles of illuminated manuscripts, Pisanello's lines respond to the interplay of light as it falls on a horse that stands before him. His strokes are as carefully varied in thickness as the earlier illuminations, but their new mission is the accurate recording of form as revealed by the play of light on a three-dimensional surface. Significantly, the horse is not drawn in diagrammatic profile but appears to exist in three-dimensional space. In drawings of this period illusion takes precedence over symbolic representation.

The Renaissance was a complex period that simultaneously sought to revive the classical values of ancient Greece (the term Renaissance means rebirth), promote a life centered on humanistic learning, and define the world through the process of scientific analysis. One of the most significant developments of the Renaissance was the refinement of a system of drawing based on optical laws called *perspective*.

1.15 (below left) Antonio Pisanello, *Study of a Horse*, 15th century. Pen and ink on paper, 8⅘ × 6½ in (22.3 × 16.6 cm). Louvre, Paris.

1.16 (below right) Paolo Uccello, *Perspective Study of a Chalice*, 1430–40. Pen and ink, 13⅜ × 9½ in (33.9 × 24.1 cm). Uffizi, Florence.

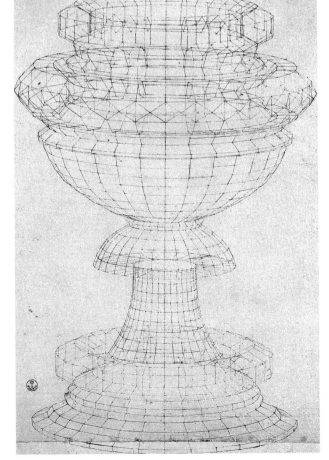

Paolo Uccello was one of the first Renaissance artists to wholeheartedly embrace the study and application of this system. His drawing *Perspective Study of a Chalice* (Fig. **1.16**) is a striking example of how the Renaissance unified scientific analysis and visual expression. Uccello logically broke down the circular form of the chalice into a series of geometric facets and *elliptical* shapes. This three-dimensional form is drawn with such accuracy that any skilled craftsperson might easily fabricate its exact shape in metal. Certainly this visualization of three-dimensional form was of great practical interest to Renaissance artists, who were often goldsmiths and sculptors (see Chapter 8, "Perspective").

By the late Renaissance, drawing, at least in the hands of inspired artists such as Leonardo da Vinci, was a powerful resource that could be directed toward practical concerns. Leonardo's notebook drawing, *Plans for a Spinning Wheel* (Fig. **1.17**) describes with great technical accuracy the workings of a highly efficient industrial machine that could be used in the textile industry. Much of the wealth generated during the Italian Renaissance derived from the wool trade so the development of machines such as this one was of great economic importance.

Although the concept of the drawing as an independent work of art, that is, done for its own aesthetic sake, advanced steadily during the Renaissance, drawing was also destined to play a major role in the realization of large-scale, architecturally related paintings. The red chalk drawings Michelangelo completed as studies for his frescos in the Sistine Chapel command as much attention today as the murals themselves. *Studies for the Libyan Sibyl* (Fig. **1.18**) reveals Michelangelo's obsession with the visual and psychological power of the human body. Tirelessly, he searched for the right pose and facial expression that would prove most effective for his painted compositions. For artists like Michelangelo, drawing offered a way to efficiently explore compositional effects and refine many details of *gesture* and form.

1.17 (below left) Leonardo da Vinci, *Plans for a Spinning Wheel*, c. 1490. Biblioteca Ambrosiana, Milan. Courtesy, Archiv für Kunst und Geschichte, Berlin.

1.18 (below) Michelangelo, *Studies for the Libyan Sibyl*, 1511. Red chalk on paper, 11⅜ × 8⅜ in (28.8 × 21.3 cm). The Metropolitan Museum of Art, New York. Joseph Pulitzer Bequest.

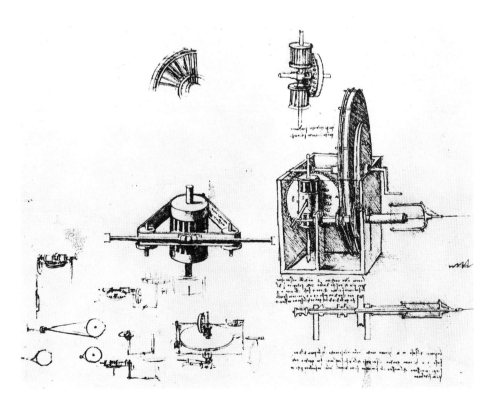

NORTHERN EUROPE

Like Italy, northern Europe also enjoyed an economic, political, and artistic resurgence during the fifteenth century. But the work of French, Flemish, and German artists expressed a different set of traditions and sensibilities. The northern Europeans worked on a smaller scale than the Italians and their art was characterized by a high degree of precision and control. Therefore, they preferred pen and *ink* and *silverpoint* to the more spontaneous materials of *charcoal* and chalk.

Silverpoint, the predecessor of today's pencil, is nothing more than a thin wire of silver held in a holder, or stylus. This tool, used extensively during the Middle Ages and the Renaissance, produced a fine light gray line much like that of a modern hard lead pencil. But silverpoint requires a specially prepared paper because the relatively hard metal does not leave a mark on ordinary soft paper surfaces. To make the paper surface more abrasive it was coated with a mixture of finely ground bone dust and glue stiffener. Often a small amount of *pigment* was added to the stiffener to create pale blues, pinks, grays, and earth tones.

Jan van Eyck, a fifteenth-century Flemish artist, created this subtly modeled, highly detailed portrait of Cardinal Albergati (Fig. **1.19**) using silverpoint on grayish-white prepared paper. Silverpoint is a demanding, time-consuming process but one which

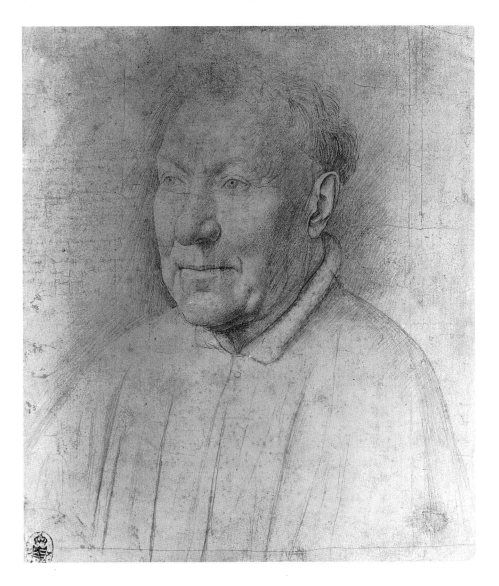

1.19 Jan van Eyck, *Portrait of Cardinal Albergati*, 1431. Silverpoint on paper, 8³/₁₆ × 7 in (21.3 × 17.8 cm). Staatliche Kunstsammlung, Dresden.

1.20 Albrecht Dürer, *Knight on Horseback*, c. 1513. Pen and brown ink, 9⁷/₁₀ × 7³/₁₀ in (24.6 × 18.5 cm). Biblioteca Ambrosiana, Milan.

produces luminous tonal areas and meticulous details. Northern Renaissance artists believed that the visible world was but a mirror of God's divine light and truth. Van Eyck's keenly observed and accurately rendered portrait of Cardinal Albergati expresses this philosophical attitude with great conviction.

While most of the fifteenth and sixteenth-century Italian draftsmen were primarily painters, their colleagues in the north, influenced by centuries-old monastic book production traditions, developed a keen interest in the process of making and publishing prints. No doubt the financial rewards that came with publishing and selling printed images had much to do with this interest. The process of "engraving" (and later "etching") involves making fine linear grooves on the smooth surface of a metal plate and then filling in these depressions with ink. Pressure from a press transfers the inked lines of the plate onto a piece of dampened paper. Engravings and etchings greatly resemble drawings made with a fine-nibbed pen and ink.

One of the most accomplished sixteenth-century draftsmen was Albrecht Dürer. The preliminary study shown in Figure **1.20** was done in preparation for a copperplate engraving Dürer was working on. In this drawing the artist determines the exact position of the horse and rider with loosely flowing but accurate lines. A brown ink wash darkens the background and dramatically spotlights the mounted horseman. In order to use this drawing of the knight and horse as an exact pattern, Dürer made the ink and wash drawing the same size as the planned print and even blocked it out with a grid to facilitate transfer of the image.

During the seventeenth century, artists working in the Netherlands developed drawing styles that were less formal and more naturalistic than the German artists who had come before them. One of the greatest graphic artists of this period was Rembrandt van Rijn. Compared to Italian art of this period, his style was more subdued and more naturalistic yet at the same time quite dramatic and emotionally expressive.

Christianity was no longer the sole theme of works of art during this century and like other northern artists Rembrandt explored the visual splendors of the landscape and the quiet beauty and pleasures of domestic scenes such as those seen in *A Woman and Her Hairdresser* (Fig. **1.21**).

Unlike many of his contemporaries Rembrandt never traveled to Italy to study at first hand the extroverted painting styles of the Italians (particularly that of Caravaggio); but through a friend who had spent considerable time in Rome, Rembrandt was introduced to southern compositional styles. In his mature work Rembrandt manages to brilliantly synthesize the highly controlled, analytic northern mode with the Italian Baroque style of art, which favored dynamic compositions and

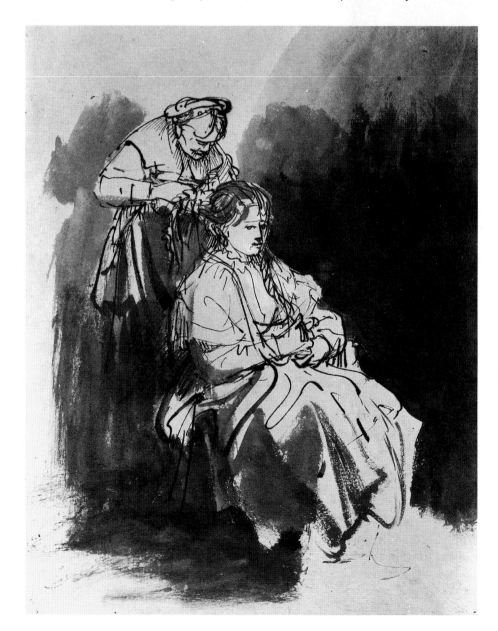

1.21 Rembrandt van Rijn, *A Woman and her Hairdresser*, 1632–4. Pen and bister, with bister and india ink wash, 9⅛ × 7 in (22.3 × 18 cm). Albertina, Vienna.

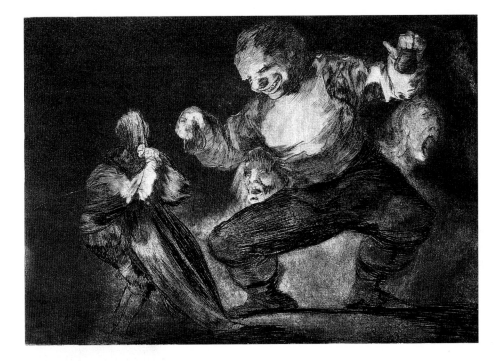

1.22 Francisco Goya, *Bobabilicon (Los Proverbios, Nr 4)*, c. 1818. Etching. The Metropolitan Museum of Art, New York. Harris Brisbane Dick Fund.

strong contrasts of light and dark. Tempered with a psychological restraint rarely seen in the south, Rembrandt's drawings and prints impress us today with their intimate celebrations of life's commonplace activities.

What is striking about Rembrandt's drawing is its spontaneity of construction and its economy of means, two qualities highly prized in modern times. Perhaps this is why we find much of Rembrandt's work today to be so accessible and moving. With a few rapidly penned lines, the artist has created a simple visual structure that is reinforced and embellished with the dark, rich tones created by an ink wash. To integrate the elements of line and *tone* in this drawing, passages of brush work mimic the dynamic, sharp lines of the pen, for example, the brushed lines in the lower portion of the seated woman's skirt. Rembrandt's choice of secular subjects, as well as his spontaneous drawing style, signaled the emergence of works of art that begin to reflect the changing social, political, and economic realities of the seventeenth century.

The French Revolution that began in 1789 raised the hopes of many intellectuals that forms of government sensitive to the rights of all people would eventually take the place of despotic monarchies. Francisco Goya, a Spanish painter and draftsman of great talent and social sensitivity, shared in this dream but lived to see it turn into a nightmare. When Napoleon's armies attacked the Spanish Monarchy, Goya and many of his countrymen hoped the event would lead to a liberal reformation of government. But the atrocities of French troops led to bitter popular resistance and a reign of anarchy. After the defeat of Napoleon, the restored Spanish Monarchy exacted its own bloody reprisals and political repression. In response to these developments Goya's art withdrew into a private world dominated by nightmarish visions and faceless terrors. His print *Bobabilicon* (Fig. **1.22**), from a series called "The Proverbs," illustrates with frightening intensity the spectre of a world gone mad. Executed in a dramatic visual style that emphasized the stark interplay of light and dark (Rembrandt was one of the masters Goya admired most) his drawings foreshadow the important role imaginative expression was to play in the drawings of the Modern Era.

31

OTHER CULTURES

So far we have focused primarily on the development of drawing in the West. Cultures other than our own, however, present us with equally significant drawing styles that have evolved from different sets of aesthetic and ideological beliefs. Societies outside of the European realm have shaped and defined their visual art to reinforce their own world views and cultural priorities.

Far Eastern draftsmen using a special long-haired calligraphic brush are able to produce an amazing amount of visually distinctive brush-strokes and line qualities that are combined in many ways in their drawings. This aspect of their art relates to the fact that the Chinese written language is comprised of thousands of unique ideograms (or picture symbols), each of which represents a specific concept or object. Before people in China learn to write they must first learn to draw.

For the most part, Oriental draftsmen avoid the static, analytic description of volume that characterizes Western drawing. Intuitive, unrepeatable visual effects are highly prized by this culture, every brush stroke represents a unique occurrence in life which can never occur again in that exact form. This artistic preference reinforces the Chinese concept of reality as a continual process of change and infinite variation.

The Chinese sensitivity to line quality in drawing has led to the recognition and naming of many distinctive marks made with the flexible oriental brush and ink. These are only a few of the descriptive and metaphorical names Chinese artists have given these codified lines: "nail heads with rats tails," "iron wire," "axe-cuts," "orchid leaves," and the "bamboo leaves" brush strokes seen in Figure **1.23**.

The artist who made this ancient Chinese brush and ink drawing was not concerned to produce a literal description of a specific landscape. He was more concerned with the evocation of feelings about the natural environment in general. Chinese landscape drawing is a highly refined art form that is designed to convey intangible qualities of meditative thought and metaphorical content.

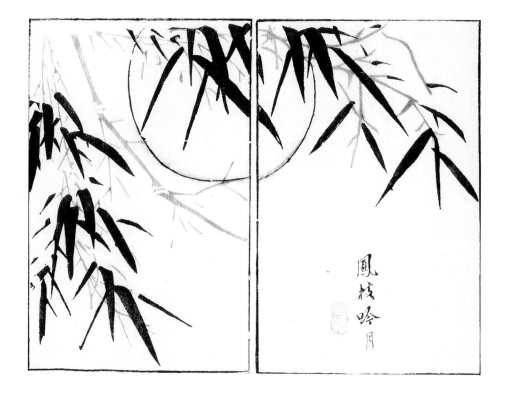

1.23 Wang Gai, from *The Mustard Seed Gardens Painting Manual*, 1679-1701. Brush and ink. British Museum, London.

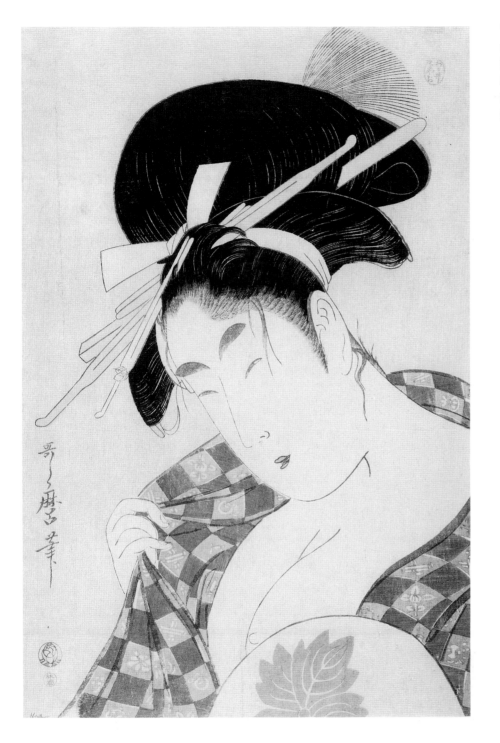

1.24 Kitagawa Utamaro, *An Oiran*, 18th century. 14^{11}/$_{16}$ × 9¾ in (37.3 × 24.8 cm). The Metropolitan Museum of Art, New York. Bequest of Mrs. H.O. Havemeyer.

Japanese art shares many of the aesthetic and visual characteristics of Chinese drawings. Until Japan's great Kamukura period (which began in the twelfth century and extended to the early part of the fourteenth century), this country's art was greatly influenced by that of China. During the Edo period (1615–1867), however, Japanese art developed stylistic characteristics that made it quite distinct and original. Kitagawa Utamaro, a well-known Japanese artist of the late 1700s, made this exquisite print of a courtesan for a growing middle class socially displaced by a changing feudal society (Fig. **1.24**). It resonates with worldly, sensual qualities absent from the ethereal landscapes and austere royal portraits of Chinese art.

1 THE EVOLUTION OF DRAWING

As Philip Rawson describes in his book *Drawing*, East Indian graphic art is similarly concerned with resonances of feeling found in Chinese art. Within this cultural tradition certain natural forms and movements convey specific metaphors: "the hip and thigh of a girl move like an elephant's trunk, her fish-shaped eyes glance like silver fish in a dark pool, her draperies flutter between her legs like ripples on a river between its banks."

In India, poetry and the visual arts were not viewed as separate disciplines as they tended to be in the West. Certainly the language cited above indicates the importance of poetic concepts to Indian draftsmen and it is matched by the elegant visual language of their drawings. Figure **1.25** depicts Krishna, one of the most popular deities in Hinduism. Aesthetic symbolism rather than realism is the aim of this drawing. It relies on the use of traditional visual conventions which are repeated in many representations of this powerful god. For instance, the artist is required to draw his brow arched, as if it were a bow ready to release an arrow.

Persian drawings, like those of India, reveal the influences of Chinese art. During the fourteenth century, elegant, carefully controlled Chinese drawings based on linear calligraphy made their way to India and Persia (now known as Iran).

The finest examples of graphic art to come out of Persia are known as "Persian Miniatures." These small drawings and paintings, many measuring only 6 by 8 inches, depicted in exquisite detail court scenes and stories from literature. *Concourse of the Birds* (Fig. **1.26**) was made by Habib Allah (c. 1600), an artist who worked in the city of Isfahan. Set within a deep blue, gold-flecked ground the framed scene depicts, in lavish detail, a great variety of birds who, according to the story, set out to find their leader – a parable of humankind's search for God. The contrast between the spacious and empty blue and gold background – like the heavens – and the teeming, lush garden of birds is very moving.

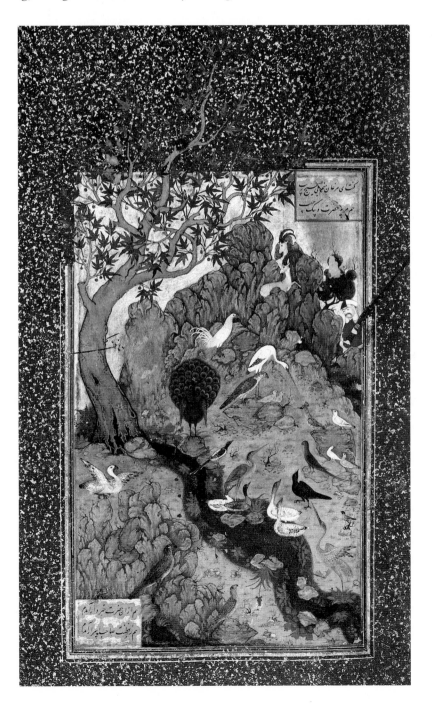

1.26 Habib Allah, *Concourse of the Birds*, from the *Mantiq at-Tayr* (Language of the Birds), c. 1600. Colors, silver, and gold on paper, 10 × 4½ in (25.4 × 11.43 cm). The Metropolitan Museum of Art, New York.

All societies and civilizations interpret and define themselves through their visual representations. Not only the visual form but the thematic content of a people's art reveals what they value and how they interpret the world. Since the Renaissance, Western art has valued objective, analytic description of space and this can be seen in countless European drawings. Other civilizations using other value systems have tended to emphasize symbolic visual representations.

The Native American circular shell gorget, or throat armor, seen in Figure **1.28** contains a drawing of an eagle and a puma prepared for combat. Talons and claws are exaggerated and emphasized in this vigorous drawing and no doubt the drawn images served as powerful visual symbols to the warrior who wore this protective body armor into combat. What was important to the maker and user of this implement was the psychological reassurance that these cultural images gave to tribal members.

Many nonEuropean cultures do not have a tradition of making representational drawings on paper. Nevertheless drawings made with a variety of other materials by so called "tribal" societies play important roles in their day-to-day life. Women of the African Kuba tribe appliqué linear designs that have specific social meanings on long lengths of raffia cloth (Fig. **1.27**). These cloths are wrapped around their waists and worn during important ceremonial dances. Instead of hanging framed images on walls, Kuba women wrap the drawings they create around themselves and perhaps incorporate their art more fully into their personal and cultural lives.

These are just a few examples of what other cultures have expressed with drawing. Future chapters will include more drawings from societies outside of the European sphere. The points of view presented by these non-Western civilizations provide us with rich resources and the opportunity to view our own traditions from a broader perspective.

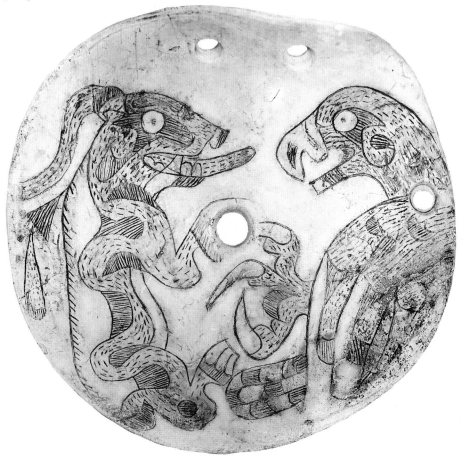

THE MODERN ERA

In the mid-nineteenth century leading French artists such as Courbet and Manet reacted against the prevailing Romantic emphasis on emotion and fantasy in art and began to forge an aesthetic sensibility based on new attitudes about realism. In the first place they insisted on a return to drawing from direct observation. Secondly, they began to develop new attitudes concerning the reality of the flat surface the painting or drawing was made on. Manet insisted in a coolly analytic way that a painted canvas or drawing is in essence a flat surface covered with pigments or drawn marks. An interesting conflict was at work in the visual arts at this time. While artists were seeking to accurately record visual appearances they were also beginning to recognize the abstract reality of the flat painting or drawing surface.

Edgar Degas's *Study for the Portrait of Diego Martelli* (Fig. **1.29**) illustrates these dualistic concerns of mid-century art. Degas's friend Diego Martelli is drawn with great concern for illusionistic representation. Yet certain passages of this chalk drawing call attention to the means of the drawing process. The coarse parallel chalk lines that represent his waistcoat are juxtaposed in meaningful contrast to the subtly modeled lines that describe his features. These two drawing methods are fused

1.27 (opposite left) *Panel from a Woman's Skirt*, Kuba, Zaire. Woven raffia, appliquéd design, 158 × 24 in (401 × 61 cm). Brooklyn Museum. Gift of Mr. and Mrs. Milton F. Rosenthal.

1.28 (opposite below right) *An Eagle and a Puma.* Circular shell gorget with incised decoration, diameter 5½ in (14 cm). Museum of the American Indian, New York.

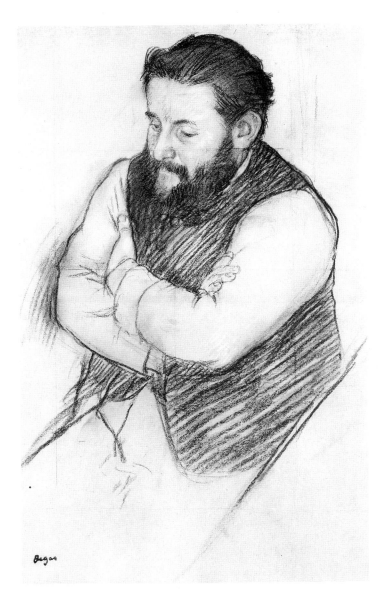

1.29 Edgar Degas, *Study for the Portrait of Diego Martelli*, 1879. Black and white chalk on tan paper, 17⁴/₅ × 11¼ in (45 × 28.6 cm). Fogg Museum of Art, Harvard University. Bequest of Meta and Paul J. Sachs.

1.30 Georges Seurat, *Woman Embroidering*, 1883. Conté crayon on paper, 12⅘ × 9⅖ in (32.7 × 24 cm). The Metropolitan Museum of Art, New York. Joseph Pulitzer Bequest.

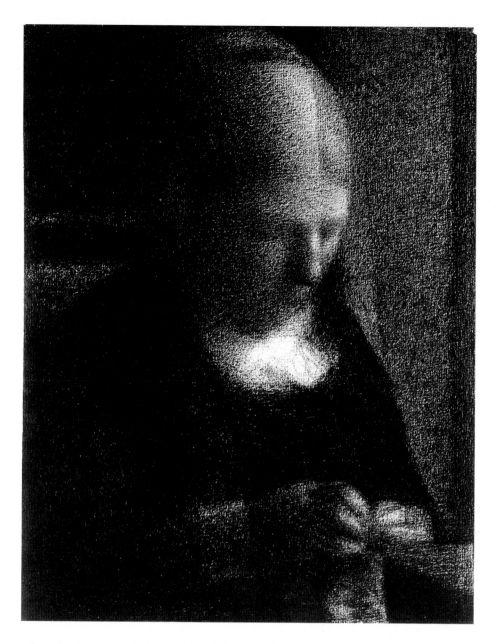

when the flatter rendering of Martelli's upper body joins the dark tone of his beard. The tension between three-dimensional illusion and our awareness of the identity of the chalk lines on a flat surface endows this drawing with a special life and sets the stage for the development of new ideas and attitudes towards drawing.

Toward the end of the nineteenth century a group of highly individual artists, called Post-Impressionists, emerged to make major contributions to the foundations of modern art. Impressionism was a form of French-dominated realist painting that sought to recreate on canvas the effects of natural light on the landscape. Paul Cézanne, Vincent van Gogh, Paul Gauguin, and Georges Seurat were the major Post-Impressionist artists who built upon and extended the ideas of Impressionism.

All these artists used drawing to develop their concepts and extend their visions (See Figs. **5.11, 6.3, 6.12, 6.15, 8.18, 10.2, 11.4, 11.25**). But the drawings of Georges Seurat deserve special attention in view of their unique characteristics. Perhaps more than any of the other Post-Impressionists, his drawings establish a new identity and role for drawing, as independent of painting and fully capable of standing on their own as complete works of art.

Seurat's drawings draw much of their energy from some meaningful contradictions that embrace them. Although Seurat tried to make use of the latest scientific developments in perception and color theory, his work appears driven by deep intuitive feelings rather than formal theory. *Woman Embroidering* (Fig. **1.30**), for example, depicts an intimate, personal activity yet, like many of Seurat's mature compositions, it does so through a neutral, almost analytic drawing technique. The expressive possibilities of mark making are suppressed in Seurat's drawings in favor of meticulous tonal control. The key to this drawing technique is Seurat's use of a specially textured drawing paper. By controlling how hard he pressed on the paper with his conté crayon, the artist could vary the tonal variations from dark to light. The harder he pressed the more his conté crayon would fill in the textural "peaks" and "valleys" of the paper's surface. By pressing lightly, just the raised surfaces of the paper would be darkened leaving the depressions white. Seurat furthered the scientific inquiry of perception begun by the Impressionists but he did so in a highly personal and unique way.

By the first decade of the twentieth century the tendency toward conceptualization and the abstraction of forms that could be seen in the work of the Post-Impressionists was boldly advanced by two artists working in Paris, Georges Braque, a native Frenchman, and Pablo Picasso, a Spaniard by birth.

Both artists were influenced in large part by Cézanne's earlier concern for form and structure in his art. Cézanne felt that Impressionist art lacked the solidity and cohesive visual unity which characterized great art of the past. In *House Among Trees* (Fig. **1.31**) Cézanne has reduced the view of a house nestled among trees into an orderly arrangement of lines, shapes, and tones that represent the essence of the scene's visual and spatial components. These visual elements have given up some of their illusionistic tasks and have assumed new conceptual roles in the life of the drawing.

1.31 Paul Cézanne, *House among Trees*, c. 1900. Watercolor and pencil on paper, 11 × 17⅛ in (27.9 × 43.5 cm). Collection, The Museum of Modern Art, New York. Lillie P. Bliss Collection.

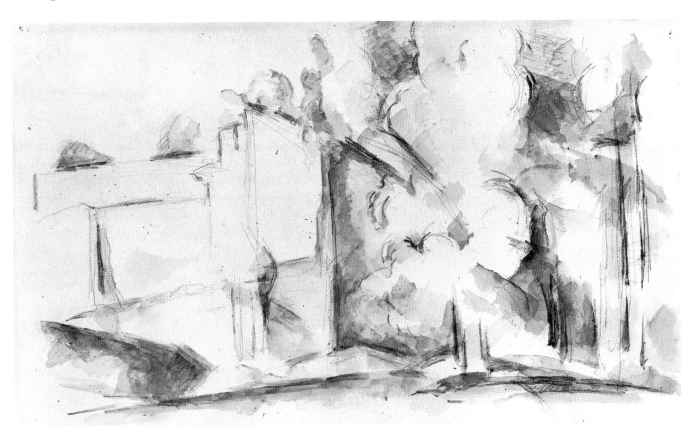

**1.32 (left) Georges Braque,
Musical Forms, 1913. Oil, pencil,
and charcoal on paper, 36½ ×
23½ in (92.7 × 59.7 cm).
Philadelphia Museum of Art.
Louise and Walter Arensberg
Collection.**

**1.33 (right) Paul Klee, *Hurt*,
1940. Black pastel color, 16½ ×
11⅝ in (41.7 × 29.5 cm). Paul
Klee Foundation, Bern,
Switzerland.**

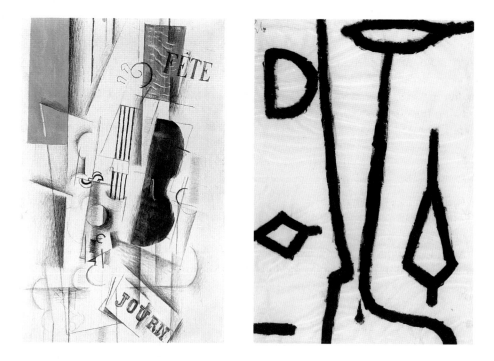

Taking their cues from Cézanne's work, Braque and Picasso developed a style of drawing and painting called Cubism, based on the representation of three-dimensional forms as a complex network of interlocking, flattened planes. Braque's Cubist drawing of 1913, *Musical Forms* (Fig. **1.32**) shows a kaleidoscopic array of fragmented images and visual constructs, including bits of lettering. Part of the theory behind Cubism was the realization that modern reality could no longer be represented by a single, fixed point of view. Here Braque disassembles the violin and presents the parts within an organizational structure of flat planes and shallow relief.

The implied structure of time itself is called into question by this Cubist drawing. The image of the violin shows up simultaneously at a variety of junctures rather than in one central location: lines cut across other lines and forms, and shapes overlap as if they were transparent. This Cubist drawing effectively mirrors the newly emerging modern world – complex, interrelational, and conceptually abstract.

Despite the abstract qualities of *Musical Forms*, clear references to representational forms are retained. Later in the twentieth century, drawing and painting evolve toward increasingly personal and self-referential forms of abstraction.

Paul Klee, a Swiss artist born in 1879, exploited the innately abstract properties of line and shape perhaps more fully than any other pioneer of the modern movement. Much of his art was based on complex theories and formal visual analysis yet the end result was anything but remote and unfeeling. Klee's drawing, titled *Hurt* (Fig. **1.33**), may strike us at first as a formal arrangement of simple black lines on a white surface. Yet the more we look at it, the less abstract and arbitrary it becomes. Somehow the precise visual organization affects our unconscious in elusive yet compelling ways. Formal analysis cannot completely explain the way this drawing rivets our attention as we carefully study it.

CONTEMPORARY DRAWING

In the contemporary art world drawings can no longer be considered a minor form of art. More and more drawings – often referred to as "works on paper" – are shown in galleries and museums as fully independent works of art that in no way take a back seat to paintings or sculpture.

Some of the reasons for drawing's great popularity in the present day have to do with the inherent characteristics of this artform such as its economy of means, spontaneity of expression, and the way in which visual structures are so clearly revealed in this medium. Drawing also seems to be able to combine and synthesize traditional concerns of art with the need for new forms of expression. The following drawing categories reveal the various functions drawings can perform employing a wide range of visual effects and aesthetic sensibilities.

Visual Description

Despite dramatic changes in the form and function of art in the twentieth century, the traditional role of visual documentation and description is very much alive in contemporary drawing practices.

Aristide Maillol's charcoal drawing of a nude, *Thérèse* (Fig. **1.34**), is impressive in its representation of the subtle modulations of form that characterize his subject. Here, Maillol plays down linear effects in order to emphasize the way the female form responds to the soft light that bathes it. Much of the success of this drawing lies in the artist's accuracy of description, particularly his carefully controlled use of light and dark tones. Shading along the edges of the model's body strongly reinforces the illusion of three-dimensionality and gives a clear idea of the body's position in space. Maillol's sensitive modeling creates a visually and psychologically compelling work of art.

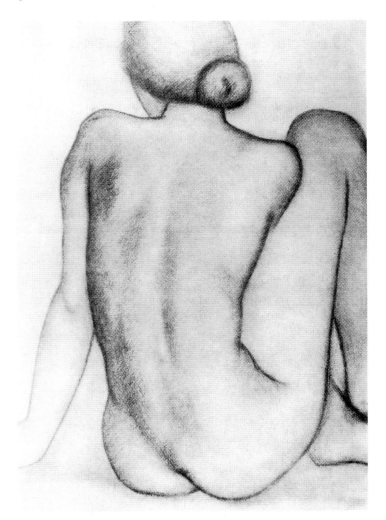

1.34 Aristide Maillol, *Thérèse*, 1929. Charcoal, 28¾ × 21½ in (73 × 54.6 cm). Collection, Dina Vierny, Paris.

41

Imaginative Expression

Drawing also has the unique ability to give visual form to what artists conceive in their minds. Thus the expressive power of drawing is extended beyond the realm of documentation into the fertile world of the artist's imagination.

Most of the drawings that we have reviewed in this chapter made some use of representational imagery. But many contemporary artists firmly believe in the validity of nonrepresentational or abstract forms of art.

Frank Stella is one of the most articulate and accomplished practitioners of this type of art. Stella's art seems to represent the view that because of the conceptual nature and complex structure of today's world, abstract art is the most relevant form of visual expression for our era. Certainly his print, *Swan Engraving III* (Fig. **1.35**) offers convincing support for this thesis.

This work vibrates with an intense visual life and presence that is independent of any imagery other than its own self-generated matrix of swirling textures, geometric structures, and energetic lines. There is nothing tentative or timid about this drawing. It is remarkably self assured and confident of its identity. Even its enormous size, 5½ feet high, communicates clearly to the viewer the assertiveness of this artwork and its desire to visually dominate the world around it.

One of the most intriguing aspects of contemporary drawing is the relationship that exists between modern visual expressions and the work of non-Western cultures. For example, compare the drawing by Queenie Kemarre, a contemporary Aboriginal artist from Australia (Fig. **1.36**) with that by Frank Stella (Fig. **1.35**).

1.35 (below left) Frank Stella, *Swan Engraving III*, 1982. Etching, 66 × 51½ in (167.6 × 130.8 cm). Printed and published by Tyler Graphics Ltd.

1.36 (below right) Queenie Kemarre, *Untitled*, from the *Utopia Suite*, 1990. Woodcut on paper, edn 20, 17¾ × 11¾ in (45 × 30 cm). Courtesy, Utopia Art, Sydney.

Kemarre's untitled drawing makes use of themes, symbols, and forms that have been used for centuries by her ancestors, the native inhabitants of Australia. In the past, these symbols and images served to visually communicate information important for the tribe's survival as well as to provide the cultural cohesion necessary for the group's psychological well-being. Today, these images serve to remind these peoples of their rich cultural heritage. Although native artists of this land now mostly create their art in new buildings using contemporary materials and processes, the traditional themes of their ancestors often serve as the catalyst for their own personal expression. Images once made with *ocher* (a reddish mineral substance) applied to bark are now created with ink and paper in modern studios.

Diagrammatic Space

Another role of drawing is to explore theoretical or diagrammatic space. When physicists make drawings of atoms showing a nucleus surrounded by orbiting electrons they are making a diagram of how the workings of an atom might be understood rather than presenting us with a picture of how it looks. Diagrammatic drawings are usually made for the purpose of developing an idea and to give visual form to thought.

Bruce Nauman's drawing *Dream/Passage/w1 Room* (Fig. **1.37**) presents us with a diagrammatic view of how a specially constructed room might function as a site-specific or environmental work of art. For many years Nauman has been creating conceptually oriented sculpture and architectural structures large enough for a person to enter and move through. Nauman's linear drawing provides us with an X-ray view of the proposed room revealing all of its construction details and intricacies. Drawn in perspective from an elevated point of view, it allows us to look downward into the room and imagine ourselves moving through it. Drawing is the most economic and precise way for Nauman to develop his ideas and visually express his thoughts about these large scale environments.

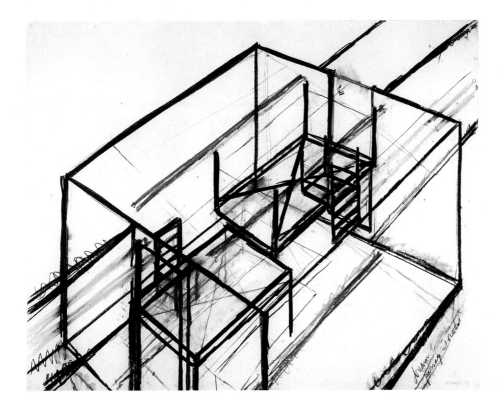

1.37 Bruce Nauman, *Dream/ Passage/w1 Room*, 1983. 65 × 80 in (165.6 × 203.2 cm). Berjegeijk, Netherlands, Martin Visser.

43

1.38 Agnes Denes, *Teardrop – Monument to Being Earthbound*, 1984. Ink on mylar, 46 × 80 in (116.8 × 203.2 cm). Collection of the artist, New York. The sculpture consists of a circular base and a teardrop-shaped top which levitates above the center of the base afloat on an elastic cushion of magnetic flux. The top is gently and mysteriously moved about by air currents but held in place by superconductive elements. When lit, the teardrop resembles the flame of a candle.

Agnes Denes is another artist who works in the realm of conceptual drawing space. Her diagrammatic drawings, many of which reveal the invisible structures of scientific concepts, offer visual insights into many areas of inquiry. Although trained as an abstract painter, Denes has spent the last twenty years exploring the aesthetic possibilities of such scientific disciplines as astronomy, crystallography, biology, and genetics.

Denes's fine line ink drawings on mylar, a special type of sheet plastic, have the look of computer-plotted renderings coupled with the world-view of a visionary artist. *Teardrop – Monument to Being Earthbound* (Fig. **1.38**) is, in the words of the artist, "a monument to being earthbound." Free from the constraints of gravity the teardrop shape hovers languidly above the circular grid below and seems to embody humanity's age-old dream of physical freedom from the restraining forces of the earth.

By now it is evident that contemporary drawing is capable of expressing an enormous range of visual possibilities and personal interests. Your own use of this exciting medium can only serve to further extend and define the broad perspective of drawing today.

As developing students we cannot possibly know what we may wish to express with our drawings in the future. Therefore it makes sense to study drawing from a variety of perspectives rather than from one fixed ideological point of view. Learning to interpret and record what we see on a sheet of paper will provide us with a solid foundation for any work we may later wish to do in the visual arts. Now that we have a better understanding of some of the graphic and conceptual means artists employ, we can begin our own hands-on exploration of this exciting medium.

(opposite) Vincent van Gogh, *Peasant Woman Gleaning*, 1885. Black chalk, 20²⁄₇ × 16¹⁄₃ in (51.5 × 41.5 cm). Folkwang Museum, Essen.

— PART II —
THE ELEMENTS OF DRAWING

2 Exploring Basic Materials

One advantage of drawing is the modest amount of equipment and materials needed to pursue this artform. And, while the start-up costs may temporarily put a small dent in your budget, buying such things as a drawing board, paper and drawing instruments, the ongoing expenses are small compared with other visual media such as painting, printmaking, and sculpture. There is an elegant simplicity to drawing that transcends its modest material means – some of the greatest drawings in the world were done with what amounts to a few cents worth of ink and paper. In this artform the artist's thematic concepts and skill in manipulating visual elements such as lines, tonal values, and textures are of primary concern. Learning how various instruments and materials interact and respond to your touch is an important part of this artform's craft. Once you have gained first hand experience with basic drawing media you will have a better understanding of the significant roles these materials play in the process of drawing.

The materials and equipment required for these initial exercises have purposely been kept simple in order to focus on the visual concepts and drawing skills you will be learning. At the end of this chapter is a concise shopping list of materials and equipment required to get started. By no means is this a comprehensive list of all the materials you might need in the future. This is a basic list of supplies that can be added to as your drawing experience grows. While you are at the art supply store take the time to browse through their selection of papers and drawing media, making mental notes about materials which you might like to use in the future.

Drawing Boards

Before you begin to draw you will need a smooth, portable surface to work on. Although you may have access to an adequate table or desk in your classroom or at home, a portable drawing board measuring approximately 20 by 26 inches offers many advantages. Since it is designed to be used as a drawing support, you do not have to worry about scratching it or marring its surface. More importantly, it is highly portable and can be moved when you want a different view of your subject or for working out of doors.

Most art supply stores offer two types of drawing boards: those made out of *basswood* and *masonite*. Each has its advantages and disadvantages. The basswood board is made of a smooth-grained, lightweight yet strong wood. In many ways it is an ideal drawing surface since basswood is quite rigid and will hold up well to all kinds of drawing processes. One particularly good feature of this board is that individual sheets of paper can be pinned easily to the surface with thumb tacks or push-pins. It does cost more than masonite, however.

Masonite is a composite material made by bonding wood by-products under pressure. Its extreme hardness prevents paper from being easily pinned to it but this limitation can easily be overcome by using drafting tape (masking tape with a weaker adhesive that is much less likely to tear the paper) or metal spring clips.

Papers

When it comes to the kind of paper best suited to the needs of most drawing students, the choice is simple – *newsprint* or the slightly more expensive *bond* paper pads. Both are convenient to use and available at relatively low cost. Like any performance based artform, practice is the single most important learning element. You need to be able to draw as uninhibitedly and as frequently as possible without the worry of undue expense. For these reasons 18 by 24 inch newsprint pads are well suited for most student needs.

2.1 (opposite) Paul Cézanne, *Portrait of Achille Emperaire*, c. 1867–70. Charcoal, 19¼ × 12⅕ in (49 × 31 cm). Louvre, Dépt des Arts Graphiques.

Newsprint, however, is relatively fragile, tearing easily and quickly damaged by rough handling or the use of liquid media. Furthermore it physically deteriorates over time. Because of the residual acids left from its manufacture, newsprint becomes brittle and turns yellow with age and exposure to light. Despite these limitations newsprint is still one of the most cost-effective and suitable papers for students to use. Its textured surface responds well to dry media such as charcoal, crayons, and graphite.

The other type of paper most suitable for student work in drawing is called bond. Compared to newsprint, bond paper is usually smoother in texture and whiter in color. "Bond" is a general term used today to indicate paper that is of better quality than newsprint. At one time the term "bond" referred to paper that was used for important legal and financial records where a high degree of permanence was required. Prior to the development of wood pulp as a paper base, cotton fibers were used. Today, because of the expense of this natural material, many bond papers may simply be of a higher quality pulp paper and contain no cotton fiber. Some bond papers, particularly those sold in single sheets, may contain up to 25 percent cotton fiber for superior strength and permanence but most of the bond drawing pads will consist of pulp paper. Professional quality paper will play an important role in your drawing when you have gained some experience and are working on projects that take longer than a few minutes.

Special Papers

As you develop your drawing skills and experiment with different media there will come a time when you will want to try some of the fine 100 percent cotton *rag* papers widely available today. The term "rag" came about because prior to the development of pulp paper, discarded cotton rags were collected, processed, and used in the manufacture of paper. In the 1800s even daily newspapers were printed on all cotton paper. Specially made 100 percent cotton-fiber paper is one of the most beautiful and permanent surfaces you can draw upon. Long after today's newspapers, magazines, and even many of our hard cover books have grown yellow and brittle with age, properly stored drawings on rag paper will still retain their flexibility and original color. But longevity is not the only reason for choosing a professional grade cotton paper. For one thing, most fine rag drawing papers are far heavier and sturdier than even the better quality pulp papers. They can stand up to considerable handling, reworking, and erasures without tearing or wearing dangerously thin. Most importantly, these papers will interact with your drawing instruments in significant ways. The sensation of drawing on good quality rag paper is unique and your response to this material may result in more effective drawings.

When you get to the point in your drawing study where you are achieving results that please you, try some of these special papers. Go to a good art supply store and browse through their selection of professional quality paper. Let your personal judgement guide you and select a few sheets with intriguing surfaces and tonalities.

THE DRAWING ASSIGNMENTS

The sequence of projects that follow in this chapter and the next are designed to lead you step-by-step from simple exercises that explore the nature of drawing materials to more complex assignments that enable you to expressively combine and organize lines, shapes, and tones in a variety of ways. In order to learn the basic skills of drawing you must suppress, for the moment, your desire to make what you think of as "good" drawings. The purpose of these assignments is not necessarily

to produce beautiful drawings but to teach you the conceptual and technical skills you will need to draw effectively. Paradoxically, the more you forget about making successful drawings and concentrate on the objectives of the exercises, the closer you will be to realizing your goal. Sequentially, each exercise enables you to learn some basic principle or skill and gradually forms the foundation upon which all of your drawing abilities are based. Your willingness to thoroughly explore the concepts they express will greatly enhance the effectiveness of these studies.

After you feel you have met the requirements of the project, think up your own creative variations and extend the parameters to suit your expressive interests. Practice is everything. The more you draw the faster you will progress.

GOOD WORK HABITS

If your instructor assigns a project as homework, find a place away from distracting activity that allows you to work uninterrupted for an hour or two at a stretch. Your drawing classroom or other studio art space might be available during evenings or weekends. If the natural light in this space is lacking, or if you do a lot of work during the evening, invest in a few 100 watt floodlights and aluminum clamp-on reflectors. Any good hardware store will be able to guide you in this purchase. Also, try and make use of a comfortable light-weight chair that can be easily moved when you want to shift drawing positions.

The use of an *easel* is a matter of personal preference. Some people like to work with the drawing flat, others prefer it upright on an easel. Also think about where you will store your drawing materials and finished work. Take the time to organize a studio-like space where it is conducive for you to work. Since much depends on concentrated practice, develop consistent work habits. Schedule certain times or days as work periods and stick to this plan.

Before you start on a project read through the entire section and if there are any illustrations offered as examples study them thoroughly. Remember to keep the objectives of the exercise in mind as you execute the drawings. Although the assignment may not always direct you to do several drawings, that is what you probably have to do in order to achieve the objective. Each time you repeat an exercise you reinforce what you have learned and discover something new.

SELF-EVALUATION

No doubt during class meetings with your instructor you will have regularly scheduled group and individual critiques. This is where the teacher will evaluate your drawings on the basis of how successfully they have achieved their goals. This critical evaluation is an important aspect of the learning process. Take the time after a drawing session to go over what you have done and develop the habit of evaluating your own drawings in terms of the goals of the assignment. This self-study analysis will enable you to begin to make an effective critique of your own work and thus optimize the speed at which you learn.

One final word before you begin your first project. For the time being save all your drawings, even those you are not pleased with. Put them in a folder or red-rope envelope and keep them for future reference. Develop a habit of reviewing your work at least once a week and putting it in a safe place. By the time you are mid-way through the course your earliest drawings will clearly show you how far your learning has progressed.

DRAWING MEDIA

The materials that produce marks, lines, and tones on the surface or support of the drawing are called "media." Although there are scores of materials that can be used to draw with, all of them fall into two basic categories: dry, "abrasive" materials such as charcoal, chalk, pencil, and crayons; and "wet" media such as pen and ink, brush and ink, and watercolor. For our learning purposes we will explore the use of *charcoals, conté crayon, graphite*, and *ink*. These media should prove more than adequate to begin our study of the drawing process.

CHARCOAL AND CHALK

In many ways, charcoal is the ideal beginner's drawing material. It is easy to apply and to erase and it can readily produce a wide range of lines from thin and light to thick and black. Two basic types of charcoal are available in art supply stores: *vine charcoal* and *compressed charcoal*. Vine charcoal is irregularly shaped and thinner than rods of compressed charcoal, a manufactured product made by combining powdered charcoal with a binder under pressure. Vine charcoal is produced by carbonizing dried plant vines in a kiln from which air is excluded. Because of its organic origins and variables in the manufacturing process different batches of vine charcoal may vary considerably in terms of width and how dark a line they make. Compressed charcoal is more consistent in shape and it comes in a variety of carefully controlled grades from soft to hard. Soft charcoals produce darker, more diffused lines while hard densities create sharper, lighter marks.

Before you begin to draw from a subject – such as a still-life – you need to understand and experience the way basic drawing materials interact and respond to paper. The way you manipulate and control these mark-making instruments will greatly affect your drawings. The first exercises in this chapter are designed to introduce you to mark making and to show you how your control of the lines and tones affects the look of your drawings. This is an important element of drawing. Unlike complex media like painting and sculpture, drawing usually relies on making the most of a few simple materials. Unless you learn to understand, control, and exploit the visual qualities of the basic drawing media your drawings will probably achieve only limited success. Perhaps the most pronounced and consistent flaw in beginning students' drawings is their failure to fully exploit the full potential of their drawing instrument and flat, monotonous effects are the result.

The visual impact of a drawing greatly depends upon the relationship between the mark and the surface of the paper. Drawing a single line from edge to edge anywhere on a sheet of paper radically changes the way we perceive the space of the drawing surface. The paper and the drawn mark are greatly dependent on each other for, without the whiteness of the empty paper, the visual effects of the dark lines or marks would be nil.

In essence drawing is very much about opposition. The juxtaposition between the flat, open space of the paper and the varying marks and shapes organized on its surface is an essential element of this artform. All drawings, both abstract and representational, are created through this interplay of light and dark areas and empty and filled spaces.

Project 1

Exploring Charcoals

Materials: 18 by 24 inch newsprint pad, vine charcoal and compressed charcoal.

Charcoal is a soft, pressure-sensitive material capable of producing quite a large variety of tones and marks. The harder you press on this drawing instrument, the darker and thicker the line. Take a stick of vine charcoal and, holding it between your thumb and forefinger near the part that contacts the paper, explore its tonal range by making a series of continuous up and down strokes on the paper from left to right beginning with very heavy pressure and gradually decreasing it as you cross the page (Fig. **2.2**). The lines on the left should be the darkest and decrease in intensity until you reach the lightest tones possible at the paper's right margin.

Depending on the shape of the vine charcoal's tip, and the angle at which it makes contact with the paper, the width of the line can vary greatly. Experiment freely with different tip shapes and angles on a piece of newsprint to see how thin and thick the charcoal lines can be made. Once you have experimented with line thickness, do a variation of Project 1 and cover the surface of the newsprint with gracefully looping and intersecting lines that change in terms of thickness, darkness, and direction (Fig. **2.3**). If you have varied the size of the loops and how hard you press, you will find that these lines begin to suggest three-dimensional forms in space. Some portions of your drawing will appear to come forward or recede. The combination of shifting line directions and changes of width and tone all contribute to creating spatial illusions on the flat paper surface.

2.2 Tonal range of charcoal.

2.3 Charcoal exercise

2.4 Camille Pissarro, *Waterloo Bridge*, **c. 1890–91. Charcoal, 5 × 6¾ in (12.7 × 17.1 cm). Ashmolean Museum, Oxford.**

Camille Pissarro's drawing of *Waterloo Bridge* (Fig. **2.4**) makes effective use of this versatile material. Notice how the charcoal responds to the varying pressure of the artist's hand. The bridge and boats are rendered in the darkest tones while lighter lines describe buildings in the distance and the water in the foreground. Vine charcoal usually produces marks and lines that are quite dark and moderately soft in tone.

If you use compressed charcoal and newsprint for these exercises, you will notice that they result in a different line quality. Compressed charcoal is generally thicker than vine charcoal so its line is wider. This material comes in a variety of grades from hard to soft. Given equal pressure, the harder the charcoal the lighter the mark. Try several grades of compressed charcoal on pieces of scrap paper at your art supply store and buy an assortment to keep on hand.

What makes vine charcoal such a useful drawing tool for the beginner, apart from its easily varied line width and tone, is the ease with which it can be erased and corrected. Drawing students have traditionally made use of a soft cloth, called a *chamois* (pronounced "shammy"), which can be used to quickly wipe away large sections for redrawing. More precise erasures should be made with a *kneaded eraser*, a soft, pliable eraser that can be kneaded clean when it has picked up a lot of charcoal dust. Both of these erasing methods work quite well with vine charcoal but less efficiently with compressed charcoal because of its density and darkness. Try this out for yourself, making some dark marks on a piece of newsprint with vine and compressed charcoal and erasing them with a chamois and kneaded eraser.

One cautionary note about vine charcoal as a drawing material. The same quality that makes it easily erasable also makes it prone to smudging and smearing. Leave your drawings in their original pad or interleaved between clean sheets of paper.

Another method of preserving charcoal drawings is through the use of spray fixatives. Aerosol cans of *workable fixative* are available at art supply stores and properly used help drawings resist smudging. However, fixative does not offer total protection and it changes the tonal qualities of the charcoal lines. Carefully follow

directions on the can for proper application and, above all DO NOT breathe the fumes or overspray from these fixatives. The vaporized solvents in these pressurized cans are harmful if you inhale them. Use these fixatives only out of doors downwind or in large rooms where you can leave the windows open, quickly spray the drawings, and leave the room. Depending on the ventilation in the room, you can probably safely return in an hour or so. If you can still smell the fumes, it is not safe to be there. In extreme cases of prolonged and heavy exposure, people have become seriously ill from the toxic effects of these substances. Used with restraint and caution, however, they should pose no hazard to your health.

Chalks are closely related to vine and compressed charcoals. These are made by mixing various pigments together with *binders* that allow them to be molded into cylindrical or rectangular shapes. The term *pastel* describes colored chalks made by mixing fine particles of pigment with binders such as gum arabic.

Black chalk is capable of producing some of the darkest tones possible in the dry media and typically the quality of its mark is sharper and more precisely defined than vine charcoal. Daubigny's black chalk drawing in Figure **2.5** reveals the full tonal range of this material, from the deep velvety blacks of the tree and its shadows to the fine lines which describe the clouds in the distance.

Conté crayon is a popular drawing medium that seems to nicely bridge the gap between brittle, chalky materials such as pastel, and oily or waxy tools such as *lithographic crayons*. While retaining many of the qualities of the chalks, conté crayons, because of the addition of a soapy material to the binder, have a smoother feel to them. Explore the range and textural qualities of chalk and conté crayon and find out how their mark-making ability differs from vine and compressed charcoal.

2.5 Charles François Daubigny, *Rocky Landscape*, c. 1860. Black chalk on brown paper, 17²/₃ × 24³/₄ in (44.9 × 62.9 cm). The Metropolitan Museum of Art, New York. Gift of Mrs. Arthur L. Strasser.

EXPLORING GRAPHITE

Graphite is the dark slippery material found at the core of the familiar "lead" pencil. Like compressed charcoal, this manufactured drawing material comes in a variety of grades. There are over twenty grades of graphite pencils ranging from the hardest and lightest to the softest and darkest. In the hard category the grades run from 1H, the least hard, to 9H the hardest and lightest. B grade pencils range in softness from 1B, the least soft, to 8B the softest and darkest. Three more designated grades lie between these two categories: from the softest to the hardest they are F, HB, and H.

2.6 Mary Cassatt, *Girl Seated on a Sofa*, c. 1883. Pencil, 8²/₃ × 5³/₄ in (21.9 × 14.5 cm). National Gallery of Art, Washington. Ailsa Mellon Bruce Collection.

The hardness of graphite is determined by the quantity of binder mixed with the powdered graphite, a natural earth mineral. The more clay in the graphite mixture the harder the pencil grade.

The best graphite pencils for drawing are found in art supply stores rather than stationery outlets. Normal writing pencils are often too hard (that is, they produce only relatively light lines) and are limited to narrow graphite widths. Any decent art supply store should be able to supply you with a variety of the graphite drawing instruments mentioned in the shopping list at the end of this chapter. Graphite comes in forms other than pencils such as rectangular blocks and rods. One particularly interesting graphite tool imported by an American distributor from Czechoslovakia is simply a solid rod of graphite the diameter of a pencil coated with a thin plastic shell to make handling cleaner. Sharpened to a conical point this particular tool will produce a wide range of lines and marks.

Graphite is capable of a wide range of visual effects. Mary Cassatt's pencil drawing of a young child on a sofa (Fig. **2.6**) beautifully exploits the unique mark-making abilities of graphite. Dark tonal masses, the result of pressing hard on the pencil, are juxtaposed with lines of incisive movement and subtle tonality.

Medardo Rosso, a late nineteenth-century Italian artist, achieved very different results with this medium. In *Effect of a Man Walking Down the Street* (Fig. **2.7**), the street is represented by broad strokes made with his pencil point held parallel to the paper surface. The material reality of this street scene fades into a formless visual world described by the graphite's soft, silvery gray tones.

2.7 Medardo Rosso, *Effect of a Man Walking Down the Street*, c. 1895. Pencil on card, 7 × 3⁴⁄₇ in (17.7 × 9.1 cm). Museo Rosso, Barzia.

Project 2

Exploring Graphite

Materials: 9 by 12 inch sheets of medium weight bond paper, an assortment of soft to medium hard graphite drawing tools.

For this exercise we will use bond drawing paper in order to get an idea of how this material differs from newsprint and because it will accept vigorous drawing efforts without tearing.

Using one of the softer drawing pencils such as a grade 6B, explore graphite's tonal range by making a series of closely spaced horizontal lines beginning with the lightest marks and gradually pressing harder on the instrument until its darkest mark is achieved. Next, sharpen your pencil and freely experiment with line qualities that can be achieved by varying your angle and pressure (Fig. **2.8**). Try making some vigorously drawn lines that cross each other and create varying textures and tones.

For the moment forget your preconceived notions of what a drawing should look like and concentrate on the task at hand. You will find that you enter a mode of thought and activity far removed from logic-based thinking. By doing these activities you are developing response patterns that are necessary in order to draw with fluency and ease. If you lose yourself in concentration you will find that only after you stop are you aware of the time that has elapsed. You have participated in a form of spatial and visual thinking that is based more on holistic thought patterns than analytical reasoning. In future drawing sessions try to regularly enter this visual thought mode and suspend fully conscious analytical reasoning until after the drawing session.

2.8 Graphite exercise.

EXPLORING BRUSH AND INK

The combination of brush and ink represents a particularly dynamic drawing medium. No other instruments can achieve such intense blacks and easily flowing variably thick lines and shapes. There is also something appealing about the ease with which the liquid ink flows on the paper creating vivid contrasts between the black shapes and the white spaces of the paper.

Theodore Géricault's study for *The Raft of the Medusa* (Fig. **2.9**) makes dramatic use of brush and ink to achieve a forceful and dynamic composition. Géricault's bold interplay of black and white shapes evokes the jubilant emotions the shipwrecked sailors on the raft must have felt when they first spotted their rescue vessel on the horizon. Thin swirling lines in the foreground and in the makeshift mast contrast beautifully with the writhing black shapes created by brush and ink.

Kevin Connors's student drawing (Fig. **2.10**) also makes appropriate use of this liquid drawing medium to create dramatic visual effects. The aura of light surrounding the burning torches contrasts nicely with the solid black background on the top and the boldly alternating black and white nib-shapes on the bottom.

Working with brush and ink, however, requires some confidence, or at least a willingness to accept without changing what you have done. Once the ink touches the paper and is absorbed, no erasure of the mark can be made short of cutting a section out of the drawing. The key to controlled, easy application of ink is the brush itself. One of the best all purpose instruments to work with is a number 8 or 10 round, sable-hair brush that naturally shapes itself to a fine point when wet – at least the better ones do. Because of the rarity of fine quality red sable, and the skilled labor needed to properly form this tool, a good brush sells for what seems to be an exorbitant price. It is well worth the cost to serious students of drawing for nothing else will do exactly what this fine instrument can accomplish. For one thing, a number 8 or 10 sable-hair brush will do the work of many smaller brushes made out of cheaper materials. And it retains its shape much better than other natural hairs. With proper handling and care, it should last for many years. In short this instrument is an investment rather than an expenditure.

2.9 Theodore Géricault, Study for *The Raft of the Medusa*, **c. 1819. Pen and sepia wash, 8 × 11³/₁₀ in (20.2 × 28.7 cm). Musée des Beaux-Arts, Rouen.**

2.10 Student Drawing. Kevin Connors, Felician College. Ink wash, 24 × 18 in (60.9 × 45.7 cm).

Project 3

Exploring Brush and Ink

Materials: Medium sized sheets of heavy bond or watercolor paper, india ink, #8 or 10 round watercolor brush (an inexpensive Japanese squirrel-hair brush would make an acceptable substitute).

Although brush and ink are not pressure sensitive materials like charcoal, chalks, and graphite, they also respond when increased force is applied. As you touch the tip of the ink laden brush to the paper and gradually increase the pressure it fans out and produces a wider line. It is also capable of producing some of the broadest, blackest lines and marks to be found in the realm of drawing.

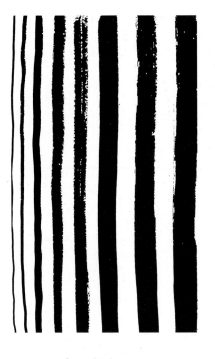

2.11 Brush and ink exercise.

To begin this exercise, position your paper vertically. Dip your brush halfway into the india ink, and press it against the side of the bottle to remove excess ink and shape the brush hairs into a point. Hold the brush near the end of the handle, and very lightly touch the tip of the brush to the top left of the paper and make a thin line extending to the bottom. Close to it on the right, make a similar line but this time press slightly harder creating a wider line. Continue this process until you have a sheet full of vertical lines gradually progressing from the thinnest to the thickest possible (Fig. **2.11**).

Study the brush and ink drawing by Géricault that we saw in Figure **2.9** before attempting the next exercise. The object is not to copy this drawing but to observe how the artist combined thick black ink forms and the negative spaces of the white paper to create an integrated arrangement of black and white forms. Take note of how the artist has created white shapes within the mass of dark ink passages in the center of the raft. After you have studied this illustration, place it out of sight and freely improvise a series of thick black lines and shapes that surround and enclose areas of white paper. The object of this exercise is to achieve the interaction of black and white, or "negative" and "positive," forms. J. Verona's student drawing in Figure **2.12** creates just such a visual dialogue.

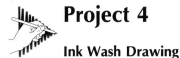

Project 4

Ink Wash Drawing

Materials: Bond paper, #8 or 10 sable-hair brush, india ink, three small wax-paper cups, a large jar of water.

The next exercise will reveal the extended range of tones that can be achieved with brush and ink by diluting the india ink with water. Place the three cups in front of you. The first cup will hold a modest amount of full-strength ink. The second cup should be mixed with half water, half ink while the third cup should be half filled with water into which several drops of ink are placed. These three dilutions represent the range of ink washes that you can use to draw with.

Richard Diebenkorn, a contemporary American artist, made use of a wide range of ink marks and tones to produce this visually rich composition, using as his subject a girl looking into a mirror (Fig. **2.13**).

After studying this illustration put it away and make a series of improvised dots, various sized shapes, and interlocking lines that vary in tone from the blackest black to the lightest gray. Do not wash the brush out every time you move from the various dilutions. See how many different tones you can achieve within the same composition. Make sure your improvisational drawing employs the same full spectrum of tones.

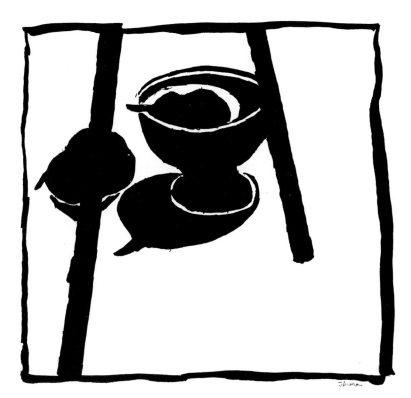

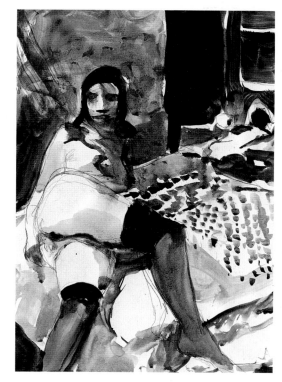

SHOPPING LIST OF BASIC SUPPLIES

One basswood or masonite drawing board, 20 by 26 inches

Newsprint pad, 18 by 24 inches

White bond drawing pad, 18 by 24 inches

An assortment of graphite drawing pencils (4B, 6B, 8B) and other solid graphite drawing instruments

Packet of vine charcoal (soft) and compressed charcoal (0)

Black chalk

Conté crayon (black)

Heavy metal clips to hold paper to the board

Kneaded eraser

Soft pencil eraser

Chamois

India ink

A medium sized round sable-hair brush – #8 or 10 (or substitute an inexpensive medium Japanese squirrel-hair brush)

Drafting tape (a form of masking tape with a weaker adhesive that is less likely to tear the drawing paper)

Push pins

2.12 (above left) Student Drawing. J. Verona, San Francisco University. Brush and ink, 10 × 11 in (25.4 × 27.9 cm).

2.13 (above right) Richard Diebenkorn, *Untitled*, 1962. Ink and pencil, 17 × 12⅜ in (43 × 31 cm). San Francisco Museum of Modern Art.

3 SEEING AND RESPONDING

Now that you have first-hand experience of the nature of basic drawing materials and how they interact, you are ready to begin working from a subject. At first it is important to focus your attention on the process rather than the product. These exercises are designed to teach you ways of seeing and responding that will form the foundation for future work in drawing. You may not initially produce the kind of drawings that you eventually hope to do, but these sessions are important because, later, they will enable you to visually respond to what you see in meaningful ways. Just as student musicians need to learn scales and the basic theories of harmony to gain control of their instruments, so you need to learn the rudimentary language of drawing. In order to fully commit these visual patterns of thought to memory, you need to consciously develop skills of thinking and responding that will later be used unconsciously and with greater ease and fluency.

GESTURE DRAWING

One basic concept unites all forms of drawing. They are all created by hand-held instruments that move across the surface of the drawing, leaving behind a record of their movement. This movement is inherent to the nature of drawing and perhaps no approach better expresses this motion, or kinetic activity, than the use of gesture drawing techniques.

The term "gesture" refers to the kind of rapidly drawn line we might make in order to record or visualize basic visual information in a short period of time. Eugene Delacroix's drawing, *Arab Attacking a Panther* (Fig. **3.1**), was probably completed in several minutes as a preliminary sketch for what would eventually become a large, elaborate painting with lots of detail. This highly energized gesture drawing conveys the dramatic action of a mounted horseman swinging his sword at a crouching panther. Here Delacroix was searching for the essential visual gestures or basic elements that would express his ideas. No other technique better captures action or more economically communicates visual form than gesture drawing. Gesture is concerned with communicating the essence of an idea not its fine points.

The gestural line is also a means of recording on paper not only what we see but how we see it. Quickly drawn lines mimic the rapid back and forth, up and down movement our eyes make as we visually explore a new form. Using our hand, arm, and upper torso to make rapid gestural lines, we can define important characteristics of the subject we wish to draw – its basic shapes, proportions, and its general position in space. This type of drawing does not concentrate on details, but responds instead with quickly drawn lines to the forms we perceive.

Through the use of gesture, Honoré Daumier's drawing of a clown (Fig **3.3**, p.62) captures the dynamic feeling and atmosphere of this nineteenth-century Parisian circus. Daumier is not primarily interested in recording details, his quickly drawn lines evoke the movement and theatrical quality of this scene in a convincing way.

Roxanne Cammilleri's student gesture drawing (Fig. **3.2**) sums up the essence of the figure in a few succinct lines. The general form and potential for movement of the human body is convincingly communicated to us by her rapidly drawn lines that gracefully loop around and encompass the form. As you can see from this illustration gesture does not solely record the edges or *contours* of the form, a technique which will be explored at length in the next chapter. The gesture method seeks to describe something basic about the whole form and it does it in an economic and dynamic way. Naturally you want to make drawings that look "correct" (that is, accurately drawn and faithfully rendered) but mastering the concepts of gesture drawing will prepare you to make future drawings that are more fluent and visually expressive.

3.1 (opposite) Eugene Delacroix, *Arab Attacking a Panther*, 19th century. Graphite on white paper, 9½ × 8 in (24 × 20.4 cm). Fogg Museum of Art, Harvard University. Bequest of Meta and Paul J. Sachs.

3.2 Student Drawing. Roxanne Cammilleri, Felician College. Charcoal.

3.3 Honoré Daumier, *A Clown*, 19th century. Charcoal and watercolor, 14³⁄₈ × 10 in (36.5 × 25.4 cm). The Metropolitan Museum of Art, New York. Rogers Fund.

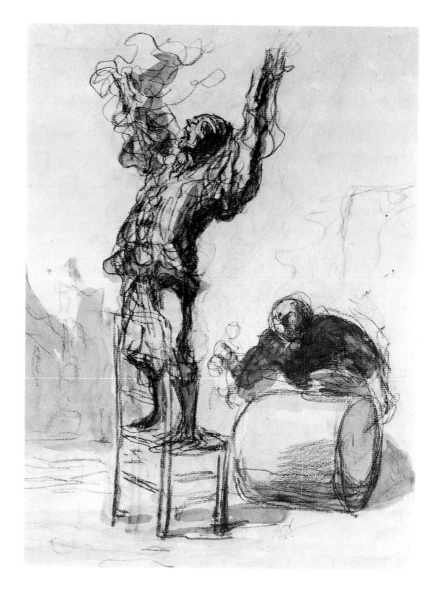

Project 5

Gesture Drawing

Materials: 18 by 24 inch newsprint paper, vine charcoal or conté crayon.

Create your still-life subject by draping a white or solid pastel bedsheet over three or four randomly positioned, medium size cardboard cartons, preferably set against a bare wall (Fig. **3.4**). If possible arrange the lighting so that a strong unidirectional light (such as a window, or spotlight and reflector) illuminates the subject. This will create strongly contrasting shadows and *highlights*, making it easier to perceive the three-dimensional character of the subject and to respond to it with massed gesture.

Before you begin to draw take a few minutes to study the scene. Where are some of the most prominent visual shapes in this arrangement? Try to view the subject as complete, comprising of various interrelated parts. Since we are concerned with rapidly responding to the forms in front of us, we must not let

ourselves become bogged down with minor detail. For this reason there is a time limit of two to three minutes for this exercise. Hold the charcoal in a relaxed way, study the subject and allow your hand and arm to follow your eyes as they move over the forms of the still-life (Fig. **3.5**).

Because gestural response should be spontaneous make sure you use the full dimensions of your newsprint pad. Avoid unconsciously placing a small drawing in the center of a large sheet of paper but rather consciously maximize the range of your arm movements in order to make full use of the paper. Look for major movements that run through the entire scene and record them with gestural lines. In this assignment it is better to err on the side of boldness rather than timidity.

Once you feel comfortable with this exercise try putting to use what you have learned from the exercises that explored the pressure-sensitive nature of charcoal. To register dark undercut folds, press harder. Minor creases should be drawn with less pressure. Changing the angle of the charcoal against the paper will also change the width of the line. Develop a "push" and "pull" response to the subject. Changing the intensity of the line might be coordinated with the object's changes in depth or direction.

After you have made a series of short, timed drawings, stop and take a look at them. Could your lines be more flowing and expressive? Have you sufficiently emphasized major divisions in the form? Are you using the whole page? Shift your position to avoid monotony and visual familiarity. Make several more gesture drawings, keeping in mind the previous instructions. Think of the lines as uncoiled strings that follow the forms and fold of the subject. Be aware of the natural movement of your eyes as you trace these flowing forms. For the time being, forget about how accurate these drawings are and concentrate on the linear movements of the gesture lines.

3.4 (below left) Bedsheet draped over cardboard boxes.

3.5 (below right) Student Drawing. Marisol Torres, Felician College. Charcoal, 24 × 19 in (60.9 × 48.2 cm).

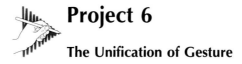

Project 6

The Unification of Gesture

Materials: 18 by 24 inch newsprint paper, vine charcoal or conté crayon.

This exercise is designed to make you more aware of how all of the visual elements in your drawing could be organized to work together in harmony. This arrangement of your drawing's shapes, spaces, lines, and tones is referred to as its "composition." One of the earmarks of an effective drawing is the way it unifies all its elements to create a feeling of wholeness and completion.

Look for several objects that have simple, uncomplicated shapes such as vases, books, and a shoe-box. (Ignore any advertising labels on the boxes. We are responding to the three-dimensional forms instead of surface design.)

Take some care in arranging your still-life subjects and place them in a group on top of a table in an uncluttered area where the light is good. Arrange some touching one another and some at short and medium distances. Stand back and view the arrangement as an informal composition rather than a collection of objects.

We will do a series of three to five minute poses for this still-life. Since the shapes of these objects probably do not relate to each other visually we will have to create this effect with our gestural responses. Pay particular attention to how lines and marks might visually connect and spatially integrate these unrelated objects. We should be able to look at the drawing and see the still-life objects as a unified grouping.

Avoid placing small drawings of these objects in the center of the page. As you draw, allow your eye to travel across one form and onto the one next to it. Respond freely with your charcoal as you mimic the movement of your eyes.

In these initial exercises remember not to dwell on details. We are developing spontaneous response patterns to drawing that will be put to use later in more controlled ways. Stay with these gestural drawing exercises until you feel you have gained some proficiency. It would make sense to thoroughly explore the possibilities of basic exercises such as this one before continuing. Keep in mind, as you progress from one project to the next, that returning to earlier exercises will hardly be a waste of time. Drawing skills are cumulative, and over time our experience enables us to handle increasingly complex problems.

3.6 (opposite) Alberto Giacometti, *Portrait of an Interior*, 1955. Pencil, 15³/₈ × 10⁷/₈ in (39 × 27.6 cm). Collection, The Museum of Modern Art, New York. Gift of Mr. and Mrs. Eugene Victor Thaw.

Alberto Giacometti, a modern Swiss artist, used energetic and searching lines to visually link all the contents of a room in *Portrait of an Interior* (Fig. **3.6**). Through Giacometti's relentlessly searching and interpenetrating lines the inanimate objects in the room are unified and brought to life. Notice the way all the visual elements in this scene appear to be connected to each other to form a unified whole.

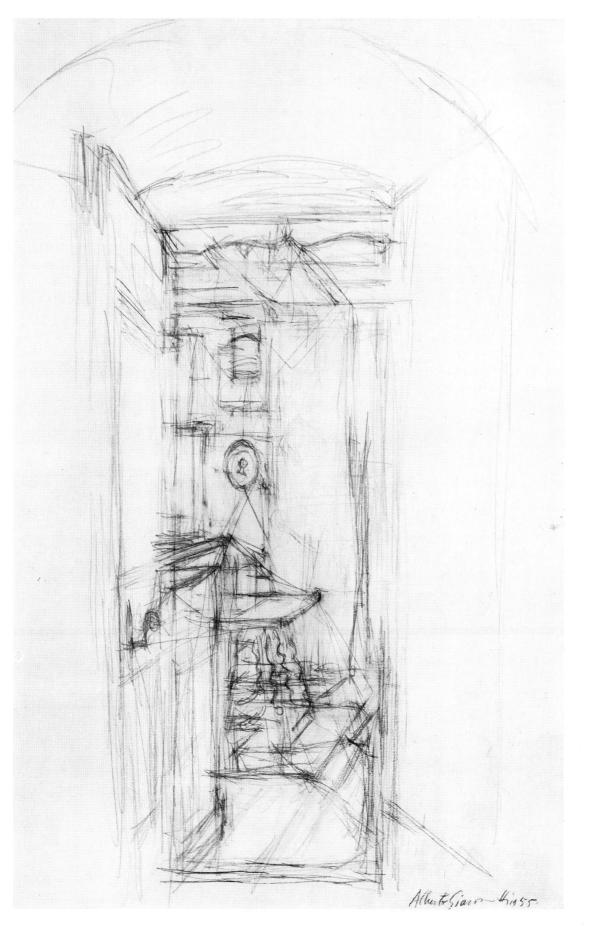

GENERAL GUIDELINES

Here is a summary of guidelines to remember as you work on the drawing projects in this chapter and throughout the book.

Position yourself comfortably and allow plenty of space to move your arms freely when working on a drawing.

Unless directed otherwise use 18 by 24 inch paper (newsprint or bond).

Consider the physical parameters of your subject in relationship to the format or edges of your drawing paper before starting to draw.

Use the entire drawing space of your paper. Do not place small drawings in the center.

Exploit the full range of tones and marks your drawing instrument is capable of making.

Practice keeping your eye on the subject while your hand responds with motions that enscribe the forms on the paper.

Avoid cardboard cut-out outlining in gesture drawing. Use lines that visually "touch" the subject in many places not only its outer edges.

3.7 Rembrandt van Rijn,
***Elephant,* c. 1637. Black chalk,**
9¹³/₁₆ × 14 in (24.9 × 35.6 cm).
Albertina, Vienna.

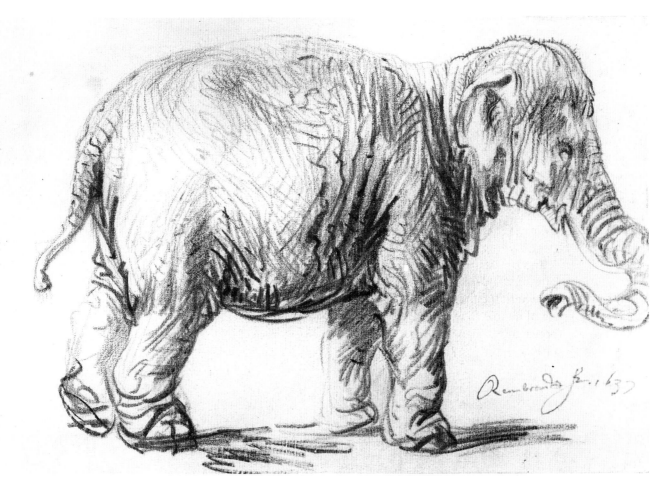

Project 7

Using Massed Gesture Lines

Materials: 18 by 24 inch newsprint paper, vine charcoal.

In this project you will use *massed gesture* lines to quickly block in shadow areas and broadly define areas of light and dark in your subject. The time limit on this assignment should be between five and eight minutes.

Your choice of subject and the way you light it will play an important role in the success of this assignment. Use simple household objects similar to those used in Project 6. Illuminate this still-life with a strong unidirectional light source from a lightbulb and aluminum reflector to produce strong highlights and deep shadows. This will make it easier for you to perceive the basic divisions of light and dark in the subject and to respond to them with massed gesture lines.

Begin by lightly indicating the basic visual structure of the still-life with quick exploratory lines. Do not emphasize the edges of forms but explore the inner and outer structure of these three-dimensional objects. At this stage you are roughly determining where the major shapes are and how they relate to the physical dimensions of your paper. Holding your stick of charcoal at a 45 degree angle to produce thicker lines make a series of close parallel lines that correspond to some to the deepest shadows in the subject. Avoid holding the charcoal completely parallel to the paper surface because the marks created by this technique tend to be smudgy and have no definition. By varying the thickness, density, and closeness of these lines, we can control how light or dark the tonal area becomes. Stay within the time limit to avoid overworking details, the idea here is to spatially describe the forms in your drawing through the means of dark and light tones. Your response should be spontaneous, direct, and bold. Take care not to cover the entire drawing surface with tones and lines. The contrasting effect of dark to light tones will be diminished. Make the paper work for you, let it represent the highlights in the subject. Rembrandt's drawing of an elephant (Fig. **3.7**) was done using the technique of massed chalk lines. Notice the way he creates the illusion of form through the interplay of dark and light tonalities.

After a few warm-up drawings change your position and before beginning to draw take note of where the darkest shadows are in the subject. What sections fall into the range of middle tones? Where should you leave the paper untouched to represent highlights?

Now that you have gained some experience with this process, practice integrating the spontaneous gestural lines you used in Project 5 with the massed-line technique of this exercise. Figures **3.8** and **3.9** (p.68) show two student drawings that make use of massed gesture lines. Again do not measure the success of your drawing by how accurate and finished it looks – that issue will be resolved with time. Strive for an extended range of tones that varies from the lightest line to the darkest passages.

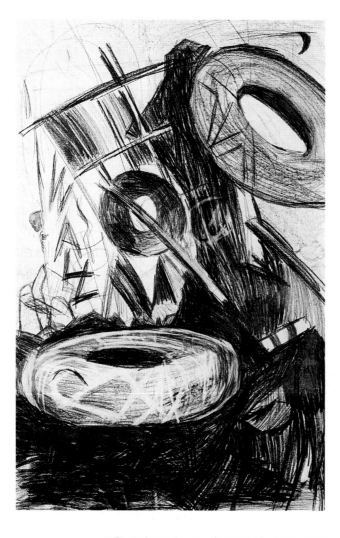

Project 8

Making Continuous Line Drawings

Materials: 18 by 24 inch newsprint or bond paper, a soft, broad point graphite pencil.

For this assignment create an effective drawing subject by draping a white bed sheet over a high-backed living room chair. Arrange the folds so that they form continuous, intersecting patterns (Fig. **3.10**) pinning folds together in order to achieve interesting visual effects.

The solid graphite drawing instrument mentioned earlier is an ideal tool for continuous line drawing because of the ease with which it glides over the surface of the paper (graphite is naturally slippery and is used as a dry lubricant for metal parts). The aim of this assignment is to construct a drawing that appears to have been made from one continuous line, developing the ability to coordinate the art of seeing with the process of drawing. Before you begin to draw, allow your eyes to freely roam and explore the physical dimensions of the still-life.

When you are ready to start your drawing, keep your eyes on the subject and repeat this viewing process, only this time, making sure your pencil remains in continuous contact with the paper, we will synchronize the movement of our eyes with the continuous pencil lines. A good strategy is to convince yourself you are touching the still-life with your pencil, drawing anything that your pencil could rest on and be guided along. You may momentarily stop the movement of the drawing instrument and look down at your drawing but keep the graphite in contact with the paper until you resume drawing. This may seem to be an awkward method, but with practice you will be able to better coordinate your eye movements with the movement of your drawing instrument. By constantly looking up and down you are impeding the continuity of perception and you are actually drawing from memory rather than direct experience.

The time limit on this assignment should be about six to eight minutes.

Donato Creti, an Italian artist of the eighteenth century, made use of continuous line drawing techniques in this fluid study titled, *Thetis Dipping the Infant Achilles into the Waters of the Styx* (Fig. **3.11**).

3.8 (opposite left) Student Drawing. Anon, San José State University. Charcoal, 40 × 26 in (101.5 × 66 cm).

3.9 (opposite right) Student Drawing. Cherry Tatum, San Francisco State University. Charcoal, 24 × 18 in (61 × 45.7 cm).

3.10 Folds arranged in continuous patterns.

3.11 (opposite bottom) Donato Creti, *Thetis Dipping the Infant Achilles into the Waters of the Styx*. Pen and brown ink, 6½ × 10⁴/₅ in (16.9 × 27.6 cm). The Metropolitan Museum of Art, New York. Gift of Cornelius Vanderbilt.

Contemporary artists like Mel Bochner have also used similar techniques to produce striking drawings that probe visual perceptions and create feelings of movement and spatial continuity (Fig. **3.12**).

INTEGRATING GESTURE DRAWING TECHNIQUES

Now that you have gained some preliminary experience in manipulating and controlling your drawing materials and you have learned to respond visually to various subjects, it is time to integrate and combine the various gestural techniques. Much of your previous effort was directed toward learning response patterns rather than achieving accurate representations. This assignment stresses combining many of the aspects of previous exercises, such as spontaneous gesture, mass gesture, and continuous line drawing, with a greater attention to accurate description.

The time limit on this series should range anywhere from ten to twenty minutes. Within this time-frame stay with the drawing as long as you do not become bogged down with minute detail. The object is to preserve some of the dynamic visual effects you achieved in the initial exercises with greater concern for overall organization and accurate description.

Andy Warhol's curiously incongruous drawing of a Campbell's soup can stuffed with dollar bills (Fig. **3.13**) reveals a technique that effectively integrates quick gesture drawing with careful placement of forms and accurate description. The vigorous gesture lines in the upper half of the drawing contrast nicely with the freely drawn design elements of the soup can and the tightly rolled wad of bills in the foreground.

3.12 (opposite) Mel Bochner, *Number Two*, 1981. Charcoal and conté crayon on sized canvas, 92 × 74 in (233.7 × 187.9 cm). Courtesy, Sonnabend, New York.

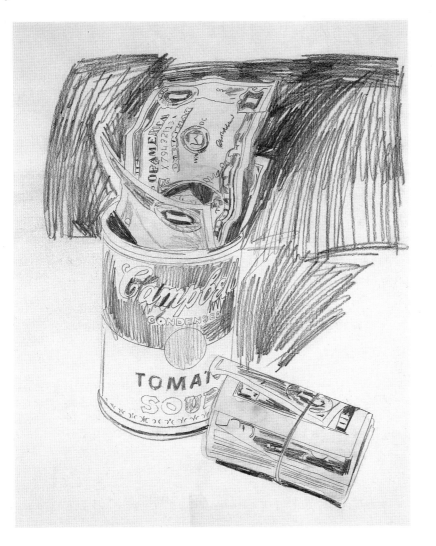

3.13 Andy Warhol, *Campbell's Soup Can and Dollar Bills*, 1962. Pencil and watercolor, 24 × 18 in (61 × 45.7 cm). Collection Roy and Dorothy Lichtenstein, New York.

Project 9

Sustained Gesture Study

Materials: 18 by 24 inch newsprint or bond paper, vine charcoal or graphite stick.

For this assignment create an appropriate still-life by using a circular or rectangular waste paper container and placing a few crumpled sheets of newsprint on it. This, coupled with some effective lighting, should make a challenging subject to draw. Take the time to study the still-life before you begin to work. Give some thought as to how you will arrange the lines and shapes on your drawing surface.

Begin by very lightly indicating on the paper where major forms will be located on the drawing plane. Since your first tentative marks will be faint you can easily erase or draw over them later in the session when you are more sure of the position of the various elements. Do not become too restrained with your drawing technique. Once you feel confident about the position of a form use vigorous, bold gesture lines. Vary your drawing methodology. As in the Warhol drawing some passages could be very free and sketchy and others more carefully delineated. We are searching for a balance in this series between the loose and controlled, the spontaneous and the planned.

After you have completed several drawings take a break and review your results. Pay particular attention to the character of the lines or marks. Are they all the same tonality, the same size? Could you improve the visual qualities of your drawing by making the marks more varied and more responsive?

Review the general guidelines presented on page 66 and make a checklist of areas you want to improve. Are you using the entire space of your drawing surface (this does not mean filling it in but making appropriate use of all of the space)? Take note of how the Warhol drawing in Figure **3.13** organizes areas of linear activity with visually quiet space.

Another important factor is the "cardboard cut-out" syndrome, a common occurrence in student drawings. Lines should search and explore the full three-dimensionality of the forms and not merely outline them. Make note of the basic improvements you wish to make in figure drawings and work toward putting these changes into effect. By the same token take stock of the elements that work and continue to emphasize these qualities.

CONSTRUCTION METHODS

So far we have concentrated on spontaneously responding to the visual forms in front of us with quickly perceived gestural lines and marks. Accuracy of description and proportion in these beginning exercises were of less importance than developing a rapport between the act of seeing and the process of drawing. We were also learning to observe, condense, and record what we saw within strict time limits. Many of these techniques are frequently used by artists when they draw from life in sketchbooks. Often in these situations there is a need to produce drawings rapidly and with a minimum of reworking – the world is moving too quickly for studied efforts. But many of the visual effects of gesture drawing are prized by artists even

when they are working in their studio because these gestural lines have visual qualities that are uniquely expressive. For instance, the vigorous and graceful lines seen in Willem de Kooning's drawing in Figure **3.14** convey a sense of power and dynamism that correspond to many aspects of twentieth-century life.

Despite the outward appearance of casual improvisation that we perceive in de Kooning's drawing, his work is the result of great control and careful structuring. He is able to organize visual components, however, in such a way that they have the appearance of spontaneity. Years of practice have enabled him to achieve the feeling of freshly perceived graphic expression even if he works on a drawing or painting on and off for years.

In order to begin to develop the fluency of visual thought that enables artists like de Kooning to effectively structure his ideas, we must have a working knowledge of how drawings are constructed. Another basic approach to drawing is to slowly and methodically respond to what we see in terms of planning, compositional structure, emphasis, and the analysis of visual relationships. Once you have gained experience with conscious planning, or construction methods, you will later be able to perform all of these analytical decisions almost without being conscious of using them. When the immediacy of gestural visual response is teamed with meaningful organization and structure we will have achieved a synthesis of thought that is the hallmark of effective drawings.

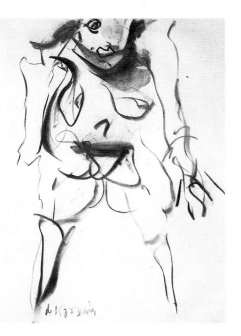

3.14 Willem de Kooning, Untitled, 1968. Charcoal on tracing paper, 24 × 18¾ in (60.9 × 47.5 cm). Collection, The Museum of Modern Art, New York. Gift of the Artist.

Project 10

Blocking Out a Drawing

Materials: 18 by 24 inch newsprint or bond paper, vine charcoal or soft graphite pencil (wide-point).

To create a still-life that offers a variety of sizes and shapes select a group of four or five moderately sized household objects, such as lamp shades, cereal boxes, or toasters and place them on a supporting surface such as a table or

chair. Organize them in an informal, clustered way, avoiding even, symmetrical spacing (Fig. **3.15**). In these exercises we will explore ways of consciously analyzing and graphically interpreting visual information.

Pick an angle of the still-life that appeals to you and get into a comfortable drawing position. Try not to work longer than twenty or thirty minutes on one drawing. Before making a mark on the paper, carefully examine the objects in front of you and consider them in relation to your drawing *format*. All the objects in your still-life should visually fit within the drawing format with some of them coming quite close to at least three edges of the paper. What part of the arrangement will come close to the top of the page? What object approaches the bottom edge of the drawing? What about the left and right limits? Begin by placing a light mark with your charcoal or pencil at specific points on the paper to indicate these parameters. At this stage of construction we are not interested in describing objects as much as we are concerned with determining their spatial and proportional relationships with each other and the dimensions of the paper. After carefully examining the still-life, visualize an imaginary line going from one of the parameter points you have chosen to another. On your paper lightly make an actual line between these points. Keep visually comparing and checking the angle and proportional length of the envisioned line in comparison to the actual drawn line. Make corrections over your previously drawn lines as you begin to note their true positions. Continue to analyze and block out the relationships of all the objects in the still-life. What you will arrive at is a series of lines that analytically define the spatial and proportional structure of the still-life. Figures **3.16, 3.17,** and **3.18** offer examples of what your progression might look like.

Pay particular attention to the space between the objects you have selected to draw. These negative spaces are as important as the objects themselves in terms of defining the compositional space of the drawing. What you will have created in this drawing session is a "map" describing the visual terrain of your still-life. The concept of a map is an excellent model for you to keep in mind. Classical drawing seeks to present forms and spaces to the viewer in a coherent, logical way. When you have developed the ability to control and manipulate what you see, you will have the freedom to creatively invent and organize anything you can imagine.

3.15 Household objects arranged into a still-life.

Project 11

Integration of Analysis and Gesture

Materials: 18 by 24 inch newsprint or bond paper, vine charcoal or graphite pencil. Rearrange the still-life used in Project 10.

Now that you have gained experience analytically blocking out a composition we will use this technique to create a skeletal structure upon which your gestural drawing is based. In this way we can combine accuracy of proportion and compositional refinement with more spontaneous lines.

Begin the drawing by determining the basic compositional organization as you did in Project 10. Make a series of horizontal and vertical lines that define the heights, widths, and general shapes of all the still-life objects and the negative space that surrounds them. These lines should continue past the objects, sometimes to the edge of the page. Keep these lines light because later you may want to draw over them and make them darker at crucial points.

Use this guide as a basis for a gestural drawing that explores some of the details of the still-life. Do not erase the preliminary lines that helped you define the composition, they reveal the visual thinking that went into the drawing and enable the viewer to share in the process of discovery.

3.19 Student Drawing. Rosemary Thompson, Felician College. Graphite, 23¾ × 18 in (60.3 × 45.7 cm).

Rosemary Thompson's student drawing (Fig. **3.19**) makes effective use of analytic drawing methods to create visual structures upon which she can further refine her composition. The large circles indicating body mass and structure and the smaller circles describing places where the legs are jointed aid her description of the donkeys' forms.

Later, as you gain proficiency with visualizing how a drawing might be organized, you might use fewer actual lines to plan its composition. Much of this analytic planning will be done unconsciously.

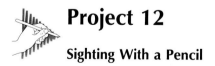

Project 12

Sighting With a Pencil

Materials: 18 by 24 inch bond paper, a 6B drawing pencil or conté crayon, a sharpened writing pencil.

Much of the difficulty of achieving accurate proportions in our drawings is because what we know about an object gets in the way of what we see. For instance, we may know that the top of a certain kitchen table is square. But,

when we see this table from a distance what we objectively perceive is a narrow rectangle. Often when we draw this table seen from a distance we will tend to make the top square. In order to help us perceive spatial relationships and determine the correct angles and line positions, certain techniques and mechanical aids can be very helpful.

Find a rectangular kitchen or dining room table that is convenient for you to draw. Sit down about 8 to 10 feet away from the table at an angle where the sides of the table do not appear parallel to the bottom of your page. Hold your *sighting* pencil at a consistent full arm's length (this is important because if your arm is sometimes bent you will introduce unwanted measurement variables) and position it parallel to the bottom edge of your drawing paper. Close one eye, and keeping the pencil at this angle, move it up until it visually appears to touch the bottom of the table leg nearest to you (Fig. **3.20**). Now it is possible to more objectively observe the angles of the table legs and the box sides in relationship to the bottom of your page. You can also use the sighting pencil held upright like a plumb line, to determine vertical alignments. Although our goal is to be able to overcome the impediment of misperception in drawing by training our mind, eye, and hand, this mechanical device can help us correct initial mistakes.

We can also use this technique to optically measure the relative proportions of shapes found in our still-life. For instance, many drawing students might at first have trouble correctly drawing the top of a table such as the one seen in Figure **3.20**.

Once again, holding the pencil in your outstretched hand, measure the length of the table leg nearest to you by visually placing the pencil point at the top of the leg and placing your thumbnail at the position that corresponds with the bottom (Fig. **3.21**). Keeping your thumb in this position with your arm still fully outstretched, compare the length of this leg to other visual measurements of the table, such as the table top. In this way you can objectively measure all the proportions of your subject and align them correctly on your drawing.

Using this sighting method accurately draw the composition you created in Project 10, paying particular attention to horizontal and vertical angles and relative proportions.

3.20 (left) Sighting with a pencil to determine angles.

3.21 (right) Sighting with a pencil to determine proportions.

Project 13

Analyzing Complex Forms

Materials: 18 by 24 inch bond paper, vine charcoal or a 6B graphite pencil.

Once you have gained a modest proficiency with the sighting pencil, purposely choose a complex subject to draw such as an opened umbrella, the blades of an electric fan, or a bicycle. Begin by blocking out the general composition of the subject and then use the pencil-sighting method to determine the exact position of shape and angles. There is no time limit on this exercise so take your time, organizing the details carefully.

VISUAL EMPHASIS

Even the simplest of drawing subjects presents us with an enormous amount of visual information – seemingly infinite gradations of light and dark values, complex and simple shapes, surface textures, and in general a wealth of spatial detail. A camera cannot help but record all the light-based information passing through its lens. By contrast a drawing might show us less but tell us more because of the way artists edit visual information and emphasize only those features important to the theme or concept.

Larry Rivers, a contemporary American artist, created a particularly expressive portrait of Edwin Denby by selectively focusing on specific facial features and eliminating or only suggesting others (Fig. **3.22**). Bold, gestural lines define sections of the figure's head and shoulder, while softer, finely hatched pencil lines describe

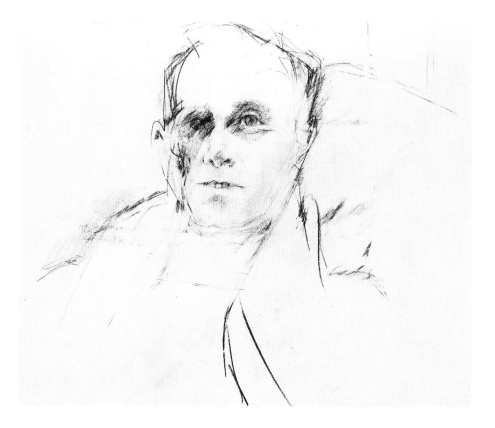

3.22 Larry Rivers, *Portrait of Edwin Denby III*, 1953. Pencil, 16³⁄₈ × 19³⁄₄ in (42 × 50 cm). Collection, The Museum of Modern Art, New York. Anonymous gift.

lips, nose and eyes, perhaps the most important areas of a portrait drawing. Large areas of the paper are left untouched and these sections act as a contrast to the complex, visually active passages. By consciously emphasizing and playing down various visual elements of Denby's features, Rivers creates a haunting portrait that appears to be half-imaginary, half-representational.

When a drawing presents us with a lot of undifferentiated visual information we may find it monotonous and dull. Rosemary Thompson, a beginning student, makes effective use of visual emphasis in her drawing (Fig. **3.23**) to counter this potential problem. By making the ceramic vase and some of the vertical forms significantly darker than other elements in this drawing, she creates interesting visual juxtapositions and encourages us to look carefully at her composition.

3.23 Student Drawing, Rosemary Thompson, Felician College. India ink, 10¾ × 10 in (27.3 × 25.4 cm).

![Project icon] **Project 14**

Selective Focus

Materials: 18 by 24 inch bond paper, soft graphite pencil or vine charcoal.

Using objects found in your house or apartment, create a still-life that combines a variety of unusual shapes and themes. You may wish to use the white sheet as in earlier sessions since it has enormous flexibility and can simplify or embellish a drawing subject. If possible, choose objects that have some personal meaning to you that could be juxtaposed with other thematically expressive objects, for instance, a childhood collection of teddy bears could be combined with other memorabilia to create interesting visual and thematic possibilities. The incongruity of some of these objects might lead to drawing ideas you would not otherwise have conceived of. Use your imagination and take some time to create a still-life that encourages involvement on all levels of thought, thematic as well as visual.

Remember that interesting subjects do not guarantee effective drawings. You will need to fully exploit the visual principles and elements that we have been learning in order to make the drawings themselves interesting.

No strict time limit is set on this assignment but be aware of the pitfalls of dwelling too long on any detail or section. Generally it should take you an hour or two to complete this drawing.

Once the subject material is arranged to your satisfaction and the lighting is complete, examine the subject from several angles. What drawing position seems to offer the most interesting compositional possibilities? What preliminary thoughts do you have about emphasizing or playing down various components in the still-life? The primary objective of this drawing is to experiment with visual selection and emphasis. What is drawn, how is it drawn, where is it placed, and just as importantly, what is left out or only tentatively suggested?

Lightly block in key points of the composition and define where the outer limits of the drawing will be. Slowly begin to develop detail in areas that are significant to you. Let the drawing activity gradually grow over the entire surface of the paper, taking care not to let any one area develop too rapidly. As the drawing evolves, step back for a minute and consider the total composition. Are certain areas in need of more development? What about the open spaces of the drawing; are they contributing to the overall effect?

During this drawing project we need to be particularly conscious of the effect of the composition as a whole. Avoid automatically placing your main focal points in the center of the page unless this is an important part of your compositional theme, otherwise you may inadvertently produce a dull, static arrangement. Larry Rivers (Fig. 3.22) placed the figure's head off-center near the upper edge of the composition. Similarly, the focal point of Rosemary Thompson's drawing (Fig. 3.23) is placed off-center. This visual organization creates an interesting tension between the empty space of the drawing and its selectively drawn details. As you draw, think carefully about what sections will be emphasized. What supportive role will other details play? What visual components could be suggested with just a few lines? Figures 3.24 and 3.25 illustrate two successful student responses to the problems of selective focus and visual editing.

3.24 Student Drawing, Christopher Brown, San Francisco State University. Charcoal, 24 × 18 in (61 × 45.7 cm).

3.25 Student Drawing. Doug Cerzosimo, Bucks County Community College, PA. Ballpoint pen, 17 × 14 in (43.2 × 35.6 cm).

By now you should have a clearer understanding of some of the basic visual concepts and skills you will need to learn in order to draw with confidence and fluency. Sitting down in front of a subject with a blank sheet of drawing paper in front of you should not be the intimidating experience it might have been in the past. Future chapters will build upon this foundation and allow you to begin to express your ideas with more assurance and skill.

4 LINE

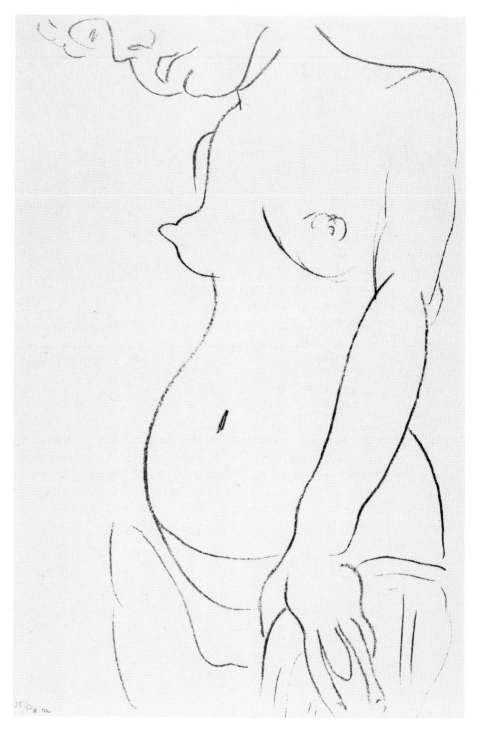

Although all the visual elements play key roles in the drawing process, line is one of the artist's most versatile and important graphic tools. There is virtually no form, concept, or emotion that cannot be expressed with line. Artists from the beginnings of recorded history to the present day have appreciated the extraordinary virtuosity of line and have used it in countless ways. This chapter will introduce you to many of the basic ways in which line can be put to creative and expressive use.

Before we begin our exploration of line it is important to realize that lines do not exist in the natural world. They are a graphic concept, first invented to communicate symbolic visual ideas and later used in the West to describe three-dimensional forms on a two-dimensional surface. Learning to draw effectively means gaining a fuller understanding of how lines work and how they can be used to achieve a variety of visual effects.

THE CONTOUR LINE

One of the most basic types of line that the artist uses to describe three-dimensional forms on a two-dimensional surface is the *contour line*. These lines follow the edges of shapes and clearly define the various volumes and parts of the whole form.

Contour lines differ from the gestural lines we used in the beginning exercises of the previous chapter in a few important ways. Gestural lines are used to visually express the basic shapes, movement, and feel of the forms we are drawing. By contrast, contour lines more accurately describe the exact shape of forms by carefully recording the placement of their edges or contours.

A clear example of contour line drawing is revealed in Henri Matisse's *Three-quarter Nude, Head Partly Showing* (Fig. **4.1**). Notice how the lines in this drawing respond to the various edges of the body and the overlapping muscles by following the contours of these forms as they flow across one another. The artist, however, is not merely making a cardboard outline of the model but is quite sensitive to the way forms overlap and move away from and toward us, communicating this three-dimensionality by occasionally leaving gaps between forms. This is evident in the upper right arm and where the model's right breast appears in front of the right shoulder.

Matisse also changes the weight of the line and controls the way it starts and stops, all devices which help create the illusion that we are viewing a form that exists in three-dimensional space.

Ellsworth Kelly's elegant contour line drawing of a tropical plant (Fig. **4.2**) economically records the shapes made by the edges of the leaves. By accurately recording these lines Kelly enables us to read the position of the leaves in space.

4.1 (opposite) Henri Matisse, *Three-quarter Nude, Head Partly Showing*, 1913. Transfer lithograph, 19¾ × 12 in (50.2 × 30.5 cm). Collection, The Museum of Modern Art, New York. Frank Crowninshield Fund.

4.2 Ellsworth Kelly, *Five-leaved Tropical Plant*, 1981. Pencil on paper, 18 × 24 in (46 × 61 cm). Private Collection.

4.3 (opposite left) Student Drawing. Anon., San Francisco State University. Felt marker, 18 × 24 in (46 × 61 cm).

4.4 (opposite right) Student Drawing. Jolly Earle, Sonoma State University. Graphite, 24 × 16 in (61 × 40.6 cm).

Like those of Matisse, Kelly's lines are sensitive to fluctuations of shape and the position of forms in space. Subtle shifts in line weight and accurate description of forms account for this drawing's illusionistic effects. The contrast between the thin, responsive contour lines and the expanse of open paper creates dramatic effects in this deceptively simple drawing.

Project 15

Exploring Contour Lines

Materials: 18 by 24 inch medium weight bond paper, a sharpened medium soft graphite pencil.

Create a still-life by arranging irregular objects such as a pair of shoes, a hand-bag, or some leather gloves on a table-top. Avoid symmetrical objects but any other objects that provide interesting spatial relationships will do. Before beginning to draw, carefully observe the shapes of the objects and how their various parts overlap.

Plan the drawing so that elements of your still-life are distributed throughout the picture plane with some close to but not touching the edge of the paper. Do not draw this set-up from a distance but move your drawing board close to the still-life in order to develop an intimate and tactile understanding of it, that is, an understanding based on touch. Keeping your eye on the subject, start with any edge and follow the contours of the objects with continuous lines. Try to feel that you are not just looking at but are also touching the objects with your moving pencil. There is no time limit on this drawing so take your time. Observation and accuracy are primary factors in this exercise. Respond to subtle changes in the edges with corresponding movements of your drawing instrument. When you come to the juncture where one object or section of an object disappears behind another, stop. Take a few seconds to compare your drawing with the subject. Begin drawing the visible contour of the partially hidden object until it too disappears behind another form. Your proportions may be off but do not be overly concerned. What we want to focus on in this section is the use of contour lines that respond to the constantly varying edges of the three-dimensional forms. After you have made several contour drawings, change the arrangement of the still-life materials and do several more.

Another good variant of this project would be to use organic forms such as bananas or green peppers to introduce variety. Rubber tree plants and other indoor vegetation with large well-defined leaves would also make appropriate subjects for contour drawing.

Contour lines are capable of a variety of visual effects. The student drawings shown in Figures **4.3** and **4.4** give us some idea of the visual effects it is possible to achieve using this basic linear drawing technique.

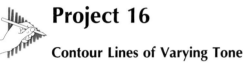

Project 16

Contour Lines of Varying Tone

Materials: 18 by 24 inch bond paper, vine charcoal, compressed charcoal, or soft graphite.

This drawing session will explore the effects of contour lines that vary in terms of how light or dark they are.

Choose drawing subjects that are basically curvilinear in shape such as vases, tubular objects, plates, sections of cut logs, or the rubber tree plant mentioned in the previous session would be appropriate. The task is to describe these forms with contour lines that vary in tonal weight. As you follow the contour of the subject vary the pressure you exert on your charcoal or graphite in response to the three-dimensionality of the forms: as they come toward you, increase the pressure to create sharp, dark lines; as they move away from you make the contour line gradually lighter to signal this spatial change. Another drawing technique to put into practice is to leave a small gap between lines that indicate overlapping forms. The distance of this gap could indicate the degree of separation: where forms are close to one another, the gap might be nonexistent or narrow; where the distance between forms is great the gap might be larger. Go back and look again at the Matisse drawing in Figure **4.1**, and take special note of how the artist used this technique to achieve his spatial effects.

Gaston Lachaise's fluid contour drawing of a nude (Fig. **4.5**) makes effective use of continuously varying linear tones to describe the voluptuous three-dimensional form of his female model. Contour line in the hands of this artist achieves visual effects that are anything but flat and "cut-out" in appearance.

After this drawing session take the time to analyze your drawings and make mental notes about what you can do in future contour drawings to exploit more fully the possibilities of this technique.

4.5 Gaston Lachaise, *Standing Woman with Drapery*, c. 1929–31. Pencil, 18 × 12 in (45.7 × 30.5 cm). Collection, The Museum of Modern Art, New York. Gift of Edward M.M. Warburg.

CROSS-CONTOUR DRAWING

Until now we have investigated a linear drawing technique that described the edges of forms carefully and deliberately. But artists also make use of a more spontaneous variation of contour drawing called *cross-contour*. In this type of drawing lines follow the edges, or contours, and also come through and across the forms. Through the means of this technique we can accurately record information not just about the outer edge of a three-dimensional form but its inner dimensions as well. By following the contours of a form from its edge inward we can plot the exact three-dimensional form of our subject.

Albrecht Dürer's fifteenth-century drawing of a young steer (Fig. **4.6**), makes good use of cross-contour lines to delineate with meticulous detail the skeletal and muscular structure of an animal. Notice how the direction of these lines responds to every nuance of the animal's body and how easily we can spatially read these lines as they describe the three-dimensional form of this creature.

This centuries-old linear technique is still in use today. Paul Cadmus, a twentieth-century American artist, made extensive use of cross-contour lines in *Gilding the Acrobats* (Fig. **4.7**). This pen and ink drawing describes the back-stage preparations of a traveling circus as acrobats are gilded with gold paint just before their performance. The short cross-contour lines that Cadmus uses follow the curvature of the muscles and clothing folds from a variety of angles and directions enabling us to read the scene from a three-dimensional perspective.

4.6 Albrecht Dürer, *Young Steer*, c. 1495. Pen and black ink on paper, 6⁴/₅ × 5½ in (17.5 × 14 cm). Art Institute of Chicago, Clarence Buckingham Collection.

4.7 Paul Cadmus, *Gilding the Acrobats*, 1930. Pen, ink, and white chalk on paper, 15¾ × 10½ in (40 × 26.6 cm). Robert Hall Fleming Museum, of the University of Vermont.

Project 17

Exploring Cross-Contour Lines

Materials: 18 by 24 inch newsprint or bond paper, vine charcoal or soft graphite pencil.

Create a simple still-life to explore cross-contour drawing by draping a white sheet over several geometric forms (boxes would be suitable). Using parallel lines, follow the vertical and horizontal contours of the drapery as it covers the objects beneath it. To indicate shadows make the lines in these areas darker and place them closer. Do not cover the entire surface of the paper with cross-contour lines. Use areas of blank paper to indicate highlights and light tones. Take another look at the previous illustrations featuring cross-contour lines (Figs **4.6, 4.7**). Notice the way these artists selectively used lines that followed the contour without covering the entire surface of the paper with lines. An economy of means is present in both of these drawings and contributes to their overall effectiveness.

Try exploring this drawing concept using both rapidly made cross-contour lines and more carefully constructed precise marks. This type of linear drawing is one of the most economical and widely applicable methods of drawing. Stay with this exercise until you feel comfortable using this drawing technique to describe three-dimensional forms in space.

Irregularly shaped organic forms such as large, leafy indoor plants and still-lifes composed of bananas and kitchen tools also make good subjects for variations on the theme of cross-contour drawing. You may wish to creatively apply what you have learned so far with linear drawing techniques in projects of your own choosing. The drawings illustrated in Figures **4.8** and **4.9** show what students like yourself have achieved using this basic technique.

LINE QUALITIES

In the opening section of this chapter we explored some of the ways in which line could be used to objectively describe three-dimensional forms and space. But lines are also capable of making visual statements that are personally expressive. Like our own handwritten signature every artist's linear style is unique and distinctive. Everything affects the quality of a line: the choice of drawing instrument, the surface characteristics of the paper, and the ways in which the artist's hand moves across the paper and manipulates the drawing materials. The following examples of line quality represent some of the more important categories and styles.

4.8 Student Drawing. Sophie Vareadoz, San Francisco State University. Charcoal, 18 × 24 in (45.7 × 60.9 cm).

4.9 Student Drawing. Julie Houghton, School of the Art Institute of Chicago. Charcoal, 36 × 24 in (91.4 × 61 cm).

Tonal Variation

Edward Hopper's conté crayon drawing shown in Figure **4.10**, a preliminary study for his famous painting *Nighthawks*, uses strong line contrasts to establish the melancholy mood of a large city in the middle of the night. Thin vertical lines which describe the lighted window sections are contrasted with the dark, forceful horizontal lines representing the darkened facade of the buildings. This tonal juxtaposition helps communicate the psychological feelings of isolation and loneliness Hopper was interested in expressing.

H. C. Westerman's amusing drawing *The Sweetest Flower* (Fig. **4.11**), relies heavily on linear tonal effects to express the artist's thematic interests. Although known primarily as a sculptor, Westerman often turned to drawing in order to develop certain narrative themes. Many of his motifs were derived from the rough-and-tumble life of sailors, circus performers, and blue-collar workers. In this fantasy drawing the artist depicts himself as a traveler in a foreign land meeting beautiful women in exotic seaside settings. The scratchy pen and ink lines that create the dark tonal effect of a night scene set the mood and do much to evoke the artist's imaginary vision.

4.10 Edward Hopper, Study for *Nighthawks*, 1942. Conté crayon on paper, 8½ × 11 in (21.6 × 27.9 cm). Collection, Whitney Museum of American Art, New York. Bequest of Josephine N. Hopper.

4.11 H.C. Westerman, *The Sweetest Flower*, 1978. Watercolor on paper, 22⅛ × 31 in (56.2 × 78.7 cm). Collection, Whitney Museum of American Art, New York.

Project 18

Line and Tone

Materials: 18 by 24 inch newsprint or bond paper, vine charcoal, compressed charcoal, or soft graphite pencil.

Since we are interested in exploring the expressive possibilities of tones created by multiple lines, choose still-life subjects that will produce strong contrasts of light and dark with special lighting. Using a clamp-on 100 watt spotlight to illuminate your subject will help create the visual effects you are after. Try doing this assignment in your home at night when artificial lights create dramatic pools of light and darkened areas.

Before you begin to draw, analyze your subject and anticipate where the lightest and darkest areas might be located. After you have blocked out the general organization of the composition, explore the ability of line to create a mood and evoke certain feelings. As you evaluate the results of this exercise, ask yourself if you could have exaggerated the differences between the light and dark areas to further heighten the visual effects. Do another drawing using the same theme and see how far this concept can be taken. The student drawings in Figures **4.12** and **4.13** show some of the ways line can be manipulated to express tone.

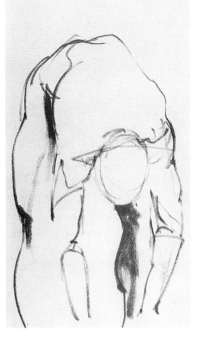

4.12 (above) Student Drawing. Lynn Ross, Sonoma State University. Charcoal, 24 × 18 in (60.9 × 45.7 cm).

4.13 (left) Student Drawing. Bruce Brems, Bucks County Community College, PA. Charcoal and pencil, 16 × 19 in (40.6 × 48.2 cm).

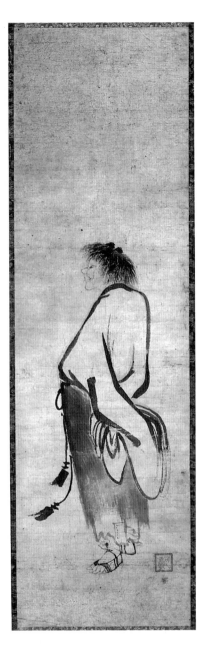

4.14 Kao, *Kanzan*, 14th century. Brush and ink on paper, 40¼ × 12¼ in (102.5 × 30.9 cm). Freer Gallery of Art, Washington, DC.

Calligraphic Line

Calligraphic lines are free-flowing lines that make use of the graceful loops and complex curves that our wrist, arm, and upper body can make as we manipulate our drawing instrument. Calligraphy means "beautiful writing" and as we learned in Chapter 1, the history of drawing is very much connected to the art of handwriting in both the West and the East.

The strongest and most direct relationships between the process of writing and the art of drawing exist in the Orient. Historically, Chinese and Japanese artists were all steeped in strong traditions of calligraphy. Kao, a Chinese artist who lived around the fourteenth century, used bold, expressive brush and ink lines to create this portrait of Kanzan, a legendary hermit (Fig. **4.14**). The sweeping lines that describe the figure's upper torso, clothing, and hanging belt are quite similar to the thick and thin brush lines used to draw the Chinese literary characters.

The visual effects of our drawings very much depend on the interactions of the drawing tool, the medium, and the physical movements our hand and body makes. Drawing and dance are two artforms that share concerns for aesthetically pleasing movement. The motion of our drawing brush or crayon over the paper leaves behind a record of its movement. Just such a visual record is evident in a *gouache* (a form of opaque watercolor) and brush drawing I made in 1990 (Fig. **4.15**). The sharply curved brush strokes and fluid lines of this drawing could only have been made by the special movements of hand and wrist working in concert with the drawing instrument and media.

Project 19

Exploring Calligraphic Line

Materials: Heavyweight bond paper or smooth watercolor paper cut to a moderate size, a 2 inch varnish brush, india ink, and a shallow tray.

Drape a white sheet over a table lamp or other moderately sized object, and arrange the folds to create sweeping vertical and horizontal movements. Hold your paper so that it is in a vertical, or portrait (longer in height than in width) format. These exercises in calligraphic line drawing depend to a certain extent on speed of execution, so they should be timed. Do not take longer than four or five minutes to complete these studies. If you labor over and rework them they will lose the sense of immediacy and quick response we are striving for.

Place some of the india ink in a shallow tray or cup. Dip the large brush in the ink (about half an inch) and respond kinetically, that is, with the movement of your own body, to the visual movements you perceive in the drapery folds. Our objective is not to make a detailed rendering of the subject but to use the visual movements in the still-life as an inspiration for our exploration of calligraphy. Look at the flowing shapes in the subject and quickly move the ink laden brush in response to what you see. Experiment with various methods of handling the brush: try gradually lifting the brush off the paper while your hand is still in motion and see how the line responds

when you roll the brush in your hand as you draw. Pause between strokes to look at the drawing and to see which areas need further work and where your next linear passage should be.

Try this same exercise with pieces of vine and compressed charcoal that have been sharpened into chisel edged instruments, and notice how they respond to various drawing angles and pressures.

Expressive Line

The expressive nature of line is a constantly changing element of drawing. By varying line weight, shape, spacing, direction, and visual rhythms the possibilities for artistic expression are endless.

Suns and Ceremonial Personages (Fig. **4.16**), a nineteenth-century Native American drawing on deerskin, makes use of particularly dynamic juxtapositions of lines and linear shapes. Each element of this drawing symbolically depicts some aspect of Apache cultural beliefs and spiritual life. Religious concepts important to the tribe are visually communicated by the bold animated forms that radiate from the central "sun," presenting us with a compelling vision of Native American ceremonial art.

4.15 (above left) Howard Smagula, *Law in Relation To Murder*, 1990. Watercolor and gouache, 9½ × 5½ in (24 × 14 cm). Courtesy, the artist.

4.16 (above right) Apache. *Suns and Ceremonial Personages*, Arizona, late 19th century. Painted deerskin. Smithsonian Institution.

4.17 Umberto Boccioni, *Study for The Dynamic Force of the Cyclist*, 1913. Pen and ink on paper, 8¼ × 12³⁄₁₆ in (20.9 × 31.1 cm). Yale University Art Gallery. Gift of Collection Société Anonyme.

Umberto Boccioni's *Study for the Dynamic Force of the Cyclist* (Fig. **4.17**) was completed in 1913 and visually communicates the concept of motion and power. Boccioni was one of the founding members of the Futurist movement, a group of Italian artists who glorified the modern concepts of energy, speed, and danger. The implied motion of a racing cyclist is expressed in this drawing through the use of energetically drawn sweeping lines and overlapping elliptical shapes.

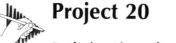

Project 20

Exploring Lines That Imply Motion

Materials: Bond paper, pen and ink or india ink and brush.

For this drawing assignment we will make use of a bicycle as our still-life. The mechanical function of a bicycle is to move; and although the object we are using to draw from is not moving we will emphasize its kinetic potential, that is its potential for motion, in our drawings. Using the bicycle form as a point of departure, create a series of drawings that express movement or visual activity. You might become inspired by the visual dynamics of *Suns and Ceremonial Personages* (Fig. **4.16**) and activate your composition with bold juxtapositions of linear spaces and shapes.

Boccioni's drawing (Fig. **4.17**) also offers a role model for your drawing in terms of the way he selectively emphasized certain elements of the bicycle and rider and ignored others. Boccioni was drawing the speed and motion of the racer not his position on the race track.

The main goal of this drawing project is to explore the dynamic, expressive possibilities of line and space. The student examples illustrated in Figures **4.18** and **4.19** reveal some of the visual effects that can be achieved through the use of expressive line.

4.18 Student Drawing. David Blankenship, San Francisco State University. Charcoal, 26 × 28 in (66 × 71.1 cm).

4.19 Student Drawing. Anon., San Francisco State University. Felt-tip marker, 18 × 24 in (45.7 × 60.9 cm).

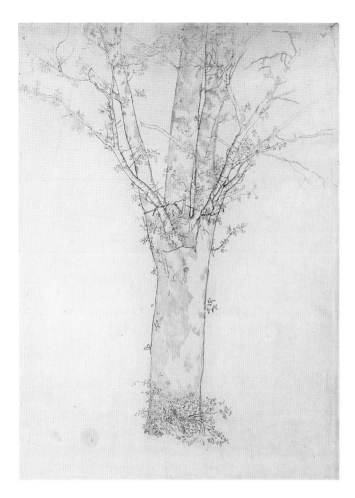

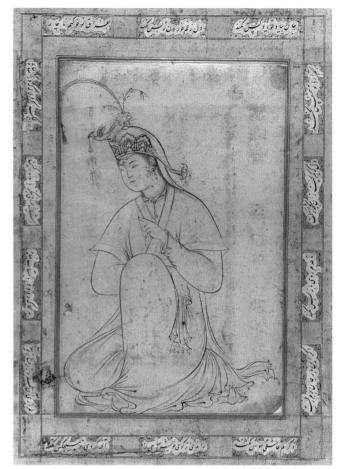

4.20 (above) Odilon Redon, *The Tree*, 1892. Lithograph, 18¾ × 12½ in (7.6 × 31.75 cm). Museum of Fine Arts, Boston. Bequest of W.G. Russell Allen.

4.21 (above right) Anon., *Portrait of a Noble Lady with Elaborate Headgear*. Near East, Persia, Safavid Period, end 16th century. Louvre, Paris.

Lyric Lines

Compared with the visual dynamics of the Apache ceremonial piece or Boccioni's drawing, the quiet lyricism of Odilon Redon's *The Tree* (Fig. **4.20**) catches us by surprise and invites thoughtful, contemplative study. The delicate traceries of the leaves create dappled patterns that suggest the peaceful experience of the countryside. Rather than attempting to draw each leaf, Redon emphasizes groupings of leaves that he juxtaposes against the open space of the paper.

The sixteenth-century Persian drawing of a noble lady in Figure **4.21** evokes similar feelings through the use of gracefully curving lines and subtle tonal nuances.

 Project 21

Exploring Lyric Line

Materials: Bond paper, medium hard graphite pencil with a sharpened point, a chisel edge or fine nib pen with india ink.

Find an isolated tree in a location convenient for you to draw. Using your sharpened pencil sketch in some light guidelines that will help you plan the organization of your drawing. With carefully selected lightly drawn lines emphasize selected portions of the tree. The image of the tree or parts of the

tree should seem to be embedded in the paper. The overall visual effect we are interested in achieving with this drawing project is one of delicacy and lightness. Much of the lyric quality of Redon's tree drawing (Fig. **4.20**) is achieved through lines and forms that appear to emerge tentatively from beneath the surface of the paper.

Another appropriate subject for this exercise in lyric line would be to obtain some fancy sea-shells with gracefully curving lines. Arrange them on a small table, position yourself close to it and respond with simple flowing lines similar to the Persian drawing in Figure **4.21**. An interesting choice of drawing instrument for your shell drawing would be a chisel edge pen nib and india ink. This tool would vary the thickness of the line as it was drawn across the paper at different angles. If you use this pen nib take some time to explore the way the lines it makes vary according to the angle it is held at.

Study the linear techniques of Figures **4.20** and **4.21** and then invent your own repetitive marks to interpret your subjects. Remember we are more interested in evoking a mood or feeling through the use of lyric lines and marks than describing everything we see. Be selective. Emphasize forms that interest you and be aware of the overall compositional effect of your drawing. Figure **4.22** illustrates one student's response to this type of assignment.

4.22 Student Drawing. Doug Cerzosimo, Bucks County Community College, PA. Ballpoint pen, 17 × 14 in (43.1 × 35.5 cm).

Fluid Line

Honoré Daumier was a nineteenth-century French artist best known for his socially conscious, satirical drawings that regularly appeared in Parisian papers. In a sense, he was a pioneering political cartoonist long before the term was coined. Since many of his drawings were done directly from life, without the use of posed studio models, Daumier developed a rapid, fluid style of drawing that enabled him to capture the fleeting realities of street life. His drawing, *Family Scene* (Fig. **4.23**), shows a businessman coming home after work and greeting his young child in front of their home. Daumier builds up masses of intertwined lines to indicate dark tonal areas while isolated thin, sinuous lines suggest aspects of the landscape and a building.

4.23 Honoré Daumier, *Family Scene*, c. 1867–70. Pen, black ink, brush, and gray wash on ivory wove paper, 8½ × 8 in (21.6 × 20.5 cm). The Art Institute of Chicago. Helen Regenstein Collection.

Project 22

Exploring Fluid Line

Materials: Medium sized bond sketch book, roller-ball black ink pen or other suitable drawing medium.

Go to a coffee shop, park, cafe, student lounge, or other place where people are engaged in activity and you can remain fairly inconspicuous. Keeping your eyes on the subjects, quickly describe their basic forms and gestural movement using searching, fluid lines. You do not have to use a strict continuous line technique, but to achieve the fluid linear quality we are after the majority of lines should appear to be connected. Once you have defined the basic composition, you can go back into the drawing to define details and indicate shadow areas. You will need to work quickly, however, recording your general impression of the scene rather than focusing on details. Background elements (which probably should be kept to a minimum) can be added later when your subjects move.

Line Variation

The unique line qualities in David Hockney's distinctive drawing, *Celia Musing* (Fig. **4.24**) were created by using ink and a brush that was attached to a long extension shaft. Hockney placed the drawing surface on the ground and drew standing up. Although relatively few lines are used in this drawing, the artist gets the most out of each line by constantly varying its character and width. As the line follows the vertical contours of the subjects, it appears and disappears with rhythmic variation creating dynamic visual effects.

4.24 David Hockney, *Celia Musing*, 1979. Lithograph, 40 × 30 in (102 × 75 cm). Courtesy, TraDHart Ltd.

Project 23

Varying the Width and Character of Lines

Materials: 18 by 24 inch medium bond paper or smooth watercolor paper, india ink, #10 round sable-hair brush, a 3 to 4 foot section of wooden dowel (about ½ inch in diameter), and masking tape.

Create a simple still-life that interests you – a few flowers placed in a vase would do quite well for this assignment. Or ask a fellow student to take turns posing so that you can draw each other.

Using a long-handled brush extension we will draw standing up with the paper on the floor in front of us. Measure the length of wooden dowel needed to make an extension handle for your brush. Tape the brush to the wooden extension and use it to do a series of drawings from a standing position. By changing the way we manipulate our drawing instrument we can modify the character and expressive possibilities of the mark. This type of drawing project needs to limit the number of lines used in order to call attention to the distinctive mark employed. Vary the character and width of the lines by controlling the amount of ink on the brush and the pressure of the drawing instrument. Experiment with other techniques to see what kind of expressive line qualities result. For instance, you could try drawing with a long, square rod of balsa wood dipped in ink to see what other visual effects are possible. Experiment with unconventional drawing instruments and see how the line quality changes as you vary techniques and media.

Hatching and Cross-Hatching

Tonal variations and modeling can also be introduced in line drawing through the use of *hatching* and *cross-hatching*. Hatching uses parallel lines which basically run in one angle or direction. Andrea Mantegna, an Italian artist of the late fifteenth century, made this drawing of the *Madonna and Child* (Fig. **4.25**) with parallel hatch lines that create different tonal variations.

Cross-hatching is a technique that makes use of criss-crossing parallel lines to establish shapes and tones. Giorgio Morandi, an Italian artist of the Modern Era, used parallel lines that intersect (cross-hatching) in his haunting landscape drawing (Fig. **4.26**). Both drawings create tones by controlling the proximity of each line to the other – the closer the spaces, the denser the tone.

4.25 Andrea Mantegna, *Madonna and Child*, c. 1495. Pen and brown ink, 7⁷⁄₈ × 5⁵⁄₈ in (19.7 × 14 cm). British Museum, London, Barck Collection.

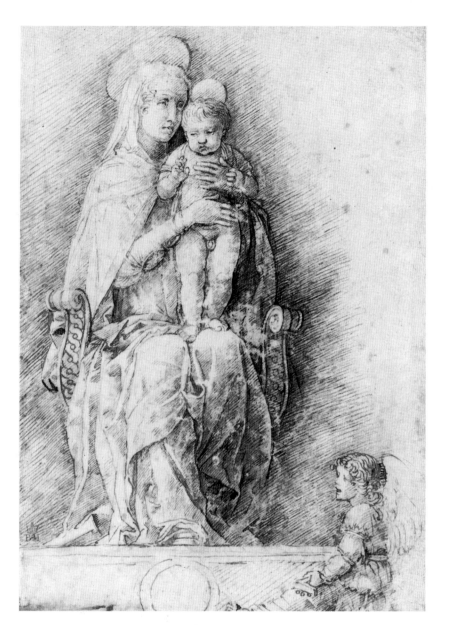

4.26 Giorgio Morandi, *Landscape*, 1933. Etching, 8¹⁄₁₆ × 11 ¹³⁄₁₆ in (20.5 × 30 cm). Collection, The Museum of Modern Art, New York.

101

4.27 Crumpled paper bag.

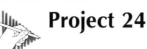

Project 24

Exploring Hatching and Cross-Hatching

Materials: 18 by 24 inch bond paper cut down to a smaller size if you desire, pen and india ink or black roller-ball pen.

Create a tabletop still-life by opening up and standing on its base a large brown or white paper bag (the kind you might get at a supermarket). Crumple it enough to put distinctive crease marks in it (Fig. **4.27**). We are going to use hatching and cross-hatching techniques to indicate the fragmented planes created by the creasing. This is one project where the lighting will profoundly affect the way we perceive and draw our subject.

Try to place the bag near a strong unidirectional light source such as a window, or use a spotlight to create distinctive shadows.

Before you begin to draw, refer to the Mantegna drawing (Fig. **4.25**), and notice how the artist used hatch lines to indicate the folds of the Madonna's garment. The creases of the paper bag are similar in structure to these folds. Using a light pencil line, indicate where major folds and shapes occur. Do not make a contour drawing of all the folds and fill them in with hatch lines. Only tentatively indicate the parameters of the composition and use parallel hatch lines to define the details. Take your time and proceed at an even, steady pace.

After you have gained some familiarity with this technique, try cross-hatching. The directions of the criss-crossing lines should relate to the angles of the facets on the paper bag. Do not cover the entire surface of your drawing paper with hatch lines but let the blank paper represent the highlights. Note where the deepest shadows appear. This is where your darkest marks should be registered.

Great subtlety of tone can be achieved by controlling how close the ink lines are spaced. Go slowly, remember you can always add more parallel lines to make a section darker but you cannot remove them to lighten that area.

PERSONAL LINEAR STYLE

Sometimes artists talk about the particular "handwriting" other artists use in drawing. What is referred to is not the way they sign their name but the special linear characteristics of their drawings. Jacob Lawrence, a well-known African-American artist, developed a drawing style that was unmistakably his own. Thematically, Lawrence's art was infused with a strong social ethic that highlighted the plight of his people.

Struggle No. 2 (Fig. **4.28**) illustrates the special line qualities that characterize his drawings. In this piece a mounted rider careers through a crowd creating havoc. Strong fuzzy-edged lines define the horseman with choppy rhythms. Thinner, smoother lines represent the unfortunate individuals struggling against their mounted adversary. The linear qualities of Lawrence's marks reinforce the thematic content of the drawing.

The line quality in Ida Applebroog's drawings (Fig. **4.29**) is quite different from that of Lawrence's. Instead of using constantly varying, choppy lines, Applebroog

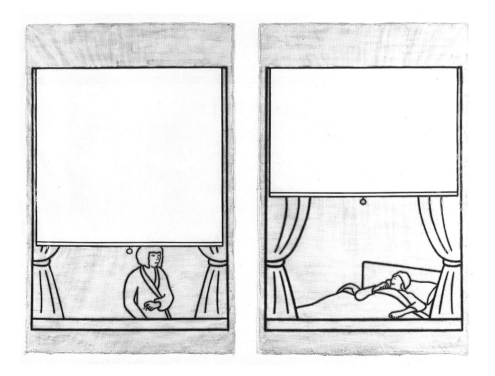

4.28 (above) Jacob Lawrence, *Struggle No. 2*, 1965. Ink and gouache on paper, 22¼ × 30¾ in (56.4 × 78.1 cm). Seattle Art Museum.

4.29 (left) Ida Applebroog, *Hotel Taft*, 1978–80. Ink and rhoplex on vellum, 2 panels, each 7 × 4½ ft (2.1 × 1.3 m). Courtesy, Ronald Feldman Fine Arts, New York.

4.30 Tapa tribe, barkcloth, from Melanesia. Sentani style, height 33¼ in (84.5 cm). The Metropolitan Museum of Art, New York. The Michael C. Rockefeller Memorial Collection. Gift of Mr. and Mrs. John J. Klejman.

makes use of long, thick, even strokes that vary little in width. With these distinctive lines this contemporary artist creates simple diagrammatic images that document the mundane existence of everyday life. Her lines assume the mechanical character of popular commercial illustrations that one might see on matchbook covers or in the telephone yellow pages. This technique creates a feeling that we are witnessing a slice of contemporary urban life with its social isolation and anonymity. Even the composition of her drawing, the lone figures in separate panels, reinforces this reading of her work and fits in beautifully with her special linear style.

The drawing shown in Figure **4.30** has all the characteristics of a modern nonrepresentational work of art. But it comes from Melanesia and was produced with natural pigments on barkcloth. Remarkable effects are derived from its sophisticated use of line and repetition which create strong three-dimensional illusions.

Project 25

Developing a Personal Linear Style

Materials: Bond paper and drawing medium of your choice.

Lawrence's, Applebroog's, and the Tapa drawings express three distinctive linear styles. No one can expect a new student to develop the graphic identity of these artists overnight, but it is not too early to begin to explore expressive drawing styles toward which you are naturally inclined.

Now is a good time to review the drawing assignments you completed in this chapter about line. As you go over them take out those that particularly interest you. What type of line was used in these drawings? Clarify in your mind the linear qualities that you find appealing. Recreate the conditions used to make these selected drawings and do a series of drawings that explore specific line qualities. Suppress for a time too strict a judgement about your work. Make a commitment to the ongoing process of drawing, returning to the same subject often to fully explore certain ideas, techniques, or materials. Return to the same general idea and exhaust every possibility. Continued involvement with a theme or idea will eventually enable you to make the breakthroughs that distinguish personally expressive work. Applying what we have learned in a creative way is the greatest challenge of all and one that will be ongoing for as long as we work in the medium of drawing.

5 VALUE

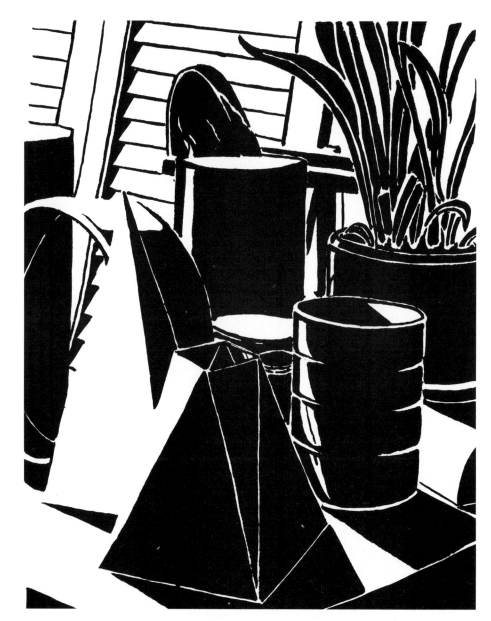

5.1 A 10-point value scale

Every object we see is made visible because of the way it interacts with light. A smooth, white form reflects most of the light falling on its surface while mat black objects absorb a great deal of the light that reaches them. The range of light and dark tones that exist between the whitest white and the blackest black is referred to as the *value* scale (Fig. **5.1**). These tones are not to be confused with the object's color or *hue*. A red and a blue vase for instance, could easily have the same value, that is, possess the same lightness or darkness of tone. If we took a black-and-white photograph of these two colored vases, they would look identical in the monochrome print. Black-and-white film only registers the amount of light reflected off an object, not the color of the light.

Since the majority of drawings are made with varying tonal marks on a white surface, it is important to train yourself to distinguish value relationships from color. This is not terribly difficult to do, and with experience you should be able to control the range of light and dark values found in your drawings.

VALUE RELATIONSHIPS

Light falling on a form can produce up to six distinct tonal categories: highlight, light, shadow, core of shadow, reflected light, and cast shadow. The illustration in Figure **5.2** reveals the position and structure of these tonal areas as they appear on a white ball that is illuminated by a strong unidirectional source of light. Because the spherical form has no right angles to create sharp shadows, tones gradually fade from light to dark and vice-versa. Even though the light source is not visible in Figure **5.2**, we can tell by the direction of shadows that it is located to our left and parallel to the surface the ball rests on. If the light were positioned higher, the shadow cast by the ball would be shorter in length. This analysis is called "light-logic" and can be used to work out the value relationships in drawings done from your imagination.

5.2 Tonal categories.

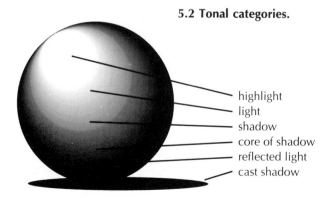

— highlight
— light
— shadow
— core of shadow
— reflected light
— cast shadow

(opposite) Student Drawing. Henry Sheving, San Francisco State University. Brush and ink, 13¼ × 10½ in (33·7 × 26·7 cm).

Project 26

Exploring Value Relationships

Materials: Medium weight bond paper, soft graphite pencils or vine charcoal.

In this drawing project we will create a special still-life and use it to explore ways in which we can express the full range of values in our drawings. Place two or three large sheets of white paper on a tabletop near a window with natural light or an indirect source of artificial light. The idea is to have a strong but diffused source of illumination lighting still-life subjects. On this surface place three or four eggs. In order to see how they respond to changing directions of light, slowly turn the piece of paper they rest on. Notice how the shadows and highlights assume different positions as the three-dimensional forms move in relation to the light's direction.

Arrange the eggs in a grouping that you find interesting. Before you begin to concentrate on the value scale of the drawing, establish the general compositional structure with light marks or lines. Remember to make effective use of the entire paper and avoid small drawings that end up in the center.

Once the drawing is blocked in, carefully observe where the highlights are located. Since our paper is white, its unmarked surface will represent these highlights. Where are the deepest shadows? This is where the darkest tones you can register with your graphite or charcoal will be. The two poles of the value spectrum have been charted, but many intermediate gradations need to be established. Using a series of light, overlapping hatch marks, follow the curvature of the eggs and begin to build gradations of value that correspond to the lighting effects seen in the still-life in front of you. Gradually build up the dark tones, stepping back from time to time to evaluate what you have established. If necessary, it is easy to make an area darker later. Keep observing how the light responds to the three-dimensional surface of the eggs.

Martha Alf's drawing, *Tomato #1* (Fig. 5.3), explores the way light interacts with the rounded, organic form of the vegetable as it sits on a table. Lynn Ross's student drawing shown in Figure 5.4 also makes effective use of value relationships to define various three-dimensional objects in space.

5.3 (below left) Martha Alf, *Tomato #1*, 1978–79. Graphite on paper, 12 × 18 in (30.5 × 45.7 cm). Collection, O'Melveny and Myers, Los Angeles. Courtesy, Newspace, Los Angeles.

5.4 (below right) Student Drawing. Lynn Ross, Sonoma State University. Charcoal, 18 × 24 in (45.7 × 60.9 cm).

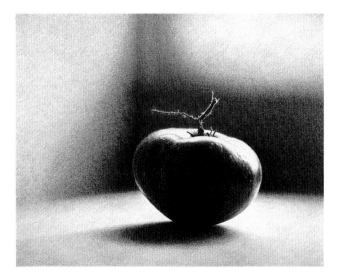

CHIAROSCURO

In their quest to accurately describe the position of forms in space, Renaissance artists perfected a methodical use of tonal values in drawing to correspond to the way light and shadow defined our perception of three-dimensional forms. This is known as *chiaroscuro*. Chiaroscuro is an Italian term that refers to the opposition of dark and light tones in drawing to create the illusion of space: "chiaro" means light, "oscuro" means dark.

Leonardo da Vinci's drawing *Five Grotesque Heads* (Fig. **5.5**) is a clear example of chiaroscuro drawing effects. While the figures' garments are defined through linear means, their heads and features are expressed by well defined highlights, middle tones, and deep shadows.

5.5 Leonardo da Vinci, *Five Grotesque Heads*, c.1494. Pen and brown ink, 10¼ × 8½ in (26 ×21.6 cm). The Royal Library, Windsor Castle. Reproduced with the gracious permission of Her Majesty Queen Elizabeth II.

109

Gustave Courbet, a nineteenth-century French artist, also makes striking use of chiaroscuro in his *Self-Portrait with a Pipe* (Fig. **5.6**). Out of a dark and mysterious background the head and features of the artist emerge dramatically. Courbet reserves the use of the lightest tone, or highlights, for his features, thus focusing our attention on this important aspect of the self-portrait.

Similarly, Allison Hinsons's student drawing (Fig. **5.7**) uses chiaroscuro's juxtapositions of light and dark. Recording the effects of a strong light source coming at an oblique angle from below, she achieves dramatic interplays of light and dark values.

5.6 (opposite) Gustave Courbet, *Self-Portrait with a Pipe*, c. 1849. Black chalk on paper, 11½ × 8¾ in (29.2 × 22.2 cm). Collection, Wadsworth Atheneum. Gift of James Junius Goodwin.

5.7 Student Drawing. Allison Hinsons, Bucks County Community College, PA. Charcoal, 20 × 13 in (50.8 × 33 cm).

Project 27

Exploring Chiaroscuro

Materials: Medium weight bond paper, soft graphite pencils, vine charcoal, or conté crayon

In order to create a still-life that lends itself easily to exploring chiaroscuro drawing techniques, use a white or pastel colored bedsheet that is draped over a few cardboard boxes or other suitable objects. Fold and arrange the sheet to create a suitable composition for this drawing project. Make sure there are sharply undercut sections that create deep shadows. Lighting will play an important role in this assignment. Use a strong unidirectional source such as a clamp-on aluminum reflector and 100 watt bulb and make sure the light rakes across the still-life at an oblique angle thus creating clear highlights and a variety of dark values from medium to dark. Remember it is the opposition of light and dark values that creates the effect of chiaroscuro and make sure the white of the unmarked paper is functioning effectively to represent your highlights.

5.8 Wayne Thiebaud, *Pie Rows*, 1964. Etching/Aquatint, 4 × 5 in (10.1 × 12.7 cm). Courtesy, Allan Stone Gallery, New York.

HIGH CONTRAST VALUES

Not all value relationships in drawing are interpreted exactly as the artist may observe them in life. For visual impact and graphic expression, artists frequently make use of heightened contrast and strong tonal juxtapositions, often setting the blackest shapes against the pure white negative shapes of the paper. Claude Lorraine, a seventeenth-century European artist, created this dramatic ink and wash drawing of a landscape bathed in brilliant sunlight with deep impenetrable shadows (Fig. **5.9**). This tonal exaggeration was the beginning of a new, more subjectively expressive interpretation of nature that is a hallmark of modern drawing traditions.

The contemporary American artist Wayne Thiebaud created a striking composition by registering only the shadow areas and highlights of his still-life, a cafeteria scene of rows of pies (Fig. **5.8**). The space in this drawing is incisively carved by the strong opposition of interlocking black and white shapes. It is as if a powerful light source is creating blinding highlights and impenetrable shadows.

113

5.10 Student Drawing. Henry Sheving, San Francisco State University. Brush and ink, 13¼ × 10½ in (33.7 × 26.7 cm).

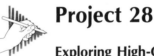

Project 28

Exploring High-Contrast Value Relationships

Materials: 18 by 24 inch medium to heavy weight bond paper, india ink, #10 round sable-hair brush.

This project will explore the expressive possibilities of drawings that make use of high-contrast value relationships. Look around your house for a group of angular objects that are small enough to be used in a still-life. If you have difficulty finding suitable forms, you may use small shoeboxes or other cardboard containers. Lighting will also be an important factor in this drawing assignment: use a floodlight or other strong, unidirectional light source to create bright highlights and deep shadows. Study the set-up and note the negative and positive shape arrangements that could work together to define the composition. You may wish first to indicate the major shape configurations with extremely light lines from a hard pencil. However, do not overwork the preliminary blocking in of the shapes. Colored-in pencil outlines do not have the immediacy of brush and ink shapes directly perceived and drawn. Use the brush to create black shapes and thin lines that work in concert with the white paper. Vary the size of the inked areas to avoid monotony. Midway through the drawing stand back and observe the interplay of white and black shapes. What could you add to make the negative shapes of the paper play a more active role? The student drawing in Figure **5.10** illustrates a response to this type of high-contrast drawing assignment.

VALUE AND MOOD

The expressive possibilities that can be achieved with the control and manipulation of value are limitless. Every drawing tool and type of paper has its own set of characteristics that can be exploited to achieve special effects. Since light plays such a profound role in the governing of our moods and perceptions, it stands to reason that value is a primary means by which artists create moods and evoke feelings.

Georges Seurat, a French Post-Impressionist, made extensive use of conté crayon and textured paper to create haunting, atmospheric drawings that seem to freeze figures in a timeless monumentality (Fig. **5.11**). Instead of using lines, Seurat worked with the natural texture of his paper to create visual effects that are now referred

5.11 Georges Seurat, *Seated Woman*, c. 1885. Conté crayon, 18⅞ × 12⅜ in (48 × 31.5 cm). Collection, The Museum of Modern Art, New York. Abby Aldrich Rockefeller Bequest.

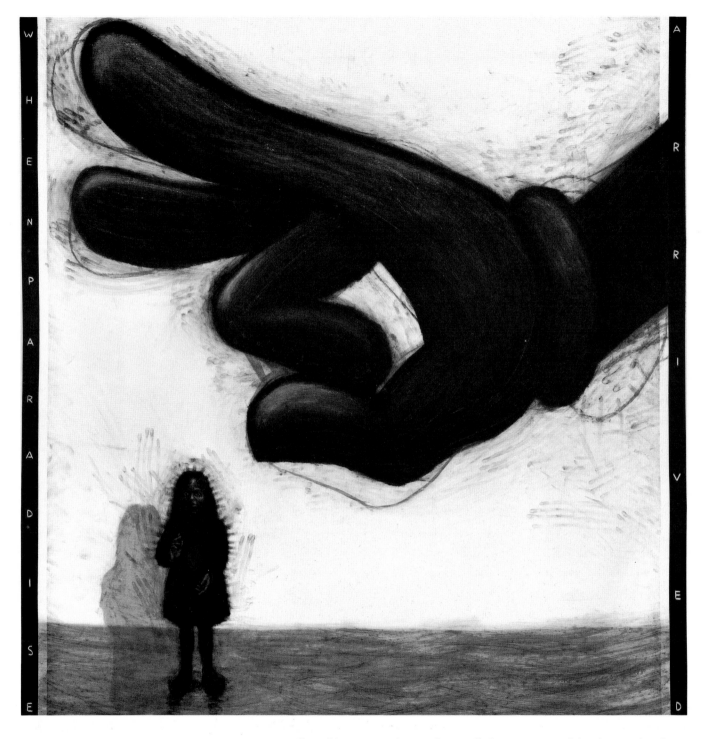

WHENPARADISEARRIVED

ARRIVEED

5.12 Enrique Chagoya, *When Paradise Arrived*, 1989. **Charcoal and pastel on paper, 80 × 80 in (203.2 × 203.2 cm). Collection, The Museum of Modern Art, New York. Di Rosa Foundation.**

to as "pointillist" (this term refers to the small dot structure of the drawing). Where he pressed heavily on the paper, his conté crayon filled in the high and low textures of the paper. Where he pressed lightly, only the high points of the paper were marked, leaving the depressions untouched. The isolated, somewhat flattened figure is bathed in an ethereal light that erodes the edges of the form and seems to be in the process of dissolving it.

Enrique Chagoya, a Mexican-American artist, uses tonal effects to evoke a mood that is quite different from Seurat's drawing. The stark contrasts between the dark and light tones in this drawing (Fig. **5.12**) serve as a means of conveying the artist's political sentiments. In it a large, dark, and menacing hand (labeled "English Only")

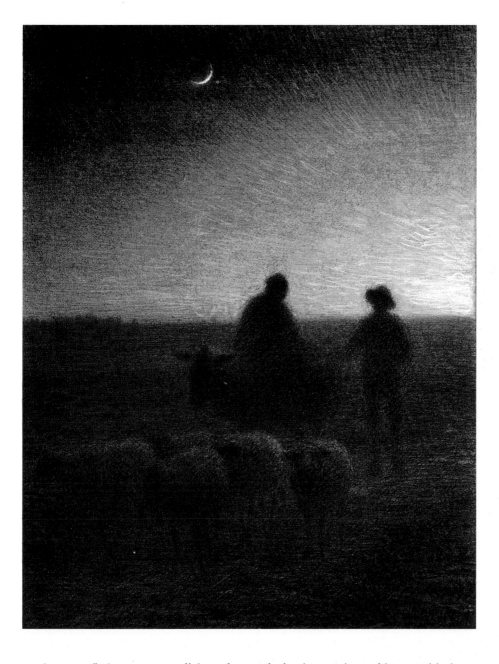

is about to flick away a small bare-foot girl clutching a heart like a teddy bear. Chagoya's commentary on what he believes to be the colonialist relationship of the U.S.A. and Mexico is clearly expressed through this drawing. The size differences and tonal contrasts of the images in this charcoal drawing go a long way toward establishing feelings of aggressive power and helplessness – two issues that Chagoya believes are present in relations between the United States and Mexico.

Jean-François Millet's crayon and pastel drawing of shepherds tending their flock at twilight (Fig. **5.13**) reveals a masterful handling of close-valued tones and shapes. Our own recollection of twilight is powerfully evoked in this romantic image of rural France in the late 1800s.

5.13 Jean-François Millet, *Twilight*, late 19th century. Black conté crayon and pastel on paper, 19⅞ × 15⅜ in (50.5 × 38.9 cm). Courtesy, Museum of Fine Arts, Boston. Gift of Quincy Adams Shaw.

Project 29

Using Value to Convey Moods

Materials: Medium weight bond paper (use a format size you are comfortable with), conté crayon, graphite, or other pressure sensitive drawing instruments.

The object of this drawing exercise is to explore the way light affects our psychological perceptions. Since reflected light and lighting are important aspects of value we will create special conditions for drawing which enhance our sensitivity to this important element.

This assignment must be done after dark or in a room that can be effectively blacked out during daylight hours. Extinguish all other lights except for a small lamp placed on a table or dresser top. Focus your drawing efforts toward rendering the way light spills downward underneath the open shade. If necessary you may wish to wrap some black paper around the shade to cut down on light transmission and thus emphasize the contrast between light and dark areas. The concept behind this series is to create a mood with value relationships through the manipulation of black and white tonalities.

Take note of the various ways in which light falls in your home, your neighbourhood, or your school. When you come across a particular effect that interests you, explore its possibilities through drawings that emphasize value relationships. You may also wish to create special lighting effects with artificial lights and objects that have a special meaning for you. This is an opportunity to work with visual and conceptual interests that are uniquely your own. Remember, we are interested in focusing on the ability of drawing to create moods and express visual concerns. The drawings of T. C. Stevenson (Fig. 5.14) and Barbara Hale (Fig. 5.15), both students, reveal some of the expressive visual effects possible through control and manipulation of value.

5.14 (opposite) Student Drawing. T.C. Stevenson, Sonoma State University. Charcoal, 24 × 18 in (60.9 × 45.7 cm).

5.15 Student Drawing. Barbara Hale, San José State University. Charcoal, 40 × 26 in (101.6 × 66 cm).

119

5.16 *Prince dara Shikok on the Imperial Elephant, named Mahabir Deb*, c. 1630. Brush drawing in india ink tinted with gold and watercolors, 13 × 16½ in (33 × 41.9 cm). Victoria and Albert Museum, London, Crown Copyright.

VALUE AND SPACE

Value relationships also play an important role in the way drawings define form and space. Wayne Thiebaud's drawing, *Nude in Chrome Chair* (Fig. **5.17**), establishes with clarity the position of the figure sitting on the chrome chair. Through the careful control of value the artist enables us to read the spatial position of the woman's body in relation to the forms of the chair. Thiebaud continually juxtaposes light tones against dark tones to establish the position of forms. For instance, notice the way the three-dimensional form of the top of the leg closest to us is established by placing a light tone next to a darker one.

The seventeenth-century drawing from India in Figure **5.16** also uses value relationships to define space, but these forms exist in a relatively shallow space. The form of the elephant is accurately described but its silhouetted pose and delicate value gradations emphasize a symbolic rather than a literal representation of this magnificent beast.

Both drawings define space through value, but the cultural milieu from which they emerged plays a central role in determining how value is used together with other visual elements to communicate concepts important to each society.

Project 30

Exploring Space with Value

Materials: Medium weight bond paper, drawing medium of your choice.

Create a still-life composed of geometric and curvilinear forms. Lighting is important in this project because we will rely on the way light interacts with three-dimensional objects to define space. Arrange a group of objects, some in front of others. Notice the way the juxtaposition of light and dark areas enables us to see the objects as three-dimensional forms. Remember to reserve open areas of the paper that correspond to the highlights in your still-life. Take your time. This type of drawing demands slow and patient work and depends on the opposition of dark and light values to work. The student response seen in Figure **5.18** is a well thought out composition that makes use of carefully adjusted tonal relationships. If you want to try this ink drawing technique you might make use of a fine-line fiber tipped marking pen available at art supply and stationery stores.

5.17 (left) Wayne Thiebaud, *Nude in Chrome Chair*, 1976. Charcoal on paper, 30⅛ × 22⅜ in (76.5 × 57.8 cm). San Francisco Museum of Modern Art. Private Collection.

5.18 (below) Student Drawing. Anon. San Francisco State University. Pen and ink, 7 × 8 in (17.8 × 20.3 cm).

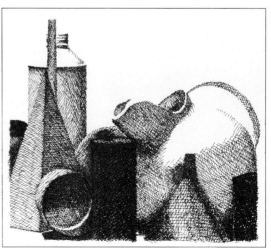

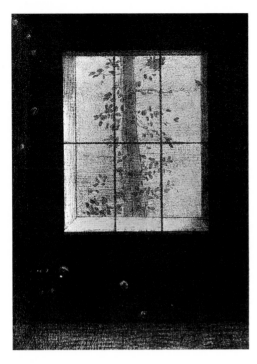

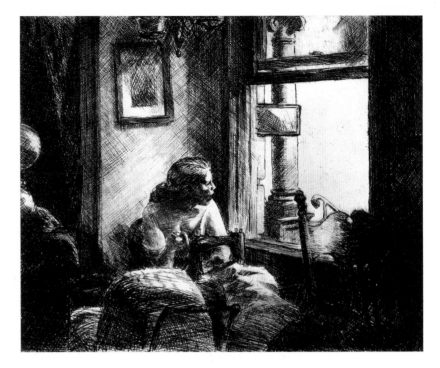

5.19 (above) Odilon Redon, *The Day*, Plate VI from *Dreams*, 1891. Lithograph, 8¼ × 6⅛ in (21 × 15.6 cm). Collection, The Museum of Modern Art, New York. Lillie P. Bliss Collection.

5.20 (above right) Edward Hopper, *East Side Interior*, 1922. Etching, 7⅞ × 9⅞ in (20 × 25 cm). Collection, The Museum of Modern Art, New York. Gift of Abby Aldrich Rockefeller.

INTERIOR AND EXTERIOR LIGHT

The quality of light that illuminates a subject plays an important role in the way we perceive forms. Strong, direct light, the kind we might experience out of doors on a sunny day, creates strong contrasts between highlights and shadows. Indoor lighting on the whole is softer and more diffused because artificial light sources are rarely as strong as sunlight; and light tends to bounce off walls and ceilings before it reaches us. But these conditions are changeable. Sometimes on cloudy days sunlight can be quite soft and indirect or, conversely, indoor lighting can be sharp and contrastable if you are working with high-wattage, or very bright, illumination. Since light is such an important ingredient of the visual arts, take note of the quality of lighting as you move from interior to exterior spaces.

Since the Renaissance, artists have been fascinated with representing both interior and exterior space in the same drawing. Because of the difference in light between these two spaces, value contrasts were often emphasized to create the desired effect. Odilon Redon's drawing *The Day* (Fig. **5.19**) creates the illusion that we are standing in a darkened room near a window that faces a tree. The juxtaposition of the dark enveloping interior and the brilliant expanse of the outdoors is quite striking. Three precise criss-crossing lines economically suggest window panes and reinforce the illusion of a portal leading to the outside world. A faint section of the floor and strange floating globular shapes are the only details visible in the interior space and relieve what would otherwise be a solid black field. This limiting of visual information in the interior serves to lead our eyes through the window and spotlights the outside tree. By contrasting interior and exterior light, Redon has created a visually powerful symbolic statement.

Project 31

Exploring Interior and Exterior Light

Materials: Bond paper or medium textured charcoal paper, conté crayon or drawing medium of your choice.

This drawing project will explore the value contrasts of interior and exterior light. Find a corner in your home or in another building where light from a window creates interesting visual effects. You may wish, so to speak, to lead us through the window – as in the Redon drawing – and focus on the outdoor scene. Another alternative is to emphasize the quality of interior light that occurs around windows. Edward Hopper's *East Side Interior* (Fig. **5.20**) relies on the dramatic value contrasts that occur when dimly lit interiors are flooded by exterior light. Whatever theme or subject matter you choose, remember that the object of this exercise is to explore the way value contributes to the effectiveness of your drawings. Claudia Hottman's student drawing in Figure **5.21** clearly responds to the light falling on her model with rich visual juxtapositions of black and white shapes.

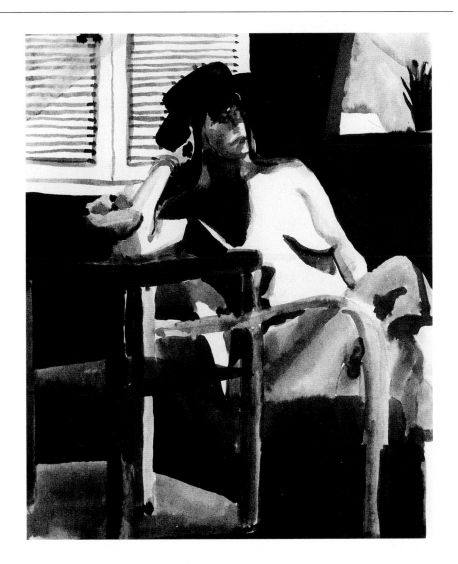

5.21 Student Drawing. Claudia Hottman, San Francisco State University. Brush and ink, 17 × 14 in (43.2 × 35.5 cm).

5.22 Robert Cumming, *Berlin Brazil*, 1987. Lithograph on black paper with silk screen, 48 × 37½ in (121.9 × 95.3 cm). Courtesy, the artist.

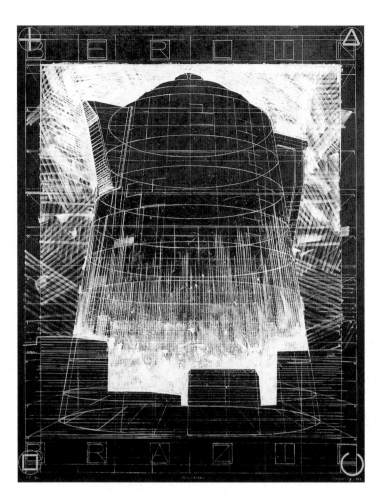

VALUE REVERSAL

The great majority of drawings are done using black marks on white paper. This convention has become so accepted that most of us would not readily consider doing a drawing using white marks on a dark surface. But this technique of value reversal comprises yet another way in which value can create unique moods and explore special themes.

Robert Cumming's witty print, *Berlin Brazil* (Fig. **5.22**) takes on a certain visual power and majesty largely through its use of white lines on a black ground. Certainly, this would be an attractive print done in the conventional mode of black marks on a white surface, but reversing the values creates a special air of mystery and strength.

In *Two Maps II* (Fig. **5.23**) Jasper Johns makes use of value reversal to achieve a distinctive and unique look. The white-lined state borders of these maps give the drawing a ghostlike quality and force us to consider these commonplace cartographical images of the United States in a new way.

Paula Modersohn-Becker was a leading European artist at the beginning of the twentieth century and an important precursor of the German Expressionist style. Through the dramatic juxtaposition of values her *Portrait of a Peasant Woman* (Fig. **5.24**) makes a powerful visual statement about the harshness of life and the inherent strength of this rural woman.

Out of a somber black rectangle the features of this woman subtly emerge. They are read as light marks set against a black background. The overall effect of this fascinating drawing is that of a person embedded in and emerging from a dark earthy mass.

5.23 Jasper Johns, *Two Maps II*, 1966. Lithograph, 33 × 26½ in (83.8 × 67.3 cm). Collection, The Metropolitan Museum of Art, New York. Gift of the Florence and Joseph I. Singer Collection.

5.24 Paula Modersohn-Becker, *Portrait of a Peasant Woman*, 1900. Charcoal on buff wove paper, 17 × 25 in (43.3 × 63.9 cm). The Art Institute of Chicago. Gift of the Donnelly Family.

125

Project 32

Exploring Value Reversal

Materials: Black charcoal paper or any other dark-toned drawing paper, white pastel or white chalk pencil.

Create a still-life that offers well defined and distinct highlights and shadow areas. Your aluminum reflector and floodlight will come in handy for this assignment. Either arrange a few sheets of crumpled paper on a tabletop or make use of some drapery material placed over a vase or a table lamp.

In order to more fully explore value we will reverse the normal value relationship of black marks on a white sheet of paper. Using the black drawing paper and the white pastel pencil make a drawing of the still-life as if you were using a graphite pencil on white paper. Shadows will be represented with white marks, the darker the shadow area the whiter the marks. The resulting drawing should look something like a photographic negative in which light values are reversed.

VALUE AND PATTERN

Vija Celmins' drawing, *Long Ocean 3* (Fig. **5.25**), makes use of contrasting value patterns to create the illusion we are viewing a section of ocean. The term *pattern* in this context refers to the repetitive shapes that range in tone from white to black. Although Celmins presents us with a seemingly repetitious field, the variety of shapes and the interplay of forms are quite hypnotic and compelling. Within this rectangular composition, complex visual rhythms are created and organized into patterns. Interestingly, some sections of the drawing feature black shapes on a white ground (at the top left) and other sections (the bottom right, for example) show light-toned wave crests on a black background.

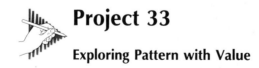

Project 33

Exploring Pattern with Value

Materials: Bond paper, drawing medium of your choice.

Search for patterns created by the interaction of light on three-dimensional surfaces that you could use as visual sources for a drawing. For example, you might do a drawing of the way sunlight filtering through blinds affects our perception of forms, or the greatly magnified texture of a stucco wall. This assignment should also make you more visually aware of your environment and help you to discover ways in which visual phenomena can be used as subject matter in your drawings.

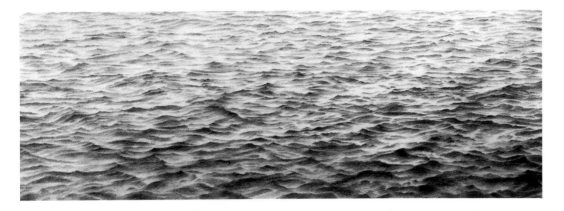

5.25 Vija Celmins, *Long Ocean 3*, 1979. Pencil. Courtesy, David McKee Gallery.

EXPRESSIVE USE OF VALUE

As we have seen throughout this chapter, value relationships play a variety of roles in the art of drawing, from describing three-dimensional forms to expressing moods and feelings. By controlling the illusion of light, you can use value to express a host of complex ideas and sensibilities. Predominantly dark drawings might suggest mystery, foreboding, and power while light-toned drawings might evoke lyricism and sensitivity. These are generalities, however, and the specific effects of each drawing depend on many factors.

The use of value in drawing can be likened to the way a musician uses volume in a composition. Loud passages are used for emphasis and to build tension; quiet sections are usually lyric and introspective. The range of expressive possibilities offered by the use of value in drawing is unlimited.

In 1913, Oskar Kokoschka, an Austrian expressionist, created a highly emotive drawing of his lover Alma Mahler, the young widow of the composer Gustav Mahler, that uses vigorous charcoal strokes and strong value contrasts to express the intensity of his feeling for this woman (Fig. **5.26**). Her features seem to be illuminated from within and emerge from a halo of dark tones that frame her face. The interplay of light and dark tones seems to communicate complex feelings of energy and pyschological tension that no doubt permeated their tempestuous relationship.

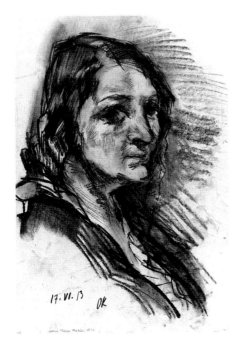

5.26 Oskar Kokoschka, *Portrait of Alma Mahler*, c. 1913. Charcoal on ivory wove paper, 19¼ × 13⁷⁄₁₆ in (48.8 × 34 cm). The Art Institute of Chicago. Anonymous gift in honor of Dr. John Gedo.

127

5.27 Julian Schnabel, *Dream*, 1983. Sugar-lift etching, 54 × 72 in (137.2 × 182.9 cm). Published by Parasol Press Ltd., New York.

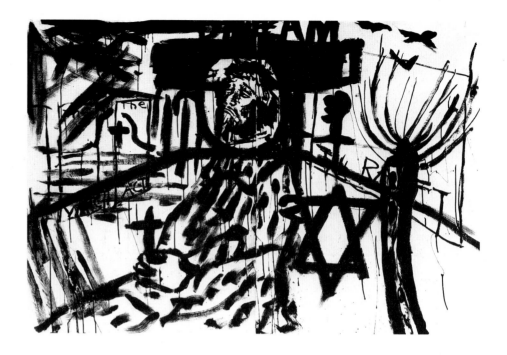

Julian Schnabel, a contemporary expressionist, uses thick, black lines and sharply defined white areas in *Dream* (Fig. **5.27**) to suggest a variety of religious themes: Crosses, Christ being crucified, a Jewish star. Closely spaced, vigorous brush strokes all suggest a highly charged (and ambiguous) emotional state.

René Magritte, a twentieth-century French artist, uses value to explore the mysteries of light and the natural cycles of day and night in his drawing *The Thought Which Sees* (Fig. **5.29**). Two silhouetted outlines of a man in a bowler hat dominate this composition. One is dark and represents night while the light section represents day. Different scenes are represented within these cut-outs. "Night" features a crescent moon and house with lighted windows while "day" allows us an ocean view with breaking surf and a cloud-dappled sky. Through the symbolic and perceptual use of value Magritte creates a dreamlike impression of night and day.

5.28 Student Drawing. Jeff Richards, San Francisco State University. Ink and charcoal, 14 × 17 in (35.6 × 43.2 cm).

128

Project 34

Exploring Expressive Use of Value

Materials: Bond drawing paper or toned charcoal paper, drawing media of your choice.

Using René Magritte's drawing *The Thought Which Sees* as an inspirational model, create a drawing that confounds our normal visual perceptions of night and day, light and dark. Draw some elements of a landscape or cityscape as if they were seen at night while others simultaneously exist in broad daylight.

Make another drawing that emphasizes the distinct shadows cast by objects when the sun is shining brightly. Take particular notice of the effects of light as you go about your normal activities. Try reversing or heightening the value relationships that you are able to observe. Be aware of how the mood of the drawing shifts and is determined by the way you manipulate and control the dark and light areas of your drawing. For instance the student drawings in Figures **5.28** and **5.30** rely heavily on effective value relationships to create aesthetic moods and to communicate many of their visual concerns.

Like line, value is one of the most basic visual elements in the repertoire of drawing. Learning to control and manipulate this element is crucial to the expressiveness of your drawings. Much depends on the mood and visual presence created by the drawing's juxtapositions of light and dark, and the overall tonal harmony of the work. A sound understanding of this important element will enable you to more fully articulate visual ideas.

5.29 (above left) René Magritte, *The Thought Which Sees*, **1965. Graphite, 15¾ × 11⅝ in (40 × 29.5 cm). Collection, The Museum of Modern Art, New York, Gift of Mr. and Mrs. Charles B. Benenson.**

5.30 (above right) Student Drawing. Candace Maas, San Francisco State University. Charcoal, 15 × 14 in (38.1 × 35.6 cm).

6 TEXTURE

The visual richness of the world is a result of many complex and interdependent factors: not only do we perceive colors, forms, space, and light and dark values, but tactile qualities (qualities associated with touch) as well. Often we can tell whether a surface is soft, hard, smooth, or rough just by looking at it. *Texture* plays an important role in the visual arts because tactile qualities are associated with many feelings and perceptions. You may be attracted to a certain tweed jacket because of the rich texture of its handwoven fabric; the mirror-smooth surface of a pond at dusk evokes feelings of tranquility and calm while the rough surface of a wind-swept ocean conveys power and strength. Learning to control and use texture in our drawings enables us to more fully express our ideas and visual concerns.

DEFINING TEXTURE

Within the context of drawing there are two types of texture: "actual" and "visual." Actual texture refers to the three-dimensional surfaces of forms we might draw, such as the rough bark of a tree, or to the tactile qualities of our drawing materials, for instance soft charcoal and rough-surfaced paper. Actual textures such as these are physically tangible and can be felt with our hands. By contrast, visual textures are illusions of roughness or smoothness created by artists through the way they manipulate their material and the visual elements. In Giambattista Piranesi's *Woman Carrying a Baby* (Fig. **6.1**), the sharp contrasts of black ink and white paper and the vigorous linear hatch marks energize the drawing with complex visual textures. The dynamic textures of this drawing contribute greatly to the impression of liveliness. Used with skill, texture can make a solid contribution to the visual and thematic expressiveness of a drawing.

ACTUAL TEXTURE

One way to experience actual texture is to make a series of drawing studies by placing your paper on top of textured surfaces, such as tree bark or rough concrete, and rubbing a piece of graphite across the surface of the paper. The three-dimensional texture beneath the paper will be recorded by the graphite. This process is called *rubbing* or *frottage*. Robert Indiana, a contemporary artist, used this technique in *The Great American Dream: New York* (Fig. **6.2**). Rather than relying on found texture, Indiana created a shallow relief template out of cardboard letters and forms, which he glued onto a heavier board. This artist is inspired by the vast array of signs and billboards that are now so much a part of the landscape – and our consumer oriented society.

Once Indiana completed his relief construction, he positioned his drawing paper on top of the shallow letter forms and with colored crayon made a series of diagonal hatch lines that recorded the three-dimensional surfaces beneath the paper.

TEXTURES OF DRAWING MATERIALS

Through the interaction of various drawing instruments with different paper surfaces, artists can achieve a wide variety of textural effects. Now would be a good time to systematically explore these textural interactions and catalog them in your mind for future reference and use.

6.1 Giambattista Piranesi,
Woman Carrying A Baby,
c. 1743. Pen and brush with ink,
6⁴/₅ × 3⁹/₁₀ in (17.4 × 10 cm).
Ashmolean Museum, Oxford.

6.2 (opposite) Robert Indiana,
The Great American Dream: New
York, **1966. Colored crayon and**
frottage on paper, 39½ × 26 in
(100.3 × 66 cm). Collection,
Whitney Museum of American
Art, New York. Gift of Norman
Dubrow.

Project 35

Experiencing Textures

Materials: Obtain the greatest variety of drawing media and papers.

Spend an hour or so in a specialist art supply store browsing among the drawing materials and looking at their selection of fine papers sold by the sheet. Within your budgetary limits buy a generous selection of chalks, crayons, pencils, pen nibs, etc. that you do not already own. Select a range of papers from the roughest watercolor paper to the smoothest hot press illustration board. Cut the paper into 5 by 7 inch sections and see how different drawing tools respond to various surfaces. Look around your house for unconventional materials that could be used to make distinctive marks: small pieces of sponge or twigs dipped in ink, or pieces of natural charcoal from your fireplace. One drawing instructor of mine delighted in telling his students how he had spontaneously made a very successful drawing using a common beverage straw dipped in ink.

The texture of drawing media is important to an artist's visual expression. It would be impossible to imagine Georges Seurat's dramatic conté crayon drawing (Fig. **6.3**) of a Paris street scene in the winter rendered with light pencil lines on a smooth illustration board. So much of the thematic content to this drawing appears to be bound to the roughly scrawled crayon marks as they interact with the hills and valleys of the handmade paper. Almost all of Seurat's mature drawings rely on this textural interplay between the soft black crayon and the roughness of his special paper.

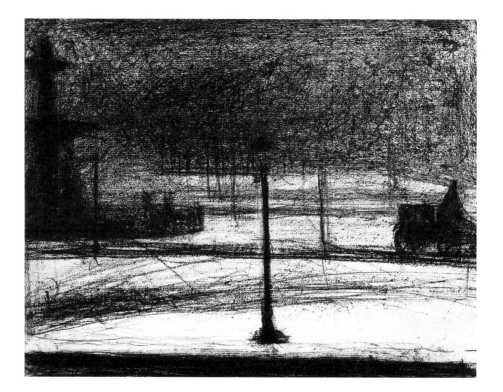

6.3 Georges Seurat, *Place de la Concorde, Winter*, 1882–3. Conté crayon, 9⅛ × 12 in (23.2 × 30.7 cm). Collection, Solomon R. Guggenheim Museum, New York.

Project 36

Rough Textured Media

Materials: Handmade paper or rough watercolor paper, chalk, charcoal, or crayons.

This project will enable us to experience the expressive possibilities of textural drawing media. Choose a subject that would benefit from the textural effects generated by the special materials used in this assignment, tree bark, shrubbery, and landscapes with groves of trees would make good subjects but don't feel limited by these choices alone. Try and use the textures created by your drawing tool and the rough paper surface to express the visual aspects of your subject.

Compared to Seurat's rough and mysterious cityscape, Jean-Auguste Dominique Ingres's neoclassical pencil drawing of two nude figures (Fig. **6.4**) represents the opposite end of the texture spectrum. Every aspect of Ingres's figure study seems to project neoclassical virtues of order and clarity. Ingres naturally chose the smooth textures of pencil and smooth paper because these media would give him the control needed to express the ideals of harmony and form embodied by these classically proportioned figures.

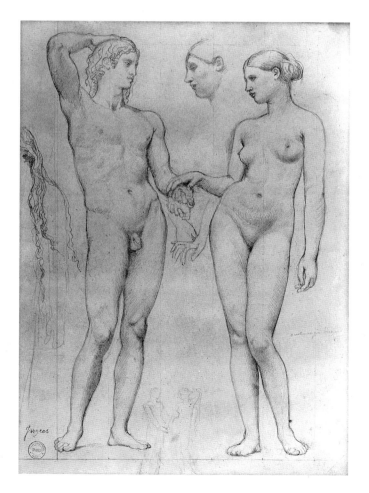

6.4 Jean-Auguste Dominique Ingres, *Two Nudes*, Study for *The Golden Age*, c. 1842. Graphite on cream wove paper, 16¼ × 12½ in (41.2 × 31.7 cm). Fogg Museum of Art, Harvard University. Grenville Lindall Winthrop Collection.

Project 37

Smooth Textured Media

Materials: Moderately hard graphite drawing pencils such as a 1H (see Chapter 2); a smooth surfaced rag paper such as cold or hot press illustration board.

This project will explore the expressive possibilities of smooth papers and relatively hard graphite drawing instruments. In view of these concerns, select still-life objects that have smooth and perhaps reflective surfaces. A solid color silk scarf draped over a small cardboard box and softly illuminated would make a good subject for this assignment. The general effects you should strive for in this drawing are gentle tonal gradations and subtle contrasts. Toward that end, merge and blend the pencil marks on the smooth surface into passages that do not call attention to individual lines.

Another drawing process that makes use of actual textures is *collage*. This term refers to the technique of attaching materials, such as fabric and paper, to the surface of the drawing.

Surely one of the most inspired contemporary masters of this technique is Romare Bearden. Until his death in 1988 this African-American artist was well known for his visually lush and textural collages, many of which drew their inspiration from recollections of the rural south where he was born. *Patchwork Quilt* (Fig. **6.5**) is an example of collage, piecing together sections of fabric much as an actual quilt might. Bearden places an image of a sleeping woman on top of the multi-colored textile patterns and in the process evokes nostalgic memories of his childhood in the rural south.

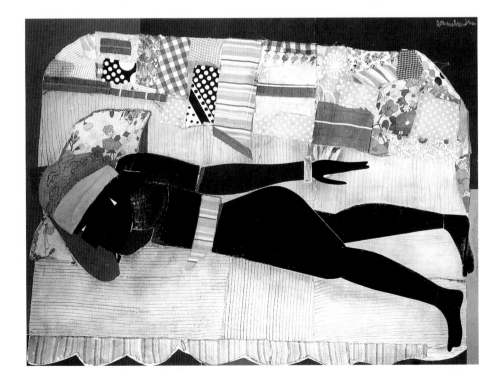

6.5 Romare Bearden, *Patchwork Quilt*, 1970. Collage, 35¾ × 47⅞ in (90.8 × 121.6 cm). Collection, The Museum of Modern Art, New York. Blanchette Rockefeller Fund.

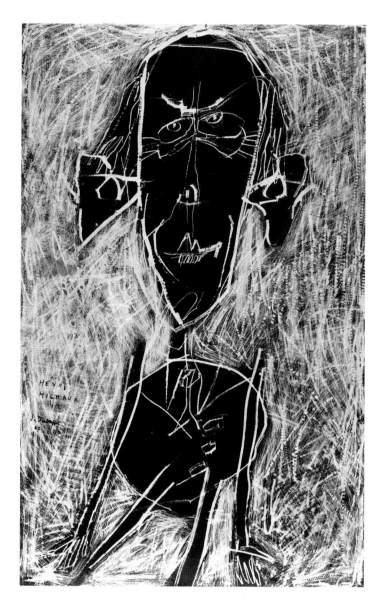

6.6 Jean Dubuffet, *Portrait of Henri Michaux*, 1947. Black india ink on board (scratchboard), 19¼ × 12½ in (48.9 × 31.8 cm). The Art Institute of Chicago. Bequest of Grant J. Pick.

VISUAL TEXTURE

Unlike the actual three-dimensional surfaces and materials we have just explored, visual textures achieve their effects through the illusion or simulation of roughness or smoothness. Most artists make use of visual textures to reinforce thematic concepts and to communicate important visual concerns. In order to further define what we mean by visual texture and to illustrate its range of expressive possibilities, we will compare two portrait drawings, one roughly, almost violently textured, and the other mysteriously smooth and elusive in feeling.

In the 1940s Jean Dubuffet, a contemporary French artist, became fascinated with drawings by mental patients, prisoners, children, and rural folk-artists. Impressed with the visual and psychological power of these works, which he found lacking in most professional art, Dubuffet adapted many of the stylistic features found in these so called "primitive" artforms to his own work. His *Portrait of Henri Michaux* (Fig. **6.6**) is striking in its directness and sharply inscribed visual textures – in fact it appears to be carved rather than drawn. This effect is achieved through the use of a "scratchboard" drawing technique, which involves coating a special paper with india ink and later scraping the dry ink away with sharp instruments. This technique

6 TEXTURE

6.7 John Graham, *Study after Celia*, 1944–5. Pencil, 23 × 18⅞ in (58.4 × 47.9 cm). Collection, The Museum of Modern Art, New York. The Joan and Lester Avnet Collection.

produces an extremely fine and well-defined line. Dubuffet's drawing technique is ideally matched to his thematic interests with the dynamic visual textures of the scratched lines reinforcing his interest in powerful psychological effects.

By contrast, the visual textures in John Graham's portrait of a model named Celia (Fig. **6.7**) are smooth and seamless. Graham was born Ivan Gratianovich Dombrovski in Kiev, Russia, in 1881. After the revolution he was imprisoned by the Bolsheviks but he managed to escape to Poland and eventually made his way to New York City in 1920. Earlier in his career he was an abstract painter but during the 1940s his work resembled that of the Renaissance masters. At this time Graham withdrew into a world of personal mysticism. His drawing *Study after Celia* reveals this trait.

The visual effect, or style, of Graham's drawing is quite different from the brutal forcefulness of Dubuffet's portrait, yet the study of Celia is no less psychologically probing. Few individual drawing marks are discernible. Carefully blended pencil lines create massed tones that fade from light to dark. Her bulging eyes and the penetrating gaze suggest an inner turmoil held in check only by great effort. Graham's use of smooth visual textures works in striking contrast to the disquieting demeanor of his subject to create a drawing of high drama and tension.

Project 38

Creating Soft and Sharp Textures

Materials: Bond drawing paper, graphite, vine charcoal, pen and india ink, or sable-hair brush and ink.

This project will allow you to further explore the expressive drawing possibilities of visual texture. In order to experience the full spectrum of textural effects we will work from two contrasting still-lifes: a group of feathers or a fur coat, and a spiny cactus plant. The range of textural effects it is possible to achieve with most drawing media is quite large, and an infinite range of expressions are made possible by combining and juxtaposing visually sharp and soft textures within the same drawing. For our purposes of study in this project, however, we will explore the polar extremes of textural effects.

For your first drawing create a still-life with some medium-size feathers or a fur coat if you can borrow one. Both the feather and the fur are inherently soft and visually express this textural quality. The artwork in Figure 6.8 shows how special textural effects can be used toward aesthetic ends. This drawing clearly communicates the softness of the monkeys' fur as they huddle together as a family. The soft visual texture of the fur contrasts with the sharply drawn branches and leaves.

Graphite and vine charcoal are probably the best materials to use for this soft texture project because they can easily be made to appear indistinct and diffused. Before you begin this assignment review the illustration of John Graham's blended graphite drawing in Figure 6.7.

6.8 Hashimoto Kansetsu, *Monkeys*, 20th century. Watercolor on silk, 19 × 22 in (48.2 × 55 cm). The Metropolitan Museum of Art, New York.

137

6.9 Student Drawing. Denise Mowry, Felician College. Pen and ink, 7 × 8½ in (17.8 × 21.6 cm).

For the second drawing of a cactus, choose a drawing medium capable of producing sharp tonal contrasts. India ink would be perfect for this assignment. Unlike the soft blurred effects of the feather or fur drawing we are looking for bold contrasts of value and shape in this project. Denise Mowry's student drawing of a cat (Fig. **6.9**) illustrates the dependence of visual texture on media and technique. The strong tonal contrasts of black ink to white paper and the sharp pen and ink lines create rich and pleasing textures.

After reviewing Mowry's ink drawing and Dubuffet's sharply inscribed *Portrait of Henri Michaux* (Fig. **6.6**), make a drawing of the cactus with pen and ink or brush and ink. If you use a brush you can vary the dilution of the ink but remember that to effectively express the textural qualities of the cactus spines you must use angular shapes and strong value contrasts.

The student drawings in Figures **6.10** and **6.11** also make use of contrasting visual textures to create different visual and psychological effects. C. Brazil's still-life evokes a dreamy, contemplative mood with its softly blended tones while Rita Christen's abstract drawing impresses us with its sharply contrasting explosive patterns.

6.10 (left) Student Drawing. C. Brazil, San Francisco State University. Charcoal, 22 × 23 in (55.8 × 58.4 cm).

6.11 (below) Student Drawing. Rita M. Christen, San José State University. Charcoal, 26 × 40 in (66 × 101.6 cm).

TEXTURE AND SPACE

Visual textures can also help to define and manipulate space in a drawing. Through the juxtaposition of contrasting textures, artists can create the illusion of deep space on a two-dimensional drawing surface. *The Crau from Montmajour* by Vincent van Gogh (Fig. **6.12**) makes use of an extraordinary range of visual textures that help to reinforce the illusion of a landscape spread out before us. Van Gogh's pen strokes in the *foreground* are broad and widely spaced creating rough textures. The strokes in the background, however, are smaller and more closely spaced. By controlling the size and position of his marks, van Gogh made use of textural differences to reinforce the spatial illusions he was interested in creating.

Visual textures can also be used to create an illusion of flatness and reinforce the two-dimensionality of the *picture plane* (the designated area of the drawing). Roy Lichtenstein's contemporary Pop Art portrait, *The Melody Haunts My Reverie* (Fig. **6.13**), makes use of an even dot pattern, similar to those used in commercial printing processes, to flatten the space of the picture plane and create a surface that, from a distance, is read as an even, gray tone.

6.12 Vincent van Gogh, *The Crau from Montmajour*, 1888. Reed and fine pen with light brown ink over black chalk, 19⅛ × 23⅞ in (49 × 61 cm). British Museum, London.

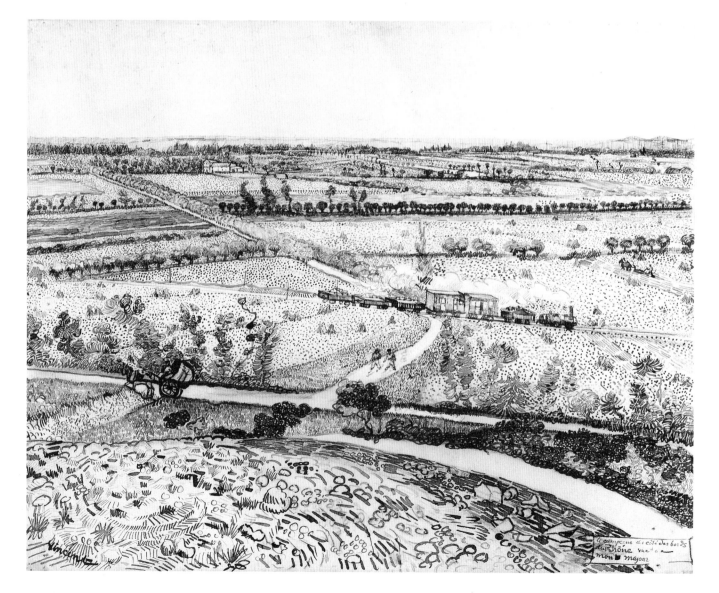

6.13 Roy Lichtenstein, *The Melody Haunts My Reverie*, from the portfolio *11 Pop Artists*, vol. II, 1965. Serigraph, 27⅛ × 22¹⁵⁄₁₆ in (68.9 × 58.4 cm). Collection, The Museum of Modern Art, New York. Gift of Original Editions.

Project 39

Creating the Illusion of Space with Texture

Materials: Bond paper, drawing medium of your choice.

Working from an actual or imaginary landscape create a unified composition that explores the spatial effects of juxtaposed textures. You may wish to acknowledge and reinforce the flatness of the drawing surface (as in the Lichtenstein drawing seen in Figure **6.13**) or create illusions of three-dimensional space using a similar method to van Gogh's (Fig. **6.12**). Before you begin this assignment refer to illustrations of landscape drawings that appear in this and other books to familiarize yourself with the traditions of this drawing genre. Try combining the use of textures in conjunction with your own developing techniques and themes. For example you may wish to combine soft visual textures with rough ones. Do not be afraid to experiment;

141

6.14 Student Drawing, Janine Kellehren, School of the Art Institute of Chicago. Brush and ink, 13 × 11 in (33 × 27.9 cm).

often the juxtaposition of seemingly disparate visual elements and thematic concepts can lead to creative insights in your personal work. Janine Kellehren's student landscape drawing (Fig. **6.14**) appropriately exploits the textures produced with brush and ink on a rough watercolor paper.

TEXTURAL HARMONIES AND RHYTHMS

As artists mature, their work usually evolves into distinctive styles that reflect their choice of themes, materials, ways of using space, and visual rhythms. Frequently, the work they produce becomes unmistakably their own, in large part because of the textural patterns found in their work. Even after seeing only a handful of van Gogh's pen and ink drawings, most of us can easily identify the drawing seen in Figure **6.15** as one of his distinctive works. *Canal with Washerwomen* pulsates with a variety of visual textures created by irregular rhythms of long and short, thick and thin lines as well as a variety of dots and half-circles. Despite the broad range of marks and lines, however, the drawing is perceived as an harmonious structure, alive with activity yet coordinated and unified.

6.15 Vincent van Gogh, *Canal with Washerwomen*, 1888. Pen and ink, 12½ × 9½ in (31.8 × 24.1 cm). Kröller-Müller Museum, Amsterdam.

143

By contrast, Fairfield Porter's drawing, *Study for the Door to the Woods* (Fig. **6.17**), evokes the quiet feeling of summertime in the countryside; thin, looping lines create lyric visual textures that suggest a world far removed from the hectic pace of urban life. Porter has created a matrix of open and closed spaces in this drawing that give us an impressionistic view of trees intermingled with shrubbery and thick vegetation.

A. R. Penck, a contemporary German artist, makes use of a wide range of textural harmonies and rhythms in *Eau de Cologne* (Fig. **6.16**). Strong value contrasts energize this complex artwork and offer us a kaleidoscopic view of the artist's world that includes portraits of famous artists (Joseph Beuys, one of the best known contemporary German artists, can be seen in the upper right wearing his trade-mark hat, and Picasso appears in the bottom right staring at us with glazed eyes), billboard signs, geometric and organic shapes, and a variety of square shapes, dots, and wavy lines. Penck has created an overall visual field that is activated by all of these textural rhythms and harmonics. Everything is interconnected and linked together and the more we look at this composition, the more recognizable images emerge.

One aspect of actual texture we have not discussed so far is the surface texture of papers artists use for their drawings. Elizabeth Murray, a contemporary artist, made effective use of the natural texture of her drawing paper in *Shake* (Fig. **6.18**). By sometimes dragging the broad side of her charcoal across the drawing surface, Murray created a powerfully evocative work that effectively makes use of both visual textures and the actual texture of the paper.

6.16 A.R. Penck, *Eau de Cologne*, 1975. Synthetic polymer paint on canvas, 9 ft 6¼ in × 9 ft 6¼ in (285 × 285.1 cm). Collection, The Museum of Modern Art, New York. Anne and Sid Bass Fund.

144

6.17 (left) Fairfield Porter, *Study for the Door to the Woods*, c. 1972. Ink on paper, 13½ × 10¼ in (34.3 × 26.1 cm). Collection, Whitney Museum of American Art, New York. Gift of Alex Katz.

6.18 (below) Elizabeth Murray, *Shake*, 1979. Charcoal on paper, 46½ × 38 in (118.1 × 96.5 cm). Collection, Whitney Museum of American Art, New York. Purchase with funds from Joel and Anne Ehrenkranz.

Project 40

Integrating a Variety of Textures

Materials: Bond paper, and drawing medium of your choice.

Working from a still-life incorporating a wide variety of materials we will do a series of drawings that integrates and synthesizes textural concerns. Spend some time beforehand collecting appropriate materials. Strong visual contrasts will create interesting visual possibilities, for instance, items like barbed wire, a section of silk cloth, steel-wool, a handful of nails, cotton balls, dirt, straw, plastics, and dried leaves would make a marvelous mixture of textures and surfaces. Do not haphazardly throw these materials together but create a composition. That is, select and choose only those items that create interesting juxtapositions in terms of the amount of texture and its placement.

145

Before you begin to draw take the time to review the illustrations and concepts in this chapter and the drawings you have done from the assignments on texture. Analyze how each artist's work made use of visual textures to express specific thematic concerns, and to create unique spaces. As you review your own work, select those drawings that you feel were particularly successful. What worked in these drawings? Consciously make note of these techniques and principles and try to keep them in mind as you work on this and future assignments.

Doing meaningful work in drawing means developing a working vocabulary of visual elements and concepts: the way you use a medium, your thematic interests, and the way you organize marks and compositional space. By consistently pursuing an idea over time, your unconscious mind is programmed to think about the drawing problems you are grappling with on a variety of levels.

After you have spent some time creating a drawing arrangement that supports your exploration of textural effects, take your time and slowly develop a drawing that integrates and incorporates a variety of visual textures; soft, sharp, smooth, abrasive, shiny, and dull. Do not give equal visual emphasis to each texture. This might in the long run prove uninteresting. Vary the amounts. For instance you may use a large amount of rough texture with small passages of softly diffused tonalities.

6.19 Student Drawing. Stephanie Ridard, San José State University. Charcoal, 26 × 40 in (66 × 101.6 cm).

6.20 Student Drawing. Lisa Iagawa, San José State University. Ink, 18 × 24 in (45.7 × 61 cm).

Do not become discouraged by the results of your first efforts. By concentrating on the drawing process and the solving of visual problems, rather than finished products, you will be paving the way toward future success. The professional work illustrating this book looks polished and effortless in terms of technical control and professional achievement. Behind this art, however, lies much developmental work, false starts, and sheer practice.

The student drawings shown in Figures **6.19** and **6.20** both make effective use of textural elements. The textures created by the interactions of drawing instruments, media, and the visual qualities of our subjects are almost infinite.

Put up some of your first drawings from this assignment in a place where you will see them frequently as you go about your daily activities. After a while you will probably notice elements in them that you will want to emphasize and use in future drawings. Conversely you will also notice ways in which they can be improved. The process of drawing is essentially an evolutionary activity that over time sharpens our visual capacity and heightens our awareness, returning again and again to familiar places enables us to see things in new ways and with new understandings.

7 COMPOSITION AND SPACE

Effective drawings do more than manipulate materials well or achieve accurate visual representations. They invariably define space in personal ways and organize all of the visual elements such as line, shape, value, and texture into unified, harmonious arrangements. "Composition" is a term that refers to the way these visual elements are structured and employed and has nothing to do with a drawing's subject matter or choice of media.

The principles of visual organization that govern a drawing's composition are used throughout the world in all of the visual media. These principles include balance, placement, rhythm, repetition, and variation. It is important to remember that these basic principles are guidelines that determine the way spaces and forms are organized, not inflexible rules. All the compositional principles outlined in this chapter are constantly redefined by artists to suit specific purposes. For instance, although you might be cautioned about placing an image in the center of the paper because it might result in a static composition, some drawings do just this and achieve favorable results. In such cases, the artists knew what they were doing when they broke the rules. In order to manipulate compositional guidelines successfully, we must first learn the underlying theories that govern them. Then we are free to either follow their direction or meaningfully contradict them.

One test of a drawing's composition is its completeness – nothing can be added or taken away without seriously affecting its balance or wholeness. In a successful composition everything is working in harmony with no single element more important than the arrangement of visual components. In terms of the "language of drawing," composition functions as a grammatical force, ensuring that everything functions in an orderly, mutually supportive way. The aims of this chapter are to familiarize you with the basic principles of composition and the expressive possibilities of organizing space.

CHOOSING A FORMAT

The first spatial and compositional decisions in a drawing are determined before the first line is made. The size and shape of the paper as well as the way it is held relative to the subject are important compositional decisions. Most sheets and pads of paper come in sizes that are slightly wider than high. This *format* (or proportional relation of length to height) fits most of our drawing requirements. But sometimes either a square or oblong format offers compositional advantages and expressive possibilities not found in traditional paper sizes.

There are two ways to alter the format of our drawing: one way is to cut or tear the paper to the desired size or intersecting pencil lines can be drawn at right angles on the paper to define the format.

Another significant format consideration is deciding whether to use the standard 18 by 24 inch paper in a horizontal or vertical position. No hard and fast rules govern this decision, rather it depends on the visual effects you want to achieve. Usually the artist determines how to hold the paper according to visual elements found in the drawing subject or according to how he or she intends to compose the subject. If you are drawing a still-life that is arranged across a table top, positioning your paper horizontally might be an appropriate response. Drawing a standing figure, however, usually calls for vertical placement of the paper. Let your intentions and your subject be your guide in helping you determine your format for the size and position of the paper should reinforce your visual concepts.

Vertical formats work well for obvious reasons when drawing buildings. In 1921, Mies Van der Rohe, a pioneer architect of the Modern Era, did a project drawing of a skyscraper (Fig. **7.1**) that visually communicated the soaring, spiritual nature of

7.1 (opposite) Ludwig Mies Van der Rohe, *Friedrichstrasse Skyscraper*, 1921. (North and east sides.) Charcoal and pencil on brown paper, 68¼ × 48 in (173.5 × 122 cm). Collection, The Museum of Modern Art, New York. Gift of the architect.

7.2 Rembrandt van Rijn, *A Winter Landscape*, c. 1648–52. Pen, brush, and brown ink on cream paper, 2½ × 6¼ in (7 × 16 cm). Fogg Museum of Art, Harvard University. Bequest of Charles Alexander Loeser.

this new architectural form. The choice of vertical format solidly reinforces the ideas the architect was trying to express in this drawing. Thrusting skyward, this image of a glass-sheathed skyscraper embodied the architect's vision of how modern materials and building techniques can express contemporary ideas.

On the other hand, horizontal formats are better-suited to ground level subjects and tend to work well with sweeping panoramas. Because our eyes, set side by side, tend to naturally sweep back and forth horizontally as we walk, these formats are effective with landscape motifs. Once we have seen Rembrandt's drawing, *A Winter Landscape* (Fig. **7.2**), it is hard to imagine this subject drawn in a standard format. The elongated shape of the paper seems perfectly suited to the austere image of the flat Dutch landscape caught in the grip of winter. With a few deft strokes of his pen and brush, Rembrandt visually pulls us into this composition and allows our eyes to move back and forth, taking in the full panorama of the Dutch lowlands.

Project 41

Exaggerated Formats

Materials: Medium weight bond paper, drawing medium of your choice.

During this session you will plan and create a drawing on an elongated format that takes into consideration the special visual qualities of your subject. The format of this drawing should be at least 2½ times as wide as it is high. You can either cut the paper to size or define the format with light pencil lines on a standard sheet of paper.

Our subject for this series of drawings will be a broom – a decidedly elongated object. For your first drawing you will need to decide whether to position the broom vertically or horizontally (you will reverse positions in the next drawing so do not agonize over this decision). Plan your format to accommodate and respond to the elongated shape of the broom.

After you have explored the drawing possibilities of the horizontal or vertical format alternate the position. What special visual opportunities does each format hold? What orientation seemed more interesting and relevant to you? Do several more drawings exploring these exaggerated formats and refine your ideas.

To help you visualize format, you may wish to make a simple sighting device to help you with composition. Cut two L-shaped sections out of a 10 by 10 inch piece of matboard. By placing these two sections together at right angles you can create a rectangular window of variable proportions (Fig. **7.3**). Remember, the format of a drawing controls the basic visual movement of our eyes as we scan the surface. Horizontal formats tend to lead our eyes left and right and vertical formats usually cause the eye to move up and down.

Tai Chin's fourteenth-century ink drawing on paper (Fig. **7.4**) uses a format that is 2½ times as wide as it is high. Because of the elongated composition, the visual elements in this drawing lead our eyes back and forth in sweeping

7.3 Sighting device made with two L-shaped pieces of matboard.

7.4 Tai Chin, *Fisherman on An Autumn River.* Ink and colors on paper, 18⅛ × 50 in (47.3 × 127 cm). Smithsonian Institution, Freer Gallery.

151

7.5 Student Drawing. Maria Trimbell, San Francisco State University. Pen and ink, 3½ × 6½ in (8.8 × 16.5 cm).

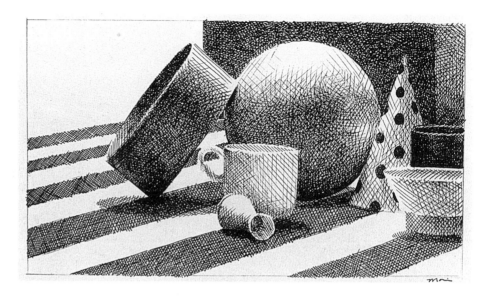

horizontal movements. The fishing boats seem to glide effortlessly in the brisk currents of the river. One could not imagine similar visual effects being created through a more conventional format.

Whatever your choice of subject matter, make sure you exploit the special compositional formats. The student drawings shown in Figures **7.5** and **7.6** both respond compositionally to their unique formats. Maria Trimbell's pen and ink still-life drawing creates predominantly horizontal eye movements while Suzanne Slattery's drawing emphasizes vertical eye movement.

THE PICTURE PLANE

Let us first define what is meant by the term *picture plane*. It is a technical term used by artists to refer to the designated area of the drawing. Basically, there are two distinct ways in which we might graphically respond to the two-dimensional surface of the picture plane. We can either create an illusion of three-dimensional space (this has been the strategy in the West since the Renaissance), or we can acknowledge and exploit the reality of a drawing's flat surface. This concept is strongly associated with modern works of art, but as you might recall from Chapter 1, other cultures and civilizations have also capitalized on the inherent flatness of the picture plane to emphasize visual patterns and rhythms.

Raphael's *Study for the Madonna Eszterhazy* (Fig. **7.7**) illustrates quite clearly the traditional Western conception of space. Raphael creates the illusion that we are viewing a scene that contains three figures in the foreground and that a landscape extends beyond in the background. Through a variety of visual means such as cross-contour lines and the careful control of light and dark tones the artist enables us to read the forms of this drawing as three-dimensional objects that exist in deep space.

The other basic concept of the picture plane acknowledges and accepts the inherent flatness of the drawing surface. Often drawings working from this concept present information to the viewer in direct and diagrammatic ways. Hannah Cohoon, a member of a religious sect, founded in the eighteenth century, known as Shakers, created a symbolic drawing of *The Tree of Life* (Fig. **7.8**) that makes effective use of flat ornamental plant shapes. Although the organic forms used in this drawing are realistic, they are presented to us as if they were pressed between two pieces of

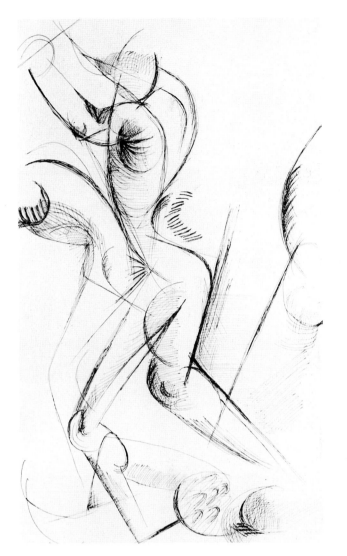

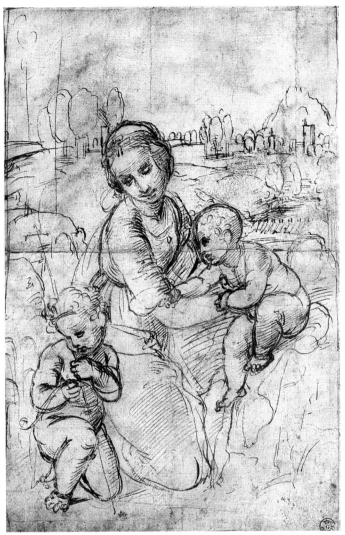

7.6 (above left) Student Drawing.
Suzanne Slattery, Bucks County
Community College, PA. Pen and ink,
20 × 12 in (50.8 × 30.5 cm).

7.7 (above right) Raphael, *Study for the
Madonna Eszterhazy*, c. 1505–10. Pen
and yellowish ink and pencil, 11²/₅ ×
7¹/₂ in (28.5 × 19.1 cm). Uffizi,
Florence.

7.8 Hannah Cohoon, *The Tree of Life*,
1854. Brown ink and watercolor on
tempera on off-white paper, 18¹/₈ ×
23¹/₄ in (46 × 59 cm). Hancock Shaker
Village, Pittsfield, Massachusetts.

7.9 Frank Stella, *Talladega Three I* from the series *Circuits*, 1982. Etching, 66 × 51⅜ in (167.7 × 130.5 cm). Collection, The Museum of Modern Art, New York. Jeanne C. Thayer and John D. Turner Funds.

glass. The rhythms created by the interlocking flat shapes are quite compelling. Certainly a more representational perspective of tree or leaf forms would not convey the same feeling of harmony, order, and symmetry.

Frank Stella, a contemporary American artist, also reaffirms the flatness of the picture plane in his print titled *Talladega Three I* (Fig. **7.9**). This composition is based on the track designs of several automobile racing tracks Stella had visited as a spectator. The artist represents them, however, not as they might be perceived visually during a race, but as flat, diagrammatic illustrations of their track design. Stella has conceptually evoked the speed and looping rhythms of a racing track on the flat surface of the paper.

PLACEMENT

No hard and fast rules define the arrangement of shapes and spaces in a composition. Generally their placement is determined by the visual concepts the artist wants to express and the forms that will be emphasized. Artists seek to create lively, interconnected spaces that allow the viewer to find interesting elements to compare throughout the composition. This is why you may sometimes be cautioned about placing a single image in the middle of the page as you may be limiting the

7.10 William Allan, *Rainbow Trout – Muir Creek*, 1972. Watercolor on paper, 18½ × 25¾ in (47 × 65.4 cm). Collection, Whitney Museum of American Art, New York. Purchase with funds from the Richard and Dorothy Rodgers Fund.

visual movements of your composition. But sometimes artists ignore this guideline and still produce successful drawings. William Allan's watercolor drawing (Fig. **7.10**) demonstrates the conditional nature of design principles that govern factors such as placement. His meticulously rendered image of a trout is deliberately placed in the center of the paper where it stands in isolated splendor. The contrast between the complex details of the image and the pristine whiteness of the empty paper adds visual drama to this drawing.

Wayne Thiebaud's drawing, *Untitled (Lipsticks)* (Fig. **7.11**) makes use of a decentralized structure. Some of the lipsticks are grouped quite close to one another, and some are widely spaced. Thiebaud also changes their angles. Some stand upright and some lie on the tabletop pointing in various directions. By carefully arranging the placement of these objects throughout the space of the drawing, the artist creates a dynamic composition that holds our interest.

7.11 Wayne Thiebaud, *Untitled (Lipsticks)*, 1972. Pastel on paper, 17 × 20 in (43.1 × 50.8 cm). Courtesy, Allan Stone Gallery, New York.

155

Project 42

Placement

Materials: Medium weight bond or other suitable drawing paper, drawing medium of your choice.

Assemble a collection of small objects that can be comfortably arranged on a tabletop. Spend some time moving these objects around and observing how the composition is affected by the changes you make. To help create an effective arrangement, you may want to make a cut-out cardboard window (similar to the one we made before) that is the same shape as your working format.

Do a series of drawings that explore the compositional effects of placement. Try different arrangements. Spread some objects across the table and place others in a tight group. As an exploration of central placement, select an object that interests you and make a detailed drawing of it in the center of the paper. How much space you leave around it will greatly affect your results, so plan the ratio of drawn image to empty space carefully.

FIGURE-GROUND INTERACTIONS

Figure-ground relationships, also known as negative and positive spaces, refer to the spatial interaction between the shapes created by the drawn mark (the *figure*) and the untouched space of the drawing (the *ground*). Often artists manipulate values, forms, and spaces to create lively and ambiguous interplays between what may be read as figure and ground. Spatial interactions such as these occur in a watercolor drawing I did of a page taken from a 150 year-old philosophy book in my collection (Fig. **7.12**). This work is part of a series which visually responds to the book page by alternately drawing thick lines and forms with the watercolor and in the process creating tangible shapes out of the uncovered text. The subject titles at the top of each page were fascinating and often proved to be a catalyst for my visual responses – this one reads "Moral History of Other Worlds." The interaction between the unusual ground of type and the bold black watercolor shapes is dynamic and is constantly changing.

In order to reinforce your understanding of this visual aspect of composition, examine drawing illustrations in this and other chapters to try and find other examples of figure-ground relationships.

BALANCE

In terms of pictorial organization, balance is perhaps one of the most significant elements of composition. Much depends on a drawing's ability to balance and integrate a variety of visual concerns. When a composition is in proper balance, everything seems to be in harmony and our eyes can move freely across the surface of a drawing finding interesting relationships everywhere.

Balance falls into two broad categories, symmetrical and asymmetrical. But in practice many works of art manifest both symmetrical and asymmetrical elements.

Symmetrical balance is achieved by dividing a format in half (either horizontally or vertically) and placing identical visual elements on each side of the dividing line.

7.12 Howard Smagula,
*Moral History of Other
Worlds,* 1991.
Watercolor and
gouache, 9½ × 5½ in
(24 × 14 cm). Courtesy,
the artist.

7.13 (right) Agnes Denes, *Pascal's Perfect Probability Pyramid: The Reflection*, Study for *Glass Pyramid in Reflecting Pool*, 1978. Ink on vellum, 31 × 24½ in (78.7 × 62.3 cm). Collection, Kunsthalle, Nuremberg, Germany. Courtesy, the artist.

7.14 (far right) Jim Dine, *Four C Clamps*, 1962. Lithograph, 18⅞ × 11¼ in (48 × 28.5 cm). Collection, The Museum of Modern Art, New York. Gift of Celeste and Armand Bartos Foundation.

Agnes Denes uses elements of symmetrical balance in her precisionist drawing titled *Pascal's Perfect Probability Pyramid: The Reflection* (Fig. **7.13**). Because the reflected bottom half of the drawing is lighter than the top half, Denes really makes use of "near symmetry." Most drawings do not make use of strict symmetry because it tends to produce static, uninteresting compositions.

Asymmetrical balance achieves a sense of order and equilibrium by organizing unequal elements in such a way that they tend to balance with each other. Jim Dine's *Four C Clamps* (Fig. **7.14**), for instance, balances a small dark section at the top of the composition with a large white space of unmarked paper. Asymmetric balance usually makes possible dynamic spatial relationships that allow for interesting visual organizations. For this reason asymmetric balance is used far more frequently than symmetry.

7.15 Student Drawing. Ken Gully, San José State University. Graphite, 18 × 24 in (45.7 × 60.9 cm).

Project 43

Exploring Balance

Materials: Bond or other suitable drawing paper, charcoal, graphite, or brush and ink.

The aim of this project is to make you more aware of the vital role balance plays in the compositional process. Since asymmetric balance is more widely used, we will focus our efforts in this direction (if the problem of symmetric balance intrigues you, by all means pursue this interest in conjunction with our assignment). To create a suitable still-life, line up a row of coffee cups on a tabletop. Keep in mind the drawing objective: the exploration of compositional elements that effect visual balance. Place the cups in the upper portion of the drawing's picture plane. How asymmetric in balance can you make your drawing before it loses its unity? Jim Dine's drawing *Four C Clamps*, appears to have reached the compositional limits of asymmetric balance with the densely black upper portion of this drawing achieving an equilibrium with the large open space below. Any changes in the amount or position of the dark shapes or in the amount of open space would shift the precarious balance Dine has achieved.

Keep playing with the relationships between drawn sections and open space in your drawing until you have achieved a satisfying arrangement. The student drawings shown in Figures **7.15** and **7.16** both make use of asymmetric composition.

7.16 Student Drawing. Michelle Tan, San Francisco State University. Charcoal, 24 × 18 in (60.9 × 45.7 cm).

159

RHYTHM AND REPETITION

The elements of rhythm and repetition are closely related. Rhythm refers to the flow of visual movements in a drawing created by the way marks and spaces are organized. The issue of repetition specifically addresses the way rhythms are repeated to achieve expressive effects or bring about compositional unity. Auguste Rodin's drawing *The Embrace* (Fig. **7.17**) makes use of flowing, curvilinear rhythms to reinforce the sensuous theme of this artwork. The embracing couple's bodies are visually intertwined and fused into a single form of curves and twists. The black masses of watercolor, which represent their hair, stand out dramatically against the rhythms of the lines describing their bodies.

By contrast, Picasso's forceful cubist portrait (Fig. **7.18**) expresses quite a different theme rhythmically. Instead of graceful linear movements Picasso presents us with brusque, powerful rhythms that dramatically oppose each other and create compelling visual and psychological tensions. During this period of his career (1910–13), Picasso was profoundly affected by primitive works of art from places like Oceania and Africa. Through jagged rhythms and angular forms, this drawing expresses feelings of power and spiritual authenticity that Picasso found lacking in highly refined European art.

The element of repetition is clearly revealed in Sol LeWitt's drawing, *All crossing combinations of arcs from corners, arcs from sides, straight lines, not straight lines, and broken lines placed at random* (Fig. **7.19**). As part of his creative process the artist uses the title as a set of instructions for creating the drawing. Visual clarity, precision, and order are high priorities for LeWitt and the variations of the arcs and straight lines creates a feeling of harmony and mathematical order.

7.17 (below left) Auguste Rodin, *The Embrace*, late 19th century. Pencil outline with watercolor washes, 13 × 9½ in (32.9 × 24 cm). Ashmolean Museum, Oxford.

7.18 (below right) Pablo Picasso, *Head of a Woman*, 1909. Gouache over black chalk, 24½ × 18⅘ in (61.8 × 47.8 cm). The Art Institute of Chicago. Charles Hutchinson Memorial Collection.

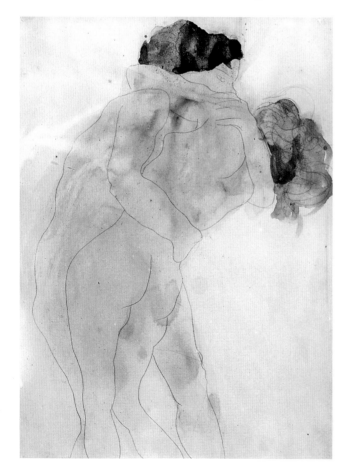

All crossing combinations of arcs from corners, arcs from sides, straight lines, not-straight lines, and broken lines placed at random

Sol LeWitt Jan 25 1972

Project 44

Exploring Rhythm and Repetition

Materials: Bond paper, medium or soft graphite pencils or pen and india ink.

Create a composition with rhythmic patterns using straight lines that follow a specific program. Write a short descriptive statement, similar to the LeWitt title used for Figure 7.19, that establishes the visual procedure you will use to create your rhythmic drawing. For example, you might divide the picture plane into a grid and draw lines from the corners of the inner rectangles to the corners of the paper. Keep the formula simple and concentrate on creating an interesting composition of intersecting lines that vary in spacing and density. Remember that you are primarily interested in the expression and repetition of rhythms. This purpose should guide you in the creation of your drawing.

7.19 Sol LeWitt, *All crossing combinations of arcs from corners, arcs from sides, straight lines, not straight lines, and broken lines placed at random,* Jan. 25, 1972. Ink on paper. Courtesy, John Weber Gallery, New York.

REVISION

No matter how carefully we plan our composition, it will always be subject to revision or change, both while we are in the process of drawing and later when we analyze our work in preparation for future drawings. Rarely are drawings complete in the artist's mind before the idea is committed to paper. The entire process of drawing can be summarized as one of visual statement, revision, restatement, until the artist considers the idea worked out, at least for the time being.

One of the most fascinating aspects of drawing is the way in which drawings clearly reveal the visual thinking that went into a work of art. Some of the most exciting historical drawings are those that were done to explore the compositional options of a large, complex painting or mural.

Federico Barocci, an Italian artist born in Urbino about 1528, was noted for the extraordinary number of preliminary drawings he made in preparation for important paintings. Many clients admired his work but complained of his slowness and deliberation. In 1582 he was commissioned by a wealthy church order to do a large painting of *The Visitation* for its chapel in Rome. Surviving preparatory drawings show the evolution of his compositional ideas from preliminary sketches to highly detailed finished works.

In preparation for this painting Barocci's first rough draft of a drawing (Fig. **7.20**) sketchily describes the meeting of the Virgin and St. Elizabeth. They are positioned slightly off-center in a horizontal format. The artist made revisions directly on the drawing by simply redrawing his corrections over the previous lines. Notice the changed positions of the figure to the right.

Later Barocci used live models to pose for him while he worked out the exact anatomical proportions and body posture that he would use to represent St. Joseph. Detailed studies of a man's hand grasping a cloth sack are juxtaposed with studies of the saint's crouching position (Fig. **7.21**).

In this detailed rendering of the final composition (Fig. **7.22**) we can see that Barocci eventually changed the composition to a vertical format and further refined the positions of all of the major characters. The feeling of joyous welcome expressed by his subjects, however, is still evident in the final drawing.

7.20 (below left) Federico Barocci, Study for *The Visitation*. Pen, ink, and wash, 4³/₅ × 6½ in (11.7 × 16.6 cm). Rijksmuseum, Amsterdam.

7.21 (below right) Federico Barocci, *Nude Studies for St. Joseph*. Chalk on paper, 16½ × 11¹/₁₀ in (42 × 28.3 cm). Uffizi, Florence.

7.22 (opposite) Federico Barocci, Copy of *The Visitation*. Pen, ink, wash, and chalk on paper, 15³/₅ × 11¹/₁₀ in (39.6 × 28.3 cm). Royal Library, Windsor Castle. Reproduced by gracious permission of Her Majesty Queen Elizabeth II.

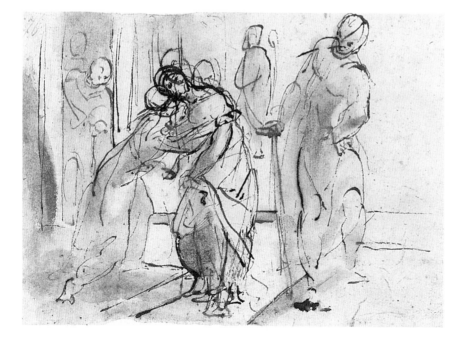

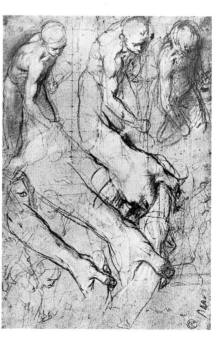

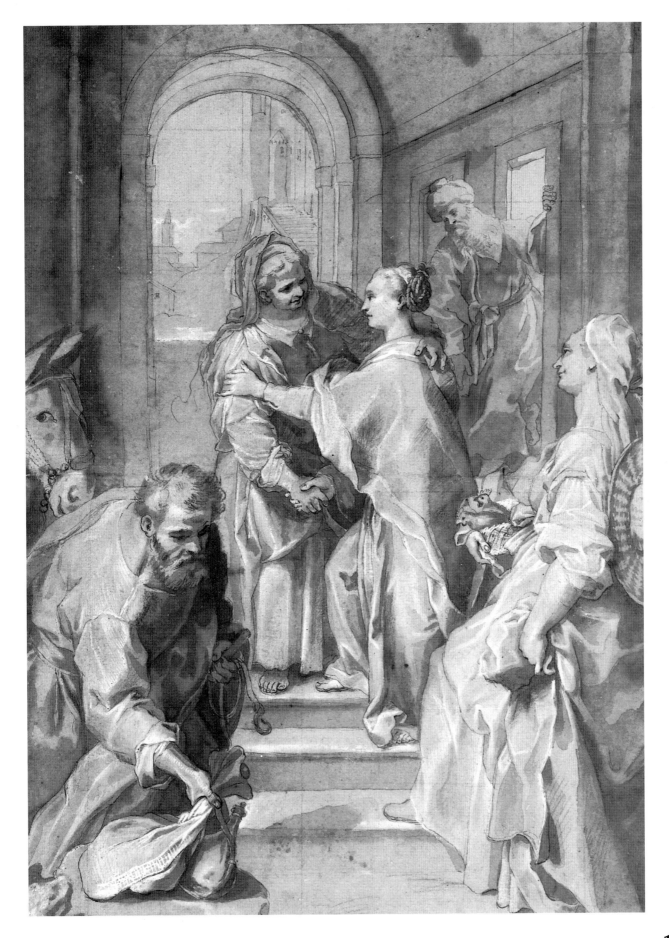

7.23 Henri Matisse, *Girl with Tulips (Jeanne Vaderin)*, 1910. Charcoal on buff paper, 28¾ × 23 in (73 × 58.8 cm). Collection, The Museum of Modern Art, New York. Acquired through the Lillie P. Bliss Bequest.

Drawings, because of their immediate and spontaneous nature, often allow us an unprecedented view into the creative process itself. Henri Matisse's charcoal drawing shown in Figure **7.23**, even allows us to feel as if we are participating in the act of visual discovery and invention. Pyramidal lines that help determine the placement of the head in relation to the shoulders are clearly revealed while a small triangular sketch in the upper left sets out the basic shape of the features. Every aspect of this drawing alludes to a process of visual investigation, preliminary statement, and revision. The subject's features are shown simultaneously from two angles and her arms in particular are represented by multiple points of view.

Project 45

The Revision Process

Materials: Paper, format, drawing media of your choice.

Do a series of drawings that make use of the technique of revision as an ongoing process. In this series revision can either refer to the method you use in individual drawings (such as the Matisse drawing in Figure **7.23**) or the way you redirect and revise your ideas from drawing to drawing. You might also want to develop and refine a composition (as Barocci did) that could be used as a study for a finished painting.

The principles of composition that we have been exploring in this chapter are not a fixed set of rules but organizational guidelines that enable artists to express a multitude of ideas and communicate a variety of visual and thematic concerns.

In the language of drawing, if line, value, and texture are the alphabet, composition is the syntax, or connecting system, that links everything together. Compositional decisions begin before you make a mark on the paper. What should the format of the drawing be? Should the paper be positioned horizontally or vertically? As you begin to develop your drawing, more compositional decisions must be made in terms of figure-ground relationships, balance, and symmetry.

This chapter will heighten your awareness of the role composition and space play in the art of drawing. But it is only an introduction to the intricacies of visual organization and expression. Your instructor will, no doubt, comment on the specifics of your drawings' compositions and be able to suggest ways in which you can improve them. Clear and effective handling of space and form come gradually over time and as you return over and over again to the task of drawing you will gain a surer vision of how you want to organize your drawing.

One of the best ways to continue to enhance your awareness of composition is to look at other drawings, for instance the work of fellow students, contemporary art in galleries, and historic examples in reproductions and museums. If museums and galleries can be found in your area by all means visit them whenever possible. Nothing can replace the experience of viewing original drawings rather than printed reproductions. We notice their actual size, subtle tonalities, and feel closer to the drawing experience. Although looking alone cannot make you a better draftsperson you will familiarize yourself with a host of visual possibilities and considerably enlarge your conceptual and technical repertoire.

8 PERSPECTIVE

This chapter will guide and assist you in learning how the principles of perspective can be applied to your drawings. Essentially, perspective is nothing more than a systematic method of determining the placement of forms in space. The theory of perspective is based on a few simple principles that help the artist to describe deep three-dimensional space on a flat surface. Certainly there are technically complex situations involving perspective that test the skill of professional artists. Yet many subjects involving simple perspective are relatively straightforward and manageable for the beginning and intermediate student. In fact, if you have drawn the cardboard boxes in previous assignments, you have already made use of perspective in your drawings.

Perspective refers to all of the visual techniques that create illusions of three-dimensional space on a two-dimensional surface. Historically, artists from many cultures and eras have been employing various forms of perspective since the beginning of recorded time. When perspective is mentioned today, however, what usually comes to mind is a specific technique of architectural drawing that originated during the Italian Renaissance (Fig. **8.1**).

Florence in the fifteenth century was an exciting center of learning and artistic activity and it was the home of two well-known architects credited with first formulating the rules of perspective, Brunelleschi and Alberti. In 1435 Alberti wrote a seminal treatise on painting, titled *Della Pittura*, which contained the first printed description of a mathematically proportioned system called perspective. Other early Italian artists who experimented with and refined perspective were Donatello,

(opposite) Charles Sheeler, *Delmonico Building*, 1926. Lithograph, 9³⁄₄ × 6¹¹⁄₁₆ in (24.8 × 17 cm). Collection, The Museum of Modern Art, New York. Gift of Abby Aldrich Rockefeller.

8.1 Etienne Duperac, *View of the Campidoglio*, 1569. Engraving. The Metropolitan Museum of Art, New York. Harris Brisbane Dick Fund.

CAPITOLII·SCIOGRAPHIA·EX·IPSO·EXEMPLARI·MICHAELIS·ANGELI·BONAROTI·A·STEPHANO·DVPERAC·PARISIENSI·ACCVRATE·DELINEATA ET·IN·LVCEM·AEDITA·ROMAE·ANNO·SALVTIS·∞ⅮⅬXIX

8.2 Lucas van Leyden, *Christ Presented to the People*, c. 1510. Engraving. The Metropolitan Museum of Art, New York. Harris Brisbane Dick Fund.

Masaccio, Uccello, Leonardo, and Piero della Francesca – a who's who list of Renaissance artists. The development of perspective was an important step in the evolution of Western attempts at pictorial realism and was to play a major role in art from the fifteenth century to the present day.

In order to comprehend perspective, it is necessary to understand the optical principles upon which it is built. The technique of linear perspective is essentially based on a few important features of our visual perception. As objects recede in the distance, they appear to become smaller. Forms close to the viewer tend to obscure and overlap more distant objects. A third quality of linear perspective (actually a consequence of the first point) is that parallel lines appear to converge at a point in the distance called a *vanishing point*. All of these characteristics of linear perspective can be seen in the Renaissance perspective drawing in Figure **8.2**.

Contemporary artists continue to use the elements of perspective in their work and have interpreted them to express modern themes. Claes Oldenburg's drawing, *Proposed Colossal Monument for Central Park, New York: Moving Pool Balls* (Fig. **8.3**), convincingly creates the illusion that immense replicas of billiard balls are placed in the large grassy fields of an urban park. Because of their size and placement, as they vertically approach the horizon they become smaller. Oldenburg creates the illusion that these gigantic billiard balls are situated on the grassy fields of New York's Central Park. By visually indicating city buildings along the horizon Oldenburg also indicates that these billiard balls are meant to be read as spheres many feet high rather than inches in diameter.

LINEAR PERSPECTIVE

During the fifteenth century, Italian Renaissance artists carefully worked out the optical principles and drawing system of linear perspective. Through the careful study of actual forms in space, they established the rules whereby artists could even determine how forms would appear from imaginary points of view, from far below or from viewpoints far above that of a ground-level spectator. The modern American artist Edward Hopper made dramatic use of this "bird's-eye" perspective in *Night Shadows* (Fig. **8.4**, p. 170) to create a compelling image of a lone figure dwarfed by the imposing buildings of Manhattan. This special perspective and dramatic lighting combine to create a mood of mystery and magic out of an ordinary urban occurrence, a lone figure walking the deserted streets in the early hours of the morning.

8.3 Claes Oldenburg, *Proposed Colossal Monument for Central Park, New York: Moving Pool Balls*, 1967. Pencil and watercolor, 22 × 30 in (56 × 76 cm). Courtesy, Store Days Inc.

8.4 Edward Hopper, *Night Shadows*, 1921. Etching, 6^{15}/$_{16}$ × 8^3/$_{16}$ in (17.6 × 20.8 cm). Collection, The Museum of Modern Art, New York. Gift of Abby Aldrich Rockefeller.

To achieve this view Hopper might have made a preliminary drawing from an apartment perched several stories above the street – drawings made from direct observation use what is called *empirical perspective* – or he could have made use of the concepts of linear perspective to imagine how it would appear to the viewer from on high. For the most part your initial efforts will be confined to projects designed to make you more able to accurately draw what you see. Later, when you have gained some facility with the techniques of perspective drawing, you may wish to work with imagined viewpoints.

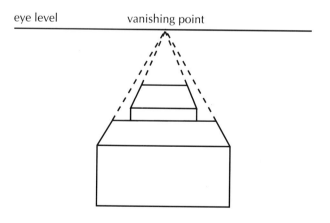

8.5 One-point perspective.

ONE-POINT PERSPECTIVE

Although perspective broadly refers to several modes of representing space in a drawing, *one-point perspective* is the simplest and most commonly used system. When the objects we are drawing, boxes for example, are directly in front of us with some sides of the forms parallel to the bottom of our drawing paper the receding parallel sides of the boxes appear to converge at a single point on the horizon, the vanishing point (Fig. **8.5**). Artists use this form of perspective, for instance, to record how a street recedes into the distance when viewed from the sidewalk at eye level. Edouard Vuillard's print, *The Avenue,* (Fig. **8.6**) makes powerful visual use of one-point perspective as the artist depicts the parallel lines of the street and sidewalk converging toward a vanishing point in the distance. Vuillard's print was drawn from an eye-level position of approximately 5 feet from the surface of the sidewalk. Had the artist been perched on top of a 15-foot ladder or made this drawing lying prone on the pavement, the position of the horizon and vanishing point would be significantly different. Linear perspective depends on maintaining a fixed and precise point of view. When we change our position in space relative to a fixed object, the visual configurations and spatial relationships also change.

As an exercise in seeing, take a piece of tracing paper and place it over Vuillard's *The Avenue*. Using a ruler, draw pencil lines that follow the converging parallel lines of the street and sidewalk (Fig. **8.7**). The lines of your tracing should converge just above the small figures in the distance along the top of the dark shape indicating the horizon line.

The position of the horizon line corresponds to the eye level of the observer. If, for instance, we were standing on a flat desert plain, the sky and earth would appear to meet at a certain point in the distance – the horizon line. If a helicopter lifted us high above the ground, we would see the horizon line shift with more land becoming visible. Conversely, if we viewed the scene from a prone position the horizon line would appear lower and more sky would appear visible. As we move in space relative to fixed objects, we change our perspective. The next project will explore one-point perspective and enable you to experience how your viewing position determines the exact perspective of what you see.

8.6 (below left) Edouard Vuillard,
***The Avenue* from the portfolio**
***Landscapes and Interiors*, 1899.**
Lithograph, 12³⁄₈ × 16⁵⁄₁₆ in
(32.2 × 41.5 cm). Collection, The
Museum of Modern Art, New
York. Gift of Abby Aldrich
Rockefeller.

8.7 (below right) Perspective
diagram of *The Avenue.*

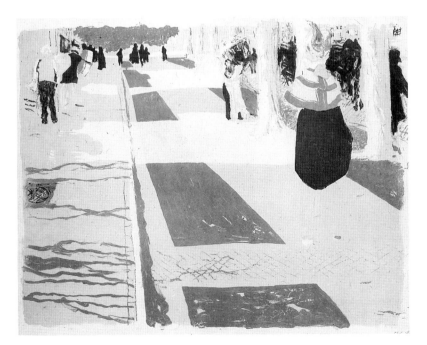

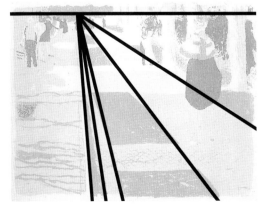

Project 46

Using One-Point Perspective

Materials: Tracing paper, bond paper, medium graphite pencil (or vine charcoal), masking tape, yardstick.

Before you begin this project, create a special still-life by cutting three or four rectangular shapes out of cardboard and intermingling these shapes with standing books set on a tabletop (Fig. **8.8**). Position yourself so that your eye-level is above the height of the table. Contrary to what you have been doing in the past, the drawing of the books and cardboard rectangles should not extend to the edges of the paper but should be smaller in scale and located near the bottom of the page. You will need empty space surrounding the drawing to determine where the horizon line and vanishing point are located. Make some preliminary lines and marks on the drawing that accurately determine the length and angles of the rectangular objects in front of you. Take your time and carefully plot the positions of the rectangles in relation to the tabletop. When you have sufficiently developed the drawing, place a piece of tracing paper the size of the drawing over it and hinge it at the top with two pieces of masking tape. Using the yardstick, plot the converging lines to their vanishing point. If they do not meet at the horizon line, which corresponds to your eye-level, use the tracing paper overlay as an aid in determining the correct angles and perspective. Do not arbitrarily change the angles to make them line up. Go back to your original drawing position and compare all of the angles and lines you have drawn with what you see in front of you. In the process make any necessary corrections.

Do two more drawings in this manner, each time significantly changing your eye level relative to the height of the table (you may want to place this still-life on the floor in order to give yourself an aerial view). Locate the vanishing point of each drawing perspective by using hinged tracing paper and plotting the converging angles at the vanishing point.

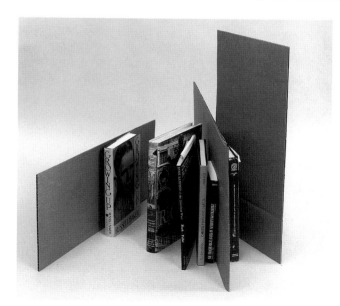

8.8 Still-life set up with cardboard rectangles and books.

8.9 Two-point perspective.

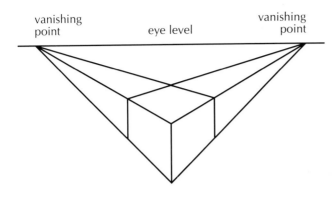

vanishing point eye level vanishing point

TWO-POINT PERSPECTIVE

Two-point perspective is used by artists when no single surface of the subject is parallel to the horizontal plane of the drawing paper. For instance, if we were to position a cardboard box so that one of its corners was directly facing us the parallel sides of the box would converge toward two vanishing points on the horizon (Fig. **8.9**).

Thomas Hart Benton's drawing of an old-time cookstove (Fig. **8.10**) makes effective use of this kind of perspective. Done in preparation for a large mural painting documenting Midwestern farm life, the vertical lines of the drawing remain parallel to the picture plane, while both sides of the stove (like the sides of the box in Figure **8.9**) lead to two vanishing points on the horizon. Benton drew from an eye level above the cooking surface of the stove. This angle accentuates the effect of the stove receding in space and makes for a more dynamic composition.

Project 47

Using Two-Point Perspective

Materials: Tracing paper, bond drawing paper, medium graphite pencil (or vine charcoal), masking tape, yardstick.

Find a table that you can move to suit your needs – a kitchen table would work quite well. Position the table so that one of its corners is directly facing you. No side of the table should be parallel to the sides of your drawing paper. In order to make the composition more interesting, place some square objects on the table. Rectangular cake pans and bread baking tins would be appropriate and would fit the theme of the drawing. Position yourself so that your eye level is above the top of the table, planning to place the drawing in the bottom portion of the paper. Get fairly close to the table to exaggerate the difference between the parallel receding planes. When your drawing is complete, place the tracing paper over the paper, hinge it and make an exploratory diagram following the two converging vanishing points. Depending on your drawing position (and the resulting horizon line), the vanishing points may converge beyond the paper. Mastering two-point perspective takes practice and some patience but your ability to draw geometric forms in perspective should increase the more you work at it.

8.10 Thomas Hart Benton, *Cookstove*, Study for the "Kansas City" mural, 1936. From *Farming Segment*. Lyman Field and United Missouri Bank, N.A., co-Trustees of Thomas Hart Benton and Rita P. Benton Testamentary Trusts.

173

THREE-POINT PERSPECTIVE

Three-point perspective is the rarest of all of the linear perspective systems. But you should at least be familiar with how to use it and its expressive potential. Three-point perspective is required, for instance, when we draw a tall building from a position close to its base. In addition to the two horizontal vanishing points (which we explored in the previous project) the top of the building appears to be converging at a third vanishing point.

Charles Sheeler's drawing of the *Delmonico Building* (Fig. **8.11**) communicates the dynamic forces at play in a modern city through the use of three-point perspective and the strong angular interplay of black and white shapes. As the building rises, the sides nearest the viewer appear to narrow. If you wish to explore this specialized perspective, take your sketchbook to a downtown urban area and do a series of drawings from this environment.

8.11 Charles Sheeler, *Delmonico Building*, 1926. Lithograph, 9¾ × 6¹¹/₁₆ in (24.8 × 17 cm). Collection, The Museum of Modern Art, New York. Gift of Abby Aldrich Rockefeller.

Iulius, Augustus, nec non et Iunius Aestas. AESTAS Adolescentiæ imago Frugiferas aruis fert Aestas torrida meßeis.

MULTIPLE PERSPECTIVES

For centuries artists have creatively manipulated and distorted perspectives to achieve expressive goals. In his print *Summer* (Fig. **8.12**), the sixteenth-century artist Pieter Brueghel meaningfully distorts the perspective in order to reveal more than can be seen from a single vantage point. Brueghel is known for his extraordinarily detailed compositions documenting the organization of life and work around the natural progression of the four seasons. In order to show more of the land in the background while maximizing detail in the foreground, Brueghel tilts the background up and toward us almost as if it were painted scenery in a theatrical production.

The important thing to remember about perspective is that it should always serve the expressive needs of the artist. As you gain visual control over your subject, you will be able to exercise more creative and expressive options.

Stacked perspective is another technique artists sometimes use. This is a visual drawing system that juxtaposes several views of a subject one on top of the other. Giambattista Piranesi, an Italian draftsman and etcher who worked in the eighteenth century, was obsessed by the city of Rome during a period when it lay in great

8.12 Pieter Brueghel, *Summer*, 16th century. Engraving, 8¹⁵⁄₁₆ × 11⁵⁄₁₆ in (22.7 × 28.7 cm). The Metropolitan Museum of Art, New York. Harris Brisbane Dick Fund.

175

8.13 Giambattista Piranesi,
Diagram of Temple Construction,
Plate 24 from *Della*
***Magnificienza,* 1761. Etching. The**
Metropolitan Museum of Art,
New York.

poverty and ruin. Over his lifespan Piranesi created close to 1,500 large, highly detailed etchings of deteriorating buildings and architectural details. In order to catalog all this visual material Piranesi made creative use of stacked perspective. In Piranesi's etching *Diagram of Temple Construction* (Fig. **8.13**), multiple perspectives are presented to us within a single format. Dramatic shifts in space are achieved when he combines a drawing of an entire temple in the central panel with enlarged construction details in the top and bottom panels.

8.14 Edvard Munch, *The Scream*, 1895. Lithograph, 13¾ × 9⅞ in (34.9 × 25.1 cm). National Gallery of Art, Oslo. Rosenwald Collection.

The creative manipulation of space and perspective has always been the concern of artists, particularly in the Modern Era. Edvard Munch, a European artist who was an important forerunner of the Expressionists of the 1920s, purposefully manipulated graphic elements and distorted perspective in his famous artwork *The Scream* (Fig. **8.14**). Many visual and thematic elements in this print are particularly disturbing and mysterious. Although the sharply angled railing defines a receding space, other visual elements contradict this seeming representation of normal perspective and contribute to the feeling of disorientation and anxiety. It is impossible either spatially or psychologically to determine where we stand when we look at this image.

177

8.15 Franz Marc, *Riding School,* **1913. Woodcut, 10⅝ × 11¾ in (27 × 29.8 cm). Collection, The Museum of Modern Art, New York. Gift of Abby Aldrich Rockefeller.**

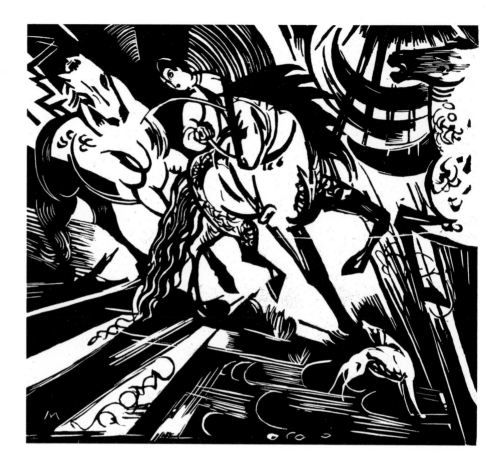

Artist Franz Marc also used spatial distortions and ambiguity through the manipulation of perspective. His woodcut, *Riding School* (Fig. **8.15**), bombards our senses with the feeling that we are viewing a scene set in motion. Marc uses an interlocking network of negative and positive shapes that seem to be drawn in a variety of perspectives. It is impossible to determine with any certainty the spatial position of many of the elements. This composition has an abstract life of its own that expands our perception and goes beyond the representation of realistic forms and space.

Project 48

Exploring Multiple Perspectives

Materials: Bond paper, drawing medium of your choice.

To create a composition with a variety of simultaneous viewpoints and perspectives, choose any household appliance with several parts. Imagine that this object has exploded and that its pieces are flying in all directions. Some sections of these tools might be drawn large and in full detail, while others might be made smaller and in the distance.

Another approach to this project would be to divide the drawing plane into rectangular sections and create a series of small drawings within a drawing. Each division could represent a unique angle and perspective of the subject. Remember to vary the scale and viewpoint to avoid monotonous compositions.

ATMOSPHERIC PERSPECTIVE

Atmospheric, or *aerial* perspective is another drawing system artists use to achieve a sense of depth. This type of perspective creates spatial illusions by controlling the sharpness and relative contrast of receding forms in a drawing. Foreground shapes are rendered more distinct and in sharper focus than those representing forms in the far distance. Natural atmospheric conditions (usually moisture in the air) cause distant objects to appear hazy and lighter in tone than those in the foreground. Albrecht Dürer used this type of drawing perspective to convincingly make the castle appear to be in the background in Figure **8.16**. By contrast the rocky outcrops in the foreground are sharp and distinct indicating a great spatial separation.

Project 49

Using Atmospheric Perspective

Materials: Bond paper, drawing medium of your choice.

Locate an outdoor vantage point that offers subject matter both in the foreground and distant background. Depending on how far away they are, and atmospheric conditions, distant forms should appear lighter and less distinct than objects that are near to us. Exaggerate the value differences between the foreground and background in order to create the illusion of depth. Also remember to use more detail in the foreground and to draw with sharper focus.

8.16 Albrecht Dürer, *Rocky Landscape with Castle*, **1494–5. Pen and ink. Albertina, Vienna.**

SCALE AND PERSPECTIVE

The ultimate purpose of learning to control space and represent three-dimensional forms through various perspective systems is to allow us to freely explore our visual ideas and communicate our interests. *Scale*, the size relationships that exist between various objects, is an important element in perspective. Without scale variations there would be no perspective. Remember that the optical basis of perspective depends on the phenomenon of objects appearing to get smaller as they recede in space.

Sometimes artists purposefully manipulate scale and perspective in order to express thematic concerns and imaginary visions. Odilon Redon's charcoal drawing *Winged Head above the Water* (Fig. **8.17**) juxtaposes an image of an enormous detached head that floats over an ordinary seascape with a sailboat. Each component of the drawing, the head and the ocean, is relatively unremarkable seen separately. By placing them together in this manner, however, they interact to produce strange effects. Scale manipulation creates a magical scene out of otherwise ordinary subjects.

8.17 Odilon Redon, *Winged Head above the Water*, c. 1880. Charcoal, 18¾ × 14⅝ in (47.6 × 37.1 cm). The Art Institute of Chicago. David Adler Collection.

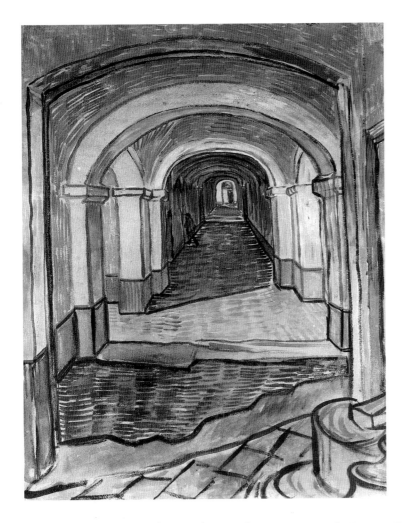

8.18 Vincent van Gogh, *Hospital Corridor at Saint Remy*, 1889. Gouache and watercolor on paper, 24⅛ × 18⅝ in (61.3 × 47.3 cm). Collection, The Museum of Modern Art, New York. Abby Aldrich Rockefeller Bequest.

Scale and perspective were also used toward expressive ends in van Gogh's watercolor and gouache drawing, *Hospital Corridor at Saint Remy* (Fig **8.18**). Placing the far end of the corridor almost directly in the center of the composition creates powerful visual and psychological effects. The tiny portal in the distance draws us in to the composition and makes us feel that this darkened corridor is closing in on us. Scale and perspective are used with great skill by van Gogh in order to express the artist's feeling of anxiety and entrapment.

Project 50

Manipulating Scale and Perspective

Materials: Bond paper, drawing medium of your choice.

Make a drawing of your room or other indoor architectural setting in which you explore the expressive possibilities of perspective. Perhaps the small size of your room or the way it is set up suggests thematic possibilities. Certain classrooms may also inspire you to manipulate scale and perspective in your drawings. The concept behind this assignment is to experiment with the elements of scale and perspective in personally expressive ways. Take some chances and see how far you can develop your ideas

IMAGINATIVE PERSPECTIVES

While Renaissance artists used perspective to focus on the rational representation of forms in space, artists have also purposefully used aspects of perspective to create ambiguous and disquieting visions that defy rational interpretation.

Along with his voluminous documentary drawings of Rome's faded glories, Giambattista Piranesi made a series of etchings called *Imaginary Prisons*. Using all the techniques of classical perspective, Piranesi created potent visual metaphors for humanity's darker side (Fig. **8.19**). Space and scale are out of kilter. Human figures are dwarfed and oppressed by an elaborate machinery that seems bent on the domination of man. Circular stairs that spiral skyward, bridges that end in mid-air, and ramps that arbitrarily criss-cross the cluttered prison cavern suggest a world controlled by madness and conceit. This symbolic conceptualization of a prison, with its dark, ambiguous spaces and confusing architectural plan, prophesies a fearful vision of mechanized hell in the modern world.

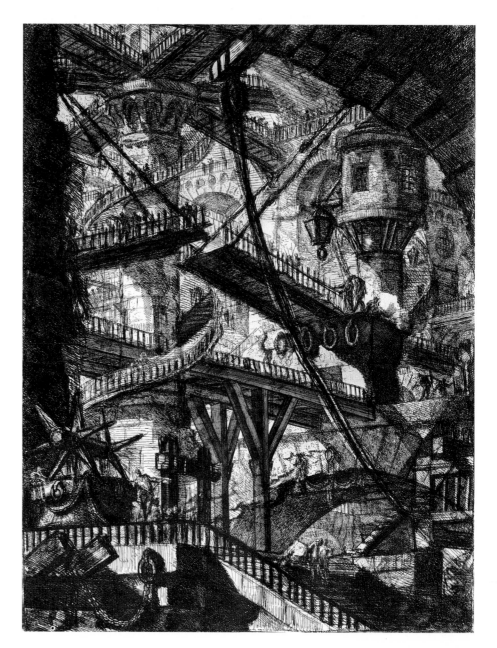

8.19 Giambattista Piranesi, *The Prisons*, c. 1760–1. Etching, 21½ × 16 in (55 × 41 cm). The Metropolitan Museum of Art, New York. Rogers Fund.

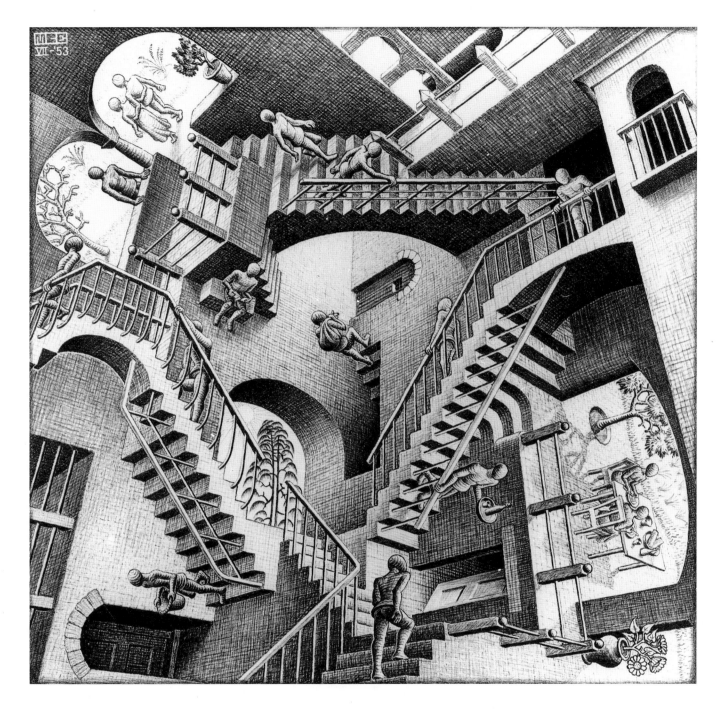

M. C. Escher's drawings also make use of purposeful distortions of perspective. Escher was a graphic artist of the Modern Era known for his enigmatic visual puzzles. The world according to Escher behaved in startling and unpredictable ways. Rivers might flow uphill and interior spaces suddenly be transformed into exterior forms. Escher realized clearly that perspective was essentially a means of achieving visual illusions and these illusions could be contradicted several times over within the composition of a single drawing (Fig. **8.20**). The more we look at Escher's print *Relativity* the less we trust the illusions of his perspective.

Amedeo Modigliani, an Italian artist working in Paris at the beginning of the twentieth century, also purposefully distorted perspective in order to achieve personally expressive results. Inspired in part by the elongated forms he saw in African sculpture, Modigliani created a consistent visual world in which all the

8.20 M.C. Escher, *Relativity*, 1953. Lithograph, 10¾ × 11½ in (27.3 × 29.2 cm). Collection, Haags Gemeentemuseum, The Hague. Print on loan from The Escher Foundation.

183

8.21 Amedeo Modigliani, *Portrait of Mme Zborowski*, 1918. Black crayon and pencil, 19³⁄₈ × 12¹⁄₂ in (48.9 × 31.7 cm). Museum of Art, Rhode Island School of Design, Providence.

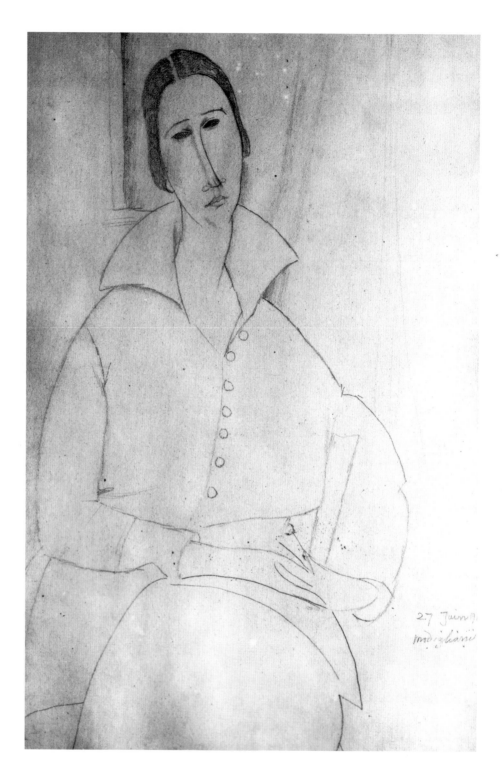

features of his model, Mme Zborowski, the wife of his dealer, were distorted and exaggerated (Fig. **8.21**). The entire drawing is constructed of graceful arcs and curved forms which fit together in a sinuous way and form their own visual logic. Modigliani's distinctive vision affects the way in which we perceive his subject and Mme Zborowski is presented as a sensitive, melancholy person of grace and charm.

In order to achieve certain visual and psychological tensions artists often use special perspectives or vantage points in their work. Lucian Freud's drawing (Fig. **8.22**) presents us with an unusual perspective in which the rabbit on the wicker

8.22 Lucian Freud, *Rabbit on a Chair*, 1944. Conté pencil and crayon, 17¾ × 11¾ in (45 × 30 cm). Courtesy, James Kirkman Ltd, London.

seat is seemingly suspended in mid-air. Through the use of this visual effect the artist creates a touching image of this furry creature floating against a richly textured background of vertical and horizontal lines.

Project 51

Using Creative Perspective

Materials: Bond paper, drawing medium of your choice.

Use the concepts and skills you have learned in this chapter to develop a series of drawings that approach the use of space and perspective in personally meaningful ways. Like Freud, you may wish to work from a distinctive angle. Or you may wish to experiment with ambiguous, convoluted spatial arrangements, seemingly impossible perspectives, or purposeful distortions. Once you have learned the laws of perspective, they will become another visual element in your repertoire to be used, reshaped or transformed. The student drawings of Rita Christen (Fig. **8.23**) and Pam Mandel (Fig. **8.24**) both control and manipulate perspective to create expressive visual effects.

8.23 Student Drawing. Rita M. Christen, San José State University. Charcoal, 40 × 26 in (101 × 66 cm).

8.24 Student Drawing. Pam Mandel, San José State University. Charcoal, 26 × 40 in (66 × 101 cm).

8.25 Common errors.

CIRCULAR FORMS

Although we usually associate perspective with the drawing of rectangular forms in space, circular objects obey the same laws of perspective and offer similar challenges and learning opportunities for the drawing student.

You may have already experienced the difficulty of drawing bowls, glasses, vases, and other circular objects in previous assignments. Many people find it hard to get the round openings of these objects to look correct. They are usually either too sharply pointed, bluntly rounded, or drawn in an inconsistent way (Fig. **8.25**).

Before we begin to learn to draw circular objects in space there are some important characteristics of these forms that we should be aware of. Unless we look directly down the opening of a circular vessel such as a drinking glass the circular form we perceive assumes the shape of a partially flattened circle or *ellipse*. Take an empty drinking glass and hold it away from you in your outstretched hand. Begin

187

8.26 Ellipses gradually changing.

by looking directly into the opening of the glass. This is the only position in which the opening will appear truly round. Slowly bring the glass to a vertical position. Each step reveals a gradually flattening ellipse until only a straight line is evident when the lip is horizontal (Fig. **8.26**).

Project 52

Learning to Draw Circular Forms in Perspective

Materials: Bond paper, black felt-tip marker, soft graphite pencil, thin cardboard, scissors, masking tape.

Since ellipses are the result of circular forms seen in perspective, we will make a series of circular drawing diagrams to aid our learning. Assemble a group of round objects of varying sizes. Ceramic vases, bowls, plates, cups, and clay flower pots make suitable subjects for this assignment. Choose three or four round vessels that offer scale and shape variation. Place them upside down on the cardboard and with a felt-tip marker trace their circular tops. In order to better understand the structure of ellipses we will create circular diagrams to aid our perception. Using a ruler draw a square that tightly encompasses the circle. Then draw bisecting vertical and horizontal lines that divide the square and circle into four equal parts (Fig. **8.27**). Cut the squares out with scissors and place these cardboard diagrams on top of their respective vessels lining up the traced shape with the openings; secure them with pieces of masking tape. Then arrange the objects in a composition that you find pleasing.

The diagrammed circles, with their horizontal and vertical dimensions revealed, should prove easier to draw. Concentrate on how the shape of the circle is affected by the angle of our vision, how, the more oblique our angle, the narrower the ellipse. Take your time with this exercise and focus on drawing the openings of the vessels in correct perspective. Be aware of the common errors illustrated in Figure **8.25** and avoid pointed ends and sausage-like shapes.

8.27 Circular pattern.

Minor axis

Major axis

Project 53

Further Practice Drawing Ellipses

Materials: Bond paper, graphite pencil or vine charcoal.

Now that you have a better understanding of the spatial structure of circles and ellipses, you will take the diagrams off the circular objects and draw them unaided. This time arrange some of the round forms so that they lie on their side angled in different directions. If you still experience difficulty in getting the ellipses to look correct, make this simple diagram on your drawing to check its proportions. Map the ellipse in terms of two basic measurements, the major axis and the minor axis (Fig.**8.28**). The major axis is the longest dimension of the ellipse and the minor axis refers to the shorter width. Remember that the axes always bisect each other at right angles. With the aid of this information, careful observation, and some practice you should soon be able to master the challenge of drawing circular forms in perspective. The student drawing in Figure **8.29** uses the circular and elliptical forms of tires to create an intriguing composition.

8.29 Student Drawing. Anon., San José State University. Charcoal, 26 × 40 in (66 × 101 cm).

At this point the thought of working in perspective should prove far less daunting than it seemed at the beginning of the chapter. You now have a much broader knowledge of perspective and realize that it is not just a system based on complex mathematical calculations but a broad and remarkably expressive means of describing forms and ordering space.

Western perspective systems are dependent on one of the most basic aspects of our visual system, that is, as objects move away from us they appear smaller. This phenomenon forms the bedrock of linear perspective, the most challenging form of spatial documentation. Recording what we see rather than what we know is a demanding skill but one that can be mastered with practice. Through your continued efforts your drawings will gradually become more sure of themselves in terms of manipulating space and putting perspective to creative use.

(opposite) Miguel Barceló, *Le Marché du Charbon*, 1988. Gouache on paper, 19¾ × 27½ in (50.1 × 70 cm). Courtesy, Leo Castelli Gallery, New York.

—PART III—
CREATIVE EXPRESSIONS

9 VISUAL THINKING

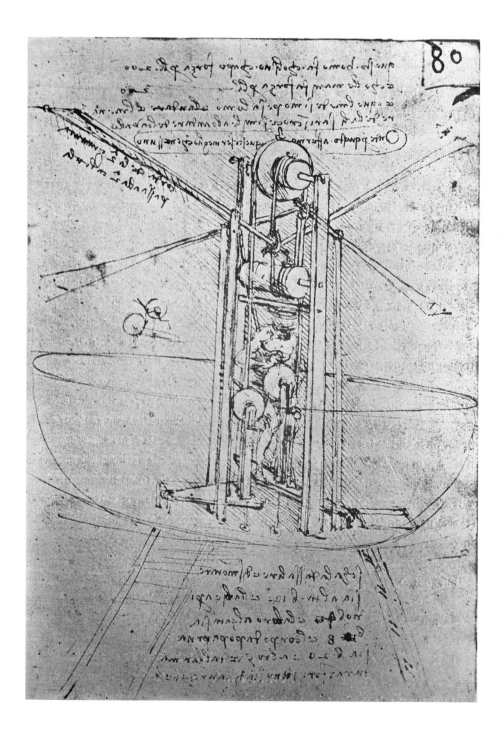

Now that you have gained some experience with fundamental drawing techniques and concepts it is time to develop these skills further and to consciously apply them toward personally expressive goals.

The drawing work you have done up until now has taught you to think in a new way, a visual way. Because of this experience you can now see, or visualize, your ideas in graphic terms. This ability to think visually is one of the key elements to creative drawing. In this chapter we will explore visual thinking and how an understanding of the creative process can enhance your work.

PERCEPTION

In order to come up with creative ideas you must develop the ability to see ordinary things in new and different ways. The process of drawing has long been used to enhance perception and to express innovative ideas.

Hundreds of years before people even dreamed of human flight, Leonardo da Vinci conceived a flying machine that functioned much like our modern helicopter (Fig. **9.1**). In order to base his invention on sound mechanical principles, he had to visualize air as an ultra-thin liquid, much like water. Since air cannot be seen, Leonardo depicted it graphically in this drawing through the use of closely spaced diagonal lines surrounding his flying machine. Once air was visualized, or relabeled as a tangible material, it was possible for Leonardo to conceive a screw mechanism that would pull the machine upward, just as a propeller moves a ship through water.

In order to begin to see more perceptively we must relabel things that we no longer notice because of everyday associations. The next project will help you to further develop your perceptual skills.

Project 54

Sharpening Your Visual Perception

Materials: Note pad, writing pencil or pen, bond sketchpad, drawing media of your choice.

Get a pad of paper and a pen and go to your living room. In your pad group the objects in the room, according to their shape (round, rectangular, curvilinear, etc.), size, color, texture, and other visual qualities. Be aware of what you see rather than what you know. For instance, the clock on the wall might be labeled round if you are directly in front of it but if you view it at an angle it might be elliptical – your vantage point determines its shape. Notice how the familiar room has taken on new attributes as colors, shapes, and spatial relationships emerge from the limbo of stereotypic vision.

Make some drawings based on one shape category. For instance, you might use as the basis for your drawings all the elliptical forms in the room.

Try dramatically shifting your perceptual viewpoint. The soft carpet on your floor viewed close-up with a magnifying glass might be transformed into a jungle of sharp and brittle textures. Make a drawing of how the carpet might appear if you were an insect walking through it.

Keep this exercise in mind when you draw in the future. Your ability to relabel and reinterpret everyday objects in imaginative ways will contribute greatly to your creative vision.

9.1 (opposite) Leonardo da Vinci, *Flying Machine*, 15th century. Scala, Florence.

THE CREATIVE PROCESS

Dr. Alex Osborn, the father of brainstorming and a pioneer in creativity enhancement training, divides the creative process into four distinct phases: preparation, analysis, incubation, and evaluation. You have already made use of some of these phases of creative thinking in your drawing efforts but you may not have been fully conscious of how the process works. Here is a brief outline of each stage and how it relates to the practice of drawing.

The preparation or planning stage involves acquiring all the relevant skills, information, and knowledge that can be brought to bear on the process of drawing. This is one of the most demanding and important stages of creative work. You cannot skip lightly over this phase of the creative process and expect significant results. Subsequent efforts are greatly dependent upon this base of drawing experience and knowledge. Many professional artists with a lifetime of experience and skill still consider themselves students of this artform and continue to actively learn. Rather than being a stage we enter and pass through, this preparatory process is continuous.

The analytic phase of the creative process refers to both the conscious and unconscious thinking we do with regard to drawing. Most of the time while you are drawing you are involved in a consuming process of response and thought. Much of your thinking occurs on an unconscious level and you adjust, correct, and direct your drawing efforts with seemingly little conscious thought. It is like riding a bicycle. When you first begin, you must consciously think about starting, stopping, steering, and balancing. After you learn to ride you still do all of these things but you do them unconsciously.

Analysis also takes place on a conscious level. For instance, after you have initially blocked out your drawing you might consciously think about whether more lines need to be added or whether there are sections needing more work. The more experience you acquire in drawing, the more competent you will become in analyzing and modifying your drawings.

After working exhaustively on a drawing series or major art project you may reach an impasse and not know where to go from there. This is where the incubation period comes in. After you take a few days off to relax or work on some other project you may know exactly what to do when you return. This break is necessary in order for the mind to unconsciously sort out, process, and pull together the information it was dealing with. Drawing, like the creative process itself, rewards persistent efforts over time.

The evaluation, or critical response phase, is best undertaken after a group of drawings is completed. To stop in the middle of a drawing for long contemplative thought might interrupt your work rhythms and interfere with the work at hand. Another reason to avoid critical evaluation during the activity stage is that you might become too judgmental, get discouraged and find it difficult to continue.

Evaluation enables you to determine how well you have accomplished what you set out to do. Look at your drawings as a group. Pin them up on a studio wall or lay them out on the floor. You want to be able to view them in relation to each other and evaluate them in terms of thematic development, use of materials, composition, and other important factors. Look for patterns. Perhaps you do not effectively exploit the tonal range of your drawing instrument or perhaps you consistently make the image too small for your format. Note and correct these problems.

When architect Michael Graves first explored design concepts for a major building competition in Portland, Oregon, one of his earliest drawings contained a wide variety of complex architectural forms (Fig.**9.2**). Graves made many drawings after this one to explore various possibilities. After evaluating the drawing in Figure **9.2**

9.2 (above left) Michael Graves, Early drawing for the Portland Building. Courtesy, Michael Graves, architect.

9.3 (above right) Michael Graves, Drawing for the Portland Building. Courtesy, Michael Graves, architect.

and other potential designs he arrived at a related but less elaborate version which was selected by the jury as the winner (Fig.**9.3**). The evaluation stage gives us the opportunity to see our work from a broad perspective and focus on aspects we wish to emphasize.

Evaluation is the last stage of the creative process but since this is a cyclic and continuing process you are led back to the other phases of preparation, analysis, and incubation.

OVERCOMING CREATIVE BLOCKS

Everyone at some time or another has faced the frustration of staring at a blank sheet of paper and not knowing what to do. This section discusses some common obstacles that prevent us from realizing our creative potential and offers help in overcoming them.

Basically, there are three different types of blocks that inhibit creative thinking. One of the most common is the emotional block, when fear and insecurity sabotage your efforts to succeed. A second type is the perceptual block, where we fail to understand the problem or do not define it effectively. Finally, we experience cultural blocks, which for the most part have to do with an excessive need for conformity and the limits social constraints place on our thinking.

Emotional insecurity is probably the most crippling and all-encompassing obstacle to productive activity. Too often, fears that the end product does not meet our expectations discourages us to the point of paralysis and defeat. You must learn to think in terms of process rather than product. By this it is meant that you must concentrate on the immediate drawing tasks and suspend critical judgement of your results. Paradoxically, the more you forget about making "good" drawings and concentrate on specific tasks the better your work will become.

The second major obstacle to the creative process is the perceptual barrier, that is, not seeing the nature of the problem correctly. Supposed facts that we assume to be true may turn out to be false assumptions that prevent us from finding creative solutions. Often when we approach a problem, rigid thinking limits our perception and prevents us from seeing its solution. The following visual puzzle illustrates the perceptual limits we place on thinking:

Without lifting your pencil off the paper draw no more than four straight lines that cross through all nine dots below.

The solution can be found on page 275 in Appendix II, but try solving this puzzle before you look it up.

A surprising number of people are unable to solve this puzzle, in large part because of their preconceptions. The instructions say nothing against going beyond the parameter of the dots, yet to succeed with this puzzle you must draw some lines well beyond the outer edges of the dots.

When you feel you have reached a perceptual barrier, it helps to brainstorm or to try out many possibilities, even those that may appear ludicrous at first. Even a seemingly foolish attempt can lead to a valuable solution. Try doing the project below as a means of learning new response patterns to creative thinking.

Project 55

Brainstorming Solutions

Materials: A portable sketchbook, graphite pencils, fiber-tipped pens, or pen and ink.

Carry a small sketchpad with you for a few days and use it to draw and think up all the possible uses you can for an ordinary telephone directory. These visual and verbal ideas do not need to be serious and practical for outlandish and humorous concepts are valid additions to the list.

We are interested in promoting two aspects of thought in this exercise, the sheer number and the greatest diversity of ideas. Carry the notebook with you during the day and keep it near you during the evening. The more sketches and notes the better. In order to help you generate ideas, think about the physical qualities of this ubiquitous book as well as its purposes, including its size, shape, number of pages, color and so on. Then, after you have reached a good number of entries, select several of your favorite uses and do a series of drawings that visually express these ideas. Remember this brainstorming process when you think you have run out of ideas.

Finally, we have a set of cultural limitations that determine how we think and behave. The pervasive environments of home life, school, and society in general greatly affect the way we think. In order to do creative work in drawing you must be open to new possibilities and develop flexible attitudes. Studying the drawings of other cultures and learning about their societies and beliefs is an excellent means of expanding your own creative vision. You may discover something personally relevant in work that at first seems far removed from your own.

Here are some practical things you can do when you think you have reached a creative impasse.

- Review past and present work. Note what you like about your drawings and what you do not. Thoroughly define what it is you dislike. Make a series of drawings that either correct or transform these negative attributes into positive elements.

- Determine if the problem is physical. Perhaps lack of sleep and a heavy work load are taking their toll. Get some rest and return to your drawing when you are rested.

- Show your work to a friend and describe the objectives of the drawings. In the process of telling someone else what is important you will also clarify your aims to yourself.

- Consciously shift your visual and psychological viewpoint. Try drawing something with materials and techniques you have never used before. Use a compositional structure that has never interested you, such as symmetry. If you have been concentrating on time-consuming finished drawings, make a series of quick sketches.

- Good work habits cut through temporary blocks. Instead of waiting for inspiration to emerge out of the blue set up a reasonable work schedule and abide by it.

- Take a past drawing that you feel is unsuccessful and selectively tear it into sections that you can collage onto a new sheet of paper. Add additional lines and tones and make new drawings out of the old.

- Go to gallery exhibitions of contemporary art and visit museums to look at their drawing collections. Spend an afternoon at the library going through art and drawing books. Seeing stimulating work gets your own creative energy flowing.

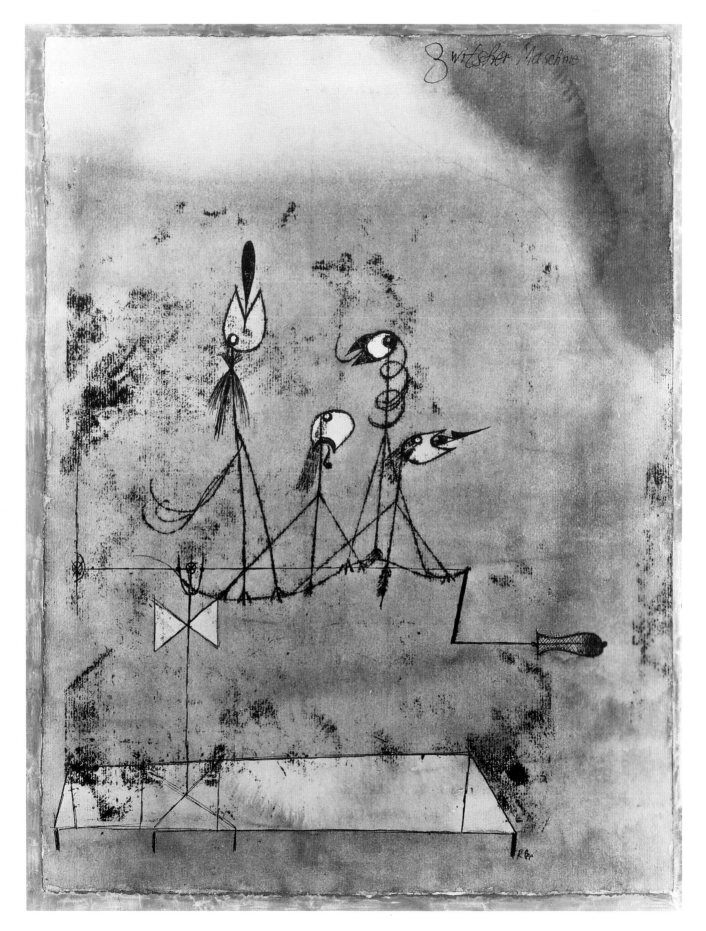

Project 56

Visualizing and Destroying Blocks

Materials: Your drawing sketchpad, sheets of heavy bond or rag paper, drawing medium of your choice.

Visualize what it is that you think prevents you from achieving the kind of creative work you would like to do. It might be lack of time, inhibitions, or the fear of failure. Identify what you think your personal blocks are and interpret them in visual form in your sketchpad. Then using these visual concepts make a drawing on the bond or rag paper of an imaginary machine that will destroy, evaporate, or filter out these blocks. This device is obviously an imaginary mechanism so you are not constrained by practical concerns. Paul Klee's whimsical *Twittering Machine* (Fig.9.4) is an inspired conception of such a fantasy device.

The remaining chapters will focus on the creative applications of drawing, so keep these thoughts and exercises in mind as you further explore the expressive possibilities of drawing.

9.4 (opposite) Paul Klee, *Twittering Machine*, 1922. Watercolor and pen and ink on oil transfer drawing on paper, 25¼ × 19 in (63.8 × 48.1 cm). Collection, The Museum of Modern Art, New York.

10 EXPLORING COLOR

Color has always been one of the most powerful elements of the visual arts. Usually, one of the first things we notice about a work of art is the overall effect of its color. Because of technological advances in communication media such as television, film, and magazines we have come to expect color visuals as a matter of course. Partly in response to this heightened presence of color in the media, and because of the availability of many different color drawing instruments, artists today often make use of color media as an integral part of the drawing process.

LIGHT AND COLOR

Professional interest in the phenomenon of color is not limited to the visual arts. Scientists in the disciplines of physics, physiology, and psychology are concerned with exploring such issues as the physical behaviour of light, the way the optical system perceives color, and the effects color has on our feelings and moods. Since we are concerned with the way color enhances the drawing process we will explore this phenomenon from an aesthetic and visual point of view.

Compared to other visual elements such as composition, line, and texture, color is perhaps the most intuitive and personally expressive visual element you will work with. Attempts to formally analyze and codify how color affects us produce dubious results: blues, for instance, can be perceived as restful and soothing as well as expressing an emotional depression. Because of the wide range of individual associations we bring to any work of art our response to color varies significantly.

An important concept to keep in mind when working with color is its ephemeral nature. Color does not exist in any material form like charcoal and paper but is entirely a product of light. When we talk about colors we are really referring to our physiological perception of colored light. Light is a visible form of electro-magnetic radiation and its frequency, or rate of vibration, determines what color we perceive. Sunlight, or "white" light, contains all the colors of the rainbow. This can easily be proven with a simple experiment. When sunlight passes through a glass prism it is separated into all its component colors, such as violet, indigo, blue, green, yellow, orange, and red.

The way our visual system perceives colored light is quite interesting and somewhat mysterious. When light moves through space and enters the inner eye it is converted into electro-chemical energy by retinal receptors. These receptors transmit encoded impulses through the optic nerve. Finally, the brain processes and interprets these signals in complex ways that are still not fully understood.

(opposite) Jasper Johns, *Cicada*, 1980. Ink and oil on plastic, 30⅛ × 22½ in (76.5 × 57 cm). Collection of Frederick M. Nicholas, California. Courtesy, Leo Castelli Gallery, New York.

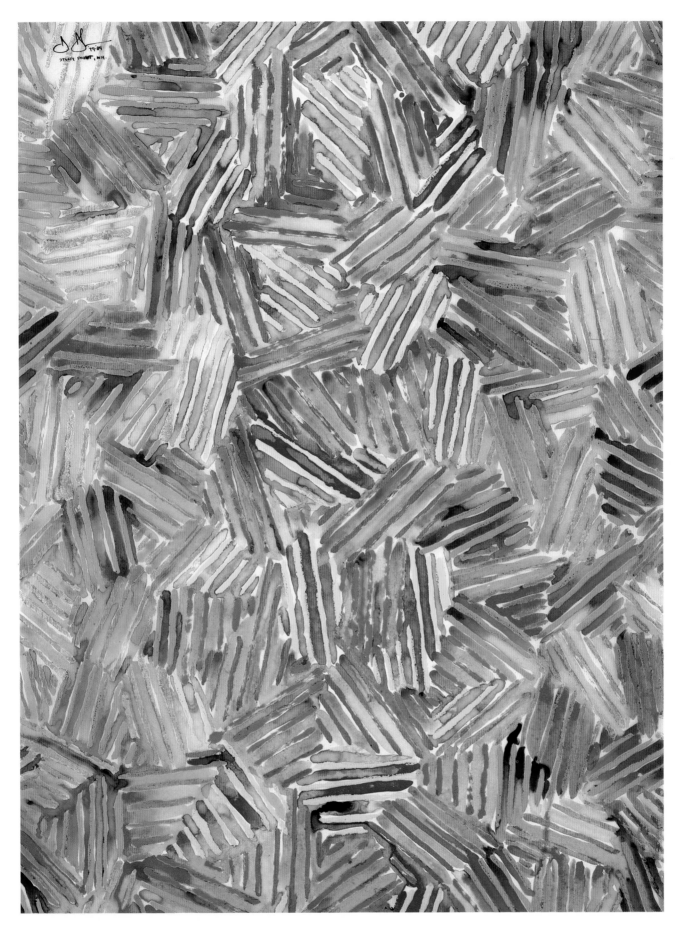

DEFINING COLOR

In order to discuss and meaningfully work with color, artists need to have an accepted vocabulary and labeling system to be able to compare and contrast the interaction of various colors. For centuries individual artists evolved personal color systems and theories which they applied to their work with varying degrees of success. It was not until 1905, however, when Albert Munsell, an artist with a keen interest in color organization, published a standardized, workable system of color description and notation.

COLOR THEORY

Munsell knew that it would be pointless to describe how colors interact if the essential elements of color could not be isolated, defined, and named. Using as a model our standardized musical notation system which defines sounds in terms of pitch, intensity, and duration, Munsell determined that color had three distinct dimensions which we call hue, value, and intensity. Hue refers to the specific name of a color such as red, yellow, or blue. A circular arrangement of colors called the Munsell *color wheel* (Fig. **10.1a**) is used by art professionals to display the twelve major hues artists work with.

Value is a term that refers to how light or dark the color is. Chapter 5 also deals with value but that chapter focuses on the lightness and darkness of the color black. When white or black pigments are added to a color this affects its value (Fig. **10.1b**). Values of the color red can be expressed as a light pink or a dark maroon.

Intensity is a term that describes a color's degree of *saturation*, or strength. Red, for instance, can be made more vividly or less vividly red. If we added some gray to a pigment we would be lowering its intensity (Fig. **10.1b**).

When artists talk about the *primary colors*, they mean those basic colors that cannot be mixed from any other colors. The primary colors are red, blue, and yellow. The *secondary colors*, orange, green, and purple, are created by mixing together two primary colors on the color wheel (Fig. **10.1a**).

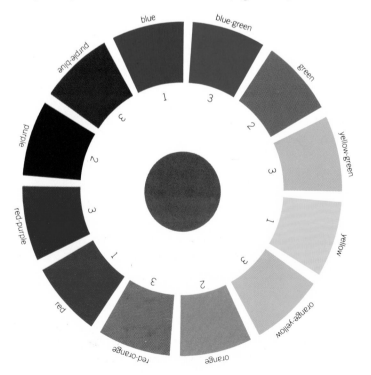

10.1a The color wheel, showing the primary colors (1), the secondary colors (2), and the tertiary colors (3).

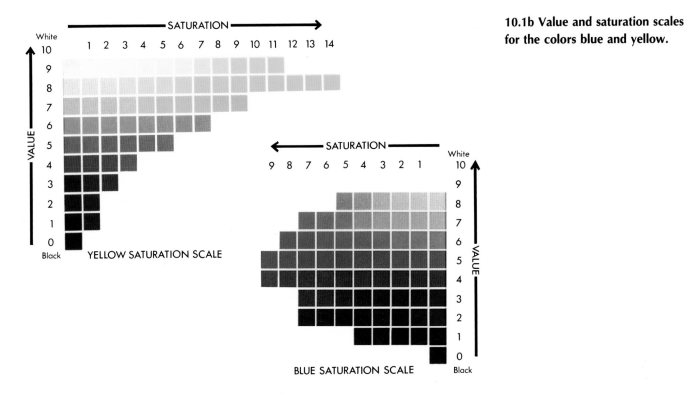

Although these colors form a concise and elementary range of colors we should be aware that by mixing adjacent primary and secondary colors in varying amounts (and with the addition of white and black) we can create an almost unlimited amount of *intermediate* or *tertiary* hues.

Complementary colors are those colors that are positioned opposite each other on the color wheel (red and green, blue and orange for example). Often artists achieve striking color effects when complementary colors are juxtaposed in their artworks.

Two more important terms that we should become acquainted with before we start to work with color media are "warm" colors and "cool" colors. Yellow, orange, red, and red-purple are examples of warm colors. Green, blue, and purple fall into the cool category. Basically if you divide the color wheel in half horizontally, the colors on the bottom of the wheel would be considered warm and the colors on the top would be cool.

This is just a rudimentary guide to the terminology and theory of color, but it is an important prelude to understanding and working with this exciting visual element.

COLOR MEDIA

The list of color drawing media available to contemporary artists today is staggering. Along with traditional materials such as pastels and watercolors, newly developed tools such as water soluble felt-tip markers, oil pastels, colored pencils, and hybrid media of all kinds are used by the modern artist. Few art professionals feel limited to the use of any single color medium, and it is common for artists to combine a variety of materials in personally expressive ways.

When working with color drawing media in this chapter, do not disregard the basic drawing practices you have already mastered. Using the element of color in conjunction with the sound drawing principles you have been using for some time will enable you to enhance the expressive range of your work.

203

10.2 Paul Gauguin, *Tahitian Woman*, 1891–3. Pastel on paper, 15³⁄₅ × 11⁷⁄₈ in (39 × 30.2 cm). The Metropolitan Museum of Art, New York. Bequest of Miss Adelaide Milton de Groot.

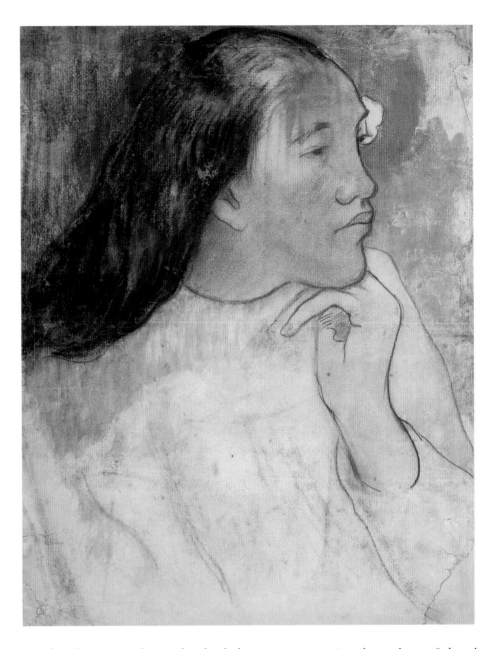

Color drawing media can be divided into two categories: dry and wet. Colored pencils, crayons, pastel and oil-stick crayons are among the most widely used dry materials today (and perhaps the easiest to control). These instruments can, for the most part, be applied just as you would graphite and charcoal. By overlapping with different colors, special *chromatic* effects can be obtained. Pastel, for instance, can be applied, smudged with your fingers, fixed with an aerosol fixative (be sure to observe the health precautions outlined in Chapter 2) and drawn over to achieve rich and varied color effects.

When Paul Gauguin made his now famous journey to Tahiti to escape what he felt were the old and stifling conventions of Europe, he discovered a world of lush and dazzling color quite different from his native France. In this pastel drawing of a Tahitian woman (Fig. **10.2**) Gauguin contrasts the shiny black hair and warm brown flesh tones of his model with an almost fluorescent passage of hot pink in the upper right. Gauguin took color far beyond naturalistic concerns and used it for symbolic effect. The warm and glowing pink that appears in this drawing shows up regularly in his Tahitian series and seems to symbolize the lost paradise on earth Gauguin sought in these warm tropic islands. *Tahitian Woman* is the drawing of a single person yet it also can be read as the portrait of a proud group of people Gauguin found living in harmony with their environment.

Many colored drawing instruments can be used just as you might use *monochromatic* materials such as graphite and black crayons, producing drawings in which only tonal variations of one color are present. Using colored pencils, for instance, should not prove difficult from a technical point of view. The main challenge here is to make appropriate use of their color properties.

While Frank Stella was working on a series of complex geometric paintings in the early 1960s he made extensive use of colored pencil drawings to work out problems of color design and scale. In his study for *Gray Scramble Concentric Squares* (Fig. **10.3**) he explores themes of central imagery and symmetrical organization. Since Stella's finished paintings measured over 8 feet square he could quickly and efficiently refine his ideas with colored pencil drawings on graph paper before he committed them to large canvas formats.

10.3 Frank Stella, Study for *Gray Scramble Concentric Squares*, detail, 1967. Pastel and pencil. Öffentliche Kunstsammlung, Basel, Switzerland.

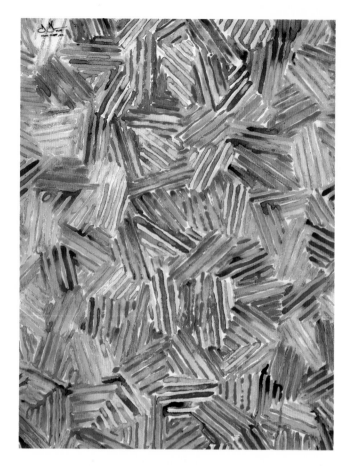

10.4 (above) Howard Smagula, *Splendid Occasions of English History,* **1988. Watercolor, gouache, collage, 29 × 21 in (73.7 × 53.4 cm). Courtesy, the artist.**

10.5 (above right) Jasper Johns, *Cicada,* **1980. Ink and oil on plastic, 30⅛ × 22½ in (76.5 × 57 cm). Collection of Frederick M. Nicholas, California. Courtesy, Leo Castelli Gallery, New York.**

Color media also come in a wide range of wet forms. Some of the most popular drawing materials in this category are watercolor, gouache, colored inks, and artist quality felt-tip markers. In addition, most forms of paint can be used to draw with by diluting them with the appropriate *solvent* and using a round, pointed brush to apply them.

Watercolor and gouache produce effects similar to those of ink wash drawing. Of course the range of color possibilities are greatly enlarged with these media. *Splendid Occasions of English History* (Fig. **10.4**) is a drawing I did that makes extensive use of watercolor and gouache media. The central image of this drawing is a reproduction taken from a second-hand book I found on the history of England. Once this image was collaged onto the watercolor paper it became the visual anchor for the hand-drawn elements that surround it. The British warship is inset within a watercolor passage that evokes both the imagery of waves and storm clouds over the ocean. Two geometrical gouache passages, one light blue and the other black-green, hover above and below the collaged ship seeming to exert some visual power over the central rectangular plane. A light blue-gray watercolor wash on the lower section of the drawing suggests the presence of a sky, yet its position in the drawing contradicts this reading. The visual harmonics between the printed and drawn elements create lively juxtapositions of color, form, and meaning.

Although watercolor and gouache have been around for centuries, modern technology has made available new drawing materials with unique properties. Colored inks are now available in a full range of colors including some that can be used on sheets of translucent plastic. Jasper Johns made use of these special inks on such a plastic support to create *Cicada* (Fig. **10.5**). To prevent the ink from beading on the nonabsorbent plastic, solvent is added to the formula. In this way the ink bonds to the surface chemically rather than being absorbed as it is on paper. The

subtle interplays of color and pattern that Johns creates in this drawing are very much a result of this special drawing medium.

There are many more materials that can be used for color drawing than we have mentioned here. As you gain experience and confidence, and your personal vision matures, you will probably discover a variety of color media you like to work with.

DRAWING WITH COLOR

No hard and fast laws govern the use of color. Color seems to work most meaningfully when it contributes to the visual impact of the drawing and when it achieves personally expressive visual goals. Color is also arguably one of the most emotionally based visual elements, so it might make sense to work with it intuitively rather than in a logical way.

In order to use color effectively, it is necessary to understand some of the factors that affect its usage. Before you begin to explore *full-spectrum* color it is important to understand that you have been using color since the very first day you picked up a stick of charcoal or used a graphite pencil, instruments which produce monochromatic color. Although we will explore the expressive possibilities of multi-colored drawing media be aware that monochromatic color is in no way inferior. Some of the most dramatic and effective drawings in existence have made splendid use of monochromatic color.

Expanded use of color does have its place in contemporary drawing techniques, however. Along with the new visual opportunities of color come new responsibilities. For instance, when more than one color is used, you will have to decide how to relate the colors within the composition. This process of organizing the way colors are arranged in a composition is known as "color orchestration." As we increase the number of colors in our composition, this issue will become quite important and play a major role in the organization of the drawing.

An important concept to keep in mind while we explore color is that of *chromatic integration*. Try to use color in such a way that it becomes an integral part of the drawing process. Avoid coloring in a drawing after you have taken it to a state of completion with pencil or pen. A better idea would be to make any preliminary sketching on the drawing with the color media you are using.

Working with the element of color in the drawing process also brings up the issue of quantity. How much of a certain color we use becomes as important as the exact hue and value. In general, drawings that use equal amounts of each color (something beginners have a tendency to do) often become too balanced and static in terms of color orchestration. This is similar to the issue of balance that was examined in Chapter 7, "Composition and Space."

CLOSE-HUED COLOR

Before you plunge into the world of full-spectrum color, we should explore the expressive possibilities that can be derived from the careful exploitation of one basic color and its secondary family of colors. By skillfully varying the value, intensity, and chromatic range of a single color, it is possible to achieve surprisingly rich coloristic effects.

From 1901 until late 1904 Pablo Picasso's work was distinguished by his overriding use of the color blue and the art produced during this period is known today as his "Blue Period." Symbolist concerns were probably the greatest motivation behind this insistent use of blue. Artists during this era were concerned with conceptually enlarging the realms of art and going beyond issues of realism.

10.6 Pablo Picasso, *Brooding Woman*, 1904. Watercolor on paper, 10⅝ × 14½ in (26.7 × 36.6 cm). Collection, The Museum of Modern Art, New York.

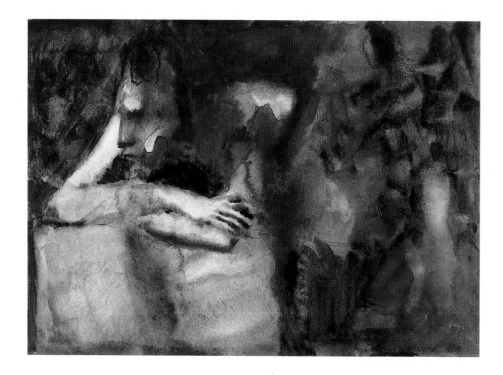

In Picasso's "Blue Period" watercolor, *Brooding Woman* (Fig. **10.6**), the domination of this cool color is complete. Picasso associates blue in this artwork with feelings of dejection and melancholy. This woman, and all the characters that appear in his "Blue Period," artworks are portrayed as poverty-stricken, lonely outcasts of Parisian life. No doubt his own financial struggles at the time contributed to this lyrically pessimistic world-view.

In order to visually communicate his sentiments, Picasso exploits the expressive range of the blue family to the full. Blues range from the palest green-blue to intense blue-blacks and magenta-blues. The color experience is so appropriate and rich in this artwork that we are not immediately aware of Picasso's limited range of color. The compelling mood generated by this drawing is testimony to the effectiveness of close-hued color. Picasso seems to achieve more with less in this evocative drawing and we never feel the absence of other colors.

Project 57

Closely Related Colors

Materials: Bond paper, four or five pastels or colored crayons of closely related colors (a selection of greens or oranges for example).

Make a landscape drawing and interpret the forms and elements primarily through the means of colors that are near each other on the color wheel (secondary colors). If the drawing is done in the spring or summer you will need an assortment of green colors. Autumn would probably necessitate using pastels in the orange-red range. When you work with color think in terms of quantity. Experiment by varying the amounts of each color used. For instance you might use a large mass of one color that is accented by small amounts of close-hued color.

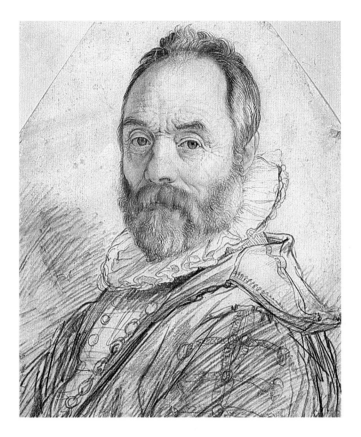

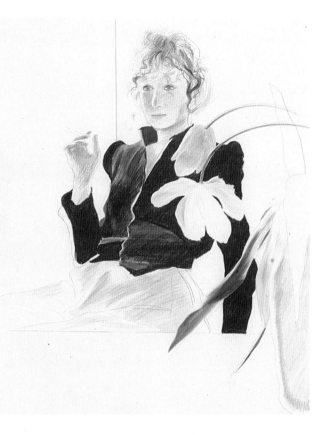

VISUAL EMPHASIS AND COLOR

While Hendrick Goltzius, a Dutch artist of the sixteenth century, was traveling through Italy, he made several large chalk portraits of artists he met there. His portrait of the sculptor Giambologna (Fig. **10.7**) is a wonderful example of how modest amounts of color can enliven a drawing and create a new visual dimension. Vigorous chalk marks in the body area are juxtaposed with meticulous detail and subtle color washes in the subject's features. Remarkably, although the drawing seems to be in full color, Goltzius achieves his effects with pale reddish and greenish watercolor washes, charcoal, and red chalk. The selective use of color focuses our attention on the features of the sitter and achieves great expressive effects.

David Hockney's contemporary portrait, *Celia in a Black Dress with White Flowers* (Fig. **10.8**), also makes economic use of color to achieve dramatic results. Large expanses of white paper in this drawing contrast with dramatically dark values of black and green. Hockney reserves the use of the delicate red-blue tones for his model's features and sections of flowers. Much of this drawing's success can be attributed to the artist's limited use of color both in terms of quantity and variety.

10.7 (above left) Hendrick Goltzius, *Portrait of Giambologna*, **1591. Charcoal, red chalk, and wash, 14¾ × 12 in (37 × 30 cm). Teylers Museum, Haarlem, Netherlands.**

10.8 (above right) David Hockney, *Celia in a Black Dress with White Flowers*, **1972. Crayon, 17 × 14 in (43.2 × 35.6 cm). Courtesy of TraDHart Ltd.**

Project 58

Using Colored Pencils

Materials: Bond paper, three or four different colored pencils.

Create a still-life with several objects that offer interesting spatial or compositional attributes. Choose one of the objects to emphasize through the

selective use of color. This object, or section of the object, should be highlighted with a more intense or complex use of color. Make sure that other areas of the drawing are defined and compositionally supportive of the entire drawing. The primary objective of this assignment is to use color as a new means of ordering and highlighting visual information.

THE RANGE OF COLOR

So far we have limited our selection of colors in order to learn how to begin to organize the element of color in our drawings. There are, however, a large number of colors available for drawing and with care they can be used with success. Media such as watercolor, pastels, and colored pencils come in an extraordinary range of hues and are capable of producing coloristic effects fully as rich as those of acrylic or oil painting. Pastels, a form of high-quality artist's chalk, lend themselves particularly well to exploring the interaction of color in the drawing process.

Wayne Thiebaud, a contemporary American artist, has for years celebrated the visual beauty of commonplace objects in our environment such as rows of cakes lined up in a bakery window, or gum-ball machines that might be found in a corner grocery store. Although Thiebaud often chooses as his subject things we may see every day, his visual treatment of these objects is anything but ordinary. Witness his pastel drawing titled *Twin Cakes* (Fig. **10.9**). In this pastel drawing the artist takes full advantage of the pure pigment used in the manufacture of artist's quality pastels (because there is no oil binder used in pastel crayons, the colors are even more vivid than paint). From a ground of pale pinks, greens, and blues, the cakes emerge and are set off through the use of shadows created by medium tones of gray and dark blue. Another important color in this pastel drawing is the bright red which represents the strawberry topping on each cake. The contrast of the pale colors used in both the ground and the body of the cakes, set against the dark shadow areas and the intense red creates a dynamic coloristic effect.

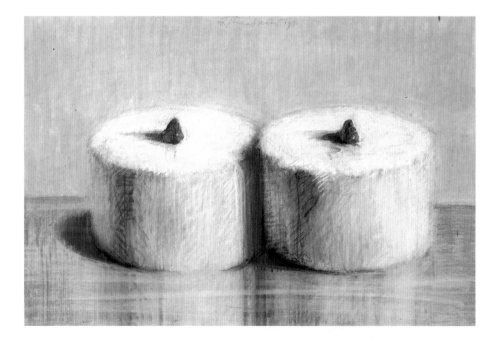

10.9 Wayne Thiebaud, *Twin Cakes*, 1980. Pastel, 16 × 23 in (40.6 × 58.4 cm). Courtesy, Allan Stone Gallery, New York.

Project 59

Using Pastels

Materials: Tinted drawing paper, selected pastels.

For this assignment you will need some tinted drawing paper from a well-stocked art supply store. These papers come in a variety of light to medium colors such as blue, green, and cream (you might like to purchase a sheet of black paper which would make a dramatic ground for any pastel color). Also these tinted papers usually have a special "tooth" or texture that makes them particularly well suited for pastel. Using a tinted paper will save you from laboriously coloring the paper in order to avoid the problem of working with subtle color on a glaring white background.

Pastels can be bought either individually or in sets of various sizes. At the very minimum you should have about eight colors covering the primaries and some of the secondaries. One thing to remember when you work with pastels is that they can be mixed and combined on the paper. With an assortment of eight basic colors you have the ability to mix a great number of hues.

Layering is the key to effective work with pastel. Spray fixative used between layers of different pastel prevents the colors from mixing and allows vibrant juxtapositions of complementary hues.

To create an appropriate drawing arrangement for this exploration go through your closet and select brightly colored articles of clothing. Arrange them on a neutral colored background – either a white wall or on a table covered with paper or a white sheet. Men's ties make excellent subjects for this assignment because of their vivid color and geometric patterns. Other articles of clothing, such as women's hats and dresses, or brightly colored tee-shirts arranged on hangers, would be equally suitable. Do not create a wall-to-wall arrangement of colored articles. Using too many brightly colored articles might create an overload of color and diminish the chromatic effect of a few intensely colored objects.

WATERCOLOR AND INK

Watercolor and ink are among the most widely used color drawing media. No doubt their popularity has much to do with their great versatility. Watercolors lend themselves to a variety of drawing techniques and methods: they can be used in large masses or *washes*, or they can create lines.

Sandro Chia, a contemporary Italian artist, makes bold use of watercolor in the drawing shown in Figure **10.10** (p. 212). In this work Chia also uses pencil and charcoal lines but clearly the vivid watercolor passages of orange, blue, and green dominate and control the composition. In recent years this artist's style has centered on combinations of classical images (the Roman youth sensually posed) and modernist devices such as the bold geometric shapes of color. There is a fresh and spontaneous quality to this drawing that takes advantage of the special qualities of the watercolor medium.

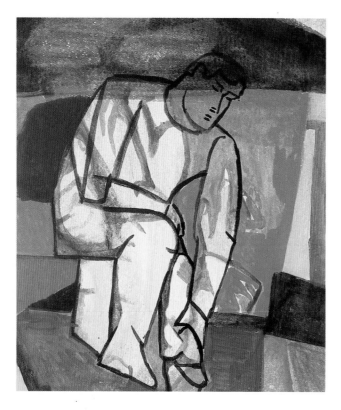

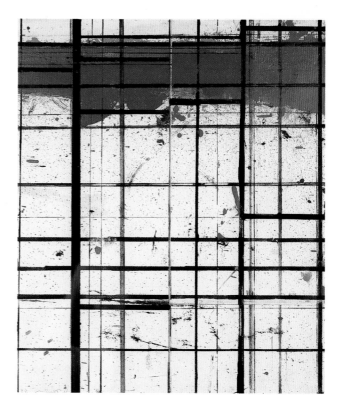

10.10 (above) Sandro Chia, *The Poetic Image*, 1989. Gouache on cardboard, 22⅞ × 20½ in (58.1 × 52 cm). Courtesy, Sperone Westwater Gallery, New York.

10.11 (above right) Brice Marden, *Painting Study 4*, 1984. Gouache, graphite, ink, and oil on paper, 14⅞ × 12⅝ in (38 × 31.8 cm). Courtesy, Mary Boone Gallery, New York.

Colored inks are similar to watercolor and also provide artists with unique visual effects. Brice Marden, a contemporary American artist, created this study (Fig. **10.11**) using gouache, graphite, and ink. The structure of the vertical and horizontal lines and shapes is basically symmetrical. But Marden plays with the formality of this composition by allowing "accidents" to happen in a consistent and controlled way. Sometimes the lines are regular and ruler drawn, and sometimes they are transformed into irregular lines and ink splotches. Marden makes effective use of these visual qualities to create a drawing that is both simple and complex, carefully planned, and spontaneous.

Project 60

Drawing with Watercolor and Ink

Materials: Rag watercolor paper (140lb weight), watercolor tubes of suitable colors and/or colored inks.

This project gives you a wide latitude in terms of theme. We are primarily interested in exploring the special qualities and color interactions of watercolors and inks. One word of caution: if you want to make some preliminary pencil lines to help you block out your composition keep them light. This might avoid having your drawing appear as if it were colored in within the lines. Better yet, do your preliminary sketch with lightly tinted watercolor and a small brush and you will not have to visually integrate a second material within your composition.

EXPRESSIONIST COLOR

The modern evolution of drawing practices has brought about not only an increased interest in the use of color, but also a dramatic change in the way color functions in works of art. Freed from the constraints of naturalism, color now plays a central role in the establishment of the mood of an artwork and as a means for personal expression.

Emile Nolde was a German artist whose dramatic watercolor drawings of the early 1900s helped form modern attitudes toward color. Nolde was particularly interested in the way art could be used to create images "...more beautiful than anything seen." Often he turned to the landscape as a motif through which he expressed his feelings about his homeland, an area of northern Germany between the villages of Utenwarf and Seebull.

Nolde's watercolor drawing, *Evening Landscape, North Friesland* (Fig. **10.12**), glows with color the like of which cannot be found in even the most dramatic of real sunsets. Nolde has intensified the colors of this drawing to the point of maximum saturation. His careful control of color relationships creates the effect of a light source that seems to radiate from within the paper. Nolde achieves this effect through the manipulation of color and value. By placing contrasting light colors next to dark colors the artist achieves the illusion of an inner source of light. Nolde also makes effective use of complementary colors (those colors on opposite sides of the color wheel) in this drawing. Blues and oranges, reds and greens, and violets and yellows are juxtaposed to achieve striking color effects. Despite Nolde's obvious references to the natural landscape, this drawing clearly presents us with an image that goes beyond naturalism and suggests the inner world of the artist's imagination.

10.12 Emil Nolde, *Evening Landscape, North Friesland*, Watercolor, 13 × 18½ in (33.3 × 47.1 cm). Ada and Emil Nolde Foundation, Seebull.

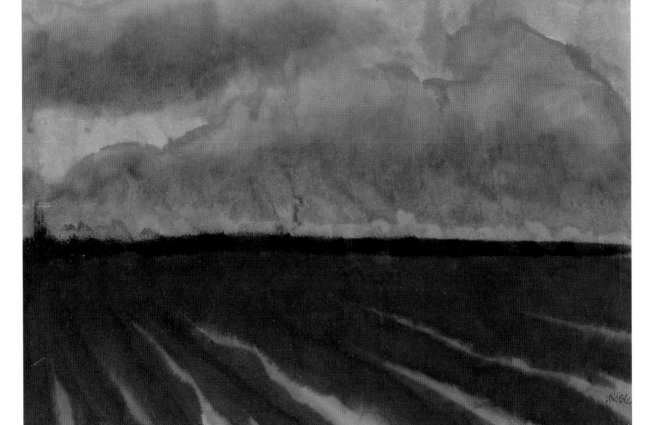

Project 61

Imaginary Landscape with Heightened Color

Materials: Watercolor paper, #10 sable-hair brush, watercolors of your choice.

Be sure to purchase a heavy to medium weight watercolor paper for this project in order to minimize warping of the paper when the water laden pigment is brushed on. You may wish to buy individual watercolor pigments in the colors of your choice rather than buy a set.

Before you begin this project, acquaint yourself with various landscape drawings in order to become familiar with some of the structural elements of this genre. You may wish to make a rough preparatory sketch on separate paper. Put it away, however, when you begin your imaginary landscape.

Work directly on the paper with the watercolor (if you must make some preliminary guide marks use pencil lines that are so light only you notice them). We want to explore the interplay of color masses and tonality so keep detail to a minimum.

Basically, the landscape motif should become a structural device through which we explore the interaction of color. Begin with light-toned washes, since these can be easily gone over later with darker-toned colors. Keep in mind the mood you are trying to express – this drawing should be read as a color statement rather than a descriptive analysis of trees, hills, and fields. A landscapular space can be suggested by using horizontal shapes of various widths stacked one on top of one another. Take another look at the Nolde watercolor drawing in Figure **10.12** and notice how its basic visual structure resembles the configuration we mentioned above.

COLORED MARKERS

Manufacturing technology and commerce have conspired in recent years to produce a variety of new drawing instruments that offer the artist convenience and unique mark-making abilities. Some of the better quality colored markers are made with light-fast pigments instead of dyes that fade within a year or two. With the advent of better color agents these markers have found wide acceptance within the contemporary art world and are used by artists for sketching and by graphic designers for developing the visual concepts and layouts of magazine advertisements.

In 1958 David Park, a Californian artist, used felt-tip markers to make a series of drawings characterized by their bold colors and vigorous line work. Tragically, Park at the time was terminally ill and could no longer muster the physical strength to paint. He did, however, find the brilliantly colored markers enabled him to continue to make art despite his condition.

Study (Landscape) (Fig. **10.13**) is alive with visual energy and dynamic color contrasts. Park portrays the complexity of a stand of trees with angular strokes that take advantage of the thick lines markers are capable of making. Dark black-purple massed lines represent tree trunks and dark forest shadows. Throughout the composition these intersecting lines form a myriad of interesting color and shape relationships. Notice the way Park used the white space of the paper to create staccato rhythms that dance across the surface.

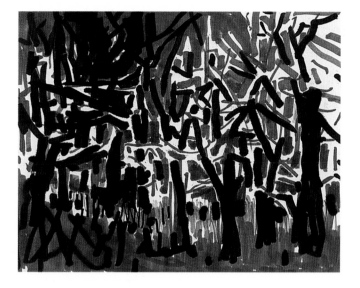

10.13 David Park, *Study (Landscape)*, c. 1958. Marker drawing, 8½ × 11 in (21.5 × 27.9 cm). Courtesy of the Salander O'Reilly Galleries, New York.

Project 62

Sketching with Colored Markers

Materials: 11 by 14 inch pad of medium weight bond paper, an assortment of water based artists' markers.

When selecting markers for this project be careful about the type you buy. Avoid markers that use hydrocarbon solvents (the kind with a strong aromatic odor). The fumes of these markers are harmful and they probably contain dyes that will fade with exposure to light. Find a good art supply store and seek the advice of a knowledgeable salesperson. The markers you are looking for should have an odorless water base and use nonfading pigments.

The portability and convenience of these drawing instruments enable you to take them with you when you go to classes or do everyday errands. If a certain scene or subject intrigues you make some fifteen or twenty-minute drawings of it using your markers. This medium is particularly well suited to field drawing and it should prove to be a productive tool in your repertoire.

Remember, color can do much to enhance the expressiveness of your drawings but only if it is effectively integrated into the composition and if it enhances the development of your thematic ideas. For color to be used effectively it must be well orchestrated, that is to say it must set up interesting color relationships and harmonies throughout the composition.

Always aim for the most efficient use of a limited amount of color rather than attempt to use every color in your possession. Study the work of accomplished colorists and notice that typically, relatively few colors are used. Each color, however, has probably been greatly varied in terms of value, intensity, and quantity.

The psychological and symbolic effects that can be achieved with color are probably the most compelling reasons to use this visual element in your drawings. By controlling the selection and placement of color you can greatly affect the way our eyes move across a picture plane and the way we read a composition. In future assignments keep the possibility of using color in mind.

11 Exploring Themes

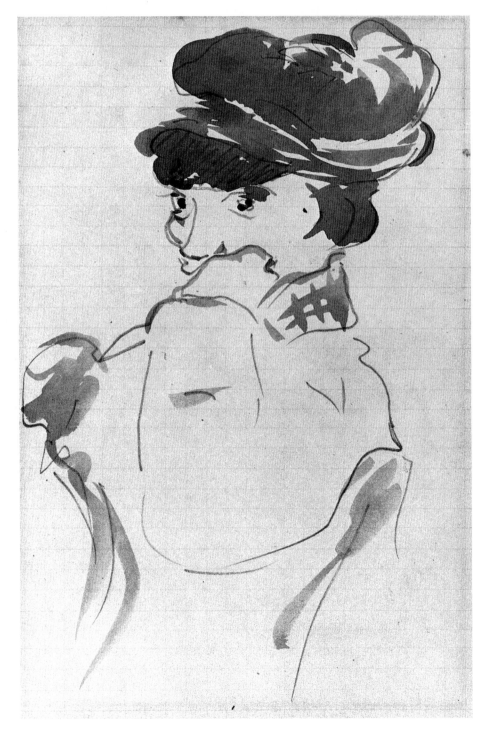

Much of the focus of our study so far has been on technical and conceptual issues such as the use of line and value, and on the organization of these elements within the picture plane. Certainly these are important, even crucial, issues for someone learning to draw. But technical mastery and virtuosity alone leave us cold without the personal insights, obsessions, and deep involvement that distinguish the truly memorable image from the merely competent. Take a close look at some drawings by your favorite artists. What aspects of their work do you find most compelling and engaging? Most likely you would focus on the subjective way they defined and interpreted a particular theme or the highly personal way in which they expressed their concerns using the drawing medium.

This chapter will take a look at how a variety of artists have interpreted a group of themes that figure greatly in Western drawing traditions such as still-lifes, figures and portraits, and the landscape.

Despite the seemingly limited set of possibilities these traditional subjects suggest, artists of the past as well as the present have interpreted these themes inventively and with remarkable imagination. Creativity in drawing does not depend on what we draw so much as how we use the elements of drawing to express unique perceptions.

The material in this section encourages you to investigate these themes for yourself and to begin to form and express your own responses in terms of individual interests and obsessions. Not every thematic category and project will strike a chord with you. This is good because it means you are beginning to respond and draw from personal needs and concerns rather than as an abstract technical exercise. Hopefully, you will begin to discover more and more about your own likes and dislikes, and the special ways in which only you express them.

SKETCHING AND SKETCHBOOKS

If you have not already made a habit out of regularly drawing in a portable sketchbook, now is the time to do so. Quite simply, the more you draw the more accomplished you become. Make it a habit to carry a sketchbook with you at all times. Often slack periods in the day can be transformed into short, productive drawing sessions. Do not be overly selective in terms of what you draw. Try and find interesting visual and conceptual avenues to explore in seemingly mundane subjects. The challenge of sketching a variety of scenes will stimulate your imagination and lead to the development of new ideas. In fact, the broader the range of visual material, the better. After you have filled up a sketchbook, determine what compositional or visual elements you find yourself returning to no matter what subject you draw. This will provide you with some knowledge about your own interpretive insights and what unique concerns affect you.

It is fascinating to review the sketchbooks of modern and historic artists. Often intimate glimpses of their special concerns and aesthetic interests can be gleaned from these collections, sometimes with greater clarity than when viewing their finished work.

For most artists, sketching is an integral part of the creative process. Sketchbooks function as a means of examining their environment, developing ideas, and analyzing images they would like to use in finished works of art.

Seated Woman Wearing a Soft Hat (Fig. **11.1**) is a drawing from the sketchbook of Edouard Manet, an important nineteenth-century French artist. Manet used his sketchbook to record visual details and sensations that he would later develop in his studio. The features of the woman in this sketch are played down and great detail is lavished on the visual structure of her hat. As an artist, Manet made us more aware

11.1 (opposite) Edouard Manet, *Seated Woman Wearing a Soft Hat*, c. 1875. Graphite and ink wash on wove graph paper, 7⅛ × 4¾ in (18.6 × 12 cm). Fine Arts Museum of San Francisco. Achenbach Collection.

of formal visual elements in his drawings such as pattern, value, and the organization of marks on the flat surface of the picture plane.

A sketchbook is also an ideal place to work on specific drawing concerns or themes. When Tim Stolzenberger, a student, realized that he needed more practice drawing hands he filled several pages of his sketchbook with studies of this complex part of our anatomy (Fig. **11.2**).

The informal activity of sketching is an important activity for professional artists as well. While this form of visual note taking may lack the finish of more ambitious works, it often allows artists to develop ideas more freely than in any other medium. Jackson Pollock took advantage of this freedom and used the process of informal drawing to refine and develop his aesthetic sensibility. In an untitled sketch (Fig. **11.3**), we can clearly see Pollock undergoing a transition from a regionalist painter to one of the founding members of the Abstract Expressionist school of art. The beginnings of his overall field compositions can be seen in the way he evenly fills the sketch page with his stylized, almost primitive, figures.

11.2 Student Drawing. Tim Stolzenberger, Felician College. Graphite, 17 × 18.5 in (43.2 × 47 cm).

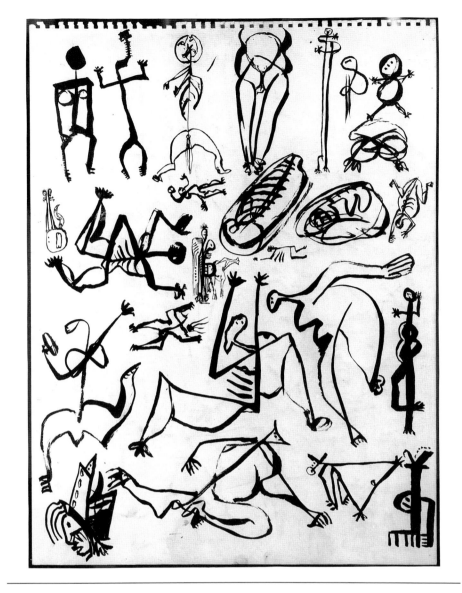

11.3 Jackson Pollock, *Untitled*, c. 1939–42. India ink on paper 18 × 13⅞ in (45.7 × 35.2 cm). Whitney Museum of American Art, New York. Purchased with funds from the Julia B. Engel Purchase Fund and the Drawing Committee.

Project 63

A Sketchbook Series

Materials: A 9 by 12 inch spiral-bound sketchbook, an assortment of pencils, pens, and markers.

Carry this sketchbook with you as a matter of habit and make a point of drawing in it every day. Soon, you will see the emergence of a certain style of visual note taking and you will return to places that were particularly rewarding to draw. You might like the bustle of activity at a favorite restaurant or the quiet solitude of your home late in the evening. Try different drawing instruments. Soft pencils might work well or you might prefer the precise line of pen and ink. Specific themes and concepts should naturally emerge out of this ongoing process of looking, thinking, and drawing. Learn to use your sketchbook as a means of exploring and developing ideas that will enable you to create a body of work that is unique to you.

STILL-LIFES

For a variety of reasons many of the assignments in this book have made use of the still-life as a drawing subject. Objects within our immediate environment are readily available and we can control the arrangements of these subjects with ease. Although still-life drawings have appeared throughout history, they have also appealed to artists of the Modern Era because they allow for the conscious exploration of new directions in form and composition.

Paul Cézanne's still-life drawings played an important role in the development of his mature vision and helped form the foundation for the modern art movement known as Cubism. *Vase with Flowers* (Fig. **11.4**) illustrates his interest in exploring and pushing the compositional limits of drawing to the limit. During his lifetime many critics misunderstood his work and dismissed it, in part because it appeared to be left unfinished. One of Cézanne's greatest accomplishments as an artist was to change the way we perceived the visual and conceptual relationship between the white paper and the marks arranged on its surface. In *Vase with Flowers*, Cézanne transforms the untouched paper into foreground, background, and even into the solid forms of the vase and flowers.

Alberto Giacometti, a modern Swiss artist, was also intrigued with the still-life as a means of expressing his artistic vision. Giacometti's pencil drawing of a vase of flowers on a table relentlessly explores the complex spatial configurations and visual relationships of these commonplace objects within his studio (Fig. **11.5**). Unlike the crystalline ordering of forms in the Cézanne still-life (Fig. **11.4**), Giacometti's drawing anxiously searches for the edges of forms. Lines are drawn and redrawn countless times until the paper vibrates with a raw energy and nervousness that poignantly reflects Giacometti's existential doubts and psychological uncertainty. *Still-Life* expresses more than a pleasing arrangement of forms and objects but communicates with great conviction Giacometti's personal vision and world-view.

11.4 (below left) Paul Cézanne, *Vase with Flowers*, c. 1890. Watercolor and graphite, 18 × 11.8 in (46 × 30 cm). Fitzwilliam Museum, Cambridge.

11.5 (below right) Alberto Giacometti, *Still-Life*, 1948. Pencil on paper, 19¼ × 12½ in (49 × 32 cm). Collection of the Modern Art Museum of Fort Worth. Gift of B. Gerald Cantor.

Gordon Cook was a contemporary West Coast artist and printmaker who worked in a classical mode yet managed to breathe new life into the genre of still-life floral arrangements. Cook earned his living as a commercial typesetter, and he brought the same concern for detail and precise spatial organization from his daytime job into his accomplished drawings and etchings. *Chrysanthemums & Baby's Breath* (Fig. **11.6**) explores with great care the many organic forms of his floral composition. Cook usually did these etchings in one sitting. Early in the evening he would pick the flowers from his garden, place them in a handy container and with almost a single line trace the complex contours before him. By contrast, the vessel holding the plants is drawn with stippled marks that create gently shaded tones. Cook also made fine compositional use of the container's shadows which interestingly assume triangular shapes.

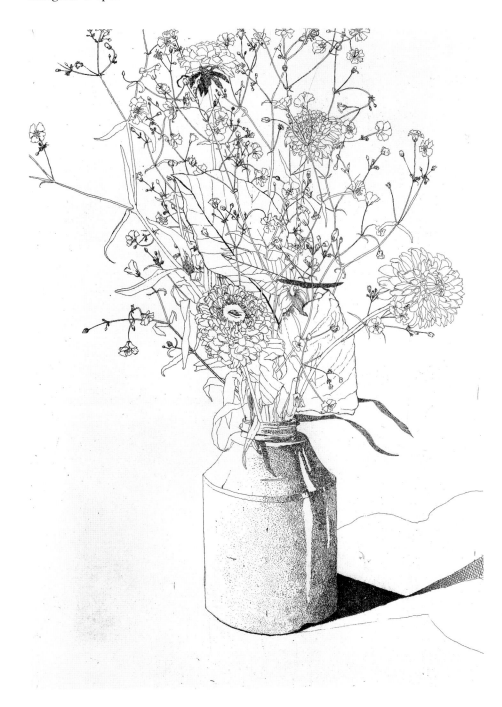

11.6 Gordon Cook, *Chrysanthemums & Baby's Breath*, 1967. Etching, 20⅝ × 14¾ in (52.3 × 37.4 cm). From *Gordon Cook, Twenty Etchings: 1957–1968*, Limestone Press, San Francisco and Houston Fine Art Press, Houston. Courtesy Hine Inc.

Project 64

A Floral Still-Life

Materials: Bond or rag paper, drawing medium of your choice.

Assemble a floral arrangement in a simple vase, place it on a table and arrange your lighting.

The last three illustrations (Figs **11.4**, **11.5**, and **11.6**) reveal some of the interpretive possibilities a vase of flowers suggested to three very different artists. Visually respond to your own floral still-life in ways that are based on any of the three styles that we looked at. Cézanne drew the flowers in terms of semi-abstract, interlocking negative and positive forms. Giacometti, in keeping with his aesthetic vision, interpreted the flowers as an integral part of the environment while Cook brought a precisionist point of view to the floral still-life with accurately drawn contour lines and carefully modulated tonal variations.

11.7 (below left) John Singer Sargent, *Sketch of a Motorcycle*, 1918. Pencil on cream wove paper, 6⅞ × 4⅞ in (17.5 × 12.4 cm). Collection, The Corcoran Gallery of Art, Washington. Gift of Miss Emily Sargent and Mrs Violet Sargent Ormond.

11.8 (below right) Thomas Hart Benton, *Lab Equipment*, Study for the "Kansas City" mural, 1936. From *Farming Segment*. Lyman Field and United Missouri Bank, N.A., co-Trustees of Thomas Hart Benton and Rita P. Benton Testamentary Trusts.

No doubt at times you feel that your subject (or lack of subject) holds you back: if only a certain object or scene were available, your work would be more inspired and effective. This is natural and certainly contains an element of truth. Often we do better when we are involved with our subject. But part of the discipline of learning to draw is to be able to exploit creative opportunities that exist in ordinary objects and scenes. The next group of drawings reveal how a variety of artists have transformed objects we view every day into source material for their art.

John Singer Sargent, an American artist of the early twentieth century, made an effective drawing using as his subject matter an ordinary motorcycle (Fig. **11.7**). Rather than draw the motorcycle in profile, Sargent positioned it so that it directly faces us creating a foreshortened view. Consequently, the front wheel is shown as an elliptical form that dramatically recedes in space. Strong tonal contrasts play an

11.9 Claes Oldenburg, *Soft Screw in Waterfall*, 1975–6. Lithograph (aluminum) printed in black on Roll Arches paper. 67½ × 45 in (171.5 × 113.4 cm). Courtesy, Gemini GEL, Los Angeles.

important expressive role in this drawing. The thick, dark lines in the foreground contrast effectively with thinner lines that represent forms in the background.

The modern American artist Thomas Hart Benton used common chemistry lab equipment for a drawing (Fig. **11.8**) done in preparation for a large mural commission. Scientists see and work with similar equipment every day and probably would not consider it suitable material for a work of art. Benton, however, became fascinated with the linear complexity of these vessels and tubes and created a fascinating drawing out of this prosaic visual material.

Claes Oldenburg is a master at visually transforming consumer items we see so often they literally disappear from our conscious view. *Soft Screw in Waterfall* (Fig. **11.9**) is a lithograph which envisions a common household screw greatly enlarged in scale, fabricated out of soft material, and placed under a cascading waterfall. Surely Oldenburg's fantastic pop monuments come to life in his drawings at least as convincingly as when they are fabricated on a grand scale. Some critics feel his project drawings surpass the constructed pieces, in part because they require more active mental participation on the part of the viewer than his full-size sculptures. Contributing to the overall effect of this drawing are Oldenburg's vigorous and expressive lines which give life to its theme.

11.10 James Dine, _Untitled, Tool Series (5-Bladed Saw)_, 1973. Charcoal and graphite, 25⁵⁄₈ × 19⁷⁄₈ in (65.1 × 50.2 cm). Collection, The Museum of Modern Art, New York. Gift of the Robert Lehman Foundation Inc.

James Dine is another contemporary artist who makes graphic use of objects so common we barely notice them in our environment. But Dine's charcoal and mixed media drawing of a carpenter's handsaw (Fig. **11.10**) presents us with a very different mood from that of Oldenburg's fanciful visions. The saw in this drawing is portrayed as an archaic and dangerous implement, more of a potential weapon than a tool of creation. Much of this psychological effect stems from the dark and hairy niche it hangs in. Somber tones and subdued highlights have been carefully employed to create an atmosphere hinting at danger and latent violence.

Project 65

Transforming Everyday Objects

Materials: Bond or rag paper, drawing medium of your choice.

Take an object or group of objects that you see, work with, or use every day. Using all the graphic means at your disposal, transform our perception of these objects. You will want to consider juxtapositions of scale, unusual points of view, or shifting the visual context of these objects in order to encourage us to view them differently. The following still-life drawings offer examples of how artists have used this genre to express aesthetic concerns.

One of the greatest strengths of the still-life as a drawing subject is its flexibility. During the early days of the modern movement, artists made use of this characteristic to further their experiments with graphic form and composition. Georges Braque, a cofounder of Cubism, created a striking still-life drawing by interpreting three-dimensional forms in terms of overlapping and interconnected flat planes (Fig. **11.11**). Fragmented details of a violin, glass, and sheet music appear

11.11 Georges Braque, _Still Life with Glass, Violin, and Sheet Music_, 1913. Oil and charcoal on canvas, 25³⁄₈ × 36 in (64.5 × 91.4 cm). Walraf-Richartz Museum, Cologne, Germany.

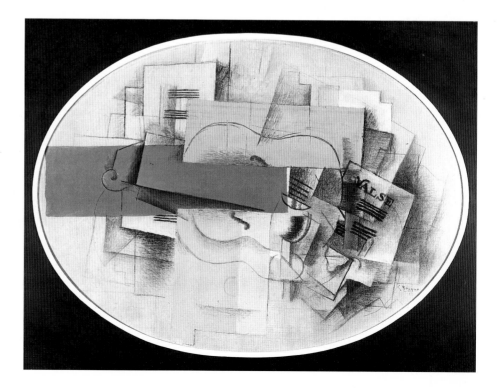

11.12 Egon Schiele, *Organic Movement of Chair and Pitcher*, 1912. Pencil and watercolor, 18⅞ × 12⅛ in (48 × 31 cm). Albertina, Vienna.

throughout this oval composition. Significantly, Braque used an oval format for this artwork, no doubt intrigued by the contrast between the geometric forms within the composition and its curvilinear parameter. Traditional perspective is not used in this artwork. Instead Braque creates a feeling of limited depth and focuses upon the complex, flat network of cubistic shapes and interlocking lines.

Egon Schiele achieved remarkable results in his drawing of a chair and pitcher (Fig. **11.12**) by merely shifting our normal viewing angle of these common objects. Schiele drew the chair and vase as if they were suspended in air above our heads, the shift of viewing angle eliciting a response of disorientation.

Janet Fish's pastel drawing of supermarket fruit (Fig. **11.13**) imparts a wry, contemporary twist to the centuries-old tradition of drawing and painting still-lifes of fruit. The most distinctive aspect of this drawing is the prepackaged nature of the fruit. Fish visually expresses this through the highlights of the plastic film and the paperboard tray the fruit rests upon. Even the arrangement of the fruit comments on the mechanized nature of our times – they are lined up in even rows as if they emerged from a factory assembly line.

By now it is obvious that the still-life's greatest asset is the way it allows the artist to use the arrangement of various shapes and space relationships as a visual starting point from which a broad range of interpretive possibilities can emerge and take form.

THE FIGURE

No other subject in the literature of drawing appears with such frequency as the figure. There are several reasons why the figure occupies a position of such importance in the hierarchy of drawing. Humanity has always been fascinated with the meaning of its own image, a preoccupation which can be seen in countless examples from Egyptian papyrus drawings to contemporary figure studies. Along with historic precedent, the figure is an eminently practical drawing subject. The human body can be arranged in endless configurations and, when combined with various props, makes for challenging and interesting subject matter.

Like any theme the figure can be interpreted in a variety of drawing styles and used to express numerous personal concerns. Gaston Lachaise, a French artist who worked in America during the 1930s, was fascinated with the spatial dimensions of the human body. Lachaise was primarily a sculptor and regularly used drawing as a means of exploring the beauty and power of the human form. *Nude* (Fig. **11.14**), portrays a female model of exaggerated proportions, a modern day fertility goddess. Lachaise describes the ample physical proportions of his female model with surging, rhythmic contour lines that create strong illusions of three-dimensional form. Being a sculptor, Lachaise used line as if it were metal wire that could be shaped and sculpted in space.

11.13 (right) Janet Fish, *Pears*, 1972. Pastel on paper, 30 × 22 in (76.2 × 55.8 cm). Courtesy, Robert Miller Gallery, New York.

11.14 (far right) Gaston Lachaise, *Nude*, c. 1930. Pencil on paper, 19 × 12 in (48.3 × 30.5 cm). The Metropolitan Museum of Art, New York. Gift of George T. Delacote, Jr.

11.15 Claudio Bravo, *Fur Coat Front and Back*, 1976. Lithograph, 2 sheets together, each 37¹³/₁₆ × 22³/₈ in (96 × 56.8 cm). Collection, The Museum of Modern Art, New York. Latin-American Fund.

Using quite a different approach to the figure, Claudio Bravo created this two-part lithograph titled *Fur Coat Front and Back* (Fig. **11.15**). Bravo shows us two opposite views of his subject rendered with great skill and in meticulous detail. In a superrealist style, using a fine-nibbed pen and a small brush and ink, the artist has created a drawing that alludes to northern Renaissance realism yet which in terms of its conceptual overtones is decidedly modern.

Because the Renaissance was a time of humanistic concerns, the proportions and measurements of the body were studied with particular interest during this period. Hans Holbein the Younger (a northern Renaissance artist) made this fascinating study of heads and hands on a single sheet (Fig. **11.16**). In order to more fully understand the body's structures they were conceived and framed in geometrical terms. In this era keen visual analysis predominates over psychological interpretation. Notice the way the hand is drawn at the bottom right of the drawing: the

11.16 Hans Holbein the Younger, *Sheet of Studies of Heads and Hands*. Pen and black ink, 5 × 7³/₅ in (12.8 × 19.2 cm). Kunstmuseum, Basel, Switzerland.

227

complex jointed sections of this body part are envisioned as mechanical forms in order to more fully comprehend their essential shapes. When you do your own drawings from the figure keep this drawing in mind since it should help you to describe the human form with accuracy.

The figure as conceived in Jean Dubuffet's drawing, *Man with a Hat in a Landscape* (Fig. **11.17**), is barely discernible and assumes a ghost like presence. Emerging from a seething mass of scratchy ink lines and calligraphic marks is the child-like image of a man in a hat. Dubuffet is greatly influenced by primitive art and the work of the insane. In this drawing there is no clear distinction between figure and ground, the landscape and the man. Everything appears to be made from ink marks that vary in thickness.

Richard Diebenkorn's drawing, *Seated Nude One Leg Up* (Fig. **11.18**), makes use of vigorous charcoal strokes to create a composition of strong visual dynamics. Diebenkorn juxtaposes details of the background with elements of the drapery partially covering the model. By doing this he creates a unified environment in which the figure is an integral part of the overall scheme. Diebenkorn masterfully integrates a variety of visual harmonics and rhythms to create this well-structured study of his model.

Alexander Archipenko, a twentieth-century artist, further abstracts the human form in his collage drawing, *Figure in Movement* (Fig. **11.19**). Head, torso, arms, and legs have been interpreted through flat stylized forms that are subtly shaded in order to create the illusion of slightly curved shallow shapes. Crayon lines visually interact with these geometric shapes to create visual tensions and the implications of movement and change.

11.17 (below left) Jean Dubuffet, *Man with a Hat in a Landscape*, 1960, from the series "Drawings in India Ink and Wash". Pen and ink on paper, 12 × 9⅜ in (30.4 × 23.7 cm). Collection, The Museum of Modern Art, New York. The Joan and Lester Avnet Collection.

11.18 (below right) Richard Diebenkorn, *Seated Nude One Leg Up*, 1965. Charcoal on paper, 17 × 14 in (43.2 × 35.5 cm). Courtesy, M. Knoedler & Co., Inc., New York.

11.19 Alexander Archipenko, *Figure in Movement*, 1913. Crayon, pencil, and collage, 18¾ × 12⅜ in (47.6 × 31.4 cm). Collection, The Museum of Modern Art, New York. Gift of Perls Galleries.

The portfolio of figure drawings we just looked at serves to remind us that the human form can be interpreted in many visual styles and express a variety of aesthetic concerns. The next project allows you the opportunity to develop your own series of figure drawings.

Project 66

Interpreting the Figure

Materials: Bond or rag paper, drawing media of your choice.

Persuade a friend or group of friends to pose for you for this project. Better still, exchange posing sessions with a fellow student as this way you have a colleague with whom you can share ideas and enthusiasms.

Choose an aesthetic approach used in one of the figure drawing examples we just looked at, or apply concepts and interests you have previously worked with to this figure assignment. You may wish to isolate the figure from the environment or to place it firmly within the visual and thematic context of a special place or room. Do a series of figure drawings that return to the same general pose or particular place. Between drawing sessions analyze your work and take note of its strengths and weaknesses. Focus on the positive aspects of your best drawings, the way they successfully control value or use calligraphic line, for example, and reinforce these qualities in the next drawing.

PORTRAITS AND SELF-PORTRAITS

For centuries portrait drawings have been an important part of an artist's repertoire of themes. This type of drawing was first commissioned by nobility and later by the newly evolving class of merchant princes and wealthy industrialists. Portraits of socially prominent individuals have for centuries formed an important part of civilizations' documentation. With the development of photography, pictorial likenesses of nearly everyone, not just the wealthy, became affordable. Modern drawing traditions reflect this technological change since the artist will attempt to express concepts and sensibilities in a portrait drawing that go beyond the visual documentation of someone's features. The form and function of portrait drawing for the most part has evolved along with the social and technological face of society.

In 1832, just before photography became widely available, Jean-Auguste Dominique Ingres completed a portrait drawing of his client Louis Bertin (Fig. **11.20**). Ingres loved to do grand paintings of historical subjects, but in retrospect his greatest gift – and steadiest source of income – was portraiture. It is interesting to note the way Ingres interpreted visual details of his subject. Lavish attention is paid to Bertin's features, which are created from finely wrought pencil hatching. By contrast his subject's upper body is spontaneously rendered with thick, rough, vigorous strokes. The visual effect is to focus our attention on the sitter's facial features which are most important, at least in terms of the client's perceptions.

Umberto Boccioni, an Italian artist associated with the Futurist movement at the turn of the century, approached his portrait model from a different aesthetic perspective. Artists of the Futurist movement were keenly interested in the ongoing mechanization of society and the beauty and speed of new machines such as automobiles and locomotives. With these concepts in mind Boccioni incorporated his ideological concerns about speed and change into this portrait of his mistress Ines (Fig. **11.21**). Boccioni drew her head at an angle and visually represented her hair as a series of swiftly flowing forms. Movement is also implied by the shifting geometric planes of her features, which exhibit overtones of Cubism. Ines looks directly at us in a marvelously personal and confrontational way. Boccioni has

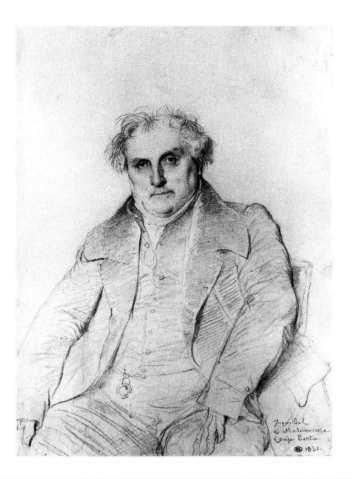

11.20 Jean-Auguste Dominique Ingres, *Louis Bertin*, 1832. Pencil drawing, 12¾ × 9½ in (32 × 24 cm). Louvre, Paris.

11.21 Umberto Boccioni, *Head of a Woman (Ines)*, 1909. Pencil on ivory wove paper, 15 × 15½ in (38.1 × 39.4 cm). The Art Institute of Chicago. Margaret Day Blake Collection.

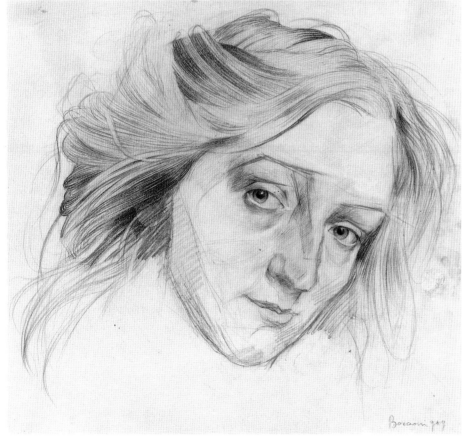

231

11.22 William H. Johnson, *Self-Portrait*, c. 1931–8. Watercolor on paper, 15 × 11½ in (38.1 × 29.2 cm). Hampton University Museum, Virginia.

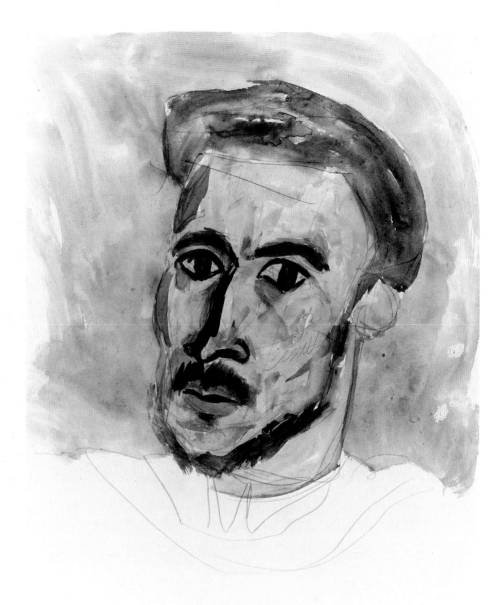

managed to convey something of his friend's vivacious presence and personality through these Futurist concepts.

Along with portraits of family, friends, and clients, artists have always turned their vision inward to create self-portraits. William H. Johnson, an African-American artist who lived between 1901 and 1970, drew the self-portrait shown in Figure **11.22**. The lively, free-flowing watercolor passages that define his features stand in marked contrast to the thin fluid lines that arc across the white space at the bottom of the paper. During the period this drawing was made in the 1930s Johnson had been living in Denmark and traveling throughout Europe and North Africa. This self-portrait seems to reflect the exuberance he must have felt on his world journeys.

Käthe Kollwitz, a German artist of the early twentieth century, moved in for a close-up (to use filmic terms) for this compelling self-portrait (Fig. **11.23**). All unwanted background detail in this drawing is eliminated, nothing distracts from her prominent features which emerge from a mass of vigorously drawn lines. We are confronted by Kollwitz's features in a most direct way and she almost seems to peer into our minds with a penetrating and haunting gaze.

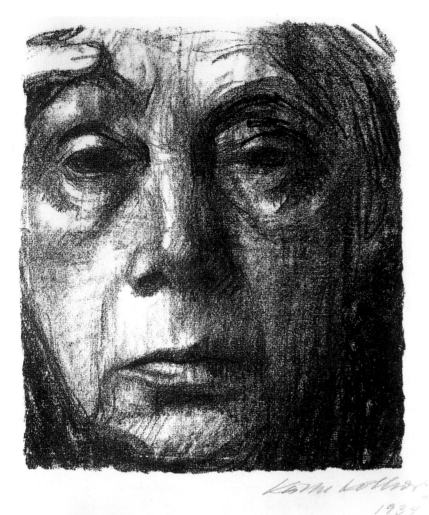

11.23 Käthe Kollwitz, *Self-Portrait*, 1934. Lithograph, 8¹/₁₆ × 7³/₁₆ in (21.9 × 18.2 cm). Philadelphia Museum of Art. Given by Dr. and Mrs. William Wolgin.

Project 67

A Portrait and a Self-Portrait

Materials: Bond or rag paper, drawing media of your choice.

Persuade a friend or family member to pose for this portrait. Do not work from a photograph as this kind of visual information is limited and you will be translating information that is already two-dimensional in nature. In preparation for this project review reproductions of portrait drawings in this and other books to familiarize yourself with this genre.

 Next try doing a self-portrait using two mirrors. Place one mirror directly in front of you and the other one at a 45 degree angle to your right or left. By using two mirrors you will be able to draw a three-quarter view without looking back and forth too much. Lighting will also play an important role in this drawing. Notice how the appearance of your features changes as the lighting shifts. This project requires careful observation and accuracy of description. Take your time and block out the space relationships of your head and torso.

11.24 Claude Lorraine, *View of a Lake Near Rome*, c. 1640. Bister wash, 7⅜ × 10¾ in (18.5 × 26.8 cm). British Museum, London.

THE LANDSCAPE

The natural world has always been one of the most compelling visual sources of art. Humanity's place in the order of things has always been measured by its relationship to the environment outside of house and city. When artists draw the landscape they are drawing the world in all its rich diversity and meaning.

Claude Lorraine was infatuated with the beauty of the countryside just outside Rome. Through countless paintings and drawings Lorraine celebrated this pastoral region perhaps more thoroughly than any native Italian artist. Using a brush and brown-toned ink, he drew the Tiber river late in the day flowing among the umbrella pines and cypresses of the Roman countryside (Fig. **11.24**). Through carefully controlled ink washes Lorraine captured the luminescence of the Tiber as it reflected the fading light of the day. Dark masses of trees that hug the river's bank are drawn deep in the gathering shadows of twilight.

Unlike the lush, romantic interpretation we see in Lorraine's Roman countryside, Vincent van Gogh's landscape drawings are characterized by visual fields of pulsating, linear energy. In his drawing, *Fountain in the Hospital Garden* (Fig. **11.25**), a profusion of nervous lines describe trees, grass, and shrubs. Nature dominates this scene despite the fact that the fountain and other architectural details are prominent. Organic elements far surpass those of the built-environment in this compelling drawing. Van Gogh's vision of the natural world as a powerful entity is thus expressed through his vigorous, animated lines and marks.

Richard Mayhew, a contemporary African-American artist, also made use of pen and ink to draw the landscape. But unlike the bristling, electrically charged atmosphere of van Gogh's hospital garden, Mayhew's vision of the natural world is quite different. *Sonata in D Minor* (Fig. **11.26**) depicts the lyrical, almost dreamlike landscape of a gently rolling meadow. Mayhew carefully controls the spaces between his short lines and looping arcs to modulate tonal densities. Dark areas in this drawing have tightly packed lines and loops while by spacing these marks farther apart lighter tones are created.

11.25 Vincent van Gogh, *Fountain in the Hospital Garden*, 1889–90. Pen and ink on paper, 18¾ × 17½ in (48 × 45 cm). Vincent van Gogh Foundation, Vincent van Gogh Museum, Amsterdam.

11.26 Richard Mayhew, *Sonata in D Minor*, 1970. Pen and ink on paper, 22 × 30 in (55.8 × 76.2 cm). Courtesy, Midtown Payson Galleries, New York.

11.27 Howard Smagula, *Sea Clouds over Tezontepec (After Wallace Stevens)*, 1991. Watercolor and gouache, 8 × 6 in (20.3 × 15.2 cm). Courtesy, the artist.

The landscape can also be symbolically expressed in terms of how a drawing uses composition, spaces, and tonal values. An imaginary landscape was the theme of a series of drawings I made titled *Sea Clouds Over Tezontepec (After Wallace Stevens)* (Fig. **11.27**). This gouache and watercolor drawing evokes the feeling of atmosphere, sky, and clouds without literally illustrating these elements. Floating near the center of this composition is a geometric shape that suggests an immense planar object suspended in the air. Tonal gradations of watercolor replicate the subtle variations of light that characterize the sky during certain times of the day. This combination of cloud-like shapes and luminous washes juxtaposed with geometric shapes creates an imaginary landscape with mysterious overtones.

Project 68

Landscape Drawing

Materials: Bond or rag paper, compressed charcoal, graphite, or pen and ink.

Make two drawings based on landscape space: one that follows the traditions of landscape drawing and one that presents us with an imaginary view of the natural world.

Before you begin the first drawing, familiarize yourself with the basic elements of landscape drawing. Study examples in this book and in books at your library. Take note of how different artists have interpreted elements such as sky, earth, open space, and the configurations of trees, hills, and meadows. If you live in a city, plan a drawing trip to the countryside or visit a large park in your region.

For the drawing of an imaginary landscape take the standard elements used in your first drawing (sky, earth, mountains, trees, and grass) and interpret them in new ways. Visual juxtaposition is the key to the effectiveness of this drawing. Scale relationships can also be manipulated toward favorable ends. If we viewed the landscape from an ant's scale and perspective we would perceive a very different and strangely ordered world.

THE URBAN ENVIRONMENT

Over the last hundred years industrialization has quite literally transformed the landscape for a majority of people in the Western world. When we look outside our windows today, we are more likely to be confronted by buildings and busy city streets than by pastoral views of mountains and streams.

Artists have always responded to their immediate environment, and in the process they have transformed our perception of the everyday world. Even the crowded environment of cities such as New York (which may not seem terribly picturesque) have provided the inspiration for drawings like Isabel Bishop's *Waiting* done in 1935 (Fig. **11.28**). Bishop captured the human drama and poignancy of a mother

11.28 Isabel Bishop, *Waiting*, 1935. Ink on paper, 7⅛ × 6 in (18.1 × 15.2 cm). Collection, Whitney Museum of American Art, New York.

and child waiting late at night in a train station. In this sometimes faceless and harsh city Bishop has given a special identity to this family. The woman remains motionless so as not to disturb her child's sleep and she stares into space lost in contemplation.

In terms of drawing technique Bishop makes effective use of visual emphasis to focus our attention on the faces of the two figures. Sharp, darkly cut ink lines contrast meaningfully with the faint ink wash lines and tonal mass to the right. Bishop achieves a feeling of spontaneity in this drawing while at the same time presenting us with a finished drawing of considerable detail.

One of the most famous paintings symbolizing the isolation and loneliness typical of large industrialized cities is Edward Hopper's *Nighthawks* (Hopper's study for this painting can be seen in Figure **4.10**, p. 90). The painting shows a few lone individuals drinking coffee in a diner during the early hours of the morning. Artists have always paid homage to admired art works from a previous generation and have sometimes recycled them in their own work. Contemporary artist Red Grooms returns to the scene of Hopper's all-night diner but visits it during the light of day. Instead of the melancholy of the early morning hours Grooms' comic version is set in the optimistic light of day. *Night Hawks Revisited* (Fig. **11.29**) is a good-natured spoof of the painting. Hopper himself is portrayed in this drawing with his hand on a coffee mug staring directly at us while Grooms depicts himself as the harried counterman struggling to fill the orders of his customers. This version of *Nighthawks* is played strictly for laughs as many slapstick details show. Flypaper hangs from the grease-encrusted ceiling, a multi-legged cat races across the street to join its pal on the garbage can, and a black limousine with ludicrous tail-fins is parked outside this neighborhood greasy spoon. Comparing these two *Nighthawk* drawings makes us aware of the extraordinary range of expressive possibilities that exist within similar thematic subjects.

11.29 Red Grooms, *Night Hawks Revisited*, 1980. Colored pencil on paper, 44½ × 75¼ in (113 × 191.1 cm). Courtesy, Marlborough Gallery. Collection of Red Grooms, New York.

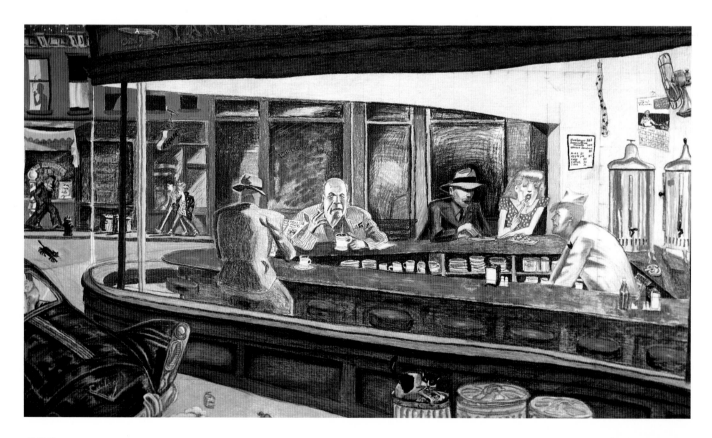

Project 69

The Urban Experience

Materials: Bond or rag paper, drawing media of your choice.

Before you begin to explore this theme on paper take some time to reexperience the sensations and sights of an urban environment. If you live in the suburbs, visit a shopping mall near your home. These commercial architectural spaces recreate the atmosphere of a city to serve the shopping needs of less densely populated areas. What strikes you as interesting about these environments? Take some notes, both verbal and visual, in preparation for a series of drawings that explore your personal perceptions of urban life. Do you feel that cities are too crowded and confusing? Or are you attracted to the sights and activities and find it a stimulating experience? These are only two polarized reactions to the urban environment. Express your attitudes about modern life in the city in your drawings. For instance, by making the space compressed and the composition dynamic, you can communicate one aspect of the urban environment. What can you tell about other artists' attitudes toward urban life and living. Compare the Hopper *Nighthawks* with the Grooms version we have just examined. Both drew the same subject – how did their drawing reflect their viewpoint? This series of drawings should explore your attitudes about the city and modern urban experiences on personal terms.

During the course of this chapter we have explored many of the thematic traditions that have inspired artists of the past and present. Many of these genres can be combined, for instance, the figure within the landscape. Nature has also been a consistent source – some say the only source – for the making of art. No one sees the world exactly as you do. This is one of the most compelling reasons to draw – to explore your perceptions and to give form to your concepts and feelings.

12 IMAGE AND IDEA

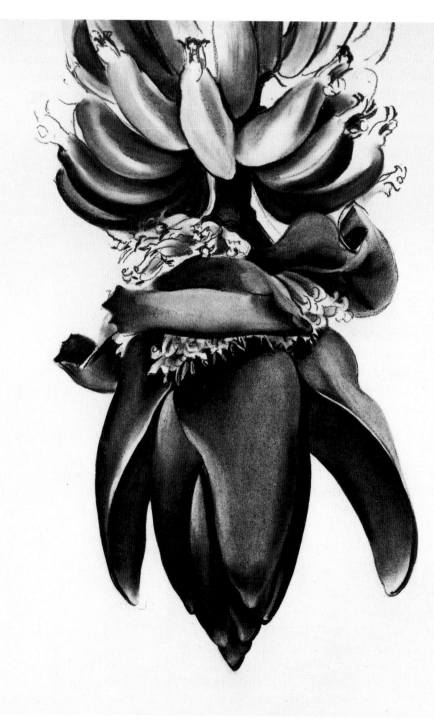

A large proportion of your efforts so far have focused on the acquisition of basic drawing skills and the application of these techniques toward solving a wide variety of visual problems. The art of drawing is a demanding discipline and by no means have you mastered all you need to learn. It is time, however, to begin to think more about how you might apply the skills you have learned toward producing more personally expressive drawings.

At this point you are no longer a beginner, yet you are probably not prepared to continue to work entirely on your own. Anyone beginning the study of art today faces a bewildering array of choices in terms of drawing styles and aesthetic directions. The issue of what to do becomes as important as how to do it. Often what hinders students is not a lack of drawing skills but confusion about the conceptual and thematic role of their work.

This chapter offers representative examples of ways in which professional artists have developed ideas and have expressed them visually. Individual artists are examined to reveal the close relationship between thematic interests and graphic technique. Through these examples and the accompanying projects, you will have the opportunity to further explore the expressive potential of the drawing process.

GEORGIA O'KEEFFE

The drawings and paintings of Georgia O'Keeffe have achieved a cultural status and popularity reserved for few individuals in the twentieth century. Perhaps it is because she manages to combine, with such great conviction, the seemingly opposite aesthetic modes of abstraction and realism. Although very much a modernist, O'Keeffe has never strayed far from nature in terms of her thematic inspiration. The origins of all her artworks are based on keen observation of the natural world. The special light of the desert high country in New Mexico where she lived and worked, the intricate sculptural form of a sea shell, and the delicate structure of flowers are all specific subjects that she has transformed in her drawings and paintings into monumental yet intimate images. O'Keeffe does not produce mirror-images of nature. Almost from the beginning of her career this pioneering artist saw the underlying structure of nature beneath the surface of the organic forms she drew. O'Keeffe distills and heightens the essence of natural forms and shapes them into deceptively simple abstractions that conjure a broad range of feelings.

O'Keeffe's life was as dramatic and unique as her art. Born in Sun Prairie, Wisconsin in the late 1880s (O'Keeffe died in 1986 at the remarkable age of 98) she attended the School of the Art Institute of Chicago for a year and then studied at the New York Art Students League before taking an art course taught by Alan Bement at the University of Virginia. While attending these classes Bement introduced her to the writings of Arthur Wesley Dow who taught at Teachers College, Columbia University. From 1914 to 1915 O'Keeffe enrolled in Dow's class and absorbed his ideas about art. Contrary to the popular thinking of this era, Dow did not stress three-dimensional illusion and realism in art, rather his system of composition was based on contrasts of light and dark forms that were flattened and organized into compositions reminiscent of Chinese and Oriental art. As a former curator of Japanese prints at the Boston Museum of Fine Arts, Dow admired the way oriental artists expressed the elemental forces of nature through simplified, stylized forms.

Banana Flower No. 1 (Fig. **12.1**) illustrates O'Keeffe's ability to transform natural forms into works of art which do not simply imitate nature but symbolize the presence of nature. By drawing the flower tightly cropped and visually detached from the rest of the plant, O'Keeffe emphasizes the sculptural aspects of these forms and enables us to see them in new ways. Because of this approach we do not

12.1 (opposite) Georgia O'Keeffe, *Banana Flower No 1*, 1933. Charcoal on paper, 22 × 15 in (55 × 38.1 cm). The Arkansas Arts Center Foundation Collection.

241

immediately read this image as a flower. The complex, curved organic forms remind us of the muscle structure of the human body and a host of other biologically based forms. Transformed by the carefully modulated tonalities of the charcoal and the magnified view, O'Keeffe's banana flower takes on a timeless feeling of power and strength that belies the reality of its fragile, organic flesh.

Flowers played a special role in the aesthetics and imagery of Georgia O'Keeffe's work. *Calla Lily* (Fig. **12.2**) also expresses the same themes of transformation and abstraction apparent in *Banana Flower No. 1*. Soft, billowing, cloud-like flower-forms fuse into one formless organic shape that floats within the pristine space of the paper. Through this compositional structure the "flowers" are conceptually isolated from the biological realities of generation, maturation, and decay.

Red Calla (Fig. **12.3**) is a continuation of O'Keeffe's transformative vision of nature. Created in 1920, one year after *Calla Lily*, this watercolor drawing seems to extend even further the artist's desire to represent nature through the use of simplified, bold visual forms. Unlike the self-contained centralized forms of *Calla Lily*, *Red Calla* appears to unfold and embrace the space around it. In the process this drawing creates lively negative shapes using untouched portions of the paper ground created by the irregular forms of the flowers' petals and leaves. Delicate watercolor washes are juxtaposed with strong tonal contrasts in this composition to create a self-contained reality related to but not dependent on the reality of everyday perception. This balance between the world our eyes perceive and the world our mind constructs accounts for O'Keeffe's unique and convincing vision.

12.2 (below left) Georgia O'Keeffe, *Calla Lily*, 1919. Watercolor on paper, 23 × 12⅞ in (58.4 × 32.5 cm). Columbus Museum of Art, Derby Fund.

12.3 (below right) Georgia O'Keeffe, *Red Calla*, c. 1920. Watercolor, 19⅜ × 13 in (49 × 33 cm). Yale University Art Gallery. Gift of George Hopper Fitch.

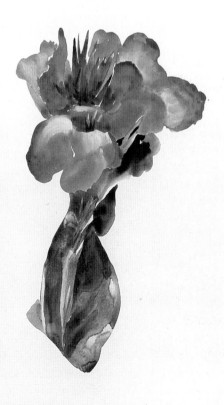

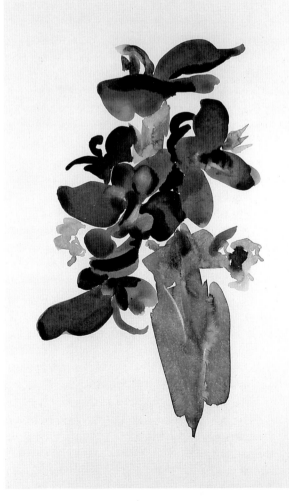

Project 70

A Selective Vision

Materials: Rag or bond drawing paper, drawing medium of your choice.

This assignment explores the creative role played by the point of view, both literal and aesthetic, we select for our drawing. Choose as your subject a flower, sea shell, bone, or other natural object that you find beautiful. Isolate this object on a white ground and position yourself close to the subject. Do not draw the entire form. Find the exact perspective and magnification that transforms this organic form into a semi-abstract composition. As in the O'Keeffe drawings, a viewer should be able to identify the form you have drawn but we should be made more aware of its sculptural form and organizational structure.

WILLEM DE KOONING

In the early 1950s, Willem de Kooning began a famous series of drawings and paintings on the theme of "woman." These drawings were to bring together in a remarkable way his three previous thematic concerns: pure abstraction, the female figure, and the landscape. By introducing the semi-abstract image of a woman into his art and combining it with elements of his abstract style, de Kooning shocked staunch followers of the New York School for whom recognizable imagery was taboo. Through the use of this "woman" image, however, de Kooning managed to maintain his connection to purely abstract visual elements while at the same time making appropriate use of classic themes of Western art: the female idol and the madonna image. In an interview in 1960 de Kooning had this to say about his "woman" image:

> The *Women* had to do with the female painted through all the ages, all those idols, maybe I was stuck to a certain extent; I couldn't go on. It did one thing for me: it eliminated composition, arrangement, relationships, light – all this silly talk about line, color and form – because that was the thing I wanted to get hold of, I put it in the center of the canvas because there was no reason to put it a bit on the side. So I thought I might as well stick to the idea that it's got two eyes, a nose and mouth and neck.

Although de Kooning was greatly interested in the concept of the female image as it was perceived throughout history, his "woman" series also functioned as a thematic basis, allowing the artist the freedom to create new compositional arrangements.

Since the 1930s de Kooning has used the visual effects of collage (as well as actual collage techniques) in many of his drawings and paintings. Many of his forms are flat overlapping shapes that are reminiscent of the collage process. When de Kooning started his "woman" series, the first six paintings in this group were begun as drawings on paper. Many of these early images were made by cutting up drawings

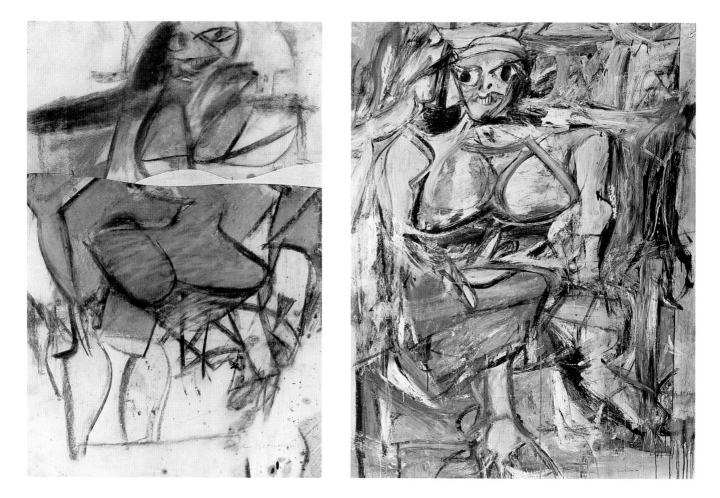

12.4 (above) Willem de Kooning, *Woman*, c. 1952. Musée National d'Art Moderne, Centre Georges Pompidou, Paris.

12.5 (above left) Willem de Kooning, *Woman I*, 1950–2. Oil on canvas, 6 ft 3⅞ in × 58 in (192.7 × 147 cm). Collection, The Museum of Modern Art, New York.

of the female figure into sections and pasting together purposefully mismatched images. The drawing seen in Figure **12.4** was completed using just such a method. De Kooning has severely reduced the image of a woman to such semi-abstract anatomical elements as the eyes, the mouth, the breasts, and the arms. These body parts are defined by angular, disjointed lines which are sometimes blurred by rubbing and erasing. The resultant image is part figural, part abstract and creates a feeling of force and brutality that is reminiscent of the German Expressionists.

Woman I (Fig. **12.5**), a large and fully developed oil painting, reveals how the artist incorporated various elements of his "woman" theme into another medium. Drawing was a way for de Kooning to quickly and efficiently explore compositional ideas and ways in which the anatomy of this terrifying idol could be visually expressed. The woman in this painting emerges out of a seething mass of angular lines and shapes. Almond shaped eyes and a sneering mouth are prominent features of this artwork and will remain a trademark of this series. All of de Kooning's drawings and paintings in this particular series exist halfway between figurative and abstract art combining relevant aspects of each mode.

Project 71

Abstracting an Image

Materials: Rag or bond paper, drawing medium of your choice.

Choose a single object, place it visually in the center of your composition, and develop a series of semi-abstract drawings from it. In each successive drawing try to isolate some visual and thematic feature of this form and develop this aspect. You may wish to use highly energized calligraphic lines that are blurred and reworked (as in de Kooning's drawings), or you may use any drawing style and method that you feel is appropriate for the expression of your concept.

ALICE NEEL

Throughout her long and productive career Alice Neel has painted and drawn psychologically piercing portraits of the broadest range of individuals one could imagine – artists, writers, wealthy business people, the underclass of Spanish Harlem, lovers, friends, museum curators, married couples, and even a brush salesman whose features intrigued her. Neel collects "souls," as she puts it, and made the decision long ago to "paint a human comedy – such as Balzac had done in literature." Living in New York, in the heart of Spanish Harlem, for many years, Neel became interested in representing the psychological presence of her sitters through vigorous line work and facial expressions that were far from the norm in terms of most portrait art. Neel looks for expressions that reveal the psychological truths of her subjects. Cézanne once said that he loved to paint people who have grown old naturally in the country. Paraphrasing this quote, Neel says that she loves to paint people mutilated and beaten up by the rat race in New York.

Neel's drawing of Stephen Brown (Fig. **12.6**) reveals a young man whose anxious gaze confronts us in a particularly poignant and direct way. The visual qualities of her line reinforce this reading. Using sharp, nervously energized lines the artist

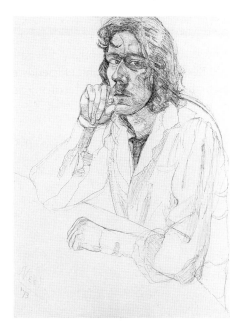

12.6 Alice Neel, *Stephen Brown*, 1973. Ink on paper, 31½ × 24 in (80 × 60.9 cm). Courtesy, Robert Miller Gallery, New York.

245

focuses our attention on the sitter's features and body position. Other visual elements of this drawing play an important supportive role but they do not distract from the subject's expression which is the central focus of the composition.

Neel believes that all good art has abstract elements but what motivates her most is her concern for communicating the human condition and revealing something about our collective psyche. In *The Youth* (Fig. **12.7**) the artist portrays a young man in his twenties leaning toward us in a gesture that might be interpreted as slightly apprehensive. He seems anxious to please and is no doubt flattered that Neel has invited him to pose.

Neel makes particularly effective use of visual emphasis in this lithograph. The dark mass of hair contrasts with the sketchy linear passages of the young man's shoulder and legs. These shifts of visual activity lend a spontaneity and life to the portrait that would be impossible to achieve if all the areas were evenly worked. Neel invites us to participate in the completion of her work by leaving selected areas sketchy and less finished than others.

Neel's figures are far removed from the idealized and flattering images that one finds in most conventional portraits. She is quick to proclaim that she never painted on commission and repeats Whistler's wry observation that "a portrait is a likeness in which there is something wrong with the mouth." Free from the potentially restrictive demands of clients, Neel has created an amazing body of portraiture that comes alive in ways that are quite unpredictable.

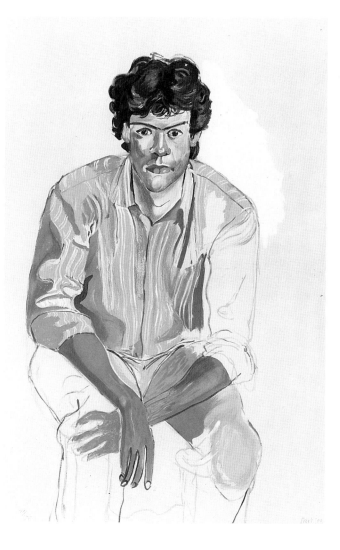

12.7 Alice Neel, *The Youth*, 1982. Color lithograph on papier d'Arches, 38 × 25 in (96.5 × 63.5 cm). Courtesy, Eleanor Ettinger Inc., New York.

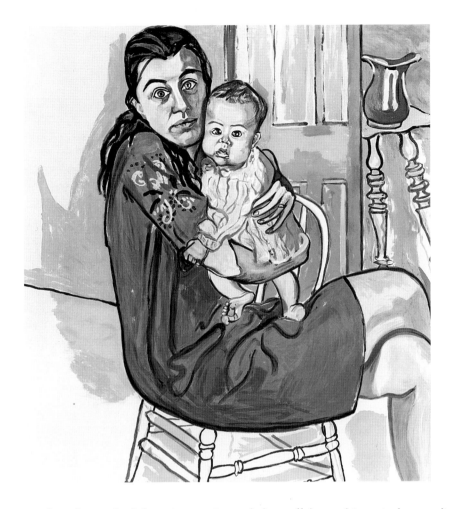

12.8 Alice Neel, *Mother with Child*, 1982. Color lithograph on papier d'Arches, 31 × 28 in (78.7 × 71.1 cm). Courtesy, Eleanor Ettinger Inc., New York.

Part of Neel's methodology is to paint and draw all her subjects in her studio rather than on their terrain. This tactic and Neel's empathetic personality usually prevents them from assuming a lifeless public demeanor and allows them to drop their defenses. Neel is something of a "method" artist and during the drawing session she assumes the identify of the sitter for a few hours. "When they leave and I'm finished, I feel disoriented," she says. "I have no self. I don't know who or what I am. It's terrible, this feeling, but it just comes because of this powerful identification I make with the person. But that's what makes a good portrait."

Because of her refusal to accept commissions Neel makes extensive use of her friends and family for her art work. Her daughter-in-law Nancy, who is Neel's business manager, has been one of her favorite subjects over the years. This drawing of Nancy and her infant daughter Olivia (Fig. **12.8**) is one of Neel's most unusual and compelling portraits. Nancy's wide-eyed (almost frightened) stare as she tightly clutches Olivia is touching and sets up unexpected psychological overtones in the viewer's mind. Was Nancy as frightened as she seems during the sitting or did Neel's admitted tendency to merge her own psyche with that of the sitter account for this anxious demeanor? Perhaps the sight of Nancy holding her child unconsciously reminded Neel of the death of her own year-old baby from diphtheria in the 1920s and the conflicts she faced during her career between care of her children and the demands of her profession. These questions do not need to be answered, however, to appreciate the intensity of feeling we get in front of one of her portraits. Although the images she presents us with may not always strike us as flattering we do sense that each person she portrays is a unique individual who shares many of our own problems and concerns in life.

Project 72

An Interpretive Portrait

Materials: Rag or medium weight bond paper, drawing media of your choice.

The main objective of this assignment is to create a portrait that does not merely describe the appearance of the sitter. We are interested in providing the viewer with some clues as to who they are.

Ask a friend or family member to pose for you. Like Alice Neel you will probably respond better to people you know and have feelings for. Do not necessarily imitate Neel's portrait style. Learn from her drawings and begin to develop your own interpretive approach to drawing the figure.

Any number of factors can be brought into play in order to express your own interests. The medium you use, the format you choose, and the environmental features you include in the drawing will all play important roles in this assignment. How you pose the subjects, or how they present themselves, will also greatly affect the outcome of your portrait. Think in terms of a series of drawings that explore various visual means and compositional approaches you have worked with. Review your past work and notice which drawing styles worked best for you. Incorporate these elements in this series.

CHUCK CLOSE

During the late 1960s Chuck Close became known for his immense, photographically realistic portrait paintings of various friends and acquaintances. As an aid to making these paintings Close photographed his subjects, drew an evenly spaced grid on the enlargement, and systematically referred to each square in the grid as he painted. The finished work was an enlarged, painted translation of the visual information contained in the photographic print. No grid work was evident in these early paintings as Close smoothly joined each square into a seamless unity.

More recently, Close has undertaken a series of drawings based on this same systematic analysis of photographic information. In these drawings he works from a gridded photograph and translates the information square by square onto paper using such media as graphite, ink, pastel, or watercolor. But instead of blending the squares together, Close preserves the identity of the grid and each mark is isolated and distinct. The result is drawings that appear partly to have been computer generated and partly to have been hand drawn.

By controlling the size of the grid in his photographic source in relation to the dimensions and grid size of his drawing format, Close can create either coarse or fine drawing images. *Mark/Pastel* (Fig. **12.9**) is a drawing that measures 30 by 22 inches. Each square in the grid of this drawing interprets with a single pastel dot the appropriate color and tonal density of its corresponding square in the photographic image. By varying the density of the grid in the drawing, Close controls how fine or coarse the image becomes. The more units per square inch of the drawing the finer the image.

Self-Portrait (Fig. **12.10**) is physically larger than *Mark/Pastel* and employs a finer grid. Its image appears sharper because the quantity of information it contains is greater. But the size of the mark is not the only factor which affects our perception. As we move toward or away from these gridded drawings they become slightly out

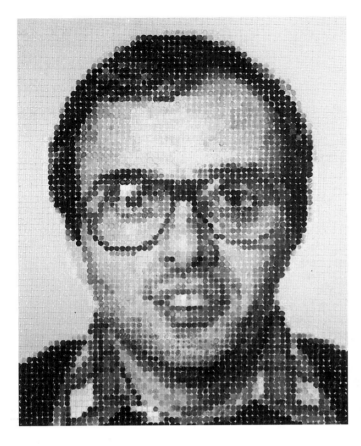

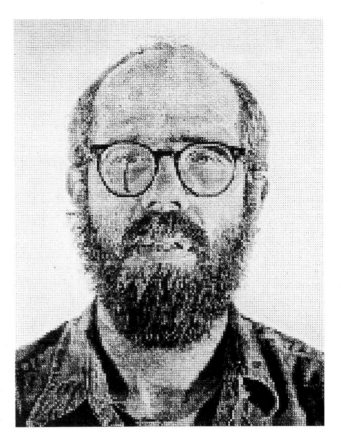

of focus. If we examine the relatively sharp self-portrait in Figure **12.10** from close up, it will appear less sharp and well defined. And to a certain extent the farther away we view the coarser portrait in Figure **12.9**, the "sharper" it appears.

Close's portrait drawings are created through an elaborate process of encoding and decoding visual information. Through this tightly organized system, however, Close enables us to experience a constantly changing and shifting world that assembles and disassembles itself as we perceive it at varying distances.

12.9 (above left) Chuck Close, *Mark/Pastel*, **1977–8. Pastel and watercolor on paper, 30 × 22 in (76.2 × 55.9 cm). The Pace Gallery, New York.**

12.10 (above right) Chuck Close, *Self-Portrait*, **1977. Etching and aquatint, 54 × 41 in (137.2 × 104.2 cm). The Pace Gallery, New York.**

Project 73

Drawing With a Grid System

Materials: Bond or rag paper with a smooth surface, tracing paper, charcoal or watercolor, a ruler.

Select a photo-image you would like to use as the basis for your grid drawing. It could be either an actual photograph or a printed image, but it should measure approximately 8 by 11 inches. Either on top of this photograph or using a transparent overlay of tracing paper to protect the print draw an evenly spaced grid of lines with a sharp pencil. For your first drawing make a grid of moderate dimensions as anything too large or too small will overly complicate things. A grid of about quarter of an inch on a photo measuring 8 by 10 inches should be large enough. The dimensions of your drawing should be larger than your gridded photograph. If you have used a ¼ inch grid on the

249

photograph, you should at least double the size of your drawn image by constructing a grid of ½ inch square dimensions. Experiment with different relationships between the grid of the photo and the grid on your drawing.

Place the prepared photo side by side with the gridded paper. Begin the drawing by analyzing the visual contents of the top left square on the photo, and translate that information into a solid tone or color that best approximates it. If the square in the photograph is not evenly toned, you will have to determine what value or color best represents it.

After you finish this drawing, you may wish to do another, perhaps one that uses a finer grid pattern, thereby achieving a sharper, more photo-realistic image.

DONALD SULTAN

One of contemporary artist Donald Sultan's primary role models is Edouard Manet, who many people consider to be one of the founders of the Modern Era. Like Manet, Sultan is compelled to document "our modern times," and he is fascinated by the drama of contemporary events. Many of his artworks are based upon newspaper photographs of such things as industrial fires, a battleship with guns blazing, and airplane crashes. The history of art, particularly nineteenth-century art, is also a primary source of material for this artist. Like Manet, Sultan enjoys reworking subject matter of the Old Masters and transforming traditional themes into highly personal visual statements.

Inspired by seeing an eighteenth-century still-life of a lemon painted by the Spanish artist Zurbarán, Sultan has since gone on to do an extensive series of semi-abstract paintings and drawings using lemons, eggs and other still-life subjects as his theme. Some of the most striking drawings in this series have imaginatively transformed this yellow fruit into brooding black forms that transcend their innocent origins. Figure **12.11** shows one of Sultan's early black lemon drawings in which the lemon is transformed into a mysterious, and somewhat foreboding, mass which hovers before us.

Sultan does not primarily use the theme of black lemons in his drawings for symbolic reaons but as a way of transforming conventional still-life material into original graphic imagery. "I wanted to introduce something black into all the lushness," he explained, "something that could be a hole and a volume at the same time. To have weight pressing on the lushness of the fruit. To introduce a mysterious quality. To make the still-life into something industrial, weighty."

Lemon and Eggs March 15 1989 (Fig. **12.12**) was completed approximately a year after the drawing shown in Figure **12.11**. Sultan makes use of a more complex compositional space in this piece by overlapping the forms of the lemon and two eggs. He makes effective use of the natural tendency of charcoal dust to spread across the paper, surrounding these black forms with a mysterious halo.

On a variation of the previous drawing Sultan tightly groups four eggs (Fig. **12.13**) into a composition that beautifully exploits the negative and positive shapes on the picture plane. All these drawings reveal Sultan's masterful ability to transform prosaic still-life materials into dynamic and compelling drawings, part image, part abstract shape.

12.11 Donald Sultan, *Black Lemon Feb. 28 1988*, 1988. Charcoal on paper, 22¼ × 17¾ in (56.5 × 45 cm). Courtesy, M. Knoedler & Co., Inc., New York.

Project 74

Developing an Image

Materials: Newsprint pad (for preliminary sketches), rag or bond paper, drawing medium of your choice.

Choose for your subject several examples of one distinct fruit or vegetable. Some possibilities that come to mind are pears, artichokes, eggplants, or even the decorative gourds and dried corn available in the fall. Do not draw one, use anything from two to four examples. Arrange them on a tabletop in an interesting composition, fix your lighting and make some preliminary sketches to determine how you will begin to develop a unique image out of these everyday images. Sultan used two visual means dramatically changing the tonal value of the lemons and drawing them closely cropped.

Your choice of medium could play an important role in achieving a distinctive vision. Try a new drawing medium or reconfigure the way you use a certain material. But you cannot simply rely on the materials to achieve your effects for you. The medium must be connected to the concept. Think in terms of refining your ideas with each successive image. Notice which aspects work and emphasize those elements in the next drawing.

12.12 (above left) Donald Sultan, *Lemon and Eggs March 15 1989*, 1989. Charcoal on paper, 48 × 60 in (121.9 × 152 cm). Courtesy, M. Knoedler & Co., Inc., New York.

12.13 (above right) Donald Sultan, *Four Eggs May 25 1988*, 1988. Charcoal on paper, 48 × 60 in (121.9 × 152 cm). Courtesy, M. Knoedler & Co., Inc., New York.

12.14 Pat Steir, *The Brueghel Series (A Vanitas of Style)*, 1982–4. Oil on canvas, 64 panels, each 28½ × 22½ in (72.3 × 57.1 cm). Courtesy, Robert Miller Gallery, New York.

12.15 Pat Steir, *Self After Rembrandt #4*, 1985. Etching, 26¼ × 20 in (66.7 × 50.8 cm). Courtesy, Crown Point Press, New York.

12.16 Pat Steir, *Self After Rembrandt*, 1985. Hardground, 26 × 20 in (66 × 50.8 cm). Courtesy, Crown Point Press, New York.

12.17 Pat Steir, *As Cézanne with a Dotted Line for Beard*, 1985. Monoprint, 24⅜ × 18 in (61.9 × 45.7 cm). Courtesy, Crown Point Press, New York.

PAT STEIR

In 1981 Pat Steir embarked on a long-term series of paintings and drawings that explored the question of style in the visual arts. "I feel there is really very little difference between stylistic modes of art history periods," she explained, "the 'alphabet' is the same but not the 'handwriting.' The difference is in the scale, in the use of space."

For some time prior to 1981, Steir had envisioned making a series of artworks that delved into the question of similarity and difference in style. Steir haunted museums in Europe – she lives part of the year in Amsterdam – looking carefully at the works of artists like Courbet, van Gogh, and Rembrandt, trying to find out what they had in common visually. But in order to begin her series on style she needed a unifying theme and image to express her ideas. One day on the train home from a museum in Rotterdam she took a better look at a poster she had just bought of Jan Brueghel's sixteenth-century floral painting. While the train sped along she excitedly folded and cut the reproduction into sections to see if it would be suitable for her series. By the time the train arrived in Amsterdam Steir knew she had found her central motif.

For two years after the discovery of this image Steir steadily worked on what was to become *The Brueghel Series (A Vanitas of Style)* (Fig. **12.14**). To create this multi-paneled artwork Steir divided the image of the Brueghel painting into a grid of sixty-four rectangles. Each of these sections was then painted in the style of a well-known artist (the individual panels measured 28½ by 22½ inches and formed a finished work almost 20 feet high and 15 feet across). Steir paid homage to the widest cross-section of artists imaginable, Vincent van Gogh, and Antoine Watteau standing side by side with contemporary artists such as Jackson Pollock and Richard Diebenkorn. The result is a macro image formed out of these micro examples of various visual styles and modes of expression.

More recently Steir has extended her inquiry into the nature of artistic style with a series of self-portraits that continue to explore art-historical issues such as graphic handwriting and appropriation (the use of historic images in contemporary art).

Since Steir spends a good part of her time in Amsterdam she has become particularly fascinated with stylistic issues of Rembrandt's work – her studio is directly across the canal from the house Rembrandt lived in. For *Self After Rembrandt #4* (Fig. **12.15**) Steir merges her psyche with that of Rembrandt and draws her image in his style. In this artwork Steir assumes a pose reminiscent of one of Rembrandt's famous portraits and manipulates tone with his concern for qualities of light and value.

Self After Rembrandt (Fig. **12.16**) imitates the kind of drawing studies that might be found in one of Rembrandt's notebooks. A finished sketch of Steir's head is ringed on the bottom of the page by detailed studies of her eye and mouth along with a less complete version of the drawing above.

Steir's "Self-After" series is by no means limited to Rembrandt. She has also used a host of other artists as conceptual models for her self-portrait series including Picasso, Courbet, and Cézanne. Her drawing titled *As Cézanne with a Dotted Line for Beard* (Fig. **12.17**) is a particularly distinctive image. Steir creates this portrait using some of the visual devices associated with Cézanne. For instance, portions of the composition are left in an unfinished state and elements of the face are reduced to simple geometric forms. What is striking about all these borrowings from the past is the way Steir manages to incorporate them into her own personal history. By holding a mirror up to the past Steir is able to see herself more clearly as an artist.

12.18 Robert Longo, *Untitled (Men in the Cities)*, 1980. Charcoal and graphite on paper, 9 ft × 60 in (274 × 152 cm). Courtesy, Metro Pictures, New York. Private Collection.

12.19 (opposite above) Robert Longo, *Men Trapped in Ice*, 1980 Charcoal and graphite on paper, 3 panels, each 60 × 40 in (152.4 × 101.6 cm). Courtesy, Metro Pictures, New York. Private Collection.

12.20 (opposite below) Robert Longo, *Untitled*, 1980. Charcoal and graphite on paper, 3 panels, each 60 × 40 in (152.4 × 101.6 cm). Courtesy, Metro Pictures, New York. Suzanne and Howard Feldman Collection.

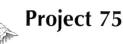

Project 75

Using Style as a Visual Element

Materials: Rag or heavyweight bond paper, drawing media of your choice.

The objective of this assignment is not to make a copy of a masterwork but to study and assimilate the stylistic methods of an artist whose work interests you. By now you might have developed a special liking and interest for one particular artist. Take out a book on this artist from your library. What kind of lines did they use? What compositional devices show up over and over again? What kind of media are most frequently employed? Analyze and take note of the artist's spatial, thematic, and graphic techniques. Then do a series of drawings of any appropriate subject in the style of this particular artist. Do not slavishly imitate them, however. Allow your own visual handwriting to merge with the assumed identity of your historic mentor. By examining the results of this assignment you should develop an increased awareness of stylistic content in drawing.

ROBERT LONGO

In the late 1970s and early 1980s Robert Longo drew critical attention for his series of monumental charcoal and graphite drawings which measured 9 by 5 feet. Each drawing in this group featured a single image of a man or woman placed on the white ground of the paper (Fig. **12.18**). These drawings were painstakingly rendered in a realistic style but what really set them apart was their ambiguous thematic meaning. They all pictured people frozen in a highly contorted pose as if they either had been shot or were simply captured by the camera wildly dancing to rock music. Many visual and thematic elements of these drawings worked together to contribute to their considerable impact: the large scale, the meticulous detail, their monochromatic tonality, and the mysterious meaning of the figures' poses.

Longo's drawing process is interesting and involves the use of the camera and optical projection equipment. Before this series Longo had made use of magazine illustrations as the basis for his work. But when he made these drawings, he had started taking his own photographs for economic reasons. During photo sessions Longo would bring his friends up to the roof of his loft and ask them to jump as high as they could while he photographed them in mid-air. Then he would put these photographic images into an overhead projector and draw the cast image onto his drawing paper.

These single images eventually led to sequential imagery that carefully orchestrated three figures within a single composition. In an interview Longo recalled some of the reasons for this change:

> I didn't want the drawings to be appreciated simply because they were drawings. That's why they became more than one drawing – diptychs, triptychs. As a group they functioned as an image – not as a drawing. They seduced the viewer, but it wasn't the craft, it was the scheme.

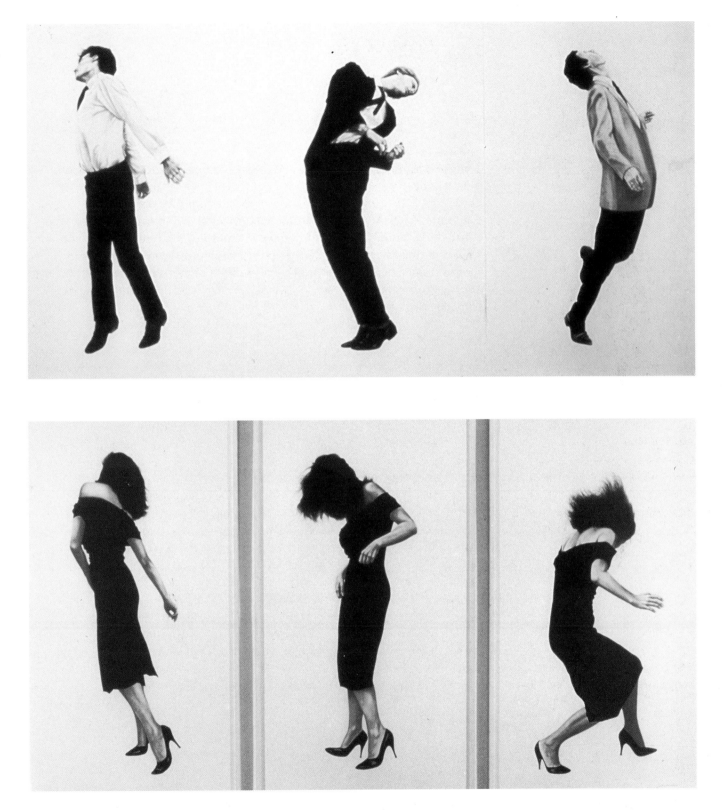

Figures **12.19** and **12.20** show the results of Longo's use of multipanel, sequential imagery. Men and woman, all attired as young professionals, are drawn in a variety of active, choreographed poses, some crouching as if they are falling, some rigidly contorted in spasms. By presenting us with groups of large-scale sequentially organized figures, Longo has created new aesthetic harmonics which are quite complex and ambiguous.

255

Project 76

Sequential Imagery

Materials: Rag or bond paper, drawing media of your choice, polaroid or ordinary camera and film.

This drawing assignment explores the use of multiple or sequential imagery in drawing. Use your camera to gather visual source material that can then be arranged and reorganized to suit your thematic interests. You might photograph a scene or object from different angles or from varying distances which in the terminology of film would correspond to a "long shot," "medium view," and "close-up." Use this photographic information as a visual reference in the creation of a multipaneled drawing. Each of the sections should be completed separately yet they must relate thematically to form a complete composition.

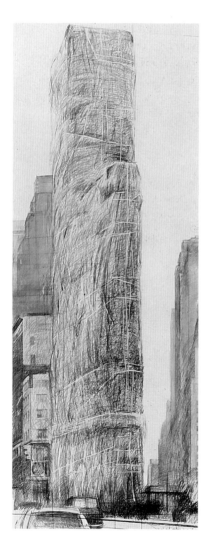

12.21 Christo, *Packed Building, Project for Allied Chemical Tower, New York,* 1968. Pencil, charcoal, and color pencil, 96 × 36 in (244 × 91.4 cm). Private Collection, Paris. Courtesy, the artist.

CHRISTO

Everyone has the ability to fantasize – without this form of imaginative dreaming we would not be entirely human. But while everyone engages in day dreams, few people manage to make their dreams a reality. Christo is a contemporary artist who has built a long and successful career on the basis of realizing his large-scale environmental art projects. Interestingly, the process of drawing plays a significant role in the materialization of these imaginative goals.

Most people have heard of Christo's major projects through the media: wrapping large sections of the Australian Coast, stretching a huge curtain across a Colorado valley, and more recently, wrapping Pont Neuf, a bridge crossing the Seine in the heart of Paris. Drawings are an intrinsic part of every stage of the Herculean task of implementing these grand schemes. During the formative stage of a project, Christo may make sketches that enable him to fully visualize what he wants to accomplish. Later more finished drawings are made to work out technical and aesthetic details. These drawings quite literally make work on the project possible as their sale to dealers, museums, and collectors raises the money to pay for expenses. Throughout the project, technical drawings are made (by engineers in Christo's employ) to show the manufacturers how to build the various parts and to show construction workers where to place structural supports or how to assemble materials.

Packed Building (Fig. **12.21**) is a project drawing envisioning how the Allied Chemical Tower in New York's Times Square would look wrapped with cloth and tied up like a package awaiting overseas postal delivery. This project was never actually realized, but the drawing allows us to clearly visualize how it might appear in reality.

Running Fence (Fig. **12.22**) graphically illustrated Christo's project for a cloth fence that would cross 24½ miles of rolling landscape in Northern California. Along with an accurate representation of how it would look, Christo used the drawing to make note of specific construction details.

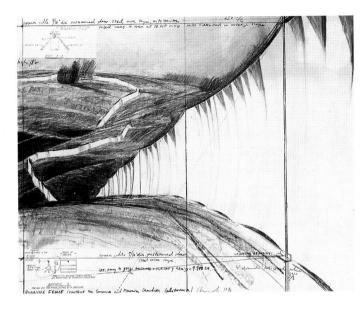

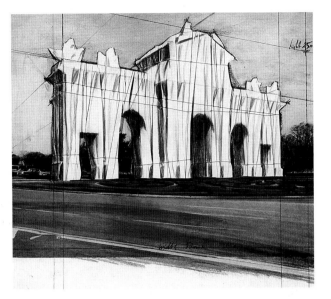

For a proposed project in Spain, Christo made use of a variety of materials and processes to communicate his ideas. *Puerta de Alcala Wrapped* (Fig. **12.23**) uses fabric, twine, a photostat, a map, a photograph and pastel, charcoal, and pencil markings. Christo draws directly on top of the photostated image of the Portal to suggest how it would look wrapped. The collaged map and photograph on the bottom of the drawing serve to situate this project geographically and show its relationship to the city of Madrid.

12.22 (above left) Christo, *Running Fence, Project for Sonoma and Marin Counties, California*, 1976. Pencil, fabric, charcoal, crayon, and engineering drawings, 22 × 28 in (56 × 71 cm). Courtesy, the artist.

12.23 (above right) Christo, *Puerta de Alcala Wrapped, Project for Madrid*, 1980. Pencil, fabric, twine, photostat from a photograph by Wolfgang Volz, pastel, charcoal, photograph, and map, 22 × 28 in (56 × 71 cm). Courtesy, the artist.

Project 77

Project Visualization

Materials: Rag or bond paper, appropriate materials of your choice.

Conceive of an environmental or sculptural project that for reasons of scale, practicality, and economics would be difficult if not impossible for you to undertake. Make a drawing or series of drawings that clearly visualizes this fantasy project. You may incorporate collaged materials such as maps and photographs to help us comprehend your vision, or you may rely entirely on drawn elements.

In this chapter we have looked at a representative sample of the images and ideas contemporary artists use in their work. Each artist has chosen to explore and develop only a few concepts out of the infinite possibilities that exist. What is important for you to understand is not so much what these individuals do, but how they visually think and how they develop their ideas using the medium of drawing. Hopefully these examples will prove to be inspirational and will encourage you to continue your creative involvement with drawing.

13 COMPUTER-AIDED DRAWING

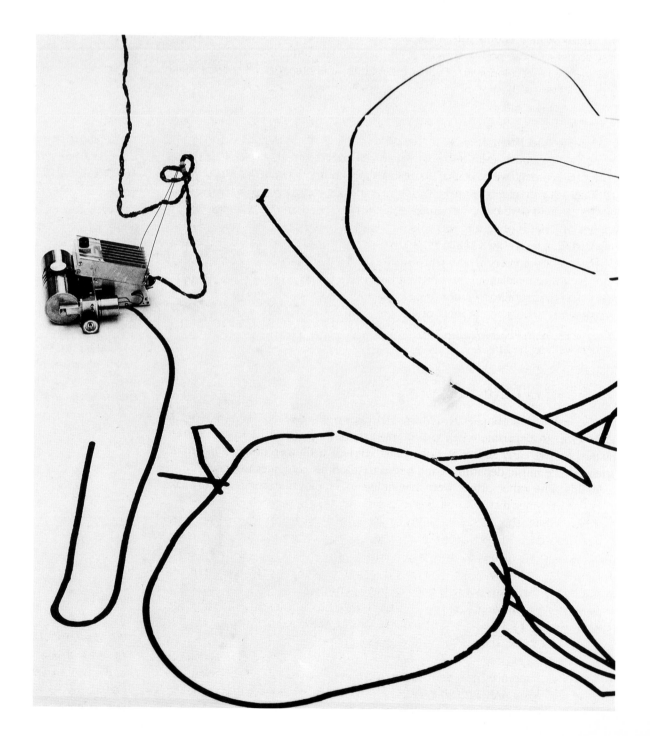

Considering the history of innovation in the visual arts, computer drawings were inevitable. Artists have, by necessity, always been inventors and adapters of new technologies that could be used in the practice of their craft. Knowledge of metallurgy, engineering, and chemistry were important tools of the trade for sculptors, architects, and painters. Even the common graphite pencil that we take for granted today was a new invention in the not too distant past and one which transformed the practice of drawing. It should come as no surprise that the personal computer has had a major impact on art, particularly in the field of drawing. In this chapter we will look briefly at the capabilities of computers and how artists are now using them. Those wishing to explore further will find some useful books listed under 'Further Reading' on p. 281.

Although computers have enjoyed widespread corporate use in our society for over thirty years it is only within the last decade that individual artists have gained easy access to these powerful tools. With the dramatic reduction in cost and size, and the rapid development of their capabilities, computers have become quite commonplace in illustrators' studios, design departments, architects' offices, and college art departments.

Strictly speaking the computer is not an artist's tool or medium but was invented as an aid to calculation. However, from your drawing experience you are now well aware of how much calculation goes into the practice of drawing. With today's computer systems we are able to manipulate encoded visual information and produce amazing graphic results. One cannot help but speculate how this versatile machine would have been used by someone like Leonardo da Vinci to explore and advance the fields of art and science.

Some people are awe-struck by the computer and attribute an almost magical power to it. Computers cannot perform any calculations you could not do yourself. They do these calculations, however, at incredibly fast speeds of up to a million a second. This capability to function rapidly and logically, coupled with an ability to magnetically store vast amounts of electronic information, has enabled computer scientists, and some artists, to teach a computer how to perform independently certain well-defined tasks.

COMPUTER DRAWINGS

Harold Cohen is an English painter who became interested in computers after he joined the art department of the University of California at San Diego in the late sixties. By the early seventies Cohen had learned computer programing from a friend in the music department and began to teach his computer to draw.

At this time other artists were beginning to employ the computer to make complex drawings that had a scientific look, but Cohen's use of the computer was more intriguing. This artist wrote a program, or set of operating instructions for the computer, that enabled his computer to make drawings independently. Once AARON – Cohen's name for the computer program and hardware system – is turned on, it draws continuously, never repeating itself. This system functions as an "expert system" or rudimentary form of artificial intelligence.

To render his drawings on paper Cohen invented a mechanical device he calls a "turtle" (Fig. **13.1**). This is a motorized pen wired to the computer that draws a line as it moves across a sheet of paper. To get the "turtle" to draw the way he wanted it to, Cohen had to program the computer to learn such drawing concepts as inside and out, the difference between image and ground, textures, and scale differences. In its earliest form AARON had at least two hundred rules. More recent versions of the software incorporate over two thousand.

13.1 (opposite) Harold Cohen's "turtle" in action at the San Francisco Museum of Modern Art, summer 1979. Courtesy, Harold Cohen.

13 COMPUTER-AIDED DRAWING

Presently, AARON can independently produce approximately four drawings an hour, each one similar in style to the previous one but unique. Once the initial program-writing phase of his work was completed and AARON was successfully making drawings on its own, Cohen considered himself a collaborator of this system and would hand-color the black and white drawings (Fig. **13.2**).

AARON has been under continuous development for over fifteen years. In its present state AARON now draws infinite variations of figures placed within lush settings of foliage and trees (Fig. **13.3**). To achieve this Cohen has coupled a thorough knowledge of classical drawing with an understanding of how the computer uses complex mathematical algorithms, or instructions, to perform certain tasks. Cohen's fascinating work with computer-aided drawing raises fundamental questions about creativity, originality, and how these issues relate to the form and function of drawing in the electronic age.

13.2 Harold Cohen, *Hand-Colored Computer Drawing,* 1982. 22 × 30 in (55.8 × 76.2 cm). Courtesy, Harold Cohen.

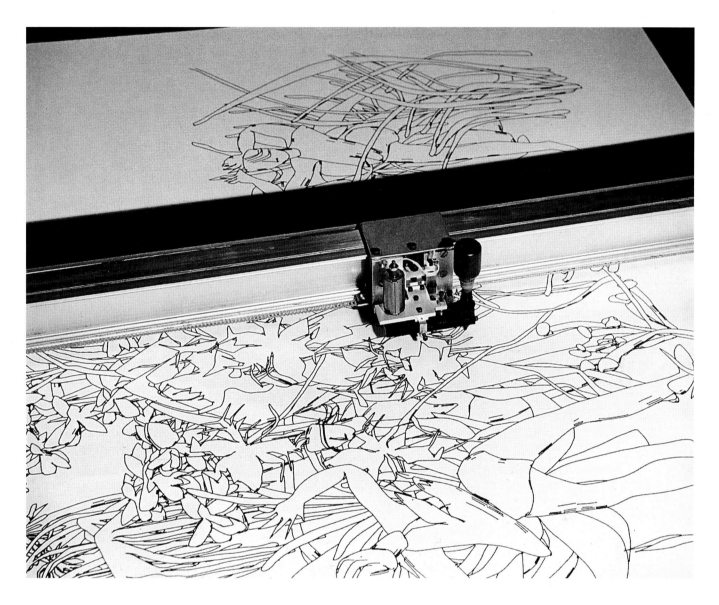

COMPUTER HARDWARE

Before you try your hand at computer-aided drawing you should have a basic understanding of computers. One of the most important concepts to understand about the computer is that it is an integrated system of both "hardware" and "software." The term hardware refers to the physical components of a computer. Software is the complex set of mathematical instructions written in a programing language that enables the computer to perform specific tasks. Before we discuss the specifics of drawing software, let us take a look at the basic equipment.

So many brands of equipment are now on the market that it is impossible to recommend one over the other (it is also beyond the scope of this book to provide detailed technical information about these products). We should at least become familiar with the various components of the computer system and have a general understanding of what they do and how they manipulate visual information.

Any computer hardware used in the graphic arts field can be broken down into three components: sensory inputs, the central processing unit, and display, or output devices.

13.3 Harold Cohen, *Drawing Machine Making AARON Drawing*, 1989. Computer-controlled pen plotter. Courtesy, Harold Cohen.

Sensory Inputs

Sensory inputs provide users with a means of feeding information to the central processing unit, or CPU, and controlling its calculations. Since the CPU can only manipulate digital information, the input devices are connected through what is called an "interface." Through this means, analogous information is converted into a special digital format that the CPU can read and understand.

There are three popular input devices that are connected to the CPU: a standard computer keyboard, a "mouse," and a scanner (other sophisticated input instruments exist but we will only discuss the most widely used).

Although some architectural drafting programs can be run efficiently with a keyboard, most drawing programs rely heavily on a mouse (Fig. **13.4**). The mouse is a palm-sized movable device wired to the CPU and used to control the movement of the cursor (a small graphic symbol used to indicate position on a computer screen). As the mouse is moved by hand on a flat surface the cursor moves correspondingly on the screen.

Scanners are relatively new input devices that are being used for computerized graphic art work (Fig. **13.5**). With this special instrument a photograph, drawing, or other flat artwork is scanned by passing the device over the image. The visual image is read by the scanner which converts it into digital information that can be used by the computer. Once the image is stored in this way by the CPU it can be manipulated and altered in a variety of ways.

13.4 (below) Mouse. Science Photo Library, London.

13.5 (right) Hand-held scanner. Courtesy, DFI Computer and Electrical UK Ltd.

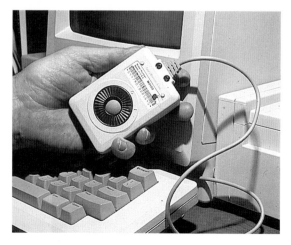

The Central Processing Unit

The central processing unit (or CPU) of the computer can be compared to our brain. It is here in a rectangular box that the complex and lightning quick computations are performed and stored in memory systems for later recall and manipulation (Fig. **13.6**).

The CPU can only work with numbers, therefore any input information must first be digitized or represented in numerical terms. In fact, the computer can only process combinations of 0 and 1. All numbers, therefore, must be transformed into binary code (sequences of 0s and 1s).

Central Processing Units vary considerably in terms of speed, physical size, the way they operate, and their memory capacity. One important aspect of the CPU is its ability to store electronic data in memory systems. One of the memory systems, the random access memory or RAM, only functions while the machine is on. If you turn the machine off, you lose the information stored there. The permanent memory system stores electronic data magnetically on small removable disks (called "floppy disks") or on a large capacity built-in device called a hard disk.

13.6 Video Monitor and Central Processing Unit. Zefa Picture Library, London.

263

You should be aware that there are two basic types of computer systems on the market: The Apple Macintosh and the IBM compatible systems. For the most part the equipment and software designed for one system will not work on the other. Until a few years ago the Macintosh line of computers enjoyed a distinct advantage in terms of suitability for graphic applications. IBM system hardware and software have now rapidly closed the gap. If in the future you plan to purchase a system to use for graphics, start by comparing and selecting the kind of software packages you would like to use. Then buy the hardware that can run these programs to your satisfaction.

Displays or Output Devices

The third component of the computer hardware system allows us to view and print the visual results of our manipulations. The two most common forms of output, or display, technology are video monitors and printing devices that produce "hard copy."

The video monitor or cathode ray tube (CRT) (Fig. **13.6**), is the computer's primary means of providing us with visual feedback. After the sensory devices input digitized information to the CPU the results can be viewed on a video screen. Monitors come in a variety of sizes and in both monochrome and color. The larger, more expensive full colour CRTs are capable of producing images of great detail and subtle tonal gradations.

Seeing your drawing on the monitor with clarity may be important, but it still does not produce a drawing on paper. This is where the output devices known as printers come in. Once you have achieved the desired results on the screen you will want to proof it on a printer. The most common types of printers are dot-matrix, ink-jet, laser, and thermal printers.

As part of the digitizing process the computer encodes visual information into what are called "pixels" (an abbreviated word that stands for "picture element"). This is the smallest bit of information that can be stored and displayed on the CRT. If you look closely at a computer screen display you will see that the image is created out of tiny colored dots (try and keep the CRT monitor you use at least an arm's length away because of concerns over excess electromagnetic radiation).

DOT-MATRIX PRINTERS use an arrangement of tiny pins or hammers which strike an inked ribbon to produce small black dots on paper that replicate the image you see on your screen.

INK-JET PRINTERS spray small dots of ink onto the paper. They are quieter than the dot-matrix impact printers, almost silent, and when colored ink is used multi-colored images can be produced.

LASER PRINTERS use a beam of laser light to form the dot-constructed image on a rotating drum. Wherever the laser beam hits the drum, toner powder is picked up and fused onto the paper to print the image.

THERMAL PRINTERS work by using heat to selectively melt wire particles that contain ink. Through this heat sensitive process the image is transferred onto paper.

Many of these printing devices are quite affordable and can be purchased by individuals for personal use. More advanced forms of output devices do exist. These are technically very sophisticated and very expensive and only owned by large businesses. A Linotronic 300 imagesetter produces 2,540 dots-per-inch resolution (compared to the maximum 300 dot resolution of the previously mentioned printers) and is used in the printing industry to produce the highest quality images suitable for reproduction.

Digitized visual information can even be fed directly into special cameras or video recorders and printed as photographs or played back as video images.

This should give you a basic overview of the hardware used in computer-aided drawing systems and a general idea of what the components do.

USING DRAWING SOFTWARE

Complete and specific software instruction is well beyond the scope of this text. In the first place there are too many computer drawing programs to choose from and each one uses its own special commands and procedures.

Among popular drawing programs worth considering are *Corel Draw* (Corel Systems Corp.), *GEM Artline* (Digital Research), and *Arts and Letters* (Computer Support Corp.). In order to give you an example of what drawing software is capable of and how it might operate, we will examine the features and operations of *Adobe Illustrator Version 3* (Adobe Corp.), one of the more popular and powerful drawing programs on the market. *Illustrator 3* runs on the Apple Macintosh system but Adobe has also published an IBM version of this software called *Illustrator for Windows*.

Making a drawing on paper with pencil or pen and ink is quicker and more direct than drawing the equivalent image with a computer. But programs like *Illustrator* enable you to modify and alter your computer drawn image quickly and easily. For instance, the weight, density, and color of a line can be easily changed through software commands. In addition, the size of the image, its orientation, and its placement on the page are easy to alter.

These features are particularly attractive to professional illustrators – the target market for this program – who must constantly consider how their artwork will work with type and how clients will respond to their efforts. If changes are requested, laborious redrawing of finished artwork is avoided, the modifications are made electronically through software commands, and another printout is quickly made.

Using "Illustrator"

When the program is installed and running, your computer screen will display important operating information in two places: the "Menu" at the top of the screen and the "Toolbox" functions on a vertical bar to the far left (Fig. **13.7**). In the middle of the screen is a white rectangular area, the drawing window, where visual elements are created and manipulated.

13.7 The screen of the Adobe Illustrator. From *Adobe Illustrator 3.0.* **Courtesy, Bantam Books, New York.**

The menu section allows you to choose among a variety of operational choices: File, Edit, Arrange, View, and Paint are among the most frequently used selections.

This is a visually driven program so every item in the tool box is identified by an "icon," or diagrammatic visual symbol. The various tools allow you to zoom closer in and farther out from an artwork, draw straight and curvilinear lines, rectangles, ellipses, blend tones, change scale, and do a variety of other tasks.

All of these option selections can be made through the use of the "mouse." To give you a feel for the way this software works we will briefly describe some of its tools and how to operate them.

The SELECTION TOOL (an arrow shaped icon) is one of the most frequently used tools of *Illustrator*. With it you can select menu functions, define groupings of lines for further work, and change the size of the working area of *Illustrator's* screen. Moving the mouse moves the selection arrow around and all you have to do to select a function is to position the arrow on the icon you wish to activate and click the mouse. The selection tool can also be used to select, resize, and move any drawing or segment of drawing on your screen. To move a visual object, or section of a drawing, without altering it you must first define exactly what you would like moved by creating a "selection marquee," or linear box around it (Fig. **13.8**). This defined group can then be dragged with the mouse and repositioned.

The HAND TOOL is used to move the entire image in the drawing area or "window" on your computer screen. To use this hand tool, you point to the hand shaped icon in the tool palette and click the mouse. The arrow turns into a hand when you move it in to the active drawing window and you can drag the image wherever you like.

13.8 Selection marquee of the Adobe Illustrator. From *Adobe Illustrator 3.0*. Courtesy, Bantam Books, New York.

The FREEHAND TOOL bears the closest relationship to a pencil or other traditional drawing instrument. Once you have chosen this tool you then use the mouse to draw the line. The moving cursor creates a line wherever it goes. Any complex, looping, and subtly modulated line can be drawn using the freehand tool and the mouse.

Although straight lines can be drawn with the freehand tool, perfectly straight lines, the kind usually drawn with a rule, are best made with the PEN TOOL. After you select the pen tool the cursor is moved by the mouse to where you want the line to begin and clicked. Position the cursor at the end point of the line and click the mouse again. A straight line appears on the screen.

The tool box icon that looks like a magnifying glass, called the ZOOM TOOL, allows you to enlarge or reduce defined areas of the active window. In this way you can zoom in for detailed manipulation of your artwork and then zoom back to get an overall view of the drawing.

Since *Illustrator* was designed to create artwork for the graphic arts trade, the TYPE TOOL allows you to incorporate type in relationship to the drawn image. You can use the type tool to create type, edit, or to set specifications for typefaces. With this tool, type is created and manipulated in the same way as drawings.

Sheared Type

For instance, with the SHEAR TOOL *Illustrator* can create special typographical effects. The line of type shown in Figure **13.9** was generated normally (not in italic) and the top was "pulled" along a horizontal axis.

Other features in the palette are the SQUARE and CIRCLE TOOLS. With these functions square, rectangle, circles, and ellipses can be accurately drawn and incorporated into any illustration or artwork.

13.9 Type sheared with the shear tool. From *Adobe Illustrator 3.0.* Courtesy, Bantam Books, New York.

Scanning

One of the most useful features of *Illustrator* is its ability to accept scanned images for alteration. For instance, a rough sketch made with marker and paper can be fed into the program through the use of a relatively inexpensive scanner. This drawing could then be used as a pattern or template and altered in a variety of ways. Photographs and copy machine images could also be used as scanner material.

Printing Your Work

Once you see results you are pleased with on the video monitor it is time to get a printout. The resolution and sharpness of your printout are dependent on the capability of the output device. Printed on a dot-matrix or ink-jet printer it will have a coarse look (suitable perhaps for proofing). Printed on a Hewlett-Packard laser printer or a printer with even higher resolution and your image will be smoother and sharper.

We have just covered some of the most basic features of *Illustrator* but this should give you some idea of what it can do and how drawing software operates. Drawing with a computer program is a complex process and it takes time to learn how to get satisfactory results. But if you plan to work as an illustrator or in the graphic arts fields these computer skills will be an essential part of your professional preparation.

13.10 Keith Ohlfs, *Mazda*. Computer-generated drawing. From *Adobe Illustrator 3.0*. Courtesy, Bantam Books, New York.

A PORTFOLIO OF COMPUTER DRAWINGS

Now that you have some idea of how computer equipment and software function together we will take a look at the different results artists and designers have achieved with this equipment.

The task of technical illustrators is to provide the viewer with an accurate picture of how a product looks and functions. Keith Ohlfs' drawing, *Mazda* (Fig. **13.10**), shows a cut-away view of an automobile revealing aspects of its internal engineering. Using Adobe's *Illustrator*, the artist found it easier to work on the complicated details of this drawing in sections and join them later. In order to draw some of the detailed mechanical featurs Ohlfs made extensive use of the zoom tool to magnify drawing sections he was working on. Line weights (the thickness of the line) are an important consideration to the technical illustrator because they help control how we read and understand a drawing. Once you draw a conventional line with ink you cannot easily change it, but with computer drawing you can draw and redraw the line until it works. Ohlfs first created the entire drawing with one line weight and later fine-tuned the image making some lines thinner and some thicker. Now that the image is in his permanent memory file he can make other versions with relative ease.

Barbara Nessim has been using computers to create art since the early 1980s and has established a well deserved reputation in this field. *Thoughts of the Moon* (Fig. **13.11**) was created on a Macintosh computer using Macpaint and Fullpaint software. In order to overcome size limits on her printer, she uses special software to divide the image into a multi-sectional "billboard" made up of 16 pages, each measuring 8½ by 11 inches. Nessim thinks of these sections as "tiles." Once they have been assembled and mounted onto a backing she hand colors each work with pastel or gouache.

13.11 (opposite) Barbara Nessim, *Thoughts of the Moon*. 1989. Computer-generated drawing with pastel on paper, 44 × 32 in (111.7 × 81.3 cm). Courtesy, the artist.

Michael David Brown is an illustrator who created the whimsical drawing shown in Figure **13.12** on a Macintosh computer system. Like many artists who have become acquainted with this new form of drawing, Brown finds the speed and flexibility of doing illustrations on the computer mesmerizing. "The computer has provided graphic options beyond anything I had ever imagined," he stated. "To have hundreds of colors at your disposal in seconds, to be able to alter your image and change colors instantly, to be able to reshape and manipulate is wonderful."

Vivienne Flesher, an American illustrator, had no prior experience with computer drawing before producing the artwork shown in Fig. **13.13**. Flesher scanned a black-and-white, hand-drawn illustration she did for Henri Bendel, an elegant New York fashion store, and modified it on the computer. By adding new lines, textures, and colors the original drawing was dramatically transformed by this technology. The hand-drawn look Flesher favors was thus maintained and modified through computer-assisted processes.

13.12 (opposite) Michael David Brown, *Pencil-headed Man*. Computer-generated drawing. Courtesy, Gerald and Cullen Rapp, Inc., New York.

13.13 (below) Vivienne Flesher, *Computer Illustration*, 1989. 14 × 10 in (35.5 × 25.4 cm). Courtesy, Vicki Morgan Associates, New York.

13.14 Wireframe telephone. Courtesy, Design Continuum, Boston.

13.15 Telephone Rendering. Courtesy, Design Continuum, Boston.

Industrial designers at The Design Continuum, a Boston-based company, now work almost exclusively at powerful desktop computers to speed the development cycle of new products. While no one has thrown away their sketchpads, more and more drawing functions are now performed on the computer.

One of the most significant aspects of new software on the market is its ability to create three-dimensional images of dazzling realism. Using 3-D capable software from Alias Research Inc., the project team from Design Continuum made a "wireframe" drawing of their product, a new telephone, as a first step in the design process (Fig. **13.14**). Any modifications at this stage could be made with a few clicks of the mouse. Once this preliminary linear skeleton was developed, designers used the specialized features of Alias software to fill in the linear framework with a smooth, variable toned "skin." This full-color rendering produced by the Alias software is so life-like that it almost appears to be a photograph of the actual telephone (Fig. **13.15**). Once Alias has been programed with information about the dimensions of the drawn object, the computer can move these illusionistic forms around in space and show how the forms look from any angle. This information can even be fed into computerized milling systems that can quickly create a working prototype.

Although these technological achievements may seem to push the limits of one's imagination, more challenging developments lie just around the corner. Artists and computer researchers have developed a process called "virtual reality" that could be of great significance to the visual arts. Virtual reality offers the opportunity to visually enter or walk into the spaces and lines of your computer drawing. By wearing special equipment hooked up to a computer such as goggles with movement sensors, miniature video monitors mounted in the eyepieces, and "data gloves" that have the power to manipulate what you see, artists can experience what it would be like to walk around inside their drawings. Imagine being able to enter the space of your computer generated landscape drawing or to experience the surrealistic still-life you created as an ant might experience it. This is not as far distant as you might imagine. A well-known software company promises to have a virtual reality program for architects on the market within months – certainly by the time you read this.

In a curious way, going forward into the brave new world of technically sophisticated graphic systems brings us full circle to the very beginnings of this medium. Virtual reality's synthetic computer-generated visions are greatly reminiscent of the magical, hallucinatory effects the earliest cave drawings produced. But all drawings are dreams of a sort if we think about it, potent dreams that have shaped our world and enriched our lives.

MUSEUMS AND GALLERIES

New York City

The Asia Society Galleries
725 Park Avenue
New York, NY 10021

The Frick Collection
1 East 70th Street
New York, NY 10021

The Metropolitan Museum of Art
5th Avenue at 82nd Street
New York, NY 10028

The Museum of Modern Art
11 West 53rd Street
New York, NY 10019

The Pierpont Morgan Library
29 East 36th Street
New York, NY 10016

North East Region

Boston Museum of Fine Arts
456 Huntington Avenue
Boston, MA 02115

Bowdoin College Museum of Art
Walker Art Building
Brunswick, ME 04011

Davison Art Center
Wesleyan University
301 High Street
Middletown, CT 06457

The Joan Whitney Payson Gallery of Art
Westbrook College
716 Stevens Avenue
Portland, ME 04103

Yale University Art Gallery
1111 Chapel Street
New Haven, CT 06103

East Coast Region

The Art Museum
Princeton University
Princeton, NJ 08544

The Carnegie Museum of Art
4400 Forbes Avenue
Pittsburgh, PA 25213

Fogg Museum of Art
Harvard University
Cambridge, MA 02138

The Institute of Contemporary Art
955 Boylston Street
Boston, MA 02115

Museum of Art
Rhode Island School of Design
224 Benefit Street
Providence, RI 02903

South East Region

The Ackland Art Museum
Columbia & Franklin Streets
University of North Carolina
Chapel Hill, NC 27599

The Baltimore Museum of Art
Art Museum Drive
Baltimore, MD 21218

The Corcoran Gallery of Art
17th Street & New York Avenue
NW Washington DC 20006

High Museum of Art
1280 Peachtree Street
Atlanta, GA 30309

**John and Mable Ringling
Museum of Art**
5401 Bay Shore Road
Sarasota, FL 34243

National Gallery of Art
4th Street & Constitution Avenue
NW Washington, DC 20565

New Orleans Museum of Art
Lelong Avenue, City Park
New Orleans, LA 70124

Smithsonian Institution
1000 Jefferson Drive
S.W. Washington, DC 20560

Mid-West Region

The Art Institute of Chicago
Michigan Avenue & Adams Street
Chicago, IL 60603

The Cleveland Museum of Art
11150 East Boulevard
Cleveland, OH 44106

**Cranbrook Academy of Art
Museum**
500 Lone Pine Road, Box 801
Bloomfield Hills, MI 48303

Des Moines Art Center
4700 Grand Avenue
Des Moines, IA 50312

Detroit Institute of Art
5200 Woodward Avenue
Detroit, MI 48202

Fort Wayne Museum of Art
311 East Main Street
Fort Wayne, IN 46802

Indiana University Art Museum
Indiana University
Bloomington, IN 49405

Milwaukee Art Museum
750 North Lincoln Memorial Drive
Milwaukee, WI 53202

The Nelson Atkins Museum of Art
4525 Oak Street
Kansas City, MO 64111

University of Iowa Museum of Art
150 North Riverside Drive
Iowa City, IA 52242

University Museum
Southern Illinois University
Carbondale, IL 62901

Walker Art Center
Vineland Place
Minneapolis, MN 55403

South West Region

Archer M. Huntington Art Gallery
University of Texas at Austin
Art Building, 23rd & San Jacinto Streets
Austin, TX 78712

Dallas Museum of Art
1717 North Harwood Street
Dallas, TX 77006

The Menil Collection
1515 Sul Ross
Houston, RX 77006

The Museum of Fine Arts
1001 Bissonnet
Houston, TX 77005

San Antonio Museum of Art
200 West Jones Avenue
San Antonio, TX 78215

University Art Museum
The University of New Mexico
Fine Arts Center
Albuquerque, NM 87131

West Coast Region

Asian Art Museum of San Francisco
The Avery Brundage Collection
Golden Gate Park
San Francisco, CA 94118

The John Paul Getty Museum
17985 Pacific Coast Highway
Malibu, CA 90265

Los Angeles County Museum of Art
5905 Wilshire Boulevard
Los Angeles, CA 90036

**Museum of Contemporary Art,
Los Angeles**
250 South Grand Avenue
California Plaza
Los Angeles, CA 90012

**San Francisco Museum of Modern
Art**
401 Van Ness Avenue
San Francisco, CA 94102

Seattle Art Museum
1st Avenue & University
Seattle, WA 98101

APPENDIX II
PUZZLE SOLUTION

GLOSSARY

AQUATINT An *etching* technique using acid on copper and producing an effect similar to *watercolor*. An unlimited range of tonal gradations from the palest grays to velvety blacks is possible with this medium.

BASSWOOD A lightweight yet hard wood often used in the manufacture of drawing boards.

BINDER The substance in paints, *pastels*, and *chalks* that holds the particles of *pigment* together in workable consistencies.

BISTER A brown *pigment* made from the soot of burnt beechwood. Before the advent of more permanent pigments, this colorant was used in paints for *watercolor* and *wash* drawings.

BOND PAPER Drawing paper that is heavier, whiter, and of a better quality than *newsprint*.

CHALK A drawing material in stick form made by binding powdered calcium carbonate with various gums (see also *pastel*).

CHAMOIS A soft pliant sheet of leather that is used to erase *charcoal* marks on paper.

CHARCOAL A drawing instrument made by charring tree and vine branches in a heated chamber.

CHIAROSCURO Literally means "light/dark" in Italian and refers to the modelling of form by means of light and dark *values*.

CHROMATIC Relating to color, especially *hue*.

CHROMATIC INTEGRATION The organization of color in the *composition*.

COLLAGE An artform in which bits of paper, cloth, or other materials are glued onto a flat surface.

COLOR WHEEL The circular arrangement of *hues* based on a specific color theory.

COMPLEMENTARY COLORS *Hues* directly opposite each other on the *color wheel* and therefore as different from each other as possible. When complementary colors are placed next to each other in a work of art, they produce intense color effects.

COMPOSITION The arrangement of visual elements such as lines, spaces, tones, and colors in a work of art.

COMPRESSED CHARCOAL A drawing instrument made by mixing powdered *charcoal* with a binding agent and, under intense pressure, forming small cylinders or square-sided sticks.

CONTÉ CRAYON A French crayon with a waxy base, which helps it flow smoothly.

CONTOUR The perceived edges of any three-dimensional form.

CONTOUR LINE In drawing or painting, the line that follows and emphasizes the *contours* of three-dimensional forms.

CROSS-CONTOUR LINES *Contour lines* that intersect one another at oblique angles.

CROSS-HATCHING Closely spaced lines that intersect one another and create modulated tonal effects (the superimposing of *hatching* in opposite directions).

EASEL A free-standing frame designed to hold a canvas or drawing board in an upright position.

ELLIPSE A closed curve having the shape of an elongated circle – visible when true circles are seen from an oblique angle.

ENGRAVING A printmaking technique in which lines are incised on a metal plate with a cutting tool known as a "burin." The plate is inked and the surface wiped clean, leaving the ink in the recessed areas of the plate. Damp paper is placed on top of the plate, picking up the ink from the recessed lines when the plate is run through a press.

ETCHING A printmaking technique in which lines are produced by using acid to corrode selective areas of a metal plate. Ink is then transferred to paper using the same technique as for an *engraving*.

FIGURE 1. In two-dimensional works of art, the principle form or forms as distinguished from the background. 2. The human form.

FOOL-THE-EYE A form of realistic drawing or painting that creates believable illusions of three-dimensional forms on a two-dimensional surface. Also known by the French term "trompe l'oeil."

FOREGROUND In two-dimensional drawings or paintings, those forms or *figures* that appear nearest to the viewer.

FORMAT The shape and size of the drawing surface and its position in relation to the viewer.

FROTTAGE See *rubbing*.

FULL-SPECTRUM COLOR The use of a wide variety of *hues*, or colors, rather than variations of a single hue.

GESTURE DRAWING A drawing technique using rapidly drawn lines to describe and emphasize the essential visual characteristics of a form or forms.

GOUACHE A water-based paint that is more opaque than *watercolor*.

GRAPHITE A soft, black, carbon-based mineral that is mixed with varying amounts of clay and used in the manufacture of drawing pencils and crayons.

GROUND 1. The surface on which a picture is drawn or painted. 2. In two-dimensional works of art, those areas that make up the background.

HARDGROUND An acid-resistant coating applied to the surface of an *etching* plate. The hardground is easily scratched off by an etching needle leaving clear lines on the plate for the acid to corrode.

HATCHING A drawing technique in which parallel lines are placed close together to create tonal areas that model three-dimensional form.

HIGHLIGHTS In a drawing or painting, those areas that represent the lightest *values*.

HUE The color quality identified by the name of a specific color, such as blue, red, or yellow.

INDIA INK A permanent black liquid drawing medium consisting of lampblack *pigment* (made from carbon) in a natural resin *binder*.

INK A liquid drawing medium consisting of *pigments* or dyes suspended in a water- or resin-based solution.

INTENSITY In color, the fullest degree of brightness or *saturation*.

INTERMEDIATE COLOR See *tertiary color*.

KNEADED ERASER A soft, rubbery, pliable material used to erase *chalk* or *charcoal* lines. The eraser is kneaded to keep it clean.

LAYERING A drawing technique in which *pastel* or *chalk* lines are drawn over one another.

LITHOGRAPHIC CRAYON A fatty-based drawing crayon that contains high amounts of wax and tallow, thus giving it smooth-flowing characteristics.

LITHOGRAPHY A printmaking technique in which a greasy substance is used to make a drawing on a stone or metal plate. Only the drawing then retains the ink when the plate is inked for printing.

MASONITE A hard, synthetic board created by compressing wood fibers together under intense pressure.

MASSED GESTURE DRAWING A drawing technique using groups of lines which describe the subject's basic tonal characteristics.

MONOCHROMATIC Having a color scheme of tonal variations of one *hue*.

MYLAR A brand of strong, thin plastic film that can be drawn upon using special inks and drawing instruments.

NEWSPRINT An inexpensive, cream-colored, wood-pulp paper suitable for beginners.

OCHER A natural earth mineral that is processed into *pigments* of various yellow and red-brown colors.

OIL STICK A modern drawing medium made by mixing *pigments* with an oil *binder*. These soft and adhesive materials can be applied directly to a surface and can also be spread and blended with a brush soaked in turpentine.

PAPIER D'ARCHES (ROLL ARCHES PAPER) Paper made by Arches, the French paper manufacturing company.

PASTEL A colored *chalk* that consists of *pigment* mixed with a water-based gum *binder* and molded into small cylinders or sticks.

PATTERN A repetitive arrangement of certain forms or designs.

PERSPECTIVE A system of representing three-dimensional space on a two-dimensional surface. Forms of perspective include:

> **Atmospheric/Aerial Perspective** Forms in the *foreground* are made clear and sharp and those in the distance are represented by blurred and less distinct shapes.

> **Empirical Perspective** A form of perspective drawing that is guided by direct experience rather than theory or formula.

> **Linear Perspective** A system of representing items in space based on the fact that parallel lines receding into the distance converge at vanishing points on the horizon.

> **One-Point Perspective** Parallel lines converge at one point on the horizon.

> **Two-Point Perspective** Parallel lines converge at two points on the horizon.

> **Three-Point Perspective** Parallel lines converge at three points on the horizon.

PICTURE PLANE The flat surface area of the drawing.

PIGMENT Finely powdered coloring material used in the manufacture of artists' paints and drawing materials.

PRIMARY COLOR A *hue*, or color, that cannot be created by mixing together other colors. Varying combinations of the primary colors can be used to create all the other colors in the spectrum. In *pigments*, the primary colors are red, yellow, and blue.

RAG PAPER High quality artists' paper made entirely from cotton fibers. This paper is characterized by its longevity and outstanding surface qualities.

RHOPLEX A trade name for a synthetic acrylic resin that is used as the *binder* in the manufacture of artists' acrylic paints. These paints are thinned with water but, upon drying, become durable and waterproof.

ROLL ARCHES PAPER See *papier d'Arches*.

RUBBING (FROTTAGE) A graphic impression of a *textured* surface made by laying paper over this surface and rubbing with *graphite, chalk* etc. until an image appears.

SANGUINE A rusty-red *chalk* used for drawing.

SATURATION The relative purity or *intensity* of a color.

SCALE The relative size of an object compared to a "normal" or constant size. In architecture, for example, the scale of a building is illustrated by the size of a human figure.

SCREENPRINTING See *serigraphy*.

SECONDARY COLOR The *hue*, or color, that results when two primary colors are mixed together. In *pigments*, the secondary colors are orange, green, and purple.

SEPIA A dark brown, semi-transparent *pigment* used in *watercolor* and *inks*. Once made from the inky secretions of the cuttlefish, more permanent synthetic pigments are used today.

SERIGRAPHY (SCREENPRINTING) A printmaking technique in which thick inks are forced through a fine mesh screen. By selectively blocking and leaving open portions of the screen (stencilling) the image is transferred to the paper.

SIGHTING A means of determining *composition* through the use of a device that creates a rectangular "window."

SILVERPOINT A drawing technique in which a thin silver wire is used to make marks on the surface of a specially coated paper.

SOLVENT The liquid that is used to thin paints or clean brushes after use. Two of the most common solvents are water and turpentine.

SUGAR-LIFT ETCHING A method of drawing directly onto the *etching* plate using a mixture of sugar dissolved in *india ink*. The plate is then covered with an acid resistant varnish and, when this is dry, the plate is immersed in warm water. The sugar gradually dissolves, lifting the varnish with it and exposing the plate to the acid.

TEMPERA A paint made by binding *pigments* in a water-based emulsion that is traditionally made from egg yolk.

TERTIARY (INTERMEDIATE) COLOR Any *hue*, or color, produced by a mixture of *primary* and *secondary* colors.

TEXTURE In a work of art, the tactile qualities of a three-dimensional surface or the representation of such qualities.

TONE A term used in art to refer to the lightness or darkness of a color.

VALUE The relative darkness or lightness of a color or neutral tone, ranging from black to white.

VANISHING POINT In *linear perspective*, the point on the horizon at which parallel lines appear to converge.

VELLUM A heavy, high-grade paper often used in certificates and diplomas. Historically, vellum was made from skins of newborn calves but today this term refers to a number of smooth, quality papers.

VINE CHARCOAL A drawing tool made by charring twigs of wood, usually willow, or pieces of vine.

WASH A thin transparent film of *ink* or *watercolor* applied to the drawing surface.

WATERCOLOR A transparent water-soluble medium consisting of *pigments* bound with gum.

WOODCUT A printmaking technique in which areas are carved away from the flat surface of a wood plank. Only the uncarved portions of the wood accept the ink and register as dark marks on the print surface.

WORKABLE FIXATIVE A thin liquid containing dissolved resin that is sprayed over a *pastel* or *charcoal* drawing to protect it from smudging. Workable fixatives allow artists to redraw over the fixed surfaces.

FURTHER READING

General Reference

Bertram, Anthony, *1,000 Years of Drawing*. London: Studio Vista, 1966.

Elderfield, John, *The Modern Drawing*. New York: The Museum of Modern Art, 1983.

Goldman, Paul, *Looking at Prints, Drawings, and Watercolors*. Santa Monica, CA: John Paul Getty Trust, 1989.

Klee, Paul, *Pedagogical Sketchbook*. London: Faber & Faber, 1968.

Leonardo da Vinci, *Leonardo da Vinci Drawings*. New York: Dover, 1983.

Mendelowitz, Daniel M., *Drawing*. Palo Alto, CA: Stanford University Press, 1980.

Moskowitz, Ira (ed.), *Great Drawings of All Time*, 4 vols. New York: Shorewood Publishers, 1962.

Rawson, Philip, *Drawing*, 2nd edn. Philadelphia, PA: University of Pennsylvania Press, 1987.

The Elements of Drawing

Chaet, Bernard, *An Artist's Notebook: Techniques and Materials*. New York: Holt, Reinhart & Winston, 1979.

———— , *Art of Drawing*, 3rd edn. New York: Holt, Reinhart & Winston, 1983.

D'Amelio, Joseph, *Perspective Drawing Handbook*. New York: Van Nostrand Reinhold, 1984.

Frank, Peter, *Line and Image: The Northern Sensibility in Recent European Drawing*. New York: Independent Curators Press, 1987.

James, Jane H., *Perspective Drawing: A Directed Study*. Englewood Cliffs, NJ: Prentice Hall, 1981.

Medar, Joseph, *The Mastery of Drawing*, Vols I and II. Pleasantville, NY: Abaris Books, 1977.

Olszewski, Edward J., *The Draftsman's Eye: Late Italian Renaissance Schools and Styles*. Bloomington, IN: Indiana University Press, 1981.

Warshaw, Howard, *Drawings on Drawing*. Santa Barbara, CA: Ross-Erikson, 1981.

Creative Expressions

Baur, Jack, text by Alice Neel, *Drawings and Watercolors*. New York: Robert Miller Gallery, 1986.

Clark, Kenneth, *Landscape into Art*. New York: Harper & Row, 1976.

Collischan van Wagner, Judy K., *Lines of Vision: Drawings by Contemporary Women*. New York: Hudson Hills, 1989.

Gardner, Howard, *Art, Mind, and Brain: A Cognative Approach to Creativity*. New York: Basic Books, 1984.

Goldstein, Nathan, *Figure Drawing*, 3rd edn. Englewood Cliffs, NJ: Prentice Hall, 1987.

Guptile, A., *Color in Sketching and Rendering*, 2nd edn. New York: Van Nostrand Reinhold, 1989.

Henks, Robert, *New Visions in Drawing and Painting*. Independence, MO: International University Press, 1984.

McClelland, Deke, *Drawing on the Macintosh*. Homewood, IL: Business I Irwin, 1990.

Miller, William C., *Creative Edge*. Redding, MA: Addison-Wesley, 1989.

Rose, Bernice , *New Work on Paper Three*. New York: Museum of Modern Art, 1985.

Spencer, Donald D. and Spencer, Susan L., *Drawing with a Microcomputer*. North Oaks, MN: Camelot Publishing, 1989.

INDEX

Numbers in italics refer to illustration captions

285